# TABLE OF CONTENTS

FALL 2022
VOLUME 3, NUMBER 1

EDITOR
**LEON WIESELTIER**

MANAGING EDITOR
**CELESTE MARCUS**

PUBLISHER
**BILL REICHBLUM**

JOURNAL DESIGN
**WILLIAM VAN RODEN**

WEB DESIGN
**HOT BRAIN**

Liberties is a publication of the Liberties Journal Foundation, a nonpartisan 501(c)(3) organization based in Washington, D.C. devoted to educating the general public about the history, current trends, and possibilities of culture and politics. The Foundation seeks to inform today's cultural and political leaders, deepen the understanding of citizens, and inspire the next generation to participate in the democratic process and public service.

*Engage*
To learn more please go to libertiesjournal.com

*Subscribe*
To subscribe or with any questions about your subscription, please go to libertiesjournal.com

ISBN 978-1-7357187-8-1
ISSN 2692-3904

EDITORIAL OFFICES
1604 New Hampshire Avenue NW
Washington, DC 20009

DIGITAL
@READLIBERTIES
LIBERTIESJOURNAL.COM

# Liberties

# CASS R. SUNSTEIN

# *The Court Gone Wrong*

What is happening on the Supreme Court of the United States? The Court has overruled *Roe v. Wade*. It has rejected the whole idea of a right to privacy. It is sharply restricting the ability of federal agencies to protect safety, health, and the environment. It is limiting voting rights. It is expanding the rights of gun owners, commercial advertisers, and those who wish to spend a lot of money on political campaigns. It is moving very quickly, and almost always in directions favored by the political right.

None of this comes out of the blue. It is the culmination of four decades of intense work, meant to move constitu-

tional law in exactly these directions — work by activists and scholars, politicians and lawyers-for-hire, corporate lobbyists and the National Rifle Association, religious organizations and the Federalist Society. It was a long process, but it seems fair to announce that they have finally won.

I received a firsthand sense of what was afoot in 2002, when I found myself in a large audience at the University of Chicago Law School, waiting to hear a speech by Douglas H. Ginsburg, who was then Chief Judge of the influential Court of Appeals in Washington, DC. Tall and thin, with a bemused and scholarly manner, Judge Ginsburg is an able and fair-minded judge. He is a generous and kind person to boot. He is also a graduate of the University of Chicago Law School, which was my home institution at the time. I like and admire him. But on that day I was flabbergasted by what I heard; actually I was appalled. Judge Ginsburg called for something like a constitutional revolution.

Judge Ginsburg contended that the Supreme Court abandoned the United States Constitution in the 1930s, when it capitulated to Franklin Delano Roosevelt and his New Deal. He sought to return to the Constitution as it was understood before the capitulation.

Ginsburg began by emphasizing that "ours is a written Constitution." Making a bow in the direction of populism, he contended that this observation is controversial in only one place: "the most elite law schools." The fact that the Constitution is written has major implications. If judges are "to be faithful to the written Constitution," they must try "to illuminate the meaning of the text as the Framers understood it."

In Ginsburg's account, judges were faithful to the Constitution for most of the nation's history — from the founding period, in fact, through the first third of the twentieth

7

century. But sometime in the 1930s, "the wheels began to come off." In that period the nation faced the Great Depression, and President Franklin Delano Roosevelt tried to do something about it, above all with his New Deal, which greatly expanded the power of federal agencies, through, for example, the creation of the National Labor Relations Board and the Securities and Exchange Commission. Responding to "the determination of the Roosevelt Administration," Ginsburg declared, the Supreme Court abandoned its commitment to the Constitution as written.

How did this happen? Judge Ginsburg's first example was Congress' power, under the Constitution, to "regulate commerce . . . among the several states." What does this mean? Judge Ginsburg referred, with enthusiastic approval, to the Supreme Court's view that Congress lacked the constitutional power to ban child labor. But his strongest complaint involved the Supreme Court's decision, in 1937, to uphold the National Labor Relations Act, which protects the right of workers to organize and to join labor unions. In upholding the Act, the Supreme Court said that when strikes occur, interstate commerce is affected. A strike in Pennsylvania often has a big impact elsewhere.

Judge Ginsburg objected that this is "loose reasoning" and "a stark break from the Court's precedent." But his complaint went much deeper. The Court's acceptance of the National Labor Relations Act was not merely "extreme." It was also "illustrative." He objected that the Supreme Court has upheld the Clean Air Act, which, in his view, violates the separation of powers by granting excessive discretion, and hence legislative power, to the Environmental Protection Agency. Under the Constitution, legislative power rests in Congress; Judge Ginsburg said that because the Clean Air Act

allows the Environmental Protection Agency to make the law, the "structural constraints in the written Constitution have been disregarded."

But even this is just the tip of the iceberg. Since the 1930s, the Court has "blinked away" crucial provisions of the Bill of Rights. Of these, Judge Ginsburg singled out the Constitution's Takings Clause, which says that government may take private property only for public use and upon the payment of "just compensation." Judge Ginsburg complained that the Takings Clause has been read to provide "no protection against a regulation that deprives" people of most of the economic value of their property. In other words, the Court allows government to impose regulations, especially in the environmental area, that do not quite "take" private property but that much diminish its value. Judge Ginsburg objected that the Supreme Court has not required government to compensate people for their losses.

At the same time that the Court has "blinked away" the individual rights of the American Constitution, judges have manufactured new rights of their own devising. In his view, these rights are fake news. In this way, members of the Supreme Court have acted not as judges, but as a "council of revision with a self-determined mandate." What does Judge Ginsburg have in mind? His chief objection was to the right of privacy. It seemed clear that he rejected *Roe v. Wade*.

But he went much further than that. He singled out the Court's decision in 1965 in *Griswold v. Connecticut*, the foundation of modern privacy law. In that case, the Court struck down a law forbidding married people to use contraceptives. Judge Ginsburg objected that a judge "devoted to the Constitution as written might conclude that the document says nothing about the privacy of" married couples. The *Griswold*

decision, he added, is "not an aberration." It is matched by recent decisions holding that the Constitution imposes limits on capital punishment, such as its decision in 2002 striking down a death sentence imposed on a mentally ill defendant.

Judge Ginsburg's narrative, then, is simple and straightforward. Until 1933 or so, the Court followed the Constitution. At that point, it adopted a "freewheeling style." But Judge Ginsburg offered real hope for the future. In recent years, a small but growing group of scholars and judges have been calling for more fidelity to the constitutional text, focusing on the original meaning. "Like archeologists, legal and historical researchers have been rediscovering neglected clauses, dusting them off, and in some instances even imagining how they might be returned to active service."

Judge Ginsburg's leading example? The Second Amendment to the Constitution, which protects the right "to keep and bear arms." Judge Ginsburg gave a strong signal that judges might well strike down gun control legislation. His exact words? "And now let the litigation begin."

Judge Ginsburg was speaking here of what he himself called the Constitution in Exile — the real Constitution, the one that should be restored. What made his argument so remarkable is that Judge Ginsburg was, and is, a responsible person with a first-rate intellect — and, in his judicial capacity, he displays a large measure of restraint. But in his speech twenty years ago, calling for radical changes in constitutional understandings, Judge Ginsburg was hardly speaking in a vacuum. On the contrary, he was summarizing a line of argument that such conservative luminaries as Robert Bork, Edwin Meese, and Antonin Scalia had been developing for decades. That line of argument had been embraced by many members of the Federalist Society and the

Republican Party as well. "And now let the litigation begin" — that was their mantra.

Judge Ginsburg set out a kind of Constitutional Wish List. The goal was to transform constitutional law, and to do so in major ways. For those on the right, the Constitutional Wish List included the following:

- A broad understanding of the individual right to possess guns.
- A rejection of *Roe v. Wade*.
- A rejection of the right to privacy in general.
- New limits on the power of modern administrative agencies, including the Environmental Protection Agency.
- Dramatically strengthened property rights.
- Sharp reductions in Congress' power under the Commerce Clause.

In 2002, all this seemed unlikely in the extreme. Would the Supreme Court really be prepared to turn so many constitutional understandings upside down? Astonishing but true, we now have to put a checkmark next to each and every item on the list. They have all been achieved.

Before 2008, the Supreme Court had rejected the idea that the Constitution creates an individual right to possess guns. Now the Court recognizes that right — and is steadily expanding it. Before 2022, *Roe v. Wade* was the law of the land. Now it is overruled. Before 2022, the right of privacy seemed firmly ingrained. Now it is gone. Until recently the Court had embraced, in ways large and small, the power of modern administrative agencies, including the Environmental Protection Agency. Now it has sharply limited that power. Just as Judge

Ginsburg hoped, property rights have indeed been enhanced. The Court did uphold the Affordable Care Act, by a vote of 5-4, but in the process it announced new limits on Congress' power under the Commerce Clause. And all this might be just the beginning. With respect to voting rights, freedom of speech, the rights of criminal defendants, freedom of religion, and much more, dramatic changes seem to be coming.

There are two ways to understand the recent developments. The first, in the spirit of Judge Ginsburg's argument, is jurisprudential. It insists that the Court is now being "faithful to the written Constitution" — that it is (finally!) following the Constitution "as written." On this understanding, the Supreme Court has become "originalist," which means that it is adhering to "the original public meaning" of the Constitution. If that is the right understanding, we need to ask a single question: Is originalism right?

The second understanding is political. It is that the Court's understanding of the Constitution is uncomfortably close to the political preferences of the current Republican Party. On that view, the Court is lawless. It is acting as a political body, even if it understands itself as being faithful to the written Constitution.

Let us begin with originalism. What is it, and what does it entail?

That is a surprisingly hard question to answer. The term itself was coined in 1980 by the Stanford law professor Paul Brest, in a law review article that sketched what, in his view, were devastating objections to the whole idea. Brest meant to challenge a view about constitutional interpretation associ-

ated with Bork and Raoul Berger (a legal historian at Harvard) that was, at the time, a kind of fringe position, with little support even among right-of-center academics. (At the time, conservative scholars tended to argue more broadly in favor of "judicial restraint," understood as respect for the decisions of the political process.) As a fringe position, originalism had little influence and political salience.

What a difference forty years make! Originalism now comes in many shapes and sizes. It is used as a political rallying cry. It has been elaborated in great detail by a host of sophisticated law professors, among them Lawrence Solum and William Baude; law professors who embrace originalism disagree vigorously with one another about what originalism means and requires. Some originalists follow Ginsburg in emphasizing the intentions of the Constitution's authors; others think that the search for the authors' intentions is a fool's errand. Some originalists think that it is important to respect precedent, even if they are not originalist; other originalists think that it is entirely wrong and that the original understanding should trump the Supreme Court's mistakes. Some originalists think there is a difference between "interpretation," where judges must follow the original meaning, and "construction," where judges have nothing to follow and must exercise discretion; other originalists reject this distinction and seem to be appalled by it.

Amid all the debates, one variety of originalism now seems to be on the ascendency. It is called "public meaning originalism." Justices Thomas, Alito, Gorsuch, and Barrett seem committed to it, and Justice Kavanaugh seems to like it a lot. On this view, the Constitution must be interpreted in a way that fits with its original public meaning. That means that terms such as "freedom of speech," "executive power," "cruel

and unusual punishment," and "due process of law" must be understood not only in accordance with their semantic meaning, but also with the meaning that people would have given to them at the time of ratification in 1789. Interpretation, in this view, depends on an inquiry into history, not on any kind of moral judgment. As Richard Fallon puts it, public meaning originalists contend that the public meaning can be "discovered as a matter of historical and linguistic fact." In Solum's words, "the meaning of the constitutional text is a function of the conventional semantic meanings of the words and phrases as they are enriched and disambiguated by the public context of constitutional communication."

Originalists are keenly aware that it is often hard to discover the original public meaning of words as they were used in the late eighteenth century. They know that reasonable people, including specialists, disagree on historical questions. They also know that unanticipated social changes can greatly complicate the search for historical answers. What is the original public meaning of "freedom of speech" as applied to radio and television? How should we understand protection against "unreasonable searches and seizures" as applied to the Internet? The most careful originalists do not ignore these questions. Still, they insist that if judges are originalists, many questions are easy. They add that when originalism leaves some questions open, or makes them really hard to answer, at least it provides the right orientation.

There is no doubt that if judges followed the original public meaning of the Constitution, constitutional law would be radically transformed. The national government would be permitted to discriminate on the basis of both race and sex. If the national government wanted to segregate people by race, it

could almost certainly do that. The right to free speech would be greatly truncated. Blasphemy could probably be made a crime. States could probably allow public figures to recover huge sums of money for defamation.

The idea of one person, one vote would be out the window. If the federal government wanted to take away people's Social Security benefits, or welfare benefits of various sorts, it might not have to give them any kind of hearing. Contrary to Judge Ginsburg's view, protection of property rights would be reduced, not expanded: some of the most careful scholarly work suggests that according to the original public meaning, the Constitution protects only against physical invasions of property, and imposes no barrier to regulation that greatly diminishes the value of property. All this, by the way, is just the beginning of what would be possible.

Originalists are acutely aware that their preferred method might lead to outcomes that many people would abhor, and they have a variety of responses. Some originalists insist on the importance of democracy and on the need to rely on democratic processes, not on courts. If originalism might allow government to do what some people consider to be terrible things — for example, to ban contraceptives or to sterilize people — originalists respond that in a self-governing society, the appropriate correctives come from We the People, not from unelected judges. Consider the case of abortion: originalists say that if the right to choose is to be protected, it must be because majorities want them to be.

Other originalists emphasize the rule of *stare decisis*: judges should ordinarily respect their own precedents, even if they are wrong. True, the Court was willing to overrule *Roe v. Wade*, but even in doing so the Court proclaimed that other privacy rulings, including those that protect the right to use

contraceptives, were not necessarily at risk. Still other original-ists contend that the answers to the historical questions might not be so terrible. Many originalists are at pains to say that on their approach, states may not segregate school children by race. Some originalists contend that on originalist grounds a broad right to freedom of speech is secure.

Most fundamentally, originalists argue that their approach is mandatory rather than optional. If it requires abhorrent conclusions, that is, in a sense, a sign of intellectual integrity, a badge of honor. In their view, originalism is the only legitimate approach to interpretation, and it is justified independently of the outcomes that it produces.

Each of these arguments must be addressed on its own terms. Democracy is fundamental of course, but is it really right to think that the scope of freedom of speech, racial equality, and personal privacy should be defined by political majorities? Would the United States have been better off if the Supreme Court in the twentieth century had limited these and other rights to the understandings of the eighteenth and nineteenth centuries? Consider these words from Justice Felix Frankfurter, from a memorandum that he wrote in 1953 for his files during the Supreme Court's deliberations over the constitutionality of school segregation:

> But the equality of the laws . . . is not a fixed formula
> defined with finality at a particular time. It does not
> reflect, as a congealed summary, the social arrangements
> and beliefs of a particular epoch. It is addressed to the
> changes wrought by time and not merely the changes
> that are the consequences of physical development.
> Law must respond to transformations of views as well
> as that of outward circumstances. The effects of changes

in men's feelings for what is right and just is equally
relevant in determining whether a discrimination denies
the equal protection of the laws.

Some originalists believe in respecting precedents, but many do not. Is it sufficient to say, on behalf of a theory of interpretation, that it would not do nearly as much damage as it might, because some judges are willing to ignore that theory?

The most important argument about originalism is that it is mandatory. Many originalists seem to think that the very idea of interpretation requires their preferred approach. This is a colossal mistake. The Constitution does not contain instructions for its own interpretation. It does not have an Originalism Clause, directing judges to be originalists. Originalism is a choice. Whether it is the right choice must depend, inevitably, on whether it would make the American constitutional order better rather than worse. That is not a hard question.

In these circumstances, it is natural and fitting to wonder: what, exactly, have liberals been doing over the last few decades? For that matter, what have conservatives been doing, if they reject originalism or seek other paths? The short answer is: a lot. Like Paul Brest in 1980, many liberals have been vigorously attacking originalism, sometimes on the grounds that it is much squishier than it purports to be, sometimes on the grounds that it would lead to a host of intolerable results.

Liberals have also been developing their own theories of interpretation. For decades, Ronald Dworkin argued for "moral readings" of the Constitution, in which judges would infuse broad phrases with their preferred moral content. Some members of the Supreme Court, including Anthony

Kennedy and Sonia Sotomayor, have seemed to agree with Dworkin; consider the Court's decision to require states to recognize same-sex marriages. In 1980, John Hart Ely published *Democracy and Distrust*, which argued that judges should protect democracy itself, by safeguarding democratic processes and those who are at a particular disadvantage in them. Some members of the Court, including Ruth Bader Ginsburg and Stephen Breyer, have often seemed to agree with Ely. Left-of-center theorists and practitioners, such as Larry Kramer, the former dean of Stanford Law School, have developed other approaches as well, with occasional (and steadily mounting) enthusiasm for a more modest role for the Court, with an insistence that the justices are most likely to protect those who have the most power. But on the current Court, dominated by Republican appointees, it is not easy to find five votes in favor of positions associated with Dworkin, Ely, and Kramer.

This point puts a bright spotlight on the elephant in the room: the relationship between constitutional law and political convictions. It would be a true miracle if originalism, properly applied, consistently led to outcomes favored by the extreme right-wing of the contemporary Republican Party. To update Ginsburg's Wish List: robust gun rights, a ban on affirmative action, reduced voting rights, restrictions on campaign finance laws, no abortion rights, no privacy rights, strengthened property rights, sharp limits on the power of administrative agencies, greater protection of commercial advertising, no right to same-sex marriage, reduced rights for criminal defendants. What are the odds, really, that a particular method

of interpretation, honestly applied, would always result in outcomes pleasing to one political side? On the Supreme Court, however, justices who favor originalism are drawn, time and time again, to rulings that belong on that particular Wish List.

It is important to say that among law professors who are interested in originalism, we can find humility or uncertainty about what, exactly, the relevant history shows. And among law professors who are interested in originalism, we can sometimes find left-of-center conclusions — as in the view that the Equal Protection Clause requires the authorities to protect people of color every bit as well, and as much, as they protect white people. But there is no mistaking the fact that as it is being practiced by real judges, originalism is consistently producing conclusions that delight the political right.

In these circumstances, it is fair to wonder whether the Supreme Court is doing law at all.

**The Court Gone Wrong**

CARISSA VELIZ

# Digitization, Surveillance, Colonialism

As I write these words, articles are mushrooming in newspapers and magazines about how privacy is more important than ever after the Supreme Court ruling that has overturned the constitutionality of the right to have an abortion in the United States. In anti-abortion states, browsing histories, text messages, location data, payment data, and information from period-tracking apps can all be used to prosecute both women seeking an abortion and anyone aiding them. The National Right to Life Committee recently published policy recommendations for anti-abortion states that include criminal penalties for people who provide information about self-managed

abortions, whether over the phone or online. Women considering an abortion are often in distress, and now they cannot even reach out to friends or family without endangering themselves and others.

So far, Texas, Oklahoma, and Idaho have passed citizen-enforced abortion bans, according to which anyone can file a civil lawsuit to report an abortion and have the chance of winning at least ten thousand dollars. This is an incredible incentive to use personal data towards for-profit witch-hunting. Anyone can buy personal data from data brokers and fish for suspicious behavior. The surveillance machinery that we have built in the past two decades can now be put to use by authorities and vigilantes to criminalize pregnant women and their doctors, nurses, pharmacists, friends, and family. How productive.

It is not true, however, that the overturning of *Roe v. Wade* has made privacy more important than ever. Rather, it has provided yet another illustration of why privacy has always been and always will be important. That it is happening in the United States is helpful, because human beings are prone to thinking that whatever happens "over there" — say, in China now, or in East Germany during the Cold War — to those "other people," doesn't happen to us — until it does.

Privacy is important because it protects us from possible abuses of power. As long as human beings are human beings and organizations are organizations, abuses of power will be a constant temptation and threat. That is why it is supremely reckless to build a surveillance architecture. You never know when that data might be used against you — but you can be fairly confident that sooner or later it will be used against you. Collecting personal data might be convenient, but it is also a ticking bomb; it amounts to sensitive material waiting for the

chance to turn into an instance of public shaming, extortion, persecution, discrimination, or identity theft. Do you think you have nothing to hide? So did many American women on June 24, only to realize that week that their period was late. You have plenty to hide — you just don't know what it is yet and whom you should hide it from.

In the digital age, the challenge of protecting privacy is more formidable than most people imagine — but it is nowhere near impossible, and every bit worth putting up a fight for, if you care about democracy or freedom. The challenge is this: the dogma of our time is to turn analog into digital, and as things stand today, digitization is tantamount to surveillance.

Behind the effort to digitize the world there is a corporate imperative for growth. Big tech companies want to keep growing, because businesses are rarely stable animals — companies that are not on their way up are usually on their way down. But they have been so successful and are so gigantic that it is not easy for big tech to find room to grow. Like Alice in Wonderland, trapped in the rabbit's house after growing too big, tech companies have their arms and legs sticking out the windows and chimney of the house of democracy. One possibility for further growth is to attract new users. But how to find fresh blood when most adults with internet access worldwide are already your users? One option, which Facebook is unscrupulously pursuing, is to focus on younger and younger children. The new target group for the tech company is children between the ages of six and nine. This option is risky. There are several investigations into Facebook and Instagram for knowingly causing harm to minors. What, then, are the other options for the expanding behemoths?

The preferred option these days is to digitize more aspects of the world. Despite the rapid advancement of digital technologies, most of our reality is still analog, even after the onset of covid. Most of our shopping is offline. Most readers prefer paper books. Much of our homes, our clothes, many of our conversations, our perceptions, our thoughts, and our loved ones are analog. That is, most of our experience has not been translated into ones and zeroes, which are the building blocks of digital technology. Experience, almost by definition, is directly lived, unmediated by a screen.

Tech giants wish to change all that. They share the desire to digitize the world because it is an easy way to gain more ground, to expand by enlarging the house. In this sense, digitization is the new colonialism. Digitization is the way to grow an empire in the twenty-first century. Everything analog is a potential resource — something that can be digitally conquered and converted into data and then traded, directly or indirectly. That is why Google keeps coming up with new products. Maps? Chrome? Android? Those were not designed *for* you. They are all different ways of collecting different data *from* you. That is why Facebook and Ray-Ban have together come out with new glasses that have microphones and a camera: more "data capture," which in reality means the conquest of life by corporate avarice. That is why Apple is launching an augmented reality product, and why Microsoft is proposing a platform that creates three-dimensional avatars for more interactive meetings. And why Facebook — sorry, Meta — is insisting on its metaverse.

23

The tech titans assure us, of course, that their new inventions will respect our privacy. What they fail to mention is what I call the Iron Law of Digitization: *to digitize is to surveil*. There is no such thing as digitization without surveillance. The very act of turning what was not data into data is a form of surveillance. Digitizing involves creating a record, making things taggable and searchable. To digitize is to make trackable that which was beyond reach. And what is it to track if not to surveil?

A good example of the close link between tracking and surveillance are AirTags. In 2021, Apple launched the AirTag: a small coin-like device with a speaker, a Bluetooth antenna, and a battery, designed to help people keep track of their items. You can attach an AirTag to your keys and link it to your phone, and if you lose your keys, the device will ping Apple products around it and use Bluetooth to triangulate its location, which you can see on a map on your phone. The AirTag can also beep to let you know where it is.

Keeping track of your keys seems innocent enough, but the AirTag is designed to track more in general. You can track a wallet instead of keys, or a purse — and not necessarily *your* purse. Privacy and security experts warned Apple that AirTags would be used for stalking. In response, Apple said it had implemented a notification feature that alerts people with iPhones if there is an AirTag following them. But this measure is insufficient in various ways. First, many people don't have iPhones, and if you have an Android you have to download an app to be notified through your phone; the vast majority of people have not downloaded it and will likely not download it. You might think that the phone notification is not necessary, because AirTags are meant to start beeping at a random time between eight and twenty-four hours after they have been separated from their paired iPhones, but the beeping is so

24

low that people might not hear it. Moreover, eight hours is plenty of time for a stalker to follow and find his victim. Even if you have an iPhone, my own experience is that there is no guarantee that you will be notified about an AirTag that is tracking you. A few months ago my brother and I rented a car from a peer-to-peer network. After a few hours of driving the car, my brother's iPhone notified him that there was an AirTag around. The owner of the car had placed it in a locked glove compartment. My iPhone, however, never notified me of the AirTag — even after having been near the car for more than twenty-four hours. We never heard any beeping.

The New Jersey Regional Operations & Intelligence Center issued a warning to police that AirTags posed an "inherent threat to law enforcement," as criminals could use them to identify officers' "sensitive locations" and personal routines. One year after their launch, there were at least 150 police reports in the United States mentioning AirTags, and recently, one murder case. That might not seem like much, but cases are likely in the thousands, given how many people might not notice they are being tracked or might not report it to the police. Not that reporting it to the police is of great help. Police often don't know what to do about it; sometimes they don't even take a report, which leaves vulnerable people (women, most often) unprotected.

Stalking affects an estimated 7.5 million people in the United States every year and, not surprisingly, it is on the rise. Last year a study by the security company Norton found that "the number of devices reporting stalkerware on a daily basis increased markedly by 63% between September 2020 and May 2021." We are producing more and more technology to track — of course stalking is on the rise! To expect anything different would be to engage in self-delusion. In the pre-in-

ternet age, it was expensive, effortful, and risky to spy on someone. Today, you can buy an AirTag for $29.

What is most striking about the AirTag example is how foreseeable these issues were. It's not that the AirTag was misused in any surprising or imaginative way. When an AirTag is used for stalking, it is being used exactly according to its design. Some dual uses of technology are surprising. Gunpowder was originally designed for medicinal purposes — who would have thought it might change war forever? But tracking technologies are designed to track — and tracking is surveillance, and surveillance amounts to control. Human beings are social beings, which means that most of the time what we are most interested in is other people. We should hardly be surprised when tracking technology is employed to track people, the most salient element of most people's lives. AirTags are the tracking device *par excellence*. They are designed to track and to do nothing else. Yet smartphones, for all their many uses, are also tracking devices. Your phone can make calls and take photographs, but above all it collects information about you and others.

Too many people enthusiastic about digital technology are under the impression, as convenient as it is misguided, that if people consent to data collection, and if the data processing happens within our own phone or computer, there is no problem with privacy. If only it were so simple. There are at least two reasons why there are still privacy issues when it comes to the collection of personal data in our devices.

First, there is no informed consent in data collection. The consent we give is neither consent, because it is not truly

voluntary, nor informed, because no one has any idea where that data may end up and what inferences may be drawn from it in the future. We are forced into "consenting" because if we do not consent we cannot be full participants in our society. There is no leeway for negotiation in platforms' "terms and conditions." It's their way or the highway, and their way can change at any time and without warning. But we could not give informed consent even if we had the chance, because data is so abstract and unpredictable in the kinds of uses it may have, and the kind of inferences it will be able to produce, that not even data scientists can give informed consent. No one knows what consequences today's data collection will have.

Second, data creation is itself morally significant. The term "data collection" is somewhat misleading, in that it seems to suggest that to collect data is to assemble things that are already there. But data are not natural phenomena, like mushrooms that we find in the forest. We do not find data. We *create* data. Data collection implies data creation. And that act of creation is a morally significant decision, because data can be dangerous. Data can tell on us: whether we are thinking about changing jobs, whether we are planning to have children, whether we might be thinking of divorcing, whether we might be considering having an abortion. Data can harm people. For this reason, data creation carries with it a moral responsibility and a duty of care towards data subjects.

"What privacy problem can there be if the data is on the user's encrypted phone?," a tech executive asked me once, assuming that users are in control of their phones, and ignoring the many examples that show otherwise. Our phones have a life of their own. They send data to third parties without us even realizing it, for starters. Every phone connected to the internet is hackable. Domestic abusers can

take advantage of technologies to control their partners and their children. If an abuser forces you to share your password, the data that your phone has created without your asking it (where you have been, who you have called, etc.) can work against you. A TSA officer can ask you to unlock your device at the border and can download your data. That can happen even if you are American, and even if it is your work phone, in which you have confidential professional data. The police can ask you to unlock your phone too. And who can guarantee that an insurer will not ask you for access to that data in the future? If you do a commercial DNA test, even if it was only for fun, you are obligated to disclose it to your insurer. Can we be sure insurance companies will not ask for access to our smartwatches or smartphones some day? As soon as personal data has been created and stored, there is a privacy risk for the data subject, which then spills on to be a risk to society.

The risks to society are significant and varied. They go from national security (all that personal data can be used to extort public officials and military personnel, for instance) to threats to democracy, which will be my focus here.

Just like the old colonialism, digitization carries with it a certain ideology that it seeks to impose. It comes with ideas of what progress looks like. Old colonialism imposed a certain language, etiquette, clothing, social institutions, and ways of life. New colonialism imposes code, exposure as etiquette, a weakening of old social institutions, and ways of life that lead to societies of control.

Technology is *never* neutral. Tech companies find it convenient to present their products as neutral tools, but marketing bears little relation to truth. Artifacts inevitably embody values. We make artifacts so that they do something for us, and we wouldn't bother making them if we did not

value whatever it is that they do. Since technology is designed with a purpose in mind, artifacts end up having affordances. An affordance is what the artifact invites you to do. It is an implicit relationship between the designer and the user through the object designed. A chair affords you to sit on it. We design things like buttons and handles to match our bodies, perceptive systems, and desires. A gun affords you to use it to threaten, hurt, and possibly kill; it does not afford you to cook with it. Pans and skillets afford you to cook. Surveillance tools afford control; they afford the chance of keeping a close watch on something or someone. A camera allows you to watch anyone who appears in its purview. And a camera is a tool for surveillance irrespective of whether the footage is encrypted and in your phone. This is not to imply that encryption is not important. It certainly is, because it adds very necessary security to sensitive data. But no amount of encryption will detract from a camera the affordance to surveil.

Contemporary surveillance tools all too often are a double-sided mirror, which not only enables you to watch others but also enables others to watch you. They are often also camouflaged as some other kind of tool, like a phone or a TV. Before the age of the internet, surveillance tools were mostly one-directional. A Stasi agent monitoring a suspect in East Berlin through a wiretap could listen to her target without thereby opening the possibility of being wiretapped herself. But the internet allows for multiple directional flows of information. You might buy an Amazon Ring camera to watch whoever gets near your door, but that device allows Amazon (and your housemates) to learn things about you. It can track when you leave your home, and when you come home and with whom. It can also be used to inform the police (in some cases without your permission and even without a

warrant). And anything that can be online is hackable, so you are enlisting into the risk of criminals accessing your footage, for example, to figure out when you are away so they may rob your home.

Your Ring camera is not only surveilling you — it is also watching and listening to your neighbors. Amazon has recently rejected the request made by Senator Ed Markey that the company introduce privacy-preserving changes to its doorbell camera after product testing showed that Ring routinely records audio conversations happening as far away as the opposite sidewalk. Your neighbor could be recording the conversations that you have at your doorstep or driveway and could post them online. If you use a screen door and keep your front door open, a Ring device could be recording the conversations you have in your living room. The potential for blackmail, stalking, and public shaming is immense.

Other surveillance tools are much less obvious than a camera. Take something like Alexa. It's a speaker that plays music. It is a timer. It can read you the news. It can allow you to order all kinds of products. It doesn't look or feel like a surveillance machine, but it is keeping a close watch on you. Amazon wants to turn Alexa into an appliance that can predict what you want. For it to accomplish its task, it has to know you very well. Alexa collects data from what you say and shares it with as many as forty-one advertising partners. If you have not opted out, human beings might be reviewing what you tell Alexa. And, sure, you can have your data periodically deleted and opt out of human review, but your data will still be used to train Alexa, whether you like it or not.

In more than one out of ten transcripts analyzed, Alexa "woke up" accidentally and recorded something surreptitiously. The same thing happens to other digital assistants. An Apple

whistleblower confessed to have "heard people talking about their cancer, referring to dead relatives, religion, sexuality, pornography, politics, school, relationships, or drugs with no intention to activate Siri whatsoever." The police might be interested in getting access to that data. Alexa recordings have already been used in all kinds of legal cases, from proving infidelity in a divorce case and identifying drug users in a household to providing evidence in murder cases. If police can access recordings made by our devices at home, how is that different from having the police living under your roof? We would never be at ease having the police living in our homes, so why do we invite Alexa in? Aren't we uncomfortably close to building a police state, or at the very least building the structure that could support an almost omniscient police state?

In the 1990s, we owned the objects we bought. Today we still pay for our phones and doorbells, but they work for other people, and often against our own interests. And of course it's not just AirTags, smart doorbells, smartphones, and Alexas. It's your smartwatch, and your smart TV, and car, and electricity meter, and kettle, and laundry machine. Everything "smart" is a spy. And while every piece of data may seem uninteresting and innocuous, you would not believe how precise a picture emerges from joining the dots of all those data points.

Data creation and data collection will only increase if we continue the trend towards augmented and virtual reality. These technologies will want to collect much more data about everything, from your indoor spaces to the movement of your eyes. Eye-tracking technology will be crucial in creating a rich digital environment. It is likely that virtual reality will mimic human sight, which focuses on something and blurs the background. If everything is equally salient, it is harder to navigate your surroundings and you can easily get

motion sickness. To simulate our natural visual experience by offering low-quality images in your peripheral vision and high-quality images on what you focus on, the tech needs to identify what you want to pay attention to. Eye-tracking is the most important source of information for that. Relatedly, eye-tracking can be used to increase the user's ability to direct and control her experience.

Unfortunately, your gaze can be incredibly revealing. Your eye movements, iris texture, and pupil size and reactions can inform others about your identity (through iris recognition), state of mind (e.g., if you are distracted), emotions (e.g., if you are afraid), cognitive abilities (based on factors like how long you look at something before acting), your likes and dislikes (including your sexual interests), your level of fatigue (through analyzing your blinking), whether you are intoxicated, and your health status (by looking for patterns of eye movements that might be symptomatic of problems such as Alzheimer's or schizophrenia). Even if some of these inferences might be scientifically questionable, experience suggests that companies are likely to try their luck with them anyway.

By creating and collecting so much personal data, it is becoming more difficult to avoid surveillance. Even if you leave your phone at home (I know, a big if), you might still get caught by surveillance through dozens of cameras as you go about your day. If we plaster our cities with sensors of various kinds, there is no opting out or escaping it. The danger is in the long term. Surveillance is a slow-acting poison. Its consequences are not immediately apparent. All of which leads to the surveillance

delusion: the mistaken belief that surveillance has many advantages and no significant costs. For every individual decision, surveillance can seem like an attractive solution in the short term, when we imagine that all goes exactly as planned: it seems to keep us safer, it helps us track what we care about. But the long-term and systemic effects of surveillance are often overlooked. Under the surveillance delusion, only the benefits of surveillance are valued, and surveillance is understood to be a convenient solution to problems that could be solved through less intrusive means. But surveillance often creates more weighty problems for democracy in the long run than the ones it can solve.

Democracy is a complex house with many pillars sustaining it, and it can crumble so slowly that we might not know immediately when we are undermining it. Journalism, for example, "the fourth estate," has long been considered an important pillar of democracy. Citizens have to be well informed enough about their society to be able to make autonomous democratic decisions, such as whom to vote for. When we reduce privacy, we weaken journalism. In July 2021, a leak revealed that more than fifty thousand human rights activists, academics, lawyers, and journalists around the world had been targeted by authoritarian governments using Pegasus, a hacking software sold by the Israeli surveillance company NSO Group. It is probably not a coincidence that the most represented country among the people who were targeted with spyware, Mexico, is also the deadliest country in the world for journalists, accounting for almost a third of journalists killed worldwide in 2020. When journalists do not have privacy, they cannot keep themselves or their sources safe. As a result, people stop going to journalists to tell their stories, and journalists quit their jobs before they lose their

lives, or they focus on safe stories, and investigative journalism slowly dies, thereby gravely hurting democracy.

Some people think that if surveillance is done by corporations and not the government, the concern is lessened. Others think the opposite: that if surveillance is done by the government and only by the government, we will be safe. Both views are wrong: corporate surveillance is as dangerous as government surveillance and vice versa, and even peer-to-peer surveillance undermines ways of life that are supportive of freedom and democracy.

Giving too much personal data to governments will grant them too much power, which can support authoritarian tendencies. As I have argued, surveillance tools afford control, and when governments hold too much control over the population they become authoritarian. You might happen to trust your current government, but you cannot be sure that you will trust the next government. And you cannot be sure that a foreign power will not hack the data held by your government, or even invade your country. One of the first stops for Nazis in a newly invaded city was the registry, because that is where the personal data was held that would lead them to Jews. The best predictor that something will happen in the future is that it has already happened in the past, and personal data has already been used to perpetrate genocide. A contemporary Nazi regime with access to the kind of fine-grained data we are collecting would be near indefeasible. That alone makes surveillance reckless. China is using its surveillance apparatus against "enemies of the state": from minorities such as the Uyghurs and the Tibetans to the defenders of democracy in Hong Kong. We must dismantle architectures of surveillance before they get used against us.

Corporate surveillance is just as much of a problem. First,

any data collected by companies can — and often does — end up in the hands of governments, whether through governments purchasing data, legitimately acquiring it (e.g., through a warrant or subpoena), or hacking it. In practical terms, corporate and government surveillance are indistinguishable. Moreover, corporations do not have our best interest at heart, and these days they are certainly not guardians of democracy or the common good. Thanks to corporate surveillance you can be unfairly discriminated against for a job, or insurance, or a loan. And personal data can be used to produce personalized propaganda, pit citizens against one another, and undermine civic friendship and democracy. Companies, after all, think of themselves as answerable only to shareholders.

Corporate surveillance is all the more worrying in the case of companies that can become more powerful than entire countries. Once again, this worry gives us reason to learn from old colonialism. At its summit, the East India Company was the largest corporation in the world, and it had twice as many soldiers as the British government. Among its many sins were slave trafficking, facilitating the opium trade, exacerbating rural poverty and famine, and looting India. A senior official of the old Mughal regime in Bengal wrote in his diaries: "Indians were tortured to disclose their treasure; cities, towns and villages ransacked; jaghires and provinces purloined." So it's not only that powerful corporations can violate human rights. To some extent, they can also act like states when they are the protagonists of colonialism. As William Dalrymple puts it,

> We still talk about the British conquering India, but
> that phrase disguises a more sinister reality. It was not
> the British government that seized India at the end

of the 18th century, but a dangerously unregulated private company headquartered in one small office, five windows wide, in London, and managed in India by an unstable sociopath — Clive.

Just like at the end of the eighteenth century, corporations are leading colonialism in the twenty-first century. This time round it is big tech doing the looting (of our privacy, at the very least). They are the entities setting the agenda and imposing a culture of exposure around the world. Big tech companies benefit from our spending as much time as possible on their devices and platforms, sharing as much personal data as possible — which is why they sell the idea of exposure as a virtue: tell us what you feel, where you go, what you eat, what you think about other people, what worries you, and how we can make money off you. And if you don't want to tell? Well, that must be because you have something to hide, which in big-tech-speak is not about protecting yourself from wrongdoers but about being a wrongdoer yourself. Big tech colonialism shames us into exposure for their own profit, and in doing so, they poison the public sphere.

Cultures of exposure are another good example of how surveillance leads to control. The pressure to overshare encourages social vices such as stalking and witch-hunting. If everyone is pressured into exposing their opinions and habits, it is a matter of time before someone finds some of them objectionable and starts hunting people for their views. It is interesting how something that used to be regarded as inappropriate — exhibitionism — has now morphed into being considered a social imperative — transparency. Some measure of transparency is certainly appropriate when it comes to institutions — but not when applied to

individual citizens. Both exhibitionism and social policing cause "either-you're-with-us-or-against-us" mentalities and thereby jeopardize civic friendship.

Liberal democracies aim to allow as much freedom to citizens as possible while ensuring that the rights of all are respected. They enforce only the necessary limits so that citizens can pursue their ideal of the good life without interfering with one another. But for a liberal order to work, it is not only governments and corporations that have to give citizens a space free from unnecessary invasions; citizens have to let one another be as well. Civility requires that citizens exercise restraint in the public sphere, especially regarding what we think of one another. To expect people to be saints is unreasonable. "Everyone is entitled to commit murder in the imagination once in a while," as Thomas Nagel has remarked. If we push people to share more than they otherwise would, we will end up with a more toxic environment than if we encourage people to edit or curate or limit what they bring into the public sphere. A culture of exposure invites us to share our imaginary acts of murder, needlessly pitting us against each other. Sparing each other from our less palatable facets is not a vice, but a virtue. Protecting privacy — our own and that of others — is a civic duty.

Totalitarian societies tend to match institutional surveillance with peer-to-peer surveillance to achieve near-total control of the population. During China's Cultural Revolution, people were encouraged to denounce their neighbors and even their family members. Children sent their parents to their deaths. The same thing happened in Stalin's Soviet Union. The East German Stasi used an astonishingly high number of informants to infiltrate the general population. When we use social media for trolling, witch-hunting, and publicly shaming

others, we behave more like subjects of totalitarian states than as citizens of free societies.

We resist the colonialism of digitization partly through culture. We defy digital colonialism when we value the analog, the unrecorded, the untracked. Tibetan Buddhist monks have a tradition of spending days creating beautifully intricate mandalas using colored sand. When they finish their work of art, they sweep it all away in a ceremony. The sand is collected in a jar which is wrapped in silk and taken to a river, where it is scattered. Sand mandalas are a homage to impermanence. Unlike paintings, which strive to resist the passage of time, sand mandalas are there to remind us that there is beauty in the ephemeral.

We challenge digital colonialism when we enjoy life without wanting to freeze it into a photograph. We resist totalitarianism when we decline to publicly shame someone for a mistake that anyone could have made. We preserve intimacy when we allow a conversation to go unrecorded. We stand up for democracy when we buy a paper book at a bookshop using cash.

Yet culture is not enough. We also need the right technology. Architectures of surveillance afford control over the population. Our current technology — all of it the result of engineering and corporate decisions, and none of it inevitable in its present configurations — is priming society for an authoritarian takeover. Analog technology is more respectful of citizens. We could also make digital technology less intrusive by creating and collecting less personal data, by periodically deleting data, and by improving our cybersecurity

standards. In a global context in which a country such as China is exporting surveillance equipment to around one hundred and fifty countries, the job of liberal democracies is to be a counterweight to that authoritarian influence by exporting privacy through culture, technology, and legal standards.

We need the right regulation to match culture and technology, because collective action problems can only be solved through collective action responses. For starters, we should ban the sale of personal data. As long as personal data can be bought and sold, companies will not resist the double temptation of creating and collecting as much of it as possible, and then selling it to the highest bidder. The trade in personal data is jeopardizing democracy through personalized propaganda. We do not sell votes, and for many of the same reasons we should not sell personal data.

We should also limit the purview of the digital. Asking technology companies not to digitize the world is like asking builders to please refrain from paving over natural spaces. Unless society sets legal limits, profit-seeking will reign. Corporations will sell our democracies if it is lucrative enough and we let them. Governments create protected areas to restrain the impulse to build over every square inch. We need similar protected areas from surveillance. It is in the very nature of big tech to turn the analog into digital, but turning everything into a spy is a threat to freedom and democracy. Full digitization equals total surveillance. There is some data that is better not to create. There is some information that is better not to store. There are some experiences that are better left unrecorded.

Just over a decade ago, enjoying digital technology was a luxury. Increasingly, luxury is being able to enjoy space and time away from digital technology. Spaces that are free of

digital technology stimulate deeper connections between people, more honest conversations, free experimentation, the enjoyment of nature, being grounded in our embodiment, and embracing lived experience. That is why Silicon Valley elites are raising their children without screens.

We need urgently to defend the analog world for everyone. If we let virtual reality proliferate without limits, surveillance will be equally limitless. If we do not set some ground rules now on what should not be digitized and augmented, then virtual reality will steamroll privacy, and with it, healthy democracies, freedom, and well-being. It is close to midnight.

# EKATERINA PRAVILOVA

# *The Autocrat's War*

*The Emperor Nicholas was alone in his accustomed writing-room in the Palace of Czarskoe Selo, when he came to the resolve. He took no counsel. He rang a bell. Presently an officer of his Staff stood before him. To him he gave his orders for the occupation of [the Danubian] Principalities. Afterwards he told Count Orloff what he had done. Count Orloff became grave, and said, "This is war."*

ALEXANDER WILLIAM KINGLAKE
*THE INVASION OF THE CRIMEA, 1863*

Alexander William Kinglake, the nineteenth-century British travel writer and historian who published a history of the Crimean War in eight volumes, could hardly have known how and in what surroundings Nicholas I made the fateful decision that caused the declaration of war by the Ottomans. In the imagination of nineteenth-century historians and writers, wars were the products of high politics, and the Crimean War, one of the most senseless, ridiculous, and tragic defeats in Russian history, was commonly blamed upon the Russian tsar and his abysmal vanity, arrogance, religious fanaticism, and nationalism. Court historiographers spilled a lot of ink trying to exonerate Nicholas I and shift the blame for launching the bloody war onto Russia's treacherous allies and insidious rivals.

It is therefore even more surprising that Nikolai Chernyshevsky — Russia's first revolutionary democrat, who apparently read Kinglake's volume in his prison cell at the Peter and Paul Fortress in 1863 — also thought that the tsar was not the guilty party: "Who shed these rivers of blood? ... Who? Oh, if only conscience and facts had allowed us to think 'the late sovereign,' how good this would have been! The late tsar is long dead, and we would not have to worry about Russia's future.... But, my dear reader, neither the dead tsar nor the government is guilty of the Sevastopol war."

According to Chernyshevsky, the main suspect was the Russian educated "public," who had laid the blame on the dead tsar and continued to dwell without punishment or remorse: "The public is immortal; it does not resign, and there is no hope that this persona that caused the Crimean war ceases to represent the Russian nation and to have great influence upon its fate." Without due respect for the greatness of Russian poets and writers, including Pushkin, Chernyshevsky blamed

them for impressing on the minds of light-minded Russians the fantasies of taking control over Constantinople and beating the Ottomans on their land.

Nobody, for sure, wanted the war, and only when they kissed their loved ones farewell did the same people who had carelessly joked about the "Russian Bosporus" understand what the war was about. Russia suffered a humiliating defeat, senselessly wasting thousands of lives and millions of rubles. Yet the horrors of the Crimean war, even if only seen through the eyes of Russian soldiers and not their Turkish (or British and French) counterparts, were soon forgotten.

Not long after the shameful debacle, the government approved the establishment of a "Slavic committee" in Moscow that aimed to "prevent" and anticipate Western influence upon the Southern Slavs of the Ottoman Empire. Twenty years later, Nicholas' son Alexander II waged another war against the Turks, claiming to protect the Christian population of the Ottoman Empire. The second Eastern war in 1877–1878 was a military success, but most importantly, it was a propagandistic triumph that took off the table the question of responsibility for another imperialist adventure. Clearly the government had learned the lesson of the Crimean embarrassment: dealing with the questions of causality and responsibility had to be an integral part of the war effort and strategy.

The catastrophic war against Ukraine that started in 2014 and entered a bloodier phase in February 2022 has already produced heated debates about its causes. The question of whether this is "Putin's war," or "Russia's war," or "the Russians' war" echoes Chernyshevsky's dilemma, but the answers, usually emotional and spontaneous, express the incomprehensibility of violence rather than a serious attempt to understand the roots of the disaster. Writers habitually

43

compare Putin's Russia to Hitler's Germany, drawing parallels between the lethargic character of the Germans' denial of Nazi crimes and the Russian public's support of war in Ukraine. While this comparison points to a plausible diagnosis — a peculiar intellectual antibiosis of society — the causes of the disease in its respective settings are most likely different. In any case, current debates about whom to blame often simplify the issue, operating with imprecise categories and ignoring the context. Scholarly analysis will have to frame the problem as broader and punchier, considering the role and responsibility of the autocrat and the ruling clique not only in waging the war but also in turning the majority of the population into his supporters and accomplices.

While a cold and dispassionate analysis of the genesis of the current war may seem improbable at the moment, there is one thing that we can do: look back at past conflicts and analyze how Russia's wars usually began. This comparison suggests that the formulas discussed above — "one man's war" or a "nation's war" — are themselves the products of the rhetorical attempts to either celebrate or exonerate rulers and to shift responsibility for waging the conflicts, either successful or failed, onto society. Wars belong to a particular category of events that are always shrouded in mythology: state propaganda doubles its efforts when it deals with armed conflicts. In the panoply of myths, one persistent trope stands out. It describes the archetypal scenario of a war's outset; and Russia's failed wars were not only those that Russia lost militarily, but also those that did not follow the prescribed scenario, the ones that laid bare the ruler's personal role. To deal with the problem of causality and responsibility, however, it is important to distinguish the rituals of launching wars from the actual political mechanisms of their enactment.

As the war in Ukraine grinds on, it is illuminating to consider the precedents of Russia's imperial wars of the nineteenth and early twentieth centuries, so as to trace how the wars began, how those beginnings were described, and what those beginnings tell us about the range of responsibility for unleashing violence. Despite the time lapse, the comparison between the politics of war in imperial Russia and in contemporary Russia is useful and legitimate: as Putin's persistent references to the Russian imperial legacy demonstrate, he intentionally and unintentionally emulates the old mechanisms of autocratic governance. Wars, and not domestic reforms, however "great" they may have been, represented the main mechanism of legitimation in autocracies. Almost all the rulers of the Romanov dynasty fought at least one war during their rule. It is reasonable, therefore, to suggest that autocracies do not merely share a general inclination toward violence, but also display similar mechanisms of geopolitical decision-making. At the outset of war, the key moment of every monarch's rule, an autocrat claims a complete authority that in peaceful times may appear limited and constrained.

This complete authority, the way in which war is used to strengthen dictatorial power, may not be put fully on display. To justify war, an autocrat may cite an alleged provocation from below or a popular demand to which he responds. He may shift the burden of responsibility for human losses onto his advisers while accruing to himself the political benefits of victories. For this reason, the real mechanisms of war politics should be critically examined. And there is the additional question of the role of society. Does it bear responsibility for the violence, as Chernyshevsky thought? Does society have agency in an autocratic state, and does the autocrat take "public

opinion" into account? Additionally, is collective responsibility a useful category, or should only individual perpetrators or groups and organizations take the stand in the makeshift court of history?

Let us begin with the role of the autocrat. In Timothy Frye's wise and counter-intuitive words, "Recognizing Putin as an autocrat ... brings into sharp focus the inherent limits of his power that are common to autocratic rule." Historians of Russian autocracy concur with this observation: at no point in Russian history, they say, was a Muscovite tsar, an empress, or an emperor fully "autocratic" in making their choices and decisions. Boyar clans, unofficial parties at court, groups of ministers, court favorites, and lobbyists all worked toward forming the sovereign's will and making him or her deliver the right decision at the right moment. Mikhail Dolbilov describes this process as "divining," that is, "constructing" the ruler's will and couching it in the language of laws and orders.

The interactions between the tsars and the advisers, however, were never one-sided: monarchs manipulated people masterfully, exploiting contradictions and conflicts among their favorites and courtiers, artificially sharpening disagreements, and shifting moral and political responsibility for crucial decisions onto representatives of the elites. In addition to these informal networks of power, autocrats also relied on a variety of political bodies. In both monarchical Russia and Putin's autocracy, legislative chambers and political offices have existed mainly to legitimize the rulers' decisions and to bind political elites by shared responsibility. There is also the class of technocrats and bureaucrats who bear the

46

burden of governance and execute the monarch's orders. We may conclude, therefore, that "autocratic will" is a complex set of mechanisms based on the preponderance of informal practices, customs, and rituals over rules and laws.

But when it comes to wars, the traditional rituals and practices of decision-making prove moot. The role of government usually recedes into the background, and the autocrat surrounds himself with unofficial advisers, often shifting gears in motion, dismissing trusted politicians and bringing forward new people and favorites from the inner circle. Such famous bureaucrat reformers as Mikhail Speransky and Sergei Witte both lost their leading positions on the eve of wars, in 1812 and 1902 respectively. Speransky's fall was staged as a tragedy: sending off his State Secretary to Siberia, Alexander I cried and lamented that he was sacrificing his adviser for the safety of the empire in view of Napoleon's imminent invasion. The replacement of Speransky with nationalist conservative politicians represented a part of the pre-war drama, but in reality it reflected the tsar's efforts to strengthen his absolute authority.

Witte's story is also remarkable: a powerful minister of finance and *de facto* first person in the imperial government, he lost the political battle against a handful of unofficial advisers to the tsar, who pushed the emperor toward the more aggressive policy in the Far East that ultimately led to a war with Japan in 1904–1905. Describing this episode in his memoir, Witte portrayed the poor gullible tsar as a weak-willed child, easily manipulated by a group of unscrupulous and militant politicians. The story, fairly accurate in details, nevertheless looks like the traditional scenario about wars' beginnings that features competition between pro-war and anti-war factions at court fighting for the tsar's attention. In these competitions,

the only winner was usually the monarch: launching wars was a way to get rid of importunate reformers, to consolidate supporters, to shake up the political establishment, and to refresh the absoluteness of the tsar's authority. In the case of the Russo-Japanese War, the trick failed, leading to revolution and the constitutional reform of 1905–1906 that stripped the tsar of some monarchical prerogatives.

Until the end of the tsarist regime, war and foreign policy remained within the protected sphere of the tsar's personal rule. The narratives of the wars' origins, considered without the long preambular part of diplomatic negotiations, were consequently staged as the dramas of the tsar's choice between different camps, actors, and opinions. Even though unleashing the war was always the tsar's personal choice and decision, the rhetoric and rituals of war dramas required the presence of others — noble defenders of the empire's honor, faint-hearted bureaucrats, or evil instigators of violence. The scenarios of wars were designed in such a way that the autocrat was always at the center — and yet never alone. A typical plot of a "good" war as portrayed in the official myths always included 1) attempts at reconciliation and the ruler's patient search for peace; 2) the people's demand, and the advisers' suggestion, to act more decisively; 3) the tsar's reluctance to shed the blood of his soldiers; and, ultimately, 4) his determination to make the sacrifice for the sake of the empire's honor and peace.

It is important to keep in mind, however, that the conventional plot of the war drama differed from the real politics of autocratic decision-making. Consider the example of the Russo-Turkish war of 1877–1878. Although Putin has never referred to it (perhaps because Turkey remains one of Russia's somewhat infidel allies), the official narrative of that war, as well the model of interactions between its political actors,

eerily resembles the situation on the eve of Russia's invasion of Ukraine this year. The Russo-Turkish war is usually portrayed as a war for the liberation of the Slavs of the Ottoman Empire, a reaction to Turkish atrocities in Bulgaria and Herzegovina. According to the traditional narrative, Alexander II reluctantly agreed to step in after Russia's diplomatic efforts to resolve the Eastern crisis had brought no results, while a collective "Europe" demonstrated a cold indifference to the fate of Christians in the Ottoman Empire. The lofty rhetoric of liberation was meant to hide the fact that Russia was ultimately the aggressor; and although it did not plan to incorporate Slavic lands into its territorial domain — it "only" wanted to create dependent satellite states in the Balkans — Russia ended up seizing a portion of Ottoman territory in Eastern Anatolia.

The official narrative of the outbreak of the Russo-Turkish war resembles the libretto of a nineteenth-century opera with a plot developed on two levels — the crowd scenes (the Russian public cheering on the Slavs) and the main drama at the tsar's court and within the imperial family. The crowd is stirred by the news about the Turks' atrocities and it demands justice; and promptly produced paintings of pale-skinned Slavic women tortured by dark-skinned barbarous Turks provided the perfect scenery. Troops of volunteers march to the Balkans, and peasants and poor folk send in their modest donations to help their Slavic brethren. Meanwhile, in the imperial palace, the tsar is tragically torn between his human compassion and his duty as the Russian monarch to put the interests of his people above all. At court, there are two forces pulling in different directions: one, exemplified by the tsar's top bureaucrats, argues for caution and restraint; another, represented by the Empress Maria Aleksandrovna and the heir to the throne, the future Alexander III, is fully

on the side of the bellicose public and the champions of the Slavs. The defense minister Dmitry Miliutin listens to the "outpourings" of the sovereign's heart and records them in his diary. The tsar is sad and alone. His "hollow cheeks" and his eyes swollen with tears betray his sufferings; his health is deteriorating. He stoically withstands unfair criticism for indecisiveness and passivity, yet he is tormented by doubts. The tsar feels for the poor Slavs, yet he knows that all blame for the losses and the casualties of war always "fall on those who make the first step." And the poignancy of the tsar's dilemma contrasts with the coldness of Russia's European counterparts, especially Austria-Hungary and Britain, who cynically pursue their political interests, faking support of the Balkan Slavs. And after a few months of honest attempts to make the Turks change their policy, Alexander II concludes that Russia cannot avoid the war and resolves to act.

The Russo-Turkish war became a turning point in Russian politics, marking the end of the era of the Great Reforms and prompting the reorientation of Russian domestic and international policies. Even if Alexander's trepidations were sincere and he came to believe in Russia's mission to liberate the Slavs, there is no doubt that he used the split of the elites to his political advantage and manipulated the groups at court as well as his family. Wars are almost never the outcomes of external factors alone: to understand their sources, one must also look inside and analyze the internal domestic tensions between the elites, the ruler, and the groups of interests.

When it comes to the current war in Ukraine, we do not yet have the luxury of first-hand accounts, but political analysts and intelligence reports suggest that Putin, just like Nicholas I, made this decision in solitude. Putin turned his obsession with Ukraine's resilience in the face of Russia's

pressure into a state matter, a creed that keeps his close friends and allies together. Little is known about Putin's inner circle; but the public appearances — and disappearances — of certain statesmen and politicians allow us to deduce that since the beginning of the invasion in February the narrow group of trusted friends and advisers has become smaller and tighter, while the role of technocrats has become entirely subsidiary. The government's influence has been significantly reduced, and the role of the Security Council, chaired by the president but unofficially led by Nikolai Patrushev, Putin's old friend and a former head of the FSB, has increased. All those who remained in power were compelled to publicly express their support of the "special operation in Ukraine."

In this case, as in multiple episodes from the war history of the Russian Empire, the decision came from the autocrat who, as the ritual prescribes, solicited advice from the people and the elites. The meeting of the Security Council, broadcast on Russian state television, showed a handful of top officials, who, shaking and in trembling voice, gave their consent to the invasion. Yet if we look beyond the ritual, wars in autocracies are always the ruler's wars. When it comes to the decision to fight a war, the "inherently limited" power of autocrats becomes, in fact, unlimited. Wars represent a way to build and maintain autocracies, even if they can also lead to their collapse.

Let us now return to Chernyshevsky's question: does a people, or just the educated part of it known as "the public," bear responsibility for unleashing the war? In the aftermath of the Crimean War, people considered themselves the victims of Nicholas I's regime. Yet in 1877 the situation looked

different. The second Eastern war was portrayed as a war by popular demand that was almost forcefully imposed on the tsar. True, the ideas of cultural and political patronage over Balkan Slavs in the 1870s had gained popularity in Russian society. The so-called Slavic Committees in Moscow, St. Petersburg, and provincial cities initially focused on strengthening cultural unity and on humanitarian help, but after the suppression of the rebellion in Herzegovina in 1875 they switched to more active support of the "insurgents," sending supplies and recruiting volunteers to fight for the freedom of Slavic "brethren." The flip side of this activity was, indeed, the rise of anti-Turkish sentiments. The government publicly demonstrated its neutrality and non-involvement; it also quietly tried to lean on the Slavic committees and to channel the outpour of pro-Slav emotions in the right direction.

But did these pan-Slavic circles — allegedly grassroot organizations supported and patronized by the ruling elite — represent "society"? A closer look at Russia's political landscape of the 1870s shows that it is almost impossible to draw a line separating the "state" from the "public." Russia did not have legal political parties until 1905, and the public sphere was closely policed by the government. As a result, a handful of conservative journalists and writers — Mikhail Katkov, Vladimir Meshcherskii, Ivan Aksakov — dominated the public mind, controlled the flows of information, and formed the language of public debates. Their influence was not, however, limited to the public. Katkov and Meshcherskii were privy to ruling circles: along with the tsar and other members of the elite, they were the main stakeholders in the campaign against the Ottomans. In contrast, liberal and democratic proponents of the Slavic cause were repressed, silenced, and exiled. The sad irony of the pro-Slavic campaign of 1876 lay in the fact that in

the same year when the tsar resolved to support the autonomy of Slavs in the Ottoman Empire, he signed the ill-famed Ems edict prohibiting both the publication of books and theatrical production in the Ukrainian language, scornfully called a "dialect" in this law. As the Ukrainian historian and politician Mykhailo Drahomanov long ago pointed out, the "liberation" of Ottoman Slavs by the anti-liberal Russian Empire, where Slavic peoples, including Ukrainians and Poles, were deprived of even basic elements of autonomy, was a misnomer. Moreover, as Drahomanov observed, all talk about public initiative in support of the Slavs made no sense: the "unofficial Russia" that championed the campaign was undistinguishable from the "official" one.

Drahomanov's words could easily be used to describe the situation in contemporary Russia. Those who are now allowed to speak on behalf of society are closely linked to the state; those who disagree with the state's policy have been silenced and jailed, or they have had to emigrate or go underground. Most of the millions of people who support Putin and his plans of imperial revival know little about the world outside Russia, or even outside their town; they have been raised on state propaganda and are unwilling to question the veracity of the myths that it produces. They are excited about military victories because different ideas have never been inculcated in their minds, neither by the schools nor by the Orthodox Church. Many of them live in misery and abandonment, and they seek emotional comfort not in kindness and compassion but in an illusionary victory in a "special operation."

Wars have always been portrayed as the moments of unification between the autocrat and the masses — a kind of political communion, a shared national epiphany. The war consensus transcends the bureaucratic buffer that, in peaceful

times, stands between the ruler and his subjects. When, in the 1870s, nationalists celebrated these consummations of unity, others saw the attempt to drag simple folks into war politics as cynical and dangerous. As Prince Petr Viazemskii remarked, "The people cannot wish the war but inadvertently push toward it ... The government silently lures the people into this political chaos, and they may pay for it dearly." Putin justified the invasion by the sufferings of the Russian-speaking population in eastern Ukraine, which was allegedly vying for autonomy and aspiring to strengthen ties with Russia. The orchestrated pro-Russian demonstrations and marches in Donetsk and Luhansk replicated almost verbatim the process of building up pro-war, pro-Slav, and anti-Turkish sentiments in the 1870s, as did the public euphoria in Russia in response to the annexation of Crimea in 2014. In lieu of the "barbarous" Turks, there are the Ukrainian "Nazis," who, according to Putin, tormented the population in eastern Ukraine. The people — duped by state propaganda — may express nationalist sentiments, but the autocrat never really takes them into consideration when he gives the order to attack.

It is important, therefore, to make a distinction between the rhetorical references to public support and the reality of the decision-making process. The historian David McDonald, commenting on certain assumptions about the state's responsiveness to nationalist sentiments in pre-revolutionary Russia, has rightly observed that these assumptions "neglect the finer mechanisms of causation and overlook the fact that imperial statesmen were highly reluctant to cede any voice at all to society in matters of foreign policy. While public opinion played an episodic role in the discussion of foreign policy, as a state matter, such issues could be considered only

by professional officials responsible to His Imperial Majesty." In autocratic orders, the notion of a war by popular demand is nonsense.

The ruler, in other words, does not care what an average Russian, or Russian society as a whole, thinks about Ukraine or the Ottoman Empire. Although a significant part of the Russian population supports the war now, it did not cause the war, and the majority had been opposed to the idea of armed conflict before the invasion. Of course, there were Russian writers, most notably Dostoyevsky, who penned pan-Slavic articles, and journalists who created the racist images of Turks, and there have been Russian politicians and intellectuals who have haughtily refused to recognize the cultural and political sovereignty of Ukraine; and they are all responsible for endorsing violence. Every soldier who has pulled a trigger, launched a missile, or thrown a grenade is complicit; every governor or theater director who has voiced support for the "special operation" bears the guilt for the lost lives of innocent Ukrainians. But all the individual responsibilities for these actions do not add up to the collective responsibility of "the Russians." The notion of collective responsibility allows war criminals and the outspoken supporters of violence to escape judgment. The "responsibility of nations" often means no one's guilt.

Does this suggest that Chernyshevsky was wrong in blaming "the public" and not the tsar for the horrors of the Crimean War? Not exactly. He was right in predicting that Russian educated society would fail to comprehend the simple thought that any war, victorious or not, is hideous, that war cannot be a source of glory and dignity, neither for a man nor for an empire. This thought remained alien to the Russian nobility, which continued to seek honor on the

battlefield, and, with the exception of Tolstoy, the holy fool of Russian literature, the thought did not find expression in literary works. It is therefore very important to understand how and why a hostility to war, or an aversion to it, failed to develop in a country where every single family has lost at least one member in one of the many wars fought in the last hundred years. Chernyshevsky was also right in pointing out the cultural hauteur of the Russian literary elite who inculcated in their "public" a sense of imperial superiority — over Turks, Europe, Ukrainians, and others. This sense of superiority now fuels support for the Ukraine war among contemporary Russians. As many commentators have already pointed out, Russia has as yet failed to go through the process of de-imperialization and reckoning with its imperial (pre-revolutionary and Soviet) past.

Another theme that emerges with surprising persistence in the "who is to blame?" debates concerns the responsibility of the West for "provoking" Putin. The West must not repent for offending Putin and injuring his self-esteem, because it would only play into the autocrat's hands. Putin's propaganda openly justifies its aggression by alleging the hostility of Western powers who have turned Ukraine into a playground for their military operations against Russia. The motive of this putative Western threat is another cliché, copy-pasted from a typical scenario of Russian imperial warfare, in which almost every war, wherever it took place, was seen as a war against a collective "West." Putin's remarks last June about the world order as divided into two camps, namely sovereign states and their colonies, and his attempts to present this war as Russia's

defense of its sovereignty against the West, repeat almost verbatim the ideas of Russian nineteenth-century nationalists.

Mikhail Katkov, one of the main proponents of war against the Ottomans, thought that only by isolating itself from the West could Russia avoid the sad fate of falling into economic and political dependence on Europe. Isolationism — the rejection of shared cultural, legal, financial, and political standards and values — appeared to be a way of regaining and strengthening Russian independence. Indeed, the war with Turkey in 1877-1878 eventually turned into a civilizational clash with Europe and ended two decades of Russia's fine attempts at Westernization and reforms. The most visible manifestation of Russia's anti-Westernism was the reactionary reign of Alexander III, his official Slavophilism and imperialist policy. For its part, the de-Westernization of Russia in 2022 will be remembered by the disappearance of McDonald's, empty shopping malls, and the deficit of imported consumer goods — but there have been less visible and more profound changes in the systems of education, industry, and finance. Russian universities and academic institutions have been cut off from networks of international cooperation, investors have walked away from the country's economy, and Russian producers have to learn from scratch how to replace imported parts and machines.

The Russian invasion of Ukraine seemed improbable until the last moment, because it defied rationality and threatened to ruin the Russian economy and inflict unthinkable losses on the Russian population. Yet its economic irrationality has been twisted by the autocrat to prove the unselfishness of the war's goals, and to demonstrate Russia's uniqueness and difference from the obnoxiously pragmatic and materialistic West. Prince Dmitrii Obolenskii expressed this mood

on the eve of the Russo-Turkish war: "I know that we have no money. I know that the generals are bad.... But this does not matter, because the main question is, *What are we?*" As in 1877, Russian authorities in 2022 high-mindedly boast about their altruism, although the main burden of war, as always, falls on the shoulders of the poor. No one can predict the human and material costs — for Russia, Ukraine, and the entire world — of the current war, but we must make sure that this accounting is made and all the losses are tallied, and that the people who inflicted the losses bear the responsibility.

The invasion in Ukraine has had profound effects not only on the physical dimensions of people's existences, but has also affected the way they experience time, place, and history. Historical planes have shifted, dumping Russia into a temporal pit without a future and with a questionable past. Putin, who directs this bloody drama, suspends the historical specificity of these events by constantly referring to his crowned predecessors and following the imperial scenarios of war, as if an atemporal pattern, a Russian destiny, is simply being re-enacted. This suspension of time is not accidental — for Putin's regime, war has turned into a mode of existence, an endless present, an eschatological battle without a strategy and a timeline. Some of Putin's critics have inadvertently fallen into his trap, mistaking his rhetoric for reality. Instead of studying Russia's imperial past to understand the precise mechanisms of autocratic power and thereby untangle the jumble and mess of Putin's ideas, they look back to the past in order to revert to meta-historical stereotypes and cliches so as to judge and accuse. The discourse about "the Russians' war" is often built on

poorly understood historical parallels and assumptions regarding Russians' genetic propensity for violence and their inability to develop an inner sense of freedom. This invidious essentializing is the mirror image of the pro-war Slavophile nonsense about the mystical singularity of Holy Russia.

The analysis of the causes of this terrible war should look beyond the rhetorical fog of Putin's propaganda and include the serious treatment of the politics of war and the structure — the logic — of autocratic power. At what point, and why, does an autocrat resolve to initiate a war? Which elements and factors in the internal dynamics of an autocratic system trigger aggression? Why do the mechanisms of restraint not work? We must also begin a careful historical inquiry into how (and whether) Russian society has dealt with the problems of violence and responsibility. Ritual repentance on Facebook pages on behalf of the Russian nation will remain useless until we understand the actual causes of war. And when the time comes, the people responsible for the horrors of the current war will (I hope) face judgment, and courts will establish the guilt of individuals complicit in encouraging, supporting, financing, or justifying the war. There is a significant nexus, analytical and moral, between causality and culpability.

59

# RICHARD TARUSKIN

# *Taste, Bad Taste, and Franz Liszt*

## I

My title may appear provocative, but I doubt whether anyone is likely to disagree that of all the great composers Liszt is the one most frequently accused of bad taste, and also that the accusation has never threatened his status among the great. Indeed, as Charles Rosen once suggested, the accusation in some sense actually identifies Liszt's particular position in the pantheon.

Rosen put it in the form of a trumped-up paradox, saying of Liszt that his "early works are vulgar and great; the late works are admirable and minor." Very cagey, this: Liszt's most-admired works, say the Faust-Symphonie or the B-minor Sonata, came in between. Take away the invidious comparison, and take away

the sophistry, and Rosen's point still resonates. But take away the vulgarity, and Liszt is no longer Liszt. Reviewing the first volume of Alan Walker's biography of Liszt in the *New York Review of Books*, Rosen went even further in his baiting, asserting that "to comprehend Liszt's greatness one needs a suspension of distaste, a momentary renunciation of musical scruples." And then, for good measure: "Only a view of Liszt that places the Second Hungarian Rhapsody in the center of his work will do him justice."

That was not an endorsement of the Rhapsody, which Rosen, along with Hanslick and Bartók, thought "trivial and second-rate." What made the provocation doubly surefire was the racial innuendo that tainted not only Liszt and the Rhapsody, but all who came in contact with them. Did not Pierre Boulez say of Bartók that his "most admired works are often the least good, the ones which come closest to the dubious-taste, Liszt-gypsy tradition"? And does that not go a long way toward accounting for Bartók's overt hostility toward a tradition, that of the so-called verbunkos, on which he remained covertly dependent? The taint even tainted the tainter — all of which was simply too much for Alfred Brendel, who, exasperated, took Rosen's bait:

> Though enjoying, once in a while, some of the Hungarian Rhapsodies and operatic paraphrases, I wince at Charles Rosen's assertion [that] in the matter of taste, no composer could be more vulnerable than Liszt....
> In contrast to Charles Rosen, I consider it a principal task of the Liszt player to cultivate such scruples [as Rosen bids us renounce], and distil the essence of Liszt's nobility. This obligation is linked to the privilege of choosing from Liszt's enormous output works that

offer both originality and finish, generosity and control, dignity and fire.

I sympathize with Brendel's aversion to Rosen's deliberately annoying formulations, but I find Brendel's fastidiousness insufficiently generous toward Liszt and the impulses that his work embodies, which, though not always noble, are undoubtedly great. Rosen came closer than Brendel did to pinpointing the fascination that Liszt exerted over his times, and continues to exert over us. Especially worthy of pursuit is Rosen's most irritating pronouncement of all: "Good taste," he teased, "is a barrier to an understanding and appreciation of the nineteenth century."

If the remark grates, it is because of the aspersion it seems to cast on the century that now looms in retrospect as the greatest century of all for music — or at least as the century in which music was accorded the greatest value. But suppose we read the aspersion the other way — as a critique of good taste? Ever since reading the Rosen-Brendel exchange a quarter of a century ago, I have had an itch to use Liszt and his reception as a tool to situate good taste (along with greatness) in social and intellectual history, and to fathom the profound ambivalence with which virtuosity has always been regarded.

So let me begin again, with another quotation — something that has been rattling in my head even longer, more than half a century now. When I was an undergraduate, I read Thomas Mann's last novel, *The Confessions of Felix Krull, Confidence Man*. At one point the social-climbing title character receives guidance from a nobleman, the Marquis de Venosta, whose

world he wants to crash. Among the many insights that the Marquis offers him is this: "You come, as one now sees, of a good family — with us members of the nobility, one simply says 'of family'; only the bourgeois can come of a *good* family."

What does this mean? What is the difference between "family" and "good family"? What it seems to come down to is that "family" is an existential category, while "good family" is an aspirational one. The bourgeoisie is the aspiring class. The aristocracy simply *is*. And so it is with "taste" and "good taste." "Taste" is something the elect possess and exercise without calculation or necessary self-awareness. "Good taste" is exhibited rather than exercised: it is something attributed to the maker of deliberate and calculated choices in recognition of their correctness, as a mark of social approval. "Taste" is a matter of predilection, "good taste" is a matter of profession. A display of good taste is a mark of aspiration to social approbation, and the standard to which exhibitors of good taste must aspire is never their own. To show good taste is to seek admission to an elite station which the possessor of "taste" occupies as an entitlement. A show of good taste is thus never a mark of election; rather, it marks one as an outsider wanting in. It implies submission as well as aspiration, hence inhibition. Like Felix Krull, people who display their good taste are trying to crash a social world.

Recall now the famous words that Haydn spoke to Leopold Mozart in February 1785:

> Before God, and as an honest man, I tell you that your
> son is the greatest composer known to me either in
> person or by name. He has taste, and, what is more, the
> most profound knowledge of composition.

**Taste, Bad Taste, and Franz Liszt**

Imagine for a moment that Haydn had said to Leopold not that Wolfgang "has taste," but that "he has good taste." The compliment would have crumbled. "Taste" (*Geschmack*), in the sense that Haydn used the word, was an existential category. Either you were of the elect or you weren't; and if you did not have taste as a birthright you could not acquire it, even though you had "the most profound knowledge of composition."

But what did it consist of? In this context, clearly enough, "taste" was an unerring and intuitive insider awareness of what was fitting. The closest any musician came to enunciating such a definition may have been Johann Mattheson in 1744, at the outset of a chapter entitled "*Vom musikalischen Geschmack*" in a book devoted to the aesthetics of opera:

> Taste, figuratively speaking, is the inner awareness,
> preference, and judgment by which our intellect
> impinges upon sensory matters. If, as Pliny would have
> it, the tongue has a mind of its own, so the mind can be
> said to have its own tongue, with which it tastes and
> evaluates the objects of its attention.

In that figurative sense, "taste" was comparable to the securely inculcated breeding that the Marquis de Venosta had in mind when he distinguished "family" from "good family."

Mattheson's ingenious, opportunistic inversion of a dimly remembered Pliny provides a link between the gustatory and the derivative or conceptual meanings of the term, while also giving off an echo of its social history; for as soon as the word "taste" was elevated beyond its purely sensory meaning in the seventeenth century, it connoted an attribute of aristocracy. The sociologist Stephen Menell locates that origin at the French court, where members of the old *noblesse d'épée*,

threatened by the ever-aspiring, ever-rising bourgeoisie, secured positions at court as "specialists in the art of consumption" (at first of food), developing hierarchies of taste and codes of behavior that stressed the restraint of gluttony and refinement of table manners. Taste had become a metaphor for discrimination.

The turn from food to art as the arena for the exercise of taste can be traced first in Italy. Giulio Mancini, the personal physician to Pope Urban VIII and a famous collector of fine painting, equated *gusto* and *giudizio* (taste and judgment) in his *Considerazioni sulla pittura*, an essay published in 1623. Half a century later, in 1670, the attempt to acquire taste without breeding was satirized for all time in Molière's *Le bourgeois gentilhomme*. The butt of the satire could be described, long *avant la lettre*, as "good taste," which was the quality or attainment to which Monsieur Jourdain aspired. Good taste, in effect, was imitation taste, not the real thing.

The notion of taste as an absolute standard, sanctioned by a consensus of the capable ("men of sentiment") and associated in the first instance with one of David Hume's most famous essays, has persisted since the eighteenth century despite the rise of less intransigent definitions. Its staying power is attributable to the conviction, among the politically conservative, that (to quote Wye J. Allanbrook) "the agreement of cultivated people about what is good and beautiful was a force for the political cohesion of the community" and a support, or occasional pinch-hitter, for hereditary aristocracy. As Schiller emphasized in *On the Aesthetic Education of Man* in 1794, "No privilege, no autocracy of any kind, is tolerated where taste rules"; but that is because taste itself offered an alternative standard of excellence, working through positive rather than negative reinforcement (the promise of esteem replacing

**Taste, Bad Taste, and Franz Liszt**

the threat of coercion) to internalize the pressure. Where its autonomy and universality are believed in, spontaneous fellow-feeling and disinterested fraternity can seem to rule. But such belief, far from spontaneous, must be cultivated, or rather, instilled.

A century and more after Schiller, T. S. Eliot echoed his sentiments when he defined "the function of criticism" as "roughly speaking, . . . the elucidation of works of art and the correction of taste." This was the formulation of a man who would shortly declare himself to be "classicist in literature, royalist in politics, and Anglo-Catholic in religion." The word for it, and it has become a fighting word, is elitism.

Where Eliot went, Stravinsky tagged dependably behind. In the *Poétique musicale*, his own pinnacle of intransigence delivered at Harvard a decade later, in 1939–1940, Stravinsky devoted the last of his six *leçons* ostensibly to musical performance, but in fact he made it clear from the outset that the subject matter of the lecture, which outwardly took the form of a diatribe against virtuosos expressly intended as a correction of taste, was in fact *d'ordre éthique plutôt que d'ordre esthétique* — "of an ethical rather than of an aesthetic order." At the height of his dudgeon, Stravinsky declared: "Whereas all social activities are regulated by rules of etiquette and good breeding, performers are still in most cases entirely unaware of the elementary precepts of musical civility, that is to say of musical good breeding — a matter of common decency that a child may learn." And yet, when invoking the *grand thème de la soumission*, the "great principle of submission," that runs like a thread through all six lessons, Stravinsky contradicts himself,

proclaiming instead that "this submission demands a flexibility that itself requires, along with technical mastery, a sense of tradition and, commanding the whole, an aristocratic culture that is not merely a question of acquired learning." There is your existential taste: something that one possesses as a birthright, as an aristocrat possesses (and is possessed by) "family."

How far this is, we are apt to think, from our colloquial concept of taste as mere personal preference, the thing that is proverbially beyond dispute. That definition, too, has a long history, going back to the anonymous Latin maxim — *De gustibus non est disputandum* — that everybody knows. That maxim, however, is less ancient than it might appear. It is by no classical author. Its origin, rather, is presumed to be medieval and scholastic by virtue of its concern to distinguish between matters open to reason and persuasion and those which philosophers, or at least scholastics, had better leave alone. As the economists George J. Stigler and Gary S. Becker put it, at the outset of a famous article in which they broke the old taboo and embarked on a path that led, for one of them, to the Nobel Prize:

> The venerable admonition not to quarrel over tastes is commonly interpreted as advice to terminate a dispute when it has been resolved into a difference of tastes, presumably because there is no further room for rational persuasion. Tastes are the unchallengeable axioms of a man's behavior.

Taste as axiomatic (and professed) personal preference seems a bulwark of personal autonomy, a democratic or egalitarian notion. As Liszt himself once said, "It is a matter of taste whether the old or the new is more charming. Taste

is quite certainly a personal thing." But consider this story, which will bring us back to music. It comes from a famous pamphlet, *Comparaison de la musique italienne et de la musique française,* issued in 1704 by Jean Laurent Lecerf de la Viéville, Lord of Freneuse, in answer to a like-named pamphlet, *Paralèle des Italiens et des Français,* issued in 1702 by another French aristocrat, Abbé François Raguenet. As Lecerf relates, a courtier fond of the brilliance and grandeur of Italian music brought before King Louis XIV a young violinist who had studied under the finest Italian masters for several years, and bade him play the most dazzling piece he knew. When he was finished, the king sent for one of his own violinists and asked the man for a simple air from *Cadmus et Hermione,* an opera by his own court composer, Jean-Baptiste Lully. The violinist was mediocre, the air was plain, nor was *Cadmus* by any means one of Lully's most impressive works. But when the air was finished, the king turned to the courtier and said, "All I can say, sir, is that that is my taste."

The king did effectively put an end to the argument by invoking his taste, but was that because there can be no disputing tastes or because there can be no talking back to a king? Lecerf's argument with Raguenet, who had waxed rapturous about the voices of *castrati,* was really all about authority, not taste. In disputes or assertions regarding tastes, authority has many surrogates. Among professionals, including musical professionals, the chief surrogate is experience. Consider this famous footnote from Johann David Heinichen's thoroughbass treatise of 1725.

> If experience is needed in any art or science, it is
> certainly needed in music. . . . But why must we seek
> experience? I will give you one little word that encom-

passes the three basic requirements in music (talent, knowledge, and experience), and its heart and its outer limits as well, and all in four letters: *Goût*. Through application, talent, and experience, a composer needs to acquire above all an exceptional sense of taste in music. The distinguishing feature of a composer with well-developed taste is simply the skill with which he makes music pleasing to and beloved by the general, educated public; in other words, the skills by which he pleases our ear and moves our sensibilities.... An exceptional sense of taste is the philosopher's stone and principal musical mystery by means of which the emotions are unlocked and the senses won over.

This is the kind of taste — something acquirable through labor and application (provided one has good instruction), hence available not only to the aristocracy of birth but also to an aristocracy of talent and training — to which Francesco Geminiani referred in the title of *A Treatise of Good Taste in the Art of Musick* (c. 1749), a title that on the surface might seem to offer a counterexample to the distinction between "taste" and "good taste." In the body of the treatise, however, Geminiani (who had lived in London since 1714 and was writing in idiomatic English) usually inserts the indefinite article before "good taste." Thus, at the beginning of the preface: "The Envy that generally attends every new Discovery in the Arts and Sciences, has hitherto deferr'd my publishing these rules of Singing and Playing *in a good Taste*"; and, at the end: "Thus I have collected and explain'd all the Ingredients *of a good Taste*."

That indefinite article does a lot of work: it is incompatible with both of the categories of taste with which we are concerned, whether with "taste" as the superior existential

endowment Haydn attributed to Mozart, or with the "good taste" in which Liszt was held by Rosen and Brendel to be deficient. When you put Geminiani's odd usage together with the title of his previous treatise, to which *A Treatise of Good Taste* was a supplement and on which it was dependent — that is, *Rules for Playing in a True Taste on the Violin, German Flute, Violoncello, and Harpsichord* (London, c. 1745) — it is clear that the two expressions "a good taste" and "a true taste" are interchangeable equivalents of "correct (or elegant) style." And indeed, it turns out that the *Treatise on Good Taste* is merely a manual on embellishment, consisting of a table of ornaments followed by models for application, chiefly to familiar Scots airs furnished with a thoroughbass. As Robert Donington comments in his foreword to the facsimile edition:

> "Good taste" was almost a technical term of the period. It was used not merely for a refined and cultured attitude toward music in general; it was used for a refined and cultured ability to invent more or less improvised ornamentation for melodies often notated in plain outline, but requiring such ornamentation in order to be given a complete performance.

Corroboration of this usage in eighteenth-century English comes from Dr. Burney, who in his musical travelogue of 1771 defined "taste" as "the adding, diminishing, or changing [of] a melody, or passage, with judgement and propriety, and in such a manner as to *improve* it." In short, therefore, and ironically, Geminiani's brand of "good taste," insofar as it implies the addition of impromptu passagework to written compositions, virtually coincides with the "bad taste" of which Liszt and his contemporaries would be accused a century after Geminiani's

time, and up to the present day. It did not take long for fashions to start changing. At the very end of his *General History of Music*, in the twelfth chapter of the fourth volume, published in 1789, devoted to the "General State of Music in England at our National Theatres, Public Gardens, and Concerts, during the Present Century," the same Dr. Burney wrote off Geminiani's guides to "a good taste" as having appeared "too soon for the present times. Indeed, a treatise on good taste in dress, during the reign of Queen Elizabeth, would now be as useful to a tailor or milliner, as the rules of taste in Music, forty years ago, to a modern musician."

## II

Yet insofar as Geminiani offered instruction in correct practice, his good taste did imply submission to a standard, a matter of meeting expectations. The taste or ability about which Heinichen and Geminiani wrote was not the personal preference of any particular performer or composer, nor of the authors themselves, nor even the consciously formulated demand of the "general, educated public." Effort and education can give us all equal access to correct style: the taste of one is (or ought to be) the taste of all. It is on the promise to impart that universal taste, which all successful composers must master, that the authority of Heinichen's or Geminiani's manuals depended. It was an authority that, in the guise of classicism, could become authoritarian.

Take, for example, Voltaire's article on *Goût* in the seventh volume of Diderot and d'Alembert's *Encyclopédie*, issued in 1757 — the same year as Hume's seminal essay, but expressing what seems to be a pre-Humean formulation, in which *l'homme du goût,* "the man of taste" (compare Hume's "men of sentiment" or the Marquis de Venosta's "person of family") is

**Taste, Bad Taste, and Franz Liszt**

expressly equated with *le connoisseur*, the one who knows the rules of style as the gourmet knows the rules of the kitchen and the dining table. "If the gourmet immediately perceives and recognizes a mixture of two liqueurs, so the man of taste, the connoisseur, will see at a glance any mixture of styles" — and, of course, disapprove. The standard is one of purism, and failure to meet it constitutes *le goût dépravé*, debased taste, otherwise known more simply as bad taste. When Voltaire admits the phrase *un bon goût*, it is as the back-formed opposite of *un mauvais gout*. Only the latter can be personal. As an idiosyncrasy it is tantamount to a flaw that one must eliminate so as to restore the universal norm, which is simply *le goût*, with no qualifier. "They say there is no point disputing tastes," Voltaire concedes:

> and this is right enough when it is only a matter of sensory taste, . . . because one cannot correct defective organs. It is different with the arts; as their beauties are real, there is a good taste that discerns them and a bad taste that does not; and the mental defect that gives rise to a wayward taste can often be corrected.

Here Voltaire anticipates Eliot: taste, for him, is no mere matter of fallible individual preference, but one of conformity to an established criterion, hence subject to correction. From there, Voltaire connects "good taste" to the idea of perfected style, or what literary historians would eventually christen "classicism":

> The taste of an entire nation can be corrupted. This misfortune usually comes about after periods of perfection. Artists, for fear of being imitators, seek untraveled

paths; they flee the natural beauty that their predecessors had embraced; there is some merit in their efforts; this merit covers their faults; the novelty-besotted public runs after them; it soon loses interest, however, and others appear who make new efforts to please; they flee even further from nature; taste disappears amid a welter of novelties that quickly give way one to another; the public no longer knows where it is, and it longs in vain for the age of good taste that will never return. It has become a relic that a few sound minds now safeguard far from the crowd.

This wholly aristocratic, existential notion of "good taste," ever resistant to destabilizing innovation, is a decreed taste, sanctioned by tradition. Still a child of the seventeenth century, Voltaire locates its source dogmatically in "nature." D'Alembert, the editor of the *Encyclopédie*, in an appendix to Voltaire's article, somewhat modernizes (that is, relativizes) Voltaire's position by vesting the power of decree in "philosophy," which at least implies human agency:

> In matters of taste, a smattering of philosophy can lead us astray, while philosophy better understood can bring us back. It is an insult to literature and philosophy alike to think that they could harm or exclude one another. Everything that pertains, not only to our way of thinking, but also to our way of feeling, is philosophy's true domain. . . . How could the true spirit of philosophy be opposed to good taste? On the contrary, it is its strongest support, because this spirit consists in returning everything to its true principles, in recognizing that every art has its own particular nature, each condition of the soul

its own character, each thing its own particular tint—in one word, that one should never transgress the limits of a given genre.

These extracts exhaust references to *le bon goût* (rather than the more usual *goût*, unmodified) in the *Encyclopédie*. The addition of the adjective does not change the meaning; "good taste" here does not differ from "taste" *tout simple*, the sense of suitability that Haydn recognized as Mozart's mark of election. And that is because the *philosophes* located the criterion of correct discrimination not in the perceiving subject but in the object perceived, rightly apprehended according to "its own particular nature," of which philosophy is the arbiter. To acquire taste, on the encyclopedists' terms, one had to submit to their authority. It became a task for a new cohort of eighteenth-century thinkers to emancipate the notion of taste from that of external authority, while nevertheless remaining faithful to the idea of its universality or its status as what Kant called a *sensus communis*, a "common sense," meaning "a sense shared by all." This required some fancy skating.

Kant's solution was to posit that taste was subjective in that it concerned not the properties of objects but the pleasure or displeasure of contemplating subjects. Hence "it is absolutely impossible to give a definite objective principle of taste . . . for then the judgment would not be one of taste at all." And yet such reactions were ideally universal because they derived from a faculty possessed by humans, only by humans, and by all humans. Within Kant's careful definitions, all have taste, and all have the same taste. It must, therefore, enjoy "a title

to subjective universality," or what we now somewhat less paradoxically call intersubjectivity.

Evidence of universality is to be sought in consensus, which must be discernible despite the great variety in subjective preference that strikes the casual observer. For Hume, this made it all the more imperative to seek, or establish, "a Standard of Taste: a rule, by which the various sentiments of men may be reconciled; at least, a decision, afforded, confirming one sentiment, and condemning another." The problem for Enlightened theories of universal taste was that of outliers, people of ostensibly normal endowment who nevertheless diverged from the intersubjective consensus. Is it possible to speak of "wrong" taste, even if, as Kant maintained (and as everyone beginning with Hume seems to agree), "the judgment of taste is . . . not a judgment of cognition," and therefore cannot be considered factual? If there can be wrong taste, then there can be bad taste; and if there is bad taste, then there can be normative good taste — something that can be aspired to. We are approaching the crux of our problem.

The most ingenious attempt to account for wrong taste within a universalist theory of taste is found in the introduction to Edmund Burke's famous *Philosophical Enquiry into the Origin of Our Ideas of the Sublime and Beautiful*, first published in 1757, the same bumper year that saw the publication of both the seventh volume of the *Encyclopédie* and Hume's essay on taste. Having defined taste as "that faculty or those faculties of the mind, which are affected with, or which form a judgment of, the works of imagination and the elegant arts," Burke invoked John Locke's distinction between wit and judgment. "Mr. Locke," he writes, "very justly and finely observes of wit, that it is chiefly conversant in tracing resemblances: he remarks, at the same time, that the business of judgment is

rather in finding differences." As we know from experience, wit is much the more pleasurable function, as the perception of resemblances is a matter of immediate sensibility, whereas the discrimination of differences requires expertise and mental effort. Thus, Burke argues, taste being a judgment, its exercise is more or less correct depending not upon what he calls "a superior principle in men," but rather "upon superior knowledge," in the sense of wide acquaintance.

That is the crucial move. Once we postulate that taste is not a simple idea but a compound of sensibility and knowledge, it follows that a deficiency of taste can be the result of a deficiency in either category. "From a defect in [sensibility]," Burke writes, "arises a want of taste," which is to say an inability or disinclination to render any judgment at all; whereas "a weakness in [knowledge] constitutes a wrong or a bad [taste]." This passage, coeval with Voltaire's *Encyclopédie* entry but the work of a newer breed of thinker, constitutes, to my knowledge, the earliest recognition that there can be such a thing as bad taste, as distinct from a want of taste. The latter can only be deplored or pitied, as it was by Voltaire and by Mann's Marquis de Venosta, whereas one can aspire, with Burke or Eliot, to correct the former.

The consequences of this distinction are far-reaching, and baleful; and Burke, to his credit, did not flinch from them. If "the cause of a wrong taste" is "a defect of judgment," he allowed, then the mis-evaluation of works of art

> may arise from a natural weakness of understanding, . . .
> or, which is much more commonly the case, it may arise
> from . . . ignorance, inattention, prejudice, rashness,
> levity, obstinacy, in short, all those passions, and all those
> vices, which pervert the judgment in other matters,

prejudice it no less in this its more refined and elegant province.

But if "bad or wrong taste" can be taken as a symptom of vice or perversion, the door has been opened wide to abuse. Burke recognizes this in an especially pregnant passage that enlarges upon an earlier point — that discrimination diminishes rather than enhances pleasure because it lessens the number of objects from which we can naively derive satisfaction.

> The judgment is for the greater part employed in throwing stumbling-blocks in the way of the imagination, in dissipating the scenes of its enchantment, and in tying us down to the disagreeable yoke of our reason: for almost the only pleasure that men have in judging better than others, consists in a sort of conscious pride and superiority, which arises from thinking rightly; but then, this is an indirect pleasure, a pleasure which does not immediately result from the object which is under contemplation.

What we are witnessing here is the birth, or at least the christening, of aesthetic snobbery, which is always and only social snobbery in disguise. An indirect or even perverse pleasure it may be, but snobbery is a powerful pleasure; and Burke's explanation of snobbery, as the sole compensation we receive for the loss of immediacy and naive pleasure that our critical judgment exacts from us, is the best account I have ever encountered of its value to snobs (a category that at times — let's admit it — tempts us all). It amounts also to an account and critique of aspirational

"good taste," which arises alongside and in response to aesthetic snobbery, the most quintessentially bourgeois of all snobberies, and might even be deemed tantamount to it.

It is not taste (*pace* Stravinsky) but "good taste" that conflates aesthetic and moral quality, and sits in judgment over them conjointly. Since it is the bastard child of snobbery, "good taste" requires the ever more exacting exercise of negative judgment. Forgetting, or affecting to reject, the Kantian proviso that taste is a property not of contemplated objects but of contemplating subjects, "good taste" constructs spurious existential categories such as "kitsch," a term that arose in the course of the emergence we are now tracing (and Google can tell you how often it is attached to Liszt). As snobbery's surrogate, aspirational "good taste" easily turns competitive. Critics who earn followings do so (as Louis Menand smirked about Pauline Kael) because they have recognized, and pander to, "the truth" that "people, at least educated people, like not to like movies, especially movies other people like, even more than they like to like them."

The conjoint promise of safety and self-congratulation gives one an incentive to expand the range of objects one can consign to the outer darkness, so as to maximize one's "conscious pride and superiority," to recall Burke's more elegant expression. Hence such impressive works of pseudo-scholarship as Gillo Dorfles' extravagant compendium *Il Kitsch: Antologia del cattivo gusto*, published in Milan in 1968 and translated into English as *Kitsch: The World of Bad Taste*, which contains, alongside what anyone might expect (Nazi and Soviet poster art, eroticized religious images, the Mona Lisa imprinted on bath towels and eyeglass cases), several items that can only have been calculated to shock the reader by their inclusion, such as New York's Cloisters, the museum

78

of medieval art endowed by John D. Rockefeller in 1938. A caption explains that "The structure is entirely modern but incorporates authentic architectural features from the cloisters of medieval monasteries. Authentic objects and works of art are displayed in the halls, which are always full of tourists." We are left in little doubt as to what — or rather, who — the aspersion is meant to degrade.

The inevitable race to the limit in the fastidious exercise of captious "good taste" was well captured by Joseph Wood Krutch in 1956 when reviewing a book by Mary McCarthy, an especially exigent arbiter. "Her method is one of the safest," he remarked.

> If you deny permanent significance to every new book or play time will prove you right in much more than nine cases out of ten. If you damn what others praise there is always the possibility that your intelligence and taste are superior. But if you permit yourself to praise something then some other superior person can always take you down by saying "So that is the sort of thing you like."

That fear afflicts performers as well as critics. There is a coruscating passage on taste in the treatise *Du chant*, from 1920, by Reynaldo Hahn, the singer, composer, and voice teacher who perhaps better than any other musician — and not only because he was Marcel Proust's lover — embodies the spirit of the *belle époque*, a time synonymous with elegance, as elegance may be thought synonymous with taste. But the writing drips with sarcasm:

> When singing is not directed by the heart (and you know that one cannot lightly command the service of the heart), when singing is not guided by feeling, by under-

**Taste, Bad Taste, and Franz Liszt**

standing, by the direct outpourings of the heart, it is taste that assumes control, directing and presiding over everything. Then it must be everywhere at once, acting in a hundred different ways. Think of it! Every detail of the vocal offering must be submitted to the dictates of taste.

Let me be precise. By *taste,* I do not mean that superior and transcendent ability to comprehend what is beautiful which leads to good esthetic judgment. In fact, we cannot ask all singers to be people of superior taste, since such a requirement would reduce still further the very limited number of possible singers. By *taste,* I mean a wide-ranging instinct, a sure and rapid perception of even the smallest matters, a particular sensitivity of the spirit which prompts us to reject spontaneously whatever would appear as a blemish in a given context, would alter or weaken a feeling, distort a meaning, accentuate an error, run counter to the purposes of art.

I repeat: A particular sensitivity of the spirit is necessary in this sort of taste, as well as emotion and a certain fear of ridicule. It is no doubt for this reason that women display a better sense of taste in singing than men.

A certain fear of ridicule. It is obvious that Hahn is speaking not of existential but aspirational taste; taste that hedges against the depredations of snobs, who censor idiosyncrasy along with sincerity and force artists (and especially, in Hahn's bigoted view, those of the weaker sex) to retreat into what Russell Lynes, the social historian of art, in a famous article in 1949 that proclaimed a new social order based not on "wealth or family" but on "high thinking," derided as the

"entirely inoffensive and essentially characterless" precincts of "good taste."

Of course, Lynes was writing in the age of Rosen and Brendel, and describes a late stage in the socio-aesthetic process whose beginnings Edmund Burke had charted long before the stultifying category of "good taste" had gained momentum, although he may be said to have predicted it. At the end of his discussion of (universal) taste, Burke notes optimistically that "the taste . . . is improved exactly as we improve our judgment, by extending our knowledge, by a steady attention to our object, and by frequent exercise." To boil it down to a formula, he proposes that *taste* = *judgment* = *knowledge*, and he who knows most judges best. Appeals to the ignorant, therefore, are subversive of taste, because they thwart the advancement of knowledge. Those who seek, or gain, the applause of the ignorant are threats to the maturation of taste.

## III

The stage has been set for our hero. But before he enters, there remains one last matter to broach, namely the ambiguous character of virtuosity and the ambivalent attitude toward it in Liszt's day on the part, not of audiences, surely, but of the newly professionalized class of tastemakers — what Liszt, in exasperation, called "the aristocracy of mediocrity."

Gillen D'Arcy Wood, a social historian of literature and music and their interrelations under romanticism, identifies Liszt's wry phrase with "an increasingly influential middle-class cultural regime that wished to be purified of virtuosic display," an aspiration he calls, straightforwardly enough, virtuosophobia. Virtuosophobia is obviously akin to what the literary historian Jonas Barish called "the antitheatrical prejudice," in a book that traced — from ancient Greece to the

middle of the twentieth century — the curious inconsistency whereby "most epithets derived from the arts" — words such as *poetic* or *epic* or *lyric* or *musical* or *graphic* or *sculptural* — "are laudatory when applied to the other arts, or to life," with the conspicuous exception of terms derived from the theater, such as *theatrical* or *operatic* or *melodramatic* or *stagey*, which, by contrast, "tend to be hostile or belittling." One reason for the antitheatrical prejudice is that theatrical acting, being by definition an act of dissembling, transgresses against ideals of sincerity; and virtuosos are often similarly accused, the terrific effect of their performances being unrelated, or not necessarily related, to genuine feeling.

This was an observation constantly made about Liszt during his lifetime, and not always invidiously. His American pupil Amy Fay, who attended his master classes in Weimar in 1873, wrote in her memoir, *Music Study in Germany*, that

> when Liszt plays anything pathetic, it sounds as if he had been through everything, and opens all one's wounds afresh. . . . [He] knows the influence he has on people, for he always fixes his eyes on some one of us when he plays, and I believe he tries to wring our hearts. . . . But I doubt if he feels any particular emotion himself when he is piercing you through with his rendering. He is simply hearing every tone, knowing exactly what effect he wishes to produce and how to do it.

To Liszt's manner, Fay contrasted that of Joseph Joachim (once Liszt's protégé, later his most zealous detractor) who exemplified the submissive and antitheatrical attitude later associated with *Werktreue.* Where the one was "a complete actor who intends to carry away the public," the other was

(that is, acted) "totally oblivious of it." Where the one "subdues the people to him by the very way he walks on the stage," the other is "'the quiet gentleman artist' who advances in the most unpretentious way, but as he adjusts his violin he looks his audience over with the calm air of a musical monarch, as much as to say, 'I repose wholly on my art, and I've no need of any "ways or manners.""

Which of course is also a means of taking possession of one's public. What Fay described were two species of charismatic — that is, histrionic — "ways or manners," as she surely knew. (And Liszt was well aware of the alternative species. Describing the charismatic playing of John Field, he showed the same subtle irony as Fay describing Joachim: "It would be impossible to imagine a more unabashed indifference to the public. . . . He enchanted the public without knowing it or wishing it. . . . His calm was all but sleepy, and could be neither disturbed nor affected by thoughts of the impression his playing made on his hearers [since] art was for him in itself sufficient reward.") The affectation of quiet absorption was the truly romantic ("disinterested") attitude, as was the antitheatrical prejudice itself and the virtuosophobia that was its musical outlet; for it was romanticism that made a fetish of sincerity. As early as 1855, in a famous letter to Clara Schumann explaining his defection from Liszt's orchestra in Weimar, Joachim broadened the antitheatrical, virtuosophobic rhetoric to encompass Liszt's compositions as well, focusing on the sacred works as especially flagrant breaches of propriety. By the end of the passage, it is impossible to separate the bad taste of Liszt the composer from that of Liszt the performer as the butt of Joachim's righteous indignation.

For a long time now I have not seen such bitter deception as in Liszt's compositions; I must admit that the

**Taste, Bad Taste, and Franz Liszt**

vulgar misuse of sacred forms, that a disgusting *coquet-terie* with the loftiest feelings in the service of effect was never intended — the mood of despair, the emotion of sorrow, with which the truly devout man is raised up to God, Liszt mixes with saccharine sentimentality and the look of a martyr at the conductor's podium, so that one hears the falseness of every note and sees the falseness of every action.

Most explicit of all was Nietzsche. In *Der Fall Wagner* he asked, rhetorically, where Wagner belonged, and his answer went beyond Wagner to indict Wagner's father-in-law as well. Wagner belongs "*not* in the history of music. What does he signify nevertheless in that history? The emergence of the actor in music: a capital event that invites thought, perhaps also fear. In a formula: 'Wagner and Liszt.'" But at least Wagner did his acting in the theater. About Liszt, who turned instrumental performance into a branch of theater, one can only think worse. Nietzsche's peroration, in three italicized "demands," points the final finger at the musician, not the actor, for music is brought down as the theatrical is elevated. "What are the three demands for which my wrath, my concern, my love of art has this time opened my mouth?" thunders Nietzsche. They are these:

*That the theater should not lord it over the arts.*
*That the actor should not seduce those who are authentic.*
*That music should not become an art of lying.*

Nor can virtuosos ever be "disinterested," to invoke Kant's principal aesthetic yardstick. Like other theatrical performers, they are never without a *Zweck*, an ulterior purpose, namely

to impress us into thunderous vanity-stroking applause and exorbitant pocket-lining expenditures; and our interest in their overcoming obstacles is a human, rather than an aesthetic, interest — the sort of interest that attends to the performances of athletes and prestidigitators as well as musicians. D'Arcy Wood gave this a social twist when writing of the "antagonism," so evident in Georgian England, and especially when Liszt tried to storm its aesthetic barricades with so much less success than he had enjoyed on the continent, "between literary (and academic) culture and the sociable practices of music, between Romantic middle-class 'virtues' and aristocratic virtuosity."

We are back again to the Marquis de Venosta, and the distinction between "family" and "good family." The former is an unearned status; the latter, a reputation earned through the exercise of virtue — which demanded vigilance against virtue's false cognate. Though etymologically descended from virtue, virtuosity, in the middle-class view, was sheer vice, inextricably associated with all the other vices, and that remains our incorrigibly Romantic, middle-class view today. The author of a serious scholarly book on Paganini, published in 2012, wanted to know, for example, whether "the greed, lust, pride, and vainglory that [were] manifested in multiple aspects of the virtuoso's life [can] be viewed any longer as separate from the aesthetic of virtuoso performance."

Hence one of the paradoxes of nineteenth-century musical reception that continues to haunt us in the twenty-first century is the simultaneous denigration of virtuosity and fetishizing of difficulty. To unpack it we might begin by returning

to Edmund Burke and his famous treatise. The section on the sublime contains a short paragraph, seemingly an afterthought, on difficulty as a "source of greatness":

> When any work seems to have required immense force and labor to effect it, the idea is grand. Stonehenge, neither for disposition nor ornament, has anything admirable; but those huge rude masses of stone, set on end, and piled each on other, turn the mind on the immense force necessary for such a work. Nay, the rudeness of the work increases this cause of grandeur, as it excludes the idea of art and contrivance; for dexterity produces another sort of effect, which is different enough from this.

Thus, difficulty overcome too dexterously is not sublime; or rather, the dexterous overcoming of difficulty destroys the sublime effect and vitiates the awe that it inspires. Substitute "virtuosity" for Burke's "dexterity" and the reason will become apparent why the English critics who wrote about Liszt in the 1840s so belittled or even deplored his "transcendent" virtuosity, associating it with triviality rather than with grandeur. The very act of transcendence was virtuosity's transgression — a transgression against the virtue of difficulty.

The works of Beethoven were, in Burke's sense, the Stonehenge of music. Even before his sketchbooks exposed "the immense force necessary for such a work" to the inquisitive eye, his labor was a proverbial struggle *per aspera ad astra*. And performing his music was likewise a proverbial struggle it became a sacrilege to appear to transcend. The approved attitude toward Beethoven — the tasteful attitude — was Stravinsky's *grand thème de la soumission*, epitomized in

Artur Schnabel's famous remark that "I am attracted only to music which I consider to be better than it can be performed. Therefore I feel (rightly or wrongly) that unless a piece of music presents a problem to me, a never-ending problem, it doesn't interest me too much." And if Schnabel's piety represents the epitome, way beyond epitome was the British conductor Colin Davis, who said of Beethoven's *Missa solemnis*, "It's such a great work, it should never be performed."

Beethoven's unique social situation was bound up equally with the new attitude toward works and difficulty — or rather, the new valuation placed on old attitudes toward them — and with his removal from society as a result of deafness. It put Beethoven at the opposite social extreme from the virtuoso, who (like Beethoven himself in the earlier stages of his career) was sociability personified. Beethoven's vaunted difficulty was abetted by his aristocratic patrons, while the virtuoso was seen as playing to the common crowd. The newly reified concept of artwork that Beethoven's talent and fate so abetted is our concept still. It is what made possible the notion of "classical music," which is to say, music conceptualized as a permanent and immutable object, at the same level of reification as the products of other artistic media like painting or sculpture: a concrete entity deserving the designation "work." From something that elapses in time, music was thus reconceptualized as something that exists ontologically in an "imaginary museum," as Lydia Goehr put it in the title of her celebrated book — a kind of notional space.

So let us imagine a reified musical work that way — as an article somehow located in a curated space. The humility so demonstratively voiced by Schnabel or Davis (whether or not we accept it at face value) is located below it. It looks *up*, like anything aspirational. But the attitude of the virtuoso —

who transcends all difficulties, makes light of them, and makes everything seem easy (as the commonplace accolade would have it) — is located, like anything transcendent, above the work. It looks *down*. And therefore it is an arrogant crossing of an ethical line, a hubristic affront to aspiration; *a fortiori*, it is an affront to "good taste." A London critic's review of Liszt's rendition of the Emperor Concerto, which casts him in the role of a bad curator, is a perfect summation of these strictures: "The many liberties he took with the text were evidence of no reverential feeling for the composer. The entire concerto seemed rather a glorification of self, than the heart-feeling of the loving disciple."

And yet — as always — one man's transgression is another man's transcendence. There is always a more "spiritual" way of viewing virtuosity: as a literal triumph over the physical. Heine wrote that where others "shine by the dexterity with which they manipulate the stringed wood, . . . with Liszt one no longer thinks of difficulty overcome — the instrument disappears and the music reveals itself." But then he immediately turns around and contradicts himself in his fascination, all but universally shared by those who experienced Liszt in the flesh, with the pianist's physical presence, obsessing over his way of "brush[ing] his hair back over his brow several times," turning his listeners into viewers, or rather voyeurs, who feel "at once anxious and blessed, but still more anxious." The phobia, repressed, returns.

The strongest avowal of virtuosophobia, the censorious distinction between virtuosity and difficulty, comes from Liszt himself, in the second of his so-called Baccalaureate Letters,

published in the Parisian *Gazette musicale* on February 12, 1837, with a dedication to George Sand. The relevant passage runs as follows:

> In concert halls as well as in private drawing rooms . . . , I often played works of Beethoven, Weber, and Hummel, and I am ashamed to say that for the sake of winning the applause of a public which was slow in appreciating the sublime and beautiful, I did not scruple to change the pace and the ideas of the compositions; nay, I went so far in my frivolity as to interpolate runs and cadenzas which, to be sure, brought me the applause of the musically uneducated, but led me into paths which I fortunately soon abandoned. I cannot tell you how deeply I regret having thus made concessions to bad taste, which violated the spirit as well as the letter of the music. Since that time absolute reverence for the masterworks of our great men of genius has completely replaced that craving for originality and personal success which I had in the days too near my childhood.

Thus, with a presumed literary assist from Marie d'Agoult, Liszt accuses himself of *mauvais goût*, a locution that was still a novel one at the time of writing. But confessions can also be a form of boasting, and self-abasement a form of self-promotion. I think it pretty clear that Liszt, at that moment engaged in a very public rivalry with Sigismund Thalberg, was using the rhetoric of penitence and contrition in this way, as part of a campaign to show that he, and not his challengers, had become (to quote a famous passage from a letter he had written several years before) "an artist such as is required today." That is to say, an artist who was abreast of the latest intellectual fashions, who

was prepared to use the press to establish good public relations, and who was therefore able to maintain preeminence in the new era of publicity. Unlike his rivals, he was displaying himself as an artist who possessed both taste and "good taste," who cultivated the aspirational posture, who looked up, not down, at "the masterworks of our great men of genius."

There is no reason to doubt the sincerity of Liszt's aspirations. But as Kenneth Hamilton has observed, "numerous reviews of his concert tours of the 1840s indicate that [as of 1837], he cultivated an attitude akin to St. Augustine's famous exhortation, 'Oh Lord, grant me chastity — but not yet!'" He was still ready and able, in the words of Carl Reinecke, to "dazzle the ignorant throng." Still, the social animus in that charge should caution us against too readily slapping a "populist" label on Liszt. Dana Gooley reminds us that some of Liszt's concert practices suggest the opposite. He imposed higher ticket prices than did any of his contemporaries, which Gooley interprets as an attempt "to siphon out the middle bourgeoisie" and ensure that his recitals remained high-prestige events, not popular entertainments. The Baccalaureate Letters themselves show him striving to found his reputation on "his nearness to the intellectual and political elites of Paris," the "cultural trendsetters."

One of the most revealing portraits of Liszt the composer-performer in all the glorious inconsistency of his behavior, accurately reflecting the ambivalences of mores in transition, is the recollection of Vladimir Vasilievich Stasov, first published in 1889, of the great pianist's debut in St. Petersburg forty-seven years earlier, in 1842:

> Everything about this concert was unusual. First of all,
> Liszt appeared alone on the stage throughout the entire

concert: there were no other performers — no orches-
tra, singers or any other instrumental soloists whatso-
ever. This was something unheard of, utterly novel, even
somewhat brazen. What conceit! What vanity! As if to
say, "all you need is me. Listen only to me — you don't
need anyone else." Then, this idea of having a small stage
erected in the very center of the hall like an islet in the
middle of an ocean, a throne high above the heads of the
crowd, from which to pour forth his mighty torrents of
sound. And then, what music he chose for his programs:
not just piano pieces, his own, his true métier — no, this
could not satisfy his boundless conceit — he had to be
both an orchestra and human voices. He took Beetho-
ven's "Adelaïde," Schubert's songs — and dared to replace
male and female voices, to play them on the piano alone!
He took large orchestral works, overtures, symphonies
— and played them too, all alone, in place of a whole
orchestra, without any assistance, without the sound of
a single violin, French horn, kettledrum! And in such an
immense hall! What a strange fellow!

In a somewhat earlier memoir, "The Imperial School of
Jurisprudence Some Forty Years Ago," Stasov recalled that,
after the first item on the program, Rossini's *William Tell*
overture, Liszt "moved swiftly to a second piano facing in the
opposite direction. Throughout the concert he used these
pianos alternately for each piece, facing first one, then the
other half of the hall." Stasov was seated near the composer
Glinka, and overheard his conversation before the concert.
When one noble lady, Mme. Palibina, asked Glinka whether he
had already heard Liszt, Glinka replied that he had heard him
the previous evening, at an aristocratic salon.

"Well, then, what did you think of him?" inquired Glinka's importunate friend. To my astonishment and indignation, Glinka replied, without the slightest hesitation, that sometimes Liszt played magnificently, like no one else in the world, but other times intolerably, in a highly affected manner, dragging tempi and adding to the works of others, even to those of Chopin, Beethoven, Weber, and Bach, a lot of embellishments of his own that were often tasteless, worthless, and meaningless. I was absolutely scandalized! What! How dare some "mediocre" Russian musician, who had not yet done anything in particular himself [by that time, Glinka had written both his operas!], talk like this about Liszt, the great genius over whom all Europe had gone mad! I was incensed. It seemed that Mme. Palibina did not fully share Glinka's opinion either, for she remarked, laughingly, *"Allons donc, allons donc, tout cela ce n'est que rivalité de métier!"* [Come now, come now, all this is nothing but professional rivalry!] Glinka chuckled and, shrugging his shoulders, replied, "Perhaps so."

So if Liszt knew enough to pay tribute, or at least lip service, to the new Romantic ideals, his public acclaim and his consummate, irrepressible virtuosity continued to threaten them. Even after his *true* capitulation to good taste, when he withdrew from the concert stage to devote himself to what was considered at the time a particularly high-minded species of modern composition, he was regarded as threatening by musicians with a different notion of high-mindedness. Liszt came to symbolize the danger of the mass audience and those who catered to it — a danger that his composing may have posed even more drastically, in the eyes of some, than his piano playing.

In the later nineteenth century the chief threat to musical idealists was no longer exercised by virtuosos, but by composers who subordinated musical values to mixed media: opera composers, to be sure, who as always commanded the largest and least discriminating audiences, but also — and worse — those who tried to turn their instrumental music into wordless operas, as Liszt did in his symphonic poems and programmatic symphonies. Whether embodied in the corruption of texts or in the corruption of media, the corruption that the fastidious really feared was the corruption of taste and mores, which looked to guardians of good taste like corruption of the flesh. In the early correspondence of Brahms and Joseph Joachim, the adjective *Lisztisch* was already a code word. In one letter, Joachim writes to Brahms of a certain passage that Brahms had written: *"Es bleibt mir häßlich — ja verzeih's — sogar Lisztisch!"* ("I think it's awful, even — forgive me — Lisztish!"). Or consider Brahms writing to Clara Schumann in 1869:

> Yesterday Otten [G. D. Otten, conductor of the Hamburg Philharmonic] was the first to introduce works by Liszt into a decent concert: "Loreley," a song, and "Leonore" by Bürger, with melodramatic accompaniment. I was perfectly furious. I expect that he will bring out yet another symphonic poem before the winter is over. The disease spreads more and more and in any event extends the ass' ears of the public and young composers alike.

This diagnosis of social pathology became quite explicit among the Brahmins, among whom Theodor Billroth, the famous surgeon, was the exemplary figure. Writing to the composer after a performance of Brahms' First Symphony, Billroth gave voice to a new aristocracy of *Bildung*,

of education, taste, and culture — or was it just Liszt's old aristocracy of mediocrity?

> I wished I could hear it all by myself, in the dark, and began to understand [the Bavarian] King Ludwig's private concerts. All the silly, everyday people who surround you in the concert hall and of whom in the best case maybe fifty have enough intellect and artistic feeling to grasp the essence of such a work at the first hearing — not to speak of understanding; all that upsets me in advance.

Billroth stands in a resistant line that gathered strength as it moved into the twentieth century: the modernist line that helped create the storied Great Divide between art and mass culture. It passes through Schoenberg — for whom "if it is art, it is not for all, and if it is for all, it is not art" — on its way to the likes of Adorno, Dwight Macdonald, and others who insisted that art identify itself in the twentieth century by creating elite occasions, which is to say occasions for exclusion. Liszt, with his generous and inclusive impulse, created many problems for that project.

As the line of social resistance passed through the twentieth century it got ever shriller, culminating in the pronouncements we have sampled by Rosen and Brendel, allies in snobbery despite their disagreement over Liszt. Charles Rosen never claimed to be a historian (as anyone knows who has read the introduction to *The Classical Style*), but it takes a singular disregard of history to assert, as he did, that "'good taste' is a barrier to an understanding and appreciation of the nineteenth century," when in fact good taste was the invention of the nineteenth century. It was the invention of

nineteenth-century bourgeoises who aspired to the condition of royalty — Billroths who wanted to be Ludwigs, surgeons who wanted to be kings.

In its present state of devolution, the line of good taste has descended to the likes of Jack Sullivan, whose Wikipedia entry identifies him as "an American literary scholar, professor, essayist, author, editor, musicologist, concert annotator, and short story writer," and who was quoted in the *New York Times*, on the very day I was drafting the paragraph you are now reading, as complaining in the Carnegie Hall program book about the standard performing version of Chaikovsky's Variations on a Rococo Theme for cello and orchestra, as revised after its premiere in 1877 by the original performer and dedicatee, Wilhelm Fitzenhagen, at the composer's request. Under the impression that the original version was to be performed by Yo-Yo Ma, with Valeriy Gergiyev and the Mariyinsky Orchestra, and paraphrasing a letter to Chaikovsky from his publisher, Sullivan grumbled that Fitzenhagen had taken Chaikovsky's "cannily constructed Neo-Classical piece and 'celloed it up' for his own grandstanding purposes." Thrice-familiar strictures, these; as is the tone of social derision that the phrase "celloed up" (compare "gussied up" or "lawyered up") is calculated to convey.

In fact, like every self-respecting virtuoso, Yo-Yo Ma had played the Fitzenhagen version, which includes all the passages (like the famous octaves at the end) that have made the Variations a concert perennial instead of the rarity it remained during Chaikovsky's lifetime. "Well, who better than Mr. Ma to play something celloed up," wrote the sharp reviewer for the *Times*, James Oestreich, exposing the obtuseness of the class warriors with a well-aimed shaft of contrarian bad taste. As I chuckled, I thought of Baudelaire and his immortal sally, "*Ce*

*qu'il y a d'enivrant dans le mauvais goût, c'est le plaisir aristocra-tique de déplaire,"* "the heady thing about bad taste is the aristo-cratic pleasure of giving offense." And I recalled the bravura defiance of William Gass, novelist and critic and curmudgeon supreme, in his immortal essay "What Freedom of Expression Means, Especially in Times Like These":

> It is a tough life, living free, but it is a life that lets life be.
> It is choice and the cost of choosing: to live where I am
> able, to dress as I please, to pick my spouse and collect
> my own companions, to take pride and pleasure in my
> opinions and pursuits, to wear my rue with a difference,
> *to enjoy my own bad taste* and the smoke of my cooking
> fires, to tell you where to go while inspecting the ticket
> you have, in turn, sent me.

What makes this story and its attendant ruminations more than a digression is the letter in which Fitzenhagen reported to Chaikovsky about his first performance, in Wiesbaden in 1879, of the celloed-up version. "I produced a furor," he assured the composer. "I was recalled three times." And then he describes the reaction of one particular member of the audience: "Liszt said to me: 'You carried me away! You played splendidly.' And regarding your piece he observed: 'Now there, at last, is real music!'" Mark that it was the sixty-eight-year-old Liszt who was encouraging Fitzenhagen to cello up, thirty years after his retirement from the concert stage and almost forty years since the baccalaureate letter in which he recanted "runs and cadenzas which [bring] the applause of the musically uneducated, but violated the spirit as well as the letter of the music." Now at peace, the venerable abbé was declaring his solidarity with the applauders.

In closing, a few words about the Second Hungarian Rhapsody. Yes, of course it is a central work for Liszt; without it, he would not be what he is in our imaginations. But what do those who object to it find objectionable? Why does Brendel exclude it from the category of "works that offer both originality and finish, generosity and control, dignity and fire"? When I hear it well played, I am amazed at the originality with which Liszt imitated the cimbalom, and I marvel at the beautifully realized (and "finished") form and pacing of the piece, and I fail to see where it is deficient either in control or in dignity. The derision with which it is treated, even by those (like Brendel) who have put in the time and effort to master it, seems a particularly crisp instance of the antitheatrical prejudice as applied to a composition that has become the test par excellence of a pianist's ability to enact the role of virtuoso, an enactment that achieves its zenith with those special performers, such as Rachmaninoff or Horowitz or Marc André Hamelin, who can top the piece off with their own nonchalant cadenzas, the nonchalance signifying the truly *Lisztisch* transgressive transcendence that drives aspirational musicians mad.

And there is more: like a gas (and of course it *is* a gas), the Second Hungarian Rhapsody has escaped its container and leeched out into the popular culture — which is only meet, after all, since that is where its inspiration had come from. (That, of course, is what objectors object to.) Many other works by nineteenth-century masters had a similar source in restaurant and recruitment music; one need think only of all those Brahms finales — to concertos for piano, for violin, and for cello plus violin, or to his piano quartets. Like Liszt's Rhapsody, they adapted the sounds of environmental music to the special precinct of the concert hall. But unlike Liszt's

Rhapsody, they were never reabsorbed into the environment. Liszt's Rhapsody inhabits animated cartoons: Mickey Mouse, Bugs Bunny, and Tom and Jerry have all played it, not to mention (arranged by King Ross) a whole animal orchestra, courtesy of Max Fleischer. It was heard, and used, in dance halls; it was in the repertoire of every swing band. It even haunts sports arenas: I am informed by Wikipedia that in the 1970s the St. Louis Cardinals' organist Ernie Hays played Hungarian Rhapsody No. 2 to signal that pitcher Al Hrabosky (nicknamed "The Mad Hungarian") was warming up before appearing as a relief pitcher. It is everywhere. There is even an LP recording of the Rhapsody by a Communist-era Hungarian fakelore ensemble, purporting to return it to an "authentic" environment from which it had never come.

Is this something to condemn, something to resist? Or is this interpenetration of the artistic and the vulgar worlds an ineluctable mark, perhaps the defining mark, of Liszt's greatness? To attempt, like Brendel, to purge Liszt of these impolite associations is indeed to misunderstand his place in our world; but Rosen, too, beholds the vulgar Liszt with distaste. Far better, in the words of Kenneth Hamilton, is to "embrace our own inner Second Hungarian Rhapsody." We've all got one, and Liszt knew it. To accept his invitation to flout snobbish "good taste" might help us reassert, or recover, taste — which is to say, Mozart's taste as defined by Haydn: namely, a reliable sense of what is fitting, and when.

CLAIRE MALROUX

# *The Unjust Fate of Man*

On the sandy path that goes by my door
and leads to the station of dreams,
where I had just walked, a muffled cry
reached my ear.
I stopped walking and saw a clump
of dry, drowsy grass.
The cry came from the ground. A root deplored
being without news from the stem up there with its boughs,
its flowers and its fruit, maybe even
its trunk in full maturity.
"Why was I, newly born,
the ancestor, thrown into a dungeon,
my maternal task complete,
like a convict, or worse, a useless being,
without my having seen, known or recognized the world—
and what mouth pronounced the injustice of my fate."

*     *     *

The Earth, stuffed to the gills with burning coals
and consuming itself from its birth
bristling with folds that sharpen into peaks, sometimes of
        short hairs
sometimes forming dark dense beards
and hollowed out with giant cavities filled with restless water
from which emerged the grand debris of its genesis
and full of shallow holes where other waters drowse

Despite the gravity, everything pushes upward
springs toward its Creator

The sun, a rival, pulls everything toward itself,
        pulls dangerously
To avoid catching fire
the grass clings to the soil, the tree spreads its foliage
In its shadow the man stretches out, then one day
lies down forever some few feet underground

\*　　\*　　\*

Mother death
you came to him
so mildly
so cruelly
　　　alternating authority with seduction

He out-of-breath following you or fleeing you

In the end
you wore the features of Morphine
and clasped her to you
cruelly
mildly

I gave his body to flames　　　　　　　101
married his ashes to the sea
and I alone burn
in the fire of absence

# *Before Nightfall*

Leaning in summer tuxes across the balcony
or reclining like nudes with their hair thrown back,
some trees, after high conversation, complained
about having to go back to the deaf earth again.
The leaves pulled on their arms to keep them
from going and to get even closer to whom?
To what? Which essential truth?
As if the human shadows inside the rooms
would give them some clarification,
some formula against the faceless barking . . .
And what did they sense in me but a trembling?
Night stood in the background.
A flame flew into the grass' eyes.
I did not move, no longer knowing who I was
or if dawn would also come for me.

*Translated from the French by Henri Cole*

# RICHARD WOLIN

# *The Cult of Carl Schmitt*

## I

As a political thinker, the German philosopher Carl Schmitt
was enamored of symbols and myths. His biographer has
shown that during the 1930s Schmitt was convinced that
providing National Socialism with a rational justification
was self-contradictory and self-defeating. The alternative
that was conceived by Schmitt, a conservative who was an
eminent member of the Nazi Party, was to establish the Third
Reich's legitimacy by means of symbolism and imagery culled
from the realms of religion and myth. Schmitt's attraction to
symbols and myths stemmed from his skepticism about the
value of "concepts," which he viewed only instrumentally, as

*Kampfbegriffe* or weapons of struggle. As Schmitt explained, about reading Hobbes' *Leviathan*, "we learn how concepts can become weapons." "Every political concept," he claimed, "is a polemical concept," a statement that reflects the essential bellicosity of his thought.

When it came to fathoming the mysteries of human existence, Schmitt insisted that the cognitive value of symbols and myths was far superior to the meager results of conceptual knowledge. This deep mistrust of reason was related to his veneration of "political theology," which Schmitt introduced into the mainstream of modern political thought. Schmitt's devaluation of secular knowledge was exemplified by his well-known dictum that "all modern political concepts are secularized theological concepts," an assertion that reflected his disdain for the legacy of Enlightenment rationalism. That disdain is what has given Schmitt's thought new life in our own bleak and inflamed times.

Schmitt was born in 1888 and died in 1985. He was a constitutional theorist who wrote brilliant polemics against parliamentary democracy and on behalf of dictatorial rule. He played a prominent role in providing a pseudo-legal justification for the Nazi seizure of power and was a virulent anti-Semite. During the early 1920s, the myth that captured Schmitt's imagination was the "myth of the nation," a trope that Mussolini had refashioned into a core precept of Italian fascism. Schmitt explored this theme in 1923 in the concluding pages of *The Crisis of Parliamentary Democracy*. His unabashedly enthusiastic treatment of unreason offers an important clue with respect to his future political allegiances.

Echoing the phraseology of the proto-fascist and anti-Dreyfusard Maurice Barrès, who died in that year, Schmitt extolled Mussolini's March on Rome as a triumph of "national

energy." He thereby acknowledged fascism's capacity to infuse modern politics with a vitality that was absent from the stolid proceduralism of political liberalism. Schmitt was present at the University of Munich in 1921 when Max Weber delivered his celebrated lecture on "Science as a Vocation." Schmitt agreed wholeheartedly with Weber's characterization of modernity as an "iron cage:" a world in which the corrosive powers of "rationalization" and "disenchantment" had precipitated a crisis of "meaninglessness."

Schmitt's antidote to this malaise, and to the intellectual maturity of liberalism, was his "decisionism" — his reconceptualization of sovereignty as the right to decide on the "state of exception." The ruler was the one, the only one, who had the power to decree a state of exception, and to enforce it. Schmitt attributed a cultural and even epistemological superiority to the "exception" as opposed to the "norm" and the "rule." It was the antithesis of Weberian disenchantment. As Schmitt exulted, "In the exception, the power of real life breaks through the crust of a mechanism that has become torpid by repetition." In keeping with the discourse of political theology, Schmitt stressed the parallels between the "state of exception" in jurisprudence and the "miracle" in theology.

Schmitt exalted the fascist coup as a historical and philosophical turning point in the struggle to surmount the straitjacket of rule-guided bourgeois "normativism," a legacy of the Enlightenment that *Kulturkritiker* such as Nietzsche and Spengler deemed responsible for modernity's precipitous descent into "nihilism." For Schmitt, the March on Rome was the state of exception come to life. The scholarly nature of his treatise notwithstanding, Schmitt was unable to conceal his prodigious pro-fascist fervor. "Until now," he wrote, "the democracy of mankind and parliamentarism has only once

been contemptuously pushed aside through the conscious appeal to myth, and that was an example of *the irrational power of the national myth*. In his famous speech of October 1922 in Naples before the March on Rome, Mussolini said, 'We have created a myth, this myth is a belief, a noble enthusiasm, it does not need to be reality, it is a striving and a hope, belief and courage. Our myth is the nation, the great nation which we want to make into a concrete reality for ourselves'."

Schmitt celebrated Mussolini's mobilization of the "national myth" as "the most powerful symptom of the decline of the... rationalism of parliamentary thought ... [and the] ideology of Anglo-Saxon liberalism." (We would now call Schmitt's position "post-liberalism.") Italian fascism was the harbinger of a brave new world of conservative revolutionary political ascendancy: a glorious form of *Herrschaft* predicated on the values of "order, discipline, and hierarchy." Mussolini's putsch represented much more than a simple "regime change." It signified a qualitative setback for the "ideas of 1789" and a resounding triumph of the counterrevolutionary ethos, as represented by the "Catholic philosophers of state" — Joseph de Maistre (1753–1821), Louis de Bonald (1754–1840), and the relatively unknown Spaniard Juan Donoso Cortés (1809–1853) — whom Schmitt revered.

Following the Great War, the political challenge that Schmitt confronted was how to "actualize" the tenets of counterrevolutionary thought in a godless secular age whose assault on the twin pillars of traditional political authority, throne and altar, had eliminated absolute monarchy as a viable political option. Schmitt's French doppelgänger, Charles Maurras, the leader

of the Action Française, grappled with this dilemma as well. Schmitt was an avid reader of *Action Française*, which Maurras edited, and he regarded Maurras as France's most interesting thinker. Maurras, despite his counterrevolutionary revulsion against the legacy of 1789, remained anachronistically wedded to monarchism. Schmitt, by contrast, opted for a *Flucht nach vorne*, what we would call a forward defense, which is to say, he went on the attack. At the dawn of what he believed would be a new post-liberal era, Schmitt made a definitive break with all forms of traditionalism with his particular doctrine of dictatorship.

Schmitt found ample ideological support for his authoritarian credo in the counterrevolutionary doctrines of Maistre and Donoso Cortés, both of whom occupied a privileged position in Schmitt's pantheon of esteemed intellectual precursors. In 1821, in *Les Soirées de St. Petersbourg*, Maistre — like Schmitt a proponent of "political theology" — exalted the figure of the Executioner as God's emissary on earth and an agent of Divine justice. Maistre apotheosized the Executioner as a *puissance créatrice*, a creative force, and an *être extraordinaire*, an extraordinary being. Maistre maintained that, in view of humanity's innate propensity for evil, the Executioner was the ultimate guarantor of secular order. As such, he alone separated human society from a headlong descent into anarchy and chaos.

Yet it was Donoso Cortés' unmatched political clairvoyance that expanded Schmitt's horizons, thereby allowing Schmitt to transcend the constraints of traditional conservatism, whose gaze — as the case of Charles Maurras demonstrated — was obsessively and counter-productively fixated on the past. In *Political Theology*, Schmitt praised Donoso Cortés as a paragon of "decisionistic thinking and a Catholic philosopher of state who was intensely conscious of

the metaphysical kernel of all politics." According to Schmitt, Donoso Cortés was the only counterrevolutionary thinker who drew the proper conclusion from the "Scythian fury" of the revolutions of 1848, which "godless anarchists" such as Bakunin and Proudhon had directed against the forces of the ancien régime: that absolute monarchy had indisputably become a thing of the past. It was over. As Schmitt put it in *Political Theology*, insofar as "there were no more kings, the epoch of royalism had reached its end." The conclusion that Donoso Cortés drew was that because "[monarchical] legitimacy no longer existed in the traditional sense... there was only one solution: *dictatorship*."

Donoso Cortés exalted dictatorship as an inviolable and sacrosanct *decision* — a decision, that, as Schmitt explained, is "independent of argumentative substantiation" and that "terminates any further discussion about whether there may still be some doubt." Schmitt's encounter with Donoso Cortés' "decisionism" was the "primal scene" of his political philosophy. It determined what Schmitt described in *Roman Catholicism as Political Form* in 1925 as the "complex oppositorum" between political theology and secular political rule. Schmitt embraced Donoso Cortés' Christological understanding of anarchists and socialist as agents of the Antichrist, as political actors whose goal it was to "disseminate Satan." For Schmitt, Donoso Cortés had correctly understood that the momentous battle between "absolute monarchy" and "godless anarchism" was not merely another profane political conflict. Instead it was a struggle that anticipated the Last Judgment.

Donoso Cortés' apocalyptic view of politics as a final struggle between Good and Evil became the cornerstone of Schmitt's "decisionism." Schmitt praised decision as a force that "frees itself from all normative ties and thereby becomes

*absolute.*" Hence, according to Schmitt, it was the "royal road" to dictatorship. As he explained in *Political Theology:*

> The true significance of counterrevolutionary philoso-
> phers of state [such as Maistre, de Bonald, and Donoso
> Cortés] lies *in the consistency with which they decide.*
> They heightened the moment of the decision to such
> an extent that the notion of legitimacy... was finally
> dissolved. As soon as Donoso Cortés realized that the
> period of monarchy had come to an end because there
> no longer were kings ... he brought his decisionism to
> its logical conclusion: *he demanded a political dictator-
> ship...* Donoso Cortés was convinced that the final battle
> had arrived. In the face of *radical evil*, the only solution
> is *dictatorship.*

Donoso Cortés' epiphany concerning the political-theo-
logical significance of dictatorship anticipated the Grand
Inquisitor episode of *The Brothers Karamazov.* The important
parallels between Schmitt's views on dictatorship and
Dostoevsky's allegorical treatment of it were not lost on the
renegade Jewish theologian Jacob Taubes. Following World
War II, Taubes wrestled profoundly with Schmitt, whom
he called the "apocalyptic prophet of the counterrevolu-
tion," and with whom he had an interesting correspondence.
Taubes' reflections concerning the totemic significance that
Schmitt attributed to Dostoevsky's parable about the political
consequences of human sinfulness are worth citing:

> I had quickly come to see Carl Schmitt as an incarna-
> tion of Dostoevsky's Grand Inquisitor. During a stormy
> conversation at Plettenberg in 1980, Schmitt told me

that anyone who failed to see that the Grand Inquisitor was right about the sentimentality of Jesuitical piety had grasped neither what a Church was for, nor what Dostoevsky—contrary to his own conviction—had "really conveyed, compelled by the sheer force of the way in which he posed the problem." I always read Carl Schmitt with interest, often captivated by his intellectual brilliance and pithy style. But in every word I sensed something alien to me, the kind of fear and anxiety one has before a storm, an anxiety that lies concealed in the secularized messianic art of Marxism. Carl Schmitt seemed to me to be the Grand Inquisitor of all heretics.

Support for Taubes' intuition about Schmitt and the Grand Inquisitor as fraternal spirits is provided by a friend from Schmitt's Munich days. In a letter in February 1922, Hermann Merk suggested to Schmitt, half-seriously, that, "if someone were to establish a *Lehrstuhl* at the University of Munich for the justification of the Spanish Inquisition, you would be the ideal person to occupy it, and I would be your most devoted student!"

Schmitt's glorification of dictatorship as a sovereign decision that "terminates any further discussion" resurfaced in his landmark debate in 1931 with Hans Kelsen, the eminent jurist and legal philosopher who was forced to leave Germany two years later because he was a Jew, about who is the "Guardian of the Constitution." Schmitt's numerous champions have portrayed his defense of executive sovereignty as a last-ditch attempt to safeguard the Weimar Republic against the encroachments of political extremism, both left and right. They have neglected to consider the political-theological underpinnings of Schmitt's worldview. In

the colloquy with Schmitt, Kelsen, a vociferous champion of *Rechtsstaatlichkeit* (rule of law), advocated strengthening the federal constitutional court as the instance of last resort. Schmitt, conversely, basing himself on Article 48, the Weimar Constitution's notorious emergency powers proviso, argued in favor of a "sovereign" presidential dictatorship. In light of Schmitt's strong commitment to the paradigm of political theology, it is difficult to avoid the conclusion that, in the debate with Kelsen, he favored "saving" democracy by destroying its institutional and normative guarantees. As Jürgen Habermas has aptly commented, "Anyone who would want to replace a constitutional court by appointing the head of the executive branch as the "Guardian of the Constitution" — as Carl Schmitt wanted to do in his day with the German president — twists the meaning of the separation of powers in the constitutional state into its very opposite."

A year later, in July 1932, Schmitt played a key role in the infamous *Preussenschlag* controversy, Chancellor Franz von Papen's constitutional coup against Prussia's Social Democratic government. Schmitt vigorously argued the case on behalf of the Reich before the federal court in Leipzig. As chancellor, von Papen had contributed significantly to Prussia's civic disarray by lifting the federal ban against the SA, in an ill-conceived attempt to curry favor with the Nazis. In January 1933, von Papen was named as Hitler's vice-chancellor. In April, he appointed Schmitt to draft legislation that merged the *Länder* with the federal government in Berlin. By eliminating the last vestiges of provincial legal autonomy, the *Gleichschaltung* (synchronization) measures promulgated by Schmitt effectively sounded the death knell of the Weimar Republic. They marked a point of no return on the way to the Nazis' consolidation of totalitarian rule.

In light of Schmitt's concerted efforts to undermine the Weimar Republic's constitutional stability, as well as the significant role that he played in providing the nascent Hitler-*Staat* with a veneer of juridical legitimacy, it is not surprising that after the war he was known as the "gravedigger of the Weimar Republic." The pivotal role that Schmitt played in contributing to the Weimar Republic's demise cannot be understood apart from his underlying commitment to the counterrevolutionary political theology of Maistre, de Bonald, and Donoso Cortés. In keeping with their visceral aversion to the heritage of "1789," Schmitt viewed political liberalism's fitful ascent during the nineteenth century with similar contempt. Following the revolutions of 1848, Donoso Cortés — an intrepid defender of monarchism and an ideological precursor of the "clerico-fascism" of Franco and Salazar — condemned the heretical strivings of a new generation of political radicals as "Satanism" pure and simple.

True to his counterrevolutionary lineage, Schmitt's lifelong ideological animus against parliamentarism and the rule of law was motivated by a similar set of political-theological concerns. Schmitt, too, displayed a visceral aversion to the precepts of modern secularism and its political corollaries: humanism, liberalism, constitutionalism, and social democracy. Consequently, following the Nazi seizure of power, Schmitt had no compunction about glorifying the Hitler-*Diktatur* as a "Katechon," a "restrainer" or "bulwark" who staves off the advent of the Antichrist, whose contemporary "agents" were the godless and heretical representatives of the political left: liberals, socialists, Bolshevists, communists, anarchists, and of course Jews.

Schmitt's glorification of the "national myth" comes in a chapter of *The Crisis of Parliamentary Democracy* devoted to "Irrationalist Theories of the Direct Use of Force." His treatment of this theme was nothing if not timely. In October 1917, the Bolsheviks, led by Lenin, overthrew Alexander Kerensky's Provisional Government and set the stage for seventy-four years of murderous dictatorial rule. The events in Russia had a significant ripple effect. In 1919, Bolshevik-inspired "council republics" were proclaimed in Bavaria and Hungary. Within months, however, both regimes were ruthlessly suppressed by counterrevolutionary militias that reveled in profligate acts of "White Terror."

Among paramilitary veterans groups, such as the German *Freikorps* and the Italian *squadre d'azione*, violence was elevated to the level of a secular religion. In Central and Eastern Europe, right-wing forces frequently targeted Jews, whom they associated with the "Bolshevik menace," notwithstanding the fact that the vast majority of Jews were steadfastly opposed to communism. In Germany, antisemitism was the ideological catalyst behind the assassination of prominent Jewish politicians such as the Bavarian Prime Minister Kurt Eisner in 1919 and Foreign Minister Walther Rathenau in 1922. In Russia and Eastern Europe, heightened antisemitism incited indiscriminate and bloody pogroms. During the Russian Civil War, from 1918 to 1921, counterrevolutionary armies in Ukraine murdered an estimated thirty thousand Jews.

During the war Schmitt was stationed in Munich, where he worked in the intelligence services of the German General Staff. His primary assignment was to monitor contacts between left-wing politicians and pacifists in neighboring Switzerland. The White Terror in Munich — much of which Schmitt witnessed first-hand — was especially bloody. Over

six hundred people lost their lives, numerous sympathizers of the "council-republics" were summarily executed after the hostilities had ceased. Similarly, in Hungary, when Béla Kun's Soviet Republic imploded in August 1919, 1,500 persons were killed, over three times the number of those who perished at the hands of the "Reds."

The political tumult that rocked Germany following the left-wing revolution in November 1918, when workers' and soldiers' councils proliferated in the wake of the *Kaiserreich's* collapse, might accurately be described as a permanent "state of emergency." Both the war years — when civilian rule was de facto suspended in favor of the Ludendorff-Hindenburg dictatorship — and the prolongation of martial law during the postwar period conditioned Schmitt to accept the *Ausnahmezustand*, or state of emergency, as the new normal. It became one of his contributions to the vocabulary of modern political philosophy. It reinforced his commitment to authoritarian rule as well as his innate mistrust of civilian interference in politics. Schmitt's inaugural lecture at the University of Strasbourg, in 1916, had examined the constitutional (*staatsrechtlich*) parameters of "Dictatorship and State of Siege." The superiority of dictatorship over "constitutionalism" and "legalism" — both of which hampered the political sovereign's ability to act forcefully and decisively in a state of emergency — became the defining theme of Schmitt's work. It was not by chance, therefore, that in 1921 Schmitt selected *Dictatorship* as the theme, and the stark title, of one of his first major scholarly works.

The apotheosis of political violence that accompanied the Great War and the spate of civil wars that followed conditioned Schmitt's famous reconceptualization of politics in *The Concept of the Political*, in 1927, as the capacity

to distinguish "friends" from "enemies." That was it: the essence, indeed the entirety, of politics. By seeking to ground sovereignty through war as the *ultima ratio* of politics, Schmitt sought to oppose the growing consensus in favor of international cooperation that followed the League of Nation's founding in 1919. Following the precedent set in that year by Spengler's *Prussianism and Socialism*, Schmitt furnished an urgent brief in support of the values of Prussian militarism. "The concepts of friend, enemy, and struggle [*Kampf*]," Schmitt insisted, "receive their real meaning insofar as they relate to and preserve the real possibility of *physical annihilation*. War follows from enmity, [from] the existential negation of another being." "The political enemy," he continued, "is the *other, the alien,* and it suffices that in his essence he is something *existentially other and alien* in an especially intensive sense . . . War, the readiness for death of fighting men, the physical annihilation of other men who stand on the side of the enemy, *all that has no normative, only an existential meaning.*" Those must be some of the most chilling words written in modernity. Schmitt's account of politics wished to replace a rational world of norms and rules with a pre-rational order of visceral ruthlessness in which tolerance was inimical to survival and war was eternal.

Another one of Schmitt's main goals in *The Concept of the Political* was to perpetuate the bellicist ethos of the *Frontgeneration*. It was an objective that was shared by other conservative revolutionary intellectuals: for example, Ernst Jünger, a conservative and a remarkable writer, whose fifty-year correspondence with Schmitt began in 1930 and ended in 1983. As Habermas has noted, "Schmitt was fascinated by the First World War's Storms of Steel, to use the title of Ernst Jünger's war diary...A people welded together in a battle for life and

death asserts its uniqueness against both external enemies and traitors within its own ranks." At one point Schmitt, invoking a metaphor taken from marksmanship, proclaimed that "the zenith of Great Politics is the moment when the enemy comes clearly into view as the enemy." In *The Concept of the Political*, Schmitt also sought to combat the spirit of anti-militarism and international comity that, in response to the unprecedented carnage of World War I, had encouraged the expansion of international law in order to ensure a peaceful resolution of regional disputes — a movement that culminated in 1928 in the Kellogg-Briand Pact, which quixotically sought to outlaw war as an instrument of national policy.

The Social Darwinist undercurrent of *The Concept of the Political* — Schmitt's insinuation that preparation for war is the *raison d'être* of "the political" — anticipated his controversial *Grossraum* doctrine of the early 1940s, which brazenly redefined "natural right" as the "right of the strongest." Although Schmitt's champions have sought to portray him as nothing more than a political realist in the tradition of Machiavelli and Hobbes, Schmitt's "existential" glorification of "war" as the "readiness for death of fighting men, the physical annihilation of men who stand on the side of the enemy ... [hence] the existential negation of another being" is significantly at odds with that tradition. After all, the point of Hobbes' *Leviathan* was to transcend the war of all against all by means of a civil compact, not to celebrate and expand it.

The ideological and political turmoil that convulsed Europe following World War I left Schmitt with a permanent fear of political instability. It also inculcated in Schmitt a hypertrophic

and abiding fear of "Jewish Bolshevism." As Paul Hanebrink observes in *The Myth of Judeo-Bolshevism*, "From the Vatican to Paris salons to paramilitary barracks in the south of Hungary, the history of the Munich Republic of Councils seemed proof of a Jewish plot to overthrow civilization and impose foreign rule on the nations of Europe." Schmitt's diaries from the 1910s are suffused with antisemitic invective. They betray a preoccupation with Jews that borders on the clinical. His Judeophobia was especially acute in the case of the assimilated Jews whom he encountered regularly during his student years and his career as a university professor. According to Schmitt, the major problem with assimilated Jews was that they made it nearly impossible to establish a clear divide between "friends" and "enemies."

In a diary entry on October 13, 1914, Schmitt spoke about his "Jewish complex," the confusing amalgam of fascination and revulsion that he felt toward Jews. Although German Jews superficially resembled "normal Germans," Schmitt held that, on a more profound level, the differences that separated these two peoples were vast. Ultimately, Schmitt's Judeophobia — which intensified during the "Judeo-Bolshevist" hysteria that coincided with the suppression of the Bavarian *Räterepublik* in April 1919 — metamorphosed into one of the defining features of his work. Schmitt's lifelong animus against political liberalism, which culminated in his confrontation withs Kelsen's "normativism," was inseparable from his fears concerning the "disintegrative" and "corrosive" character of Jewish influence. His conservative revolutionary allies excoriated the Weimar Republic as a *Judenrepublik*; it was, they claimed, *undeutsch*. In *The Crisis of Parliamentary Democracy*, Schmitt asserted that *Artgleichheit*, or "racial sameness," was one of the indispensable hallmarks of the "leader-democracy"

117

**The Cult of Carl Schmitt**

(*Führerdemokratie*) that he envisioned as parliamentary democracy's successor.

As Schmitt's diaries amply attest, he viewed the Jews as the *Drahtzieher*, or "string pullers," who were secretly orchestrating these fateful developments from behind the scenes. Already in the 1920s, Schmitt's sweeping critique of "political liberalism" and "total mechanization" flirted with the idea of a "Jewish world conspiracy" — a notion that was, among conservative revolutionary intellectuals, a truism. Schmitt's indictment of modernity as an "age of neutralizations and depoliticizations" overlapped with the ascendancy of what the historian Shulamit Volkov has called "antisemitism as a cultural code." In the discourse of Central European *Zivilisationskritik*, the agenda of antisemitism was often advanced under the semantic camouflage of a critique of "modernity," "capitalism," "technology," and "liberalism." Antisemites alleged that in all of these domains Jews played a deleterious and outsized role. A watershed in this line of attack was Werner Sombart's well-known treatise *The Jews in Modern Capitalism*, which appeared in 1911, in which he highlighted the affinities between the Jews as a "nomadic desert people" and the "extraterritoriality" of contemporary international finance, and attributed the Jews' economic success to their "rootlessness," which, he claimed, engendered a mentality that was averse to firm conviction and conducive to abstract calculation.

After 1933, when the political situation became more propitious, Schmitt was free to propound his antisemitic views unabashedly and without fear of reprisal. He wasted no time. The semantic violence that was implicit in Schmitt's disdain for Kelsen's "legal positivism" now left nothing to the imagination. In 1934, in an essay called "National Socialist

118

Legal Thinking," Schmitt explicitly celebrated the Nazi legal revolution as a victory of the German over the tyranny of Jewish "legalism." According to Schmitt, the *Volk's* triumph was abetted by its return to "the natural forms of order that emerge from *Blut und Boden* [blood and soil]." Schmitt added that "normativism's" predominance under Weimar was due to the "influx of the alien Jewish Volk." A corrosive infatuation with "legalism," claimed Schmitt, was "one of the peculiarities of the Jewish people, who for thousands of years have lived not as a state on a piece of land, but solely in the law and norm, which in the true sense of the word are 'existentially normativistic.'" With Hitler in power, the antisemitic animus that was implicit in Schmitt's critique of parliamentarism in the 1920s emerged in all its hatefulness.

## II

Not only was Schmitt enamored of political myths. He was also an adept self-mythologizer. After the war, this talent proved invaluable in the course of his struggle for rehabilitation.

During the initial years of Nazi rule, Schmitt's influence was omnipresent. In the words of his former student Waldemar Gurian, who fled Germany and became an important scholar of totalitarianism and a Catholic political theorist in the United States, Schmitt was the de facto "Crown Jurist of the Third Reich." Following the Nazi seizure of power, Schmitt accumulated, with astonishing speed, an impressive array of offices and titles. In July 1933, Hermann Goering appointed Schmitt to the Prussian State Council. Schmitt was also named to the presidium of Hans Frank's Academy of German Law. In 1934, Schmitt accepted a prestigious appointment to the faculty of law at the University of Berlin. He served on the executive committee of the Associ-

ation of National Socialist German Jurists and was editor-in-chief of the Association's journal, the *Deutsche Juristen-Zeitung*.

In July 1934, Schmitt furnished a legal brief justifying Hitler's bloody purge of the SA on June 30, 1934 — the Night of the Long Knives. It was called "The Führer Protects the Law," which became a famous slogan. Schmitt's opinion was a resounding endorsement of the *Führerprinzip* as the wellspring of legitimacy. It is difficult to construe Schmitt's article other than as a writ for unrestrained autocratic lawlessness.

Already in *Political Theology*, twelve years earlier, Schmitt had asserted that the sovereign must operate from a position outside of the constitution, at a permanent remove from the constraints of "legality." One of the reasons that, after 1945, Schmitt found it difficult to shake the "gravedigger of the Weimar Republic" epithet was the widely shared view that, in his capacity as "Crown Jurist of the Third Reich," Schmitt had merely transposed his earlier glorification of the "state of emergency" to the post-1933 circumstances.

Schmitt's talent for self-mythologization became evident with the publication of *Ex Captivitate Salus*, a memoir, or more precisely an *apologia pro vita sua*, in 1950. Invoking Herman Melville's novella *Benito Cereno* — the tale of a ship captain who, in the aftermath of a mutiny, must do the rebellious crew's dastardly bidding — Schmitt confabulated the legend that his cooperation with the Nazis merely reflected a desperate struggle for survival. He insisted that his support for the regime had been, from start to finish, involuntary: the actions of someone who, to all intents and purposes, had a gun pointed at his head. Schmitt's self-exculpatory claims are factually unsustainable. But the facts have not dissuaded a devout coterie of loyalists from accepting the *Benito Cereno*

conceit. In the English-speaking world, the cult of Carl Schmitt was first orchestrated by a clique of postmodern Salon-Bolshevists, and more recently by a little but loud movement of "post-liberals."

The legend of Schmitt's innocence derives from two articles that were published in the SS weekly *Das Schwarze Korps* in December 1936, which questioned Schmitt's National Socialist bona fides. The articles portrayed Schmitt as an opportunist who had belatedly joined the party in order to advance his career and to camouflage his pro-Catholic loyalties. Schmitt's detractors — one of whom, Reinhard Höhn, was a colleague of Schmitt's at the University of Berlin — were political rivals who resented his meteoric rise to prominence in Nazi legal circles. Moreover, since Schmitt was widely regarded as a protégé of Hans Frank — the politician who eventually headed the Nazi occupation of Poland, oversaw four extermination camps, and was convicted for crimes against humanity at Nuremberg and executed — his adversaries hoped that, by attacking Schmitt, they could also interfere with Frank's political ambitions. Following the attacks, Schmitt was stripped of his party offices. Thanks to Göring's patronage, he was permitted to keep his University of Berlin professorship and his position as Prussian state counselor. When viewed through the lens of the unending intraparty squabbles that were endemic to Nazi rule, however, the temporary setback that Schmitt experienced was hardly proof of heterodoxy. Moreover, following his rehabilitation by the SS, Schmitt was permitted to travel and lecture freely. Later Schmitt's opponents were themselves ignominiously sacked.

Ever resourceful, with one eye trained on the impending outbreak of war, Schmitt reinvented himself as a specialist in geopolitics. Schmitt's doctrine of *Grossraum* relied on

Social Darwinist arguments concerning the "natural right" of so-called "large space nations" (*Grossraum Völker*) to subsume "small space nations" (*Kleinraum Völker*), thereby making a mockery of existing international law. In essence, Schmitt's geopolitical thought underwrote the Third Reich's draconian plans for Eastern European hegemony, the *Drang nach Osten*. Schmitt outlined his geopolitical theories in "*Raum* and *Grossraum* in International Law," a lecture that he presented in Kiel on April 1, 1939, a fortnight after the German invasion of Czechoslovakia. In his lecture, Schmitt invoked the precedent of the Monroe Doctrine to justify the supremacy of the *Grossdeutsches Reich* or "Greater Germany" in Central Europe. (Hitler was so enamored of Schmitt's Monroe Doctrine analogy that he immediately included it in a speech in the Reichstag, warning President Roosevelt to refrain from intervention in the event of a future European war, which was in fact only four months away.) Schmitt's arguments summarily disqualified existing international law and traditional claims to state sovereignty on the part of so-called "small space nations." As the refugee scholar Franz Neumann observed in *Behemoth*, one of the first great studies of National Socialism, Schmitt's *Grossraum* doctrine underwrote Hitler's "*Grossdeutsches Reich* [as] the creator of its own international law for its own *Raum* or space." Neumann aptly denounced Schmitt's concept as little more than pseudo-scientific cover for the Third Reich's geopolitical ambitions: "It offers a fine illustration of the perversion of genuine scientific considerations in the interest of National Socialist imperialism."

The fact that Schmitt's doctrine of *Grossraum* seemed to lack the customary obeisances to Nazi race doctrine — one of the main arguments brandished by Schmitt's defenders to downplay his contribution to Nazi foreign policy doctrine

122

— is immaterial, since this omission also had a tactical side: it imparted a measure of credibility to Schmitt's theories in international law circles that they would have otherwise lacked.

Nor was the idiolect of Nazi race thinking entirely absent from Schmitt's arguments. In "*Grossraum* and International Law," Schmitt's disparagement of Jews as an "*artfremde Volksgruppe*" — a "racially alien people" — was tantamount to a death warrant, since, according to the tenets of *Grossraum*, "racially alien" groups were devoid of legal standing. Nazi *Grossraum* doctrine — Schmitt's included — was predicated on the twofold imperatives of *Raum* and *Boden*, "space" and "soil." Since Jews were deemed a "rootless" or *bodenloses* people, they were denied the legal protections that accrued to "rooted" or *bodenständige Völker*.

With the publication of Schmitt's *Grossraum* essays, and the adoption of his Monroe Doctrine analogy by the Führer, Schmitt's "comeback" was virtually assured. As a reporter for *The Times of London* remarked about Schmitt's address in Kiel in April 1939: "Hitherto, no German statesman has given a precise definition of Hitler's aims in Eastern Europe. But perhaps a recent statement by Prof. Carl Schmitt, a Nazi expert on constitutional law, may be taken as a trustworthy guide." Schmitt's *Grossraum* concept was rapidly embraced by a cadre of high-ranking SS officers attached to the Reich Security Main Office (RSHA) in Berlin. Infusing Schmitt's approach with a more explicit *völkisch*-ideological orientation, they proceeded to invoke *Grossraum* as a pseudo-legal justification for a Nazi-dominated Europe, for German continental hegemony — a strategy that was predicated on the idea of German racial supremacy, in keeping with Nazism's understanding of *Deutschtum*, or Germanness, as *Herrenrasse*, or the master race.

Schmitt's postwar apologetics suffered a posthumous blow in 2011, when his diaries from the early 1930s were published. They meticulously document Schmitt's reactions to National Socialism's political ascent. In an entry in February 1932, for example, Schmitt avowed that, in the upcoming presidential elections, he planned on voting for Hitler. On January 30, 1933 the day of the Nazi seizure of power, Schmitt remarked: "At the Café Kutschera [in Berlin], where I learned that Hitler had become chancellor and Papen vice-chancellor. *Excited, happy, satisfied.*" The reasons for Schmitt's "excitement" at the café are not hard to fathom. He realized that Hitler's rise to power guaranteed the demise of the Weimar "system," an entity that Schmitt viewed with contempt and whose downfall he had sought to hasten. Whatever reservations Schmitt may have harbored concerning the advent of Nazi rule prior to January 30, 1933 dissipated rather quickly.

This conclusion is supported by Schmitt's reaction to the Reichstag's approval of the Enabling Act of March 23, which allowed Hitler to legislate by decree. In his comments, which were published in the *Deutsche-Juristen Zeitung*, not only did Schmitt hail the Act's passage, he went so far as to attribute constitutional status to the emergency decrees that had been promulgated by the nascent Hitler-state. Thereby, he added, these decrees superseded the legal provisions of the Weimar Republic, whose constitution technically remained in effect. In a follow-up article that was published on May 12 in the *Westdeutscher Beobachter*, called "The Good Law of the German Revolution," Schmitt reaffirmed, unequivocally and emphatically, that "the good law of the German Revolution is not dependent on respecting the legality of the Weimar 'System'

and its constitution." Gone was the distinction that he had established in his book *Dictatorship* between "commissarial" (temporary) and "sovereign" (permanent) dictatorship. If ever there was a "sovereign" dictatorship, it was Hitler's.

The numerous political and legal commentaries that Schmitt penned in support of the Nazi dictatorship — many of which appeared in official Nazi publications such as the *Völkischer Beobachter* and the *Westdeutscher Beobachter* — are extremely revealing with respect to Schmitt's attitudes at the time. They demonstrate that Schmitt's accommodation to Nazi rule was speedy, seamless, and unstinting. It was as though, with Hitler's *Machtantritt*, a dam had burst, and the new political circumstances allowed Schmitt to freely express political views that during Weimar he had been forced to suppress. The republication last year of Schmitt's Nazi writings helped to resolve a major controversy that beset Schmitt scholarship for decades: whether January 30, 1933 marked a break with or a continuation of Schmitt's previous political self-understanding.

One important measure of the continuities in Schmitt's worldview is the persistence of race thinking. Prior to the publication of Schmitt's diaries (the most recent installment, *Tagebücher* 1924–1929, appeared in 2018), Schmitt's champions often appealed for a "pluralistic" and "differentiated" understanding of his legacy, an interpretive tack that dissuaded scholars from focusing too much on Schmitt's anti-Semitism. Yet as evidence of Schmitt's Judaeophobia began to mount, such appeals rapidly devolved into repression and denial. The publication of Schmitt's diaries has demonstrated that the "Jewish complex" to which Schmitt alluded in 1914 was merely the tip of the iceberg, the harbinger of a fevered anti-Judaism that crested during the Nazi period.

In his diary in November 1931, Schmitt excoriated the left-wing Romanian poet and historian Valeriu Marcu as a "horrible Jew, of the dumb and superficial variety." A month later, on Christmas Eve, Schmitt recounted having sung Christmas songs in his Berlin apartment and being overwhelmed by the "shame and scandal of living in a *Judenstadt* [Jew-city], insulted and shamed by Jews." Schmitt's wrath was often directed against assimilated Jews. In his eyes, by trying to pass themselves off as authentically German, they were doubly guilty. As he wrote on March 19, 1933: "Hopeful because of the Nazis, rage at the Jew [Erich] Kaufmann and the imposture of these assimilated Jews."

Kaufmann was one of Schmitt's colleagues on the law faculty of the University of Berlin. His name surfaced in a letter of denunciation that Schmitt wrote to the Minister of Education on December 14, 1934. In his missive, Schmitt claimed that Kaufmann's presence was a "slap in the face [to the] National Socialist students." It was not Kaufmann's pedagogical abilities, continued Schmitt, that were in question. Instead, it was Kaufmann's status as an assimilated Jew that mattered; or, as Schmitt put it, Kaufmann's delete-rious "influence on German spiritual life and German youth." As Schmitt urged in conclusion: "Especially today, when the German *Volk* and German students are being educated through a process of National Socialist schooling, this type of Jewish infiltration and influence must be rigorously avoided." Kaufmann was promptly dismissed.

After the war, Schmitt remained unrepentant and defiant. His journals from the years 1947-1951 are suffused with crude antisemitism. Schmitt derogated Jews as "Isra-Elites," arguing that they were the only "elites" to have survived the war. And in a classic case of "Holocaust inversion" — transforming

126

victims into perpetrators and perpetrators into victims — he claimed that the Jews had been World War II's real victors. In September 1945, Schmitt was arrested by the Allies in a "general sweep" and interned as a possible "security threat." Following his release, Schmitt was re-arrested in March 1947. He was transferred to Nuremberg, where he was interrogated by the American prosecutor Robert Kempner as a "potential defendant." The indictment centered on Schmitt's *Grossraum* articles, which Allied prosecutors regarded as a blueprint for Nazi Germany's "war of annihilation" in the East. Schmitt avoided prosecution — a direct link between his theories and Nazi policy was not legally demonstrable — and was released two months later.

The experience left Schmitt embittered. He regarded himself and his fellow Germans as the victims of the Allies' "discriminatory concept of war" and their indefensible "moralization of punishment." Schmitt's objections were consistent with his earlier fulminations against "just war" doctrine and the Versailles Treaty's "war guilt" clause. In 1958, in his foreword to the Spanish edition of his memoir, Schmitt lamented that the Allied legal proceedings had resulted in the unjustifiable "criminalization of an entire people." He continued: "As Germany lay on the ground, defeated... the Russians and the Americans undertook mass internments and defamed entire categories of the German population. The Americans termed their method 'automatic arrest.' This means that thousands and hundreds of thousands of members of certain demographic groups — for example all high-level civil servants — were summarily stripped of their rights and taken to a camp." The un-self-awareness — or sheer mendacity — of such passages is breathtaking.

Schmitt's exclusive focus on German suffering was charac-

teristic of the mood of "repression" and "silence" that prevailed in postwar Germany. Schmitt excoriated the Nuremberg Tribunal as a violation of the time-honored legal maxim *nulla poena sine lege* — one cannot be punished for doing something that is not forbidden by law. By the same token, he gave little thought to the question of what form of punishment would be appropriate for the unprecedented criminality and mass atrocities that had been perpetrated by the Third Reich and its functionaries. Nor did Schmitt display a modicum of sympathy for the victims of Nazi *Bevölkerungspolitik*: the six million Jews who perished in Nazi death camps; the three million Soviet POWs who died in German captivity; the twelve million slave laborers who were dragooned to toil in German armaments factories; and so forth. Instead, he callously rationalized these misdeeds as unavoidable "casualties of war." In Schmitt's account, they were victims without perpetrators. Schmitt also liked to attribute the war's tragic outcome to the "all-conquering progress of modern technology," whose "dislocations" he proceeded to enumerate, mocking the liberal idea of "progress" along the way: "'Progress' in the appropriation of the human individual, 'progress' in mass criminalization and mass automation. A giant apparatus indiscriminately swallows up hundreds of thousands of people. The old Leviathan appears almost cozy by comparison."

Following the war — and before Schmitt's own apologetics had time to take root — some observers recognized the significant contribution that Schmitt had made to consolidating Nazi rule. In *Deutsche Daseinsverfehlung* in 1946, Ernst Niekisch accused Schmitt's "friend-enemy" distinction of having furnished the "algorithm of bestiality" that was ruthlessly put into practice by the SA and SS. Similarly, Rudolf Smend, a former colleague at the law faculty of the University of Berlin,

denounced Schmitt as a legal "pioneer of the National Socialist system of violence." But Schmitt himself systematically eschewed questions of responsibility, personal as well as collective. Like the majority of his countrymen, he demonstrated little enthusiasm for probing the historical origins of the "German catastrophe."

From a legal and constitutional standpoint, the Federal Republic of Germany — whose *Grundgesetz*, or Basic Law, was codified in 1949 — was Schmitt's worst nightmare. In stark contrast to Weimar, the Bonn Republic was intentionally conceived as a parliamentary system. Its architects expressly sought to forestall the temptations of executive overreach that, under von Hindenburg's presidency between 1925 and 1934, had plagued German democracy, thereby paving the way for Hitler. The entire project was anathema to Schmitt. He disparaged defenders of the *Grundgesetz* as "*Grundgesetzler*" (human rights-lings) and mocked *Grundrechte* or "basic freedoms" as the "inalienable rights of donkeys." For Schmitt, the Federal Republic represented a double abnegation of politics, insofar as it elevated the "anti-political" institutions of "parliament" and "judicial review" above the prerogatives state sovereignty. Schmitt's own *bête noire* was the federal constitutional court, whose seat was in Karlsruhe. Schmitt composed a sophomoric satirical poem, which he circulated among friends, comparing the justices to lemurs. ("In Karlsruhe there grows a rubber tree/Lemurs scurry around/They append the 'value' of 'freedom' to the rubber tree.") Schmitt excoriated the Bonn Republic as a "Justizstaat" — implying that it was not a "real state" — which elevated abstract "values" such as "human dignity" over "authority." One of Schmitt's final works was called *The Tyranny of Values*.

## III

Following Schmitt's death in 1985, the German right leaped into action to popularize Schmitt's critique of German democracy. As the *Junge Freiheit*, the flagship publication of the *Neue Rechte* (New Right), put it: "Whoever sleeps with the *Grundgesetz* under his pillow has no need of Carl Schmitt. Conversely, whoever recognizes that the *Grundgesetz* is a prison in which the German res publica has been interned reaches for his work." During the European refugee crisis of 2015-2016, the right-wing ideologue Götz Kubitschek, co-founder of the Institut für Staatspolitik — a conservative revolutionary think tank allied with the far-right political party Alternative for Germany (AfD) — cited Schmitt's "state of exception" as an argument for implementing emergency measures to rebuff the influx of Syrian immigrants. Alluding also to Schmitt's "friend-enemy" dichotomy, Kubitschek declared:

> I am convinced that in a "state of exception" ... as the threats to one's own group along ethnic, cultural, and civic lines become clear, so does the question of who 'We are' and who 'We are not'... In other words, when people in this land have had enough, the question of [political] loyalty is bound to arise, as it does already when it is a question of customs, values, and the legal statutes that Islam places on the conduct of everyday life.

The New Right regarded the refugee crisis, which rocked Chancellor Angela Merkel's governing coalition to its foundations, as a classical Schmittian "state of emergency" — as a situation that, like the Algeria crisis in France in 1958 that paved the way for General Charles de Gaulle's *coup*, portended the *Bundesrepublik's* abolition and its replacement by an

ethno-populist dictatorship. That Kubitschek's advocacy of an executive decree banning asylum-seekers violated the *Grundgesetz*, as well as the tenets of European Union immigration law, seemed a matter of little concern.

Schmitt's posthumous influence on German political culture has been enormous. During the 1950s, Schmitt's site of exile in Plettenburg became a favored pilgrimage destination among radical conservative jurists who were disaffected with the Federal Republic's *Verwestlichung* (turn to the West) under Konrad Adenauer's chancellorship in 1949–1962. Among Schmitt's numerous acolytes was the jurist and future member of the Karlsruhe Constitutional Court, Ernst-Wolfgang Böckenförde, who applied Schmittian maxims in rulings that involved purported "social welfare" encroachments on state autonomy. And following German reunification in 1990, Schmitt's intellectual currency skyrocketed. German conservatives asserted that the time had come to replace the "de-politicizations" and "neutralizations" of the liberal Bonn Republic with the prerogatives of a "self-confident nation" (*selbstbewusste Nation*), in keeping with the Bismarck-era traditions of *étatisme* and *Machtpolitik*. Who better to guide the Berlin Republic's transformation in accordance with these precepts than Carl Schmitt?

During the 1990s, a contingent of radical conservative intellectuals undertook a public campaign to rehabilitate Schmitt, along with the reputations of like-minded conservative revolutionary thinkers such as Ernst Jünger and Martin Heidegger. Prior to reunification, it had been difficult for Schmitt to escape the taint of his earlier career as the Third Reich's "Crown Jurist." Following the collapse of the Berlin Wall, however, a chorus of national conservatives argued that, after forty years of democratic stability, the time had

come to lift the taboo. Schmitt was resurrected as a *deutscher Klassiker*, a "German classic." Notwithstanding the objections that were raised by a handful of intellectuals, his rehabilitation seemed complete.

Schmitt's rehabilitation in Germany was merely the prelude to a multifaceted international revival of his work. Already during the 1990s, those who were disillusioned with neoliberal triumphalism and the "end of history" ransacked Schmitt's corpus in search of political alternatives. And the ranks of the disillusioned were not confined to the right. Left-wing critics of TINA — the acronym for "there is no alternative," derived from Herbert Spencer and popularized by Margaret Thatcher, to indicate an acceptance of the liberal order — thought that they had found the support they needed in Schmitt's claim in *The Crisis of Parliamentary Democracy* that liberalism and democracy were mutually exclusive political forms. As Alan Wolfe noted in *The Future of Liberalism,* "To the extent that there is a revival of Schmitt's ideas taking place in Europe and the United States, it is not because of what is happening on the right. It is because Schmitt has become something of a hero to the postmodern left."

Schmitt's arguments about the endemic corruptions of Western liberalism became increasingly popular among former Marxists who, following the collapse of communism and the discrediting of Marx's "metaphysics of class struggle," sought out alternative paradigms of contestation in non-Marxist sources. In light of the fact that the proletariat, the putative "gravedigger of capitalism," was now comfortably ensconced amid the mind-numbing blandishments of

bourgeois consumerism, the prospects of realizing the utopia of a "classless society" seemed more distant than ever.

Nominally, these self-styled "left Schmittians" embraced Schmitt's no-holds-barred critique of liberalism in the name of "radical democracy." Ultimately, however, their animus against the normative safeguards of liberalism proved so powerful and all-consuming that, much like Schmitt, they ended up countenancing brazenly authoritarian political solutions. In their haste to transcend the liberal democratic status quo, the left Schmittians were not averse to flirting with the temptation that Jacob Talmon long ago described as "totalitarian democracy." They reprised an authoritarian political lineage that stretched from the Jacobin dictatorship of 1793–1794 to Lenin's *What is to Be Done?* (1902) to the *Chavismo* that, since the late 1990s, has made state socialist autocracy a permanent feature of the Latin American political landscape.

To restate Schmitt's critique of liberal democracy in Rousseauian terms: whereas democracy strove to realize the "general will" or "universality," liberalism, which was predicated on "interests," was incapable of rising above "particularism," or the mere "will of all," which never rose to a higher unanimity. Schmitt claimed that "parliamentarism," as a sphere of "representation" in which "interests" reigned supreme, inherently subverted the universalist strivings of democracy qua popular sovereignty. Hence Schmitt's conclusion that liberalism and democracy inherently operated at cross purposes. (This is one of Victor Orban's favorite refrains.) On the basis of these criticisms, Schmitt cynically dismissed parliament as little more than a *Schwatzbude* or "gossip chamber." Following the lead of Donoso Cortés, he disparaged the bourgeoisie as spineless and effete, a class that was prone to endless discussion but incapable of a sovereign decision.

**The Cult of Carl Schmitt**

During the 1920s Schmitt's political hopes centered on the prospects of a *Führerdemokratie*, or leader-democracy, a term that for Schmitt and Schmittians is not at all oxymoronic: a form of political authoritarianism that was shorn of pluralism and constitutional interferences, a political system that replaced the liberal idea of "representation" with the "identity" between *Führer* and *Volk*, "leader" and "people." Recall that Schmitt held that political obligation was grounded in "faith" and "myth" as opposed to rational consent. The identity between "leader" and "people" would be reinforced by an epic emotional bond.

For ex-Marxists, Schmitt's critique of political liberalism possessed numerous advantages. Unlike Marxism, it was not tied to an outmoded Hegelian philosophy of history that naively culminated in the *grand soir* of socialism. Nor was it wedded to an equally anachronistic understanding of the proletariat as the "universal class": a class that, as Marx had claimed, epitomized all of the injustices of bourgeois society, while being systematically deprived of its benefits. From an empirical standpoint, the "laboring society" of nineteenth-century industrialism on which Marx had predicated his "critique of political economy" had, to all intents and purposes, disappeared. The demise of the factory system meant that the ideas of "class" and "class struggle" had likewise forfeited their centrality. Instead, as sociologists never tired of pointing out, "social stratification" and "status differentiation" had replaced "class" as the interpretive keys to understanding modern society. It was not hard to see that, shorn of "class struggle," Marx's theory of revolution had become obsolete.

The 1960s confirmed that the locus and the nature of political struggle had fundamentally shifted. Conflict was no longer confined to the shop floor or the workplace. Instead,

the "new social movements" demonstrated that political contestation had been pluralized. Feminism, gay liberation, the civil rights movement, and environmentalism had exposed the analytical inadequacies of "class analysis." The new sites of struggle centered on "post-material values" and cultural themes that transcended the economistic focus of traditional Marxism. Among post-Marxists, Gramsci's notion of "hegemony" played a crucial role, insofar as it directly addressed the cultural dimension that Marx's critique of political economy had neglected.

For left Schmittians searching for new forms of contestation in order to combat the "Washington consensus," Schmitt's rejection of political liberalism seemed to offer possibilities of radical struggle that the parliamentary left had long abandoned. Hence, Schmitt's left-wing disciples enthusiastically embraced his "friend-enemy" opposition for infusing radical politics with an ethos of permanent conflict. As Chantal Mouffe argued in *The Challenge of Carl Schmitt* in 1999, Schmitt's "concept of the political" anticipated a new era of "political agonism," in which the consensual politics of liberal-democratic parliamentarism was swept away by a rising tide of dissent and conflict. Mouffe explained:

> In spite of [Schmitt's] moral flaws... ignoring his views would deprive us of many insights that can be used to rethink liberal democracy... Schmitt's thought serves as a warning against the dangers of complacency that a triumphant liberalism entails. His conception of the political brings the crucial deficiencies of the dominant liberal approach to the fore. It should shatter the illusions of all those who believe that the blurring of frontiers between Left and Right, and the steady

moralization of political discourse, constitute progress
in the enlightened march of humanity toward a
New World Order and a cosmopolitan democracy.

By trivializing Schmitt's rather spectacular failings as
"moral flaws," Mouffe conveniently sidestepped the interpretive question that has preoccupied Schmitt scholarship for
decades: the extent to which Schmitt's celebration of dictatorship and *Führerdemokratie* during the 1920s presaged his
conversion to Hitlerism in 1933. Moreover, was it not Mouffe
herself who "blurred the frontiers between Left and Right"
by enlisting the support of a conservative revolutionary
thinker like Schmitt for the ends of radical democracy?
Finally, in an era marked by unprecedented political polarization — "blue states" versus "red states" and so on — and ever-expanding ideological divisions, should not the construction
of a common political discourse take priority over a "political
agonistics" that would merely widen existing antagonisms?

Although Schmitt's "concept of the political" may have liberated neo-Marxists from the straitjacket of historical materialism, it left them fully exposed to the dangers of Schmitt's own
extremely dubious political choices. In fact, by embracing
Schmitt's "decisionism," as well as his inflexible "anti-normativism" — "the exception is more interesting than the norm,"
Schmitt proclaimed; "the norm is destroyed in the exception"
— Schmitt's left-wing partisans opened themselves up to the
excesses of "left fascism": a quasi-aesthetic celebration of "struggle for struggle's sake" and "conflict for conflict's sake"; a glorification of endless war that blithely scorned institutional

constraints and guardrails. Finally, in keeping with Schmitt's decisionism, his left-wing disciples turned a blind eye to the content and the ends of struggle.

A decisionistic refusal to specify the ends of struggle has also been one of the hallmarks of the Schmittianism of the Argentinian political theorist Ernesto Laclau (who was Mouffe's partner). In *On Populist Reason*, which appeared in 2007, Laclau described the content of political struggle as an "empty signifier." According to Laclau, the meaning of struggle would be provided by the populist "leader," who is tasked with aggregating the conflicting demands of the *vox populi* in order to achieve a new "hegemonic unity." Whereas Mouffe's neo-Marxism still felt obligated to pay lip service to the formal trappings of liberal democracy, Laclau held that the rituals of "parliamentarism" must be simply abolished for the sake of realizing the ever-elusive "general will." Laclau uncritically adopted Schmitt's argument in *The Crisis of Parliamentary Democracy* that "representative democracy" must be replaced by a plebiscitarian "leader-democracy"; and the Schmittian derivation of Laclau's position may help to explain his neo-Leninism, his view that only the "leader" or "party" can provide the "people" with a unified, revolutionary consciousness, thereby raising it from its "fallen" condition as an inchoate, disaggregated mass. By constructing the "real people" against the "enemies" who have betrayed it — enemies that Laclau defined as the "oligarchy" or "elites" — the leader, so to speak, "extracts" the (real) people from its oppressors.

In *The Crisis of Parliamentary Democracy*, Schmitt claimed that genuine democracy was predicated on a series of "homologies" or "identities": "the identity of governed and governing, sovereign and subject, the identity of the subject and object of state authority." If, in Schmitt's teaching, "democracy is not

137

antithetical to dictatorship," it was in part because dictatorship preserved the identity between the ruled and the ruler. According to Schmitt, dictatorship realized this identity through a process of mass "acclamation" as opposed to parliamentary "representation." In sum: "Dictatorial and Caesaristic methods [embody] the direct expression of democratic substance and power." Laclau endorsed Schmitt's condemnation of representative democracy as a liberal subterfuge that sublimated and distorted popular will, thereby obstructing the identity between "leaders" and "people." He also substituted Schmitt's proto-fascist notion of "symbolic representation" — a leftover from Schmitt's earlier political Catholicism — for the liberal democratic conception of "mandate representation." Thus, in keeping with Schmitt's framework, Laclau exalted the leader as the "symbolic representative" of the "general will." The problem with the fascist glorification of leadership, for Laclau, was only that it was too extreme, though it is hard to know what extreme means for such a proponent of unity in tyranny.

Laclau's repudiation of liberal democratic "proceduralism" — whose foremost twentieth-century representatives have been Ronald Dworkin, John Rawls, and Jürgen Habermas — was an important component of the left Schmittians' struggle against Enlightenment rationalism. This resolutely anti-Enlightenment disposition helps to explain the theoretical alliance between post-Marxists such as Mouffe and Laclau, on the one hand, and poststructuralists such as Derrida and Foucault, on the other. It also provides support for Habermas' wise suspicion, voiced during the 1980s, that "postmodernity definitely presents itself as antimodernity." "This statement," Habermas continued, "describes an emotional current of our times that has penetrated all spheres of intellectual life."

The left-wing cult of Schmitt often displayed a self-marginalizing, sectarian quality, which explains its difficulties in gaining acceptance outside of the insular confines of academe. The same cannot be said about the reception of his work among neoconservative policy circles following the 9/11 terrorist attacks, when Schmitt's pronouncements about the imperatives of emergency governance and the fecklessness of liberal democratic "legalism" assumed canonical status.

Even civil libertarians, while disagreeing sharply with Schmitt's conclusions, begrudgingly acknowledged his diagnostic prescience as well as the timeliness of his legal-juridical insights. "Mr. Schmitt Goes to Washington" was the shrewd title of Alan Wolfe's discussion of the hypertrophy of executive authority under George W. Bush's presidency. As the political theorist William E. Scheuerman conceded in *The End of Law: Carl Schmitt in the Twenty-First Century*, "Like no other political or legal thinker in the last century, [Schmitt] placed the problem of emergency government on the intellectual front burner, and he consistently did so as to unsettle those of us committed to liberal and democratic legal ideals. At the very least, his ideas about emergency rule call out for a response from those hoping to preserve the rule of law." And in 2006, in an article on "Preserving Constitutional Norms in Times of Permanent Emergencies," the legal theorist Sanford Levinson acknowledged that, in light of the Bush administration's sovereign disregard for juridical accountability, America was experiencing a "Schmittian moment." As Levinson put it, "The single legal philosopher who provides the best understanding of the legal theory of the Bush administration is Carl Schmitt, a brilliant German theorist of Weimar, who became, not

all together coincidently, the leading apologist for Hitler's takeover of what Schmitt viewed . . . as a hopelessly dysfunctional German polity." Elsewhere he noted Schmitt's status "as the jurisprudential guru of the post-9/11 world, a world in which the state of exception itself had become the new norm; in other words, as many analysts and observers assumed at the time, a permanent state of exception."

Schmitt's philosophy was indeed a great gift to the advocates of what John Yoo, a legal scholar and deputy assistant attorney general in the Office of Legal Counsel in the White House, called "the Unitary Executive." It was an idea that enjoyed a good deal of political support in the Bush years. "All law," Schmitt wrote, "is 'situation law.' The sovereign creates and guarantees the situation as a whole in its totality. He has the monopoly on this ultimate decision." The "sovereign" has *carte blanche* to respond to the changing situation as he sees fit, unimpeded by prior constitutional norms. Of course the West Wing Schmittians either misunderstood Schmitt or were using him dishonestly. Schmitt was not defending a constitutional *status quo ante* — as his champions continued to claim, despite mounting evidence to the contrary — but facilitating the transition to a "sovereign dictatorship," in keeping with his glorification of the "Age of Absolutism" as the archetype of political excellence. What on earth was his ghost doing in the White House?

Constitutionalists such as Levinson and Scheuerman reacted to the "Schmittian moment" in American governance with dismay and alarm, but not all observers were equally troubled. In 2006, in *Terror in the Balance: Security, Liberty, and the Courts*, Eric Posner and Adrian Vermeule claimed that Schmitt's arguments in favor of emergency powers unconstrained by congressional oversight and judicial review

were exactly what the war on terror demanded. Posner and Vermeule derided opponents of torture for their "self-absorbed moral preciosity." They described their goal in *Terror in the Balance* as "extracting the marrow from Schmitt and then throwing away the bones" — a rather infelicitous choice of metaphor. They sought also to combat the moral outrage of conscience-stricken civil libertarians: for example, the seven hundred law professors who, in December 2001, published a petition criticizing the Bush administration's plan to employ military tribunals to try the Guantanamo Bay detainees. By arbitrarily reclassifying the Guantanamo captives as "unlawful enemy combatants," the Department of Justice sought to strip them of the legal protections they would be entitled to under the Geneva Accords as prisoners of war.

The political challenges that the United States faced following the September 11 attacks were undeniably exceptional. For a democratic polity committed to the rule of law, however, the key to addressing the exception lies in insuring that the response is, from a constitutional standpoint, proportionate to the emergency in question. In other words, the response must be calibrated with a view toward returning to the legal-constitutional *status quo ante*. In 1861, between the attack on Fort Sumter in April and the return of Congress in July, Lincoln acted — to employ Schmitt's terminology — as a "commissarial" (or limited) dictator. But Lincoln relied on emergency powers in order to safeguard the Republic; his actions always presupposed a return to constitutional normalcy; and so his "exceptional" conduct exemplified the responsible use of executive authority. Moreover, Schmitt's attempt to define "the political" in terms of the "friend-foe" distinction, his notion of politics as war, is fundamentally at odds with central aspects of the Western political tradition,

for which justice and virtue, rather than enmity, are the *raison d'être* of politics. In American terms, certainly, Schmitt's "concept of the political" is really a concept of the anti-political, of the breakdown of politics, as in 1861. Our system of government was designed for conflict, which Madison regarded as a permanent feature of human affairs, but there is nothing Darwinian — or Schmittian — about it.

Meanwhile the left Schmittians viewed the Bush administration's proto-Schmittian apotheosis of executive authority as a welcome confirmation of their own longstanding antiliberal prejudices. Already during the 1990s, they regarded Schmitt's arguments about the bankruptcy of political liberalism as received wisdom. Under the influence of French theory, the left Schmittians enthusiastically accepted Schmitt's claim that liberal "norms" were little more than a swindle. They held that, insofar as norms were prescriptive — hence "normalizing" — they predetermined the parameters of socially permissible behavior. By pathologizing deviance and non-conformity, norms were an essential component of disciplinary society's implacable social control. The illusion of "autonomy" was merely one of the ruses that "power-knowledge" employed to deceive us into thinking that we were free. This is what happened when Foucault was added to Schmitt. As Foucault wrote, "[the] will to knowledge reveals that all knowledge rest upon injustice, that there is no right ... to truth or foundation for truth ... The instinct for knowledge is malicious, something murderous, opposed to the happiness of mankind." In the eyes of Schmitt and Foucault, the dialectic of enlightenment culminated not in emancipation, but in catastrophe.

Giorgio Agamben's *State of Exception*, which appeared in 2004, was conceived as a response to Abu Ghraib and Guantanamo, and represented the consummate synthesis of Schmitt and poststructuralism. By fusing these currents, it raised anti-Enlightenment cynicism to new heights. Agamben maintained that there was nothing "exceptional" about the "state of exception" that, following the September 11 attacks, was declared by the Bush administration. It merely exposed the hidden capacity for violence that lurked beneath the peaceable façade of liberal democratic "legalism." For Agamben, the state of exception already was "the dominant paradigm of government in contemporary politics." He praised Schmitt effusively as the theorist who, more than any other, had exposed the hidden link between the state of exception and bourgeois legal convention: "The specific contribution of Schmitt's theory is precisely to have made such an articulation between state of exception and juridical order possible. It is a paradoxical articulation, for what must be inscribed within the law is something that is essentially exterior to it: nothing less than the suspension of the juridical order itself." According to Agamben, however, the corrective to the state of exception is not to return to the rule of law, or to make law genuinely effective, since Agamben held, following Schmitt, that the state of exception is — in ways that are never clearly specified — inscribed in the rule of law itself. The vaporousness of all this was a formula for political impotence. The left Schmittians have little to offer apart from an abstract populism, an ill-defined theory of "direct action" and "agonistic struggle." But will the people follow Agamben into the streets? The notion is a little comic — though the comedy disappears in the face of Agamben's claim that there are no essential historical differences between

Guantanamo Bay and Auschwitz. They both express the hidden telos of "modernity."

And now the cult of Carl Schmitt has been again updated. Recently a new authoritarian ethos has emerged on the right, a political current proclaiming that liberal democracy has entered into a state of terminal crisis. The proponents of this ethos claim that the signs of liberalism's morbidity are omnipresent and undeniable; only fools mired in anachronistic ways of thinking would deny their obviousness. The slogan that has been widely brandished as a cure-all or panacea for liberalism-in-crisis — and an adage that has been enthusiastically embraced by autocrats and their apologists — is "illiberal democracy." Unsurprisingly, the political philosopher whose doctrines have been repeatedly invoked both to explicate the reasons for liberalism's irreversible demise and to justify the transition to a new form of authoritarian rule that will save us from its insolvency is Carl Schmitt.

Schmitt has been canonized by a new generation of "post-liberal" conservatives who have been heartened by the political "successes" of Donald Trump and the Hungarian strongman Victor Orbán. Following Schmitt, they have concluded that constitutional guarantees of civic freedom and legal equality must be jettisoned, since, as enablers of an anarchic centrifugal individualism, they bear primary responsibility for Western civilization's precipitous unraveling. Last summer Orban received an enthusiastic reception at the CPAC convention in Texas, which provoked a reporter in *Washington Post* to described the "Orbánization" of American conservatism: "to right-wingers steeped in anti-liberal grievance,

Hungary offers a glimpse of culture war victory and a template for action."

The uncritical reliance on Schmitt's positions attests to a revolting lapse of historical memory. Equally troubling, when pressed to identify a political successor to liberalism, the post-liberal responses track Schmitt's ill-advised endorsement of "leader-democracy." Schmitt's argument that liberalism is incoherent and self-negating, since, as a form of political rule it is inherently averse to "authority" and "order," in lieu of which "political rule" itself becomes meaningless, suffuses Patrick Deneen's influential anti-liberal broadside, *Why Liberalism Failed*. As Deneen observes, parroting Schmitt, "democracy, in fact, cannot survive under liberalism." The shameful lineage is clear. As Robert Kuttner noted appositely in the *New York Review of Books*, "Deneen's thinking echoes an older line of reactionary argument on the folly and perversity of liberal democracy that extends back from twentieth-century anti-liberal intellectuals, like Leo Strauss and fascist theorists Carl Schmitt and Giovanni Gentile, to monarchic critics of liberalism, like Joseph de Maistre." The fundamental flaw of *Why Liberalism Failed* is that its understanding of liberalism's inadequacies derives from the worldview of a thinker who was rabidly opposed to liberalism and everything it stood for. Faulty premises yield faulty results. Schmitt's representation of liberalism's deficiencies contains a kernel of truth, though he was hardly the first or the last to worry about the labyrinthine tendencies of liberal governance; but his portrait of liberalism was a grotesque caricature — partial, self-serving, hysterical, and exaggerated, just like Deneen's.

Deneen is not alone in his Schmittian amen corner. In *A World After Liberalism: Philosophers of the Radical Right*, Matthew Rose, a contributor to *First Things*, sounds the

death-knell not only of liberalism but also of traditional conservatism. According to Rose, in its place there will now arise "a new conservatism, unlike any in recent memory... Ideas once thought taboo are being reconsidered; authors once banished are being rehabilitated." The inspiring doctrines of the "Radical Right," whose ideas Rose seeks to retrofit for contemporary political use, emerged in Germany after World War I. "Known as the 'Conservative Revolution'... its chief figures included Carl Schmitt, Ernst Jünger, Arthur Moeller van den Bruck, and Oswald Spengler." Rose exalts these thinkers for their willingness to explore themes of "cultural difference, human inequality, religious authority, and racial biopolitics," notwithstanding the fact that their approaches "were widely viewed as invitations to xenophobia and even violence." That view was not only widely held, it was also true.

In a similar vein, Adrian Vermeule, the Harvard legal scholar and Catholic "integralist," has invoked Schmitt's adage that "all political concepts are secularized theological concepts" to indict the theological ferocity with which liberalism unrelentingly (in his account) has advanced its agenda at the expense of traditional communities, belief-systems, and lifeworlds. As with Deneen, what Vermeule's arguments lack in precision and subtlety, they compensate for in sheer force of rhetorical will. Like Schmitt, Vermeule prioritizes *voluntas* over *ratio*. Schmitt's adage was part of his more general assault on the mentality of modernity. Never mind that, in contrast to theology, modernity relies for its intellectual methods on evidentiary criteria that are "public" and "generalizable." Its proposals and claims are open to discussion and criticism. Unlike the precepts of "political Catholicism" with which Vermeule strongly identifies, they are, as a matter of principle, fallible and non-dogmatic. Does Vermeule leave

his faith at the seminar door or his reason at the church door?

There is no surer sign of intellectual and moral bankruptcy than an association with the thought of Carl Schmitt. The persistence of his cult into the present day is yet another of our time's many unhappy omens. But as long as the hard work of a free and fair society feels too onerous for some of its intellectuals, the repulsive Schmitt will live; live again and be repudiated again.

# MARK POLIZZOTTI

## *Surrealism's Children*

Back when I was an idealistic young soul, I enrolled in a PhD program in French and Comparative Literature, intent on making a career in academia. Those were the days when New Criticism and Semiotics held sway, and texts were to be read without interference from outside influences. The approach we were taught, boiled down, was that all a reader needed to know about a poem or a work of prose could be found on the page, without reference to historical context, authorial biography, or any other distractions. In class after class, we dissected poems by Ronsard and Rimbaud, the Symbolists and the Surrealists, peeling back layer upon layer of manifest and

latent meaning. It was intoxicating stuff, but I couldn't escape a nagging question: What was the point of it? Wasn't it all a bit too removed from life? Wasn't literature supposed to tell us about more than just its own internal machinery? Unable to resolve these questions, I handed in my Master's thesis and said goodbye to all that.

One effect of having left academia prematurely is that I spent the following decades still grappling with the appropriate balance between art and life, and the role that literature, literary studies, and the humanities in general have to play in our dealings with this fraught and confusing world — a world that, increasingly, seems resistant to the kinds of challenges and provocations that art and literature are best suited to pose. Is literature meant to reinforce our convictions, or to destabilize them? Should art be a safe space or a dangerous space, and what does that mean? What is the role of the off-putting, the upsetting, the offensive, and the shocking in our study and consumption of the humanities? Can art still *be* shocking in this day and age? And who, exactly, is being shocked?

The answers used to be fairly straightforward, or so it seemed. The progressive avant-garde duly épaté'd the bourgeois, who duly responded with howls of outrage as their cherished shibboleths — God, king, country, the army, the Establishment, what have you — were dragged through the slime — often in language and aesthetic forms that were themselves a provocation. Provocation was even a kind of social role, an expected feature of the societal landscape. But things are no longer so simple.

These days we find ourselves in a situation in which supposedly contradictory viewpoints circle each other, ouroboros-like — and become virtually impossible to distin-

guish. Conservatives vent their offense by banning an increasing number of books in schools and libraries, while college professors are actively discouraged from teaching material that might ruffle student sensibilities and provost's offices disinvite speakers deemed too hot to handle. Yet what better time than in college to have sensibilities ruffled? When will students ever have a more free and insulated space in which to rub shoulders with controversial ideas, and to develop the skills needed to confront those ideas in the world — that is, to view them with greater insight and deeper understanding, if only to then refute them? College is, or should be, an instruction in controversy and its skills. For this reason, the curricular exclusions on current-day campuses not only curtail what the educational experience has to offer, but, particularly in a study of the humanities, the establishment of these guardrails undermines what is most valuable about the discipline: its challenge to comfort and certainty, its impetus to make us think harder and more independently.

We are all familiar with the Golden Age of Bourgeois Indignation, in incidents ranging from theatergoers howling at the premiere of Victor Hugo's *Hernani* in 1830, to attendees at the Paris Salon in 1863 trying to slash Manet's *Déjeuner sur l'herbe*, to audiences throwing tomatoes and raw steaks at Dada performers in the 1920s. Flash forward a century and the dynamic has reversed: as Laura Kipnis has observed in these pages, it's not the rubes and the philistines who get rattled now, but rather the progressives and the illuminati who find it hard to stomach the provocations. "At some point," she writes, "offendability moved its offices to the hip side of town." Nor, even, is outrage the exclusive privilege of the avant-garde: in the current climate, mainstream art and literature can just as likely get dinged as the cutting-edge stuff, in a free-for-all of offense.

The question is, what do we sacrifice by avoiding such offense? It's not always pleasant to be rattled out of one's complacencies — the entire history of the avant-garde banked on it — but in losing the displeasure of injury, are we also losing the pleasures of discovery, and of self-discovery, that can accompany it? The price of comfort is often stagnation.

And there's a more immediate concern as well: in this time of anonymous reputation-bashing and swift retaliation against unwelcome opinion — the so-called "cancel culture" — the danger is not so much that people's ratings will suffer and their speaking engagements will be revoked, but that they will stop saying anything at all for fear of being boycotted or "shamed." We have too many crises to confront, none of which can be meaningfully addressed in 280-character soundbites, for those who can see beyond partisanship to refrain from making valid contributions. Trying to avoid offense in every instance is a fool's errand — you can't please all of the people all of the time — and holding back consequential and constructive insights, even if unpopular, impedes the free exchange of ideas and accomplishes nothing.

From its tumultuous start, the Surrealist movement was out to shock. The flurry of activity that accompanied its debut in late 1924 and early 1925, including the broadside *A Corpse* (which spat on the much beloved and recently deceased novelist Anatole France, an act of cultural blasphemy), the aggressive prose and propositions of Andre Breton's *Manifesto of Surrealism* ("Beloved imagination, what I most like in you is your unsparing quality"), and the common cause that the group tried to make with the reviled Communist Party, were not only

**Surrealism's Children**

steps toward defining a philosophical program, but also ways of slapping bourgeois proprieties repeatedly across the face.

This was true not only of their actions but also of their proclaimed choice of role models, many of whom would not have passed a modern-day ethics test. The most glaring case in point is the Marquis de Sade, poster boy for aberrant sexuality and one of Surrealism's lauded heroes. (Many more examples can be found in Breton's *Anthology of Black Humor*, a veritable rogue's gallery of dubious precursors.) Sade's novels are jam-packed with physical and mental abuse, coprophagia, cannibalism, torture, rape, and murder perpetrated indiscriminately against women and men of all ages: he did not lend his name to a major psychopathology lightly. Nor were these acts merely theoretical, for the man practiced what he predicated — not to the extent portrayed in his books, not by a long shot, but enough to keep him behind bars for nearly half his seventy-four years, first under the monarchy, then under the French Revolution, then again under Napoleon. And we must be clear: Sade was no innocent victim. He used his wealth and his privilege to indulge in prodigious sexual predation, like an eighteenth-century Jeffrey Epstein. As such, his life and his books have been a thorn in the side of progressive-minded thinkers for the past two centuries. How can you promote freedom of expression and still defend *that*?

And yet his work has been defended, and persuasively so, by such formidable intellectuals as Angela Carter, Roland Barthes, Maurice Blanchot (whose monograph *Lautréamont and Sade* owes much to Surrealist thinking), Susan Sontag, and Michel Foucault, to name just a few. Why would they do this? One answer comes from Simone de Beauvoir, in her landmark analysis of Sade's writings from 1953, titled, appropriately, "Must We Burn Sade?" Sade, she declared, "drained to the

dregs the moment of selfishness, injustice, and misery, and he insisted upon its truth. The supreme value of his testimony is the fact that it disturbs us. It forces us to reexamine thoroughly the basic problem which haunts our age in different forms: the true relation between man and man." In a rare moment of convergence between De Beauvoir and the Surrealists, the poet Paul Eluard anticipated this view in 1937 in his book *L'Evidence poétique*, writing: "Sade wanted to restore to civilized man the power of his primitive instincts . . . He believed that out of this, and this alone, true equality would come. Since virtue is its own reward, he labored, in the name of everything that suffers, to drag it down and humiliate it... with no illusions and no lies, so that those it normally condemns might build here on earth a world on the immense scale of mankind."

The arguments for and against Sade are many and complex, and they are also largely familiar. On one side, De Beauvoir defends him as a cold-eyed realist. On the other, writers such as Andrea Dworkin warn that his books, like any form of pornography, could incite acts of violence, especially against women. Both arguments have validity, and it is not a cop-out to admit that there is no single answer. If anything, the true energy of art and literature might reside in the questions they pose rather than the certainties they offer. What I will say is that, more than the events portrayed in his books, which are so over-the-top that they often become plainly absurd, perhaps the most shocking thing about reading Sade is how *un*-titillating so much of it is. As you plow though description upon minute description of various improbable scenarios, their inflexible regulation ultimately undermines any eroticism they might have been meant to contain. Ironically, the parts of Sade's work for which he is the most infamous are actually the most tedious.

The intriguing part, to pick up from De Beauvoir, is Sade's lucidity. Interspersed with the horrific actions are many pages of philosophy — I would go so far as to call it moral philosophy — that take an unsparing and admirably honest view of human interactions, and strip away the pieties with which we have comforted ourselves for two millennia. Here, for instance, is one of Sade's fictional stand-ins instructing an eager young pupil about vice and virtue:

> Nature has endowed each of us with a capacity for kindly feelings: let us not squander them on others . . . Let us feel when it is to [our] advantage; and when it is not, let us be absolutely unbending. From this exact economy of feeling, from this judicious use of sensibility, there results a kind of cruelty which is sometimes not without its delights. One cannot always do evil; deprived of the pleasure if affords, we can at least find the sensation's equivalent in the minor but piquant wickedness of never doing good.

Nietzsche is not too far away.

It is worth recalling that what landed Sade in the Bastille was not so much his acts of cruelty as the fact that he had sex with both men and women, and perhaps even more so that he was accused (though never convicted) of blasphemy against the highly influential and politically connected Church, which did not countenance challenges to its celestial worldview, or its sovereignty. It is also worth remembering that his books (such as the above-quoted *Philosophy in the Bedroom*) were written during the long years he spent in various prisons and asylums, and that in many ways their vindictive savagery — their sadism, if you will — can be read as a howl of rage against

captivity, no matter which political regime was in charge. It is again De Beauvoir who notes that "Sade does not give us the work of a free man. He makes us participate in his efforts at liberation. But it is precisely for this reason that he holds our attention." The value of a figure such as Sade, in other words, lies not in the acts that he describes but in the ethical challenges that he poses. It is one thing to create from a position of moral good, as many great writers and artists have done. But a steady diet of such work gives you only half the story, and arguably not the more necessary half.

So the question remains: Is Sade worth reading on these grounds, or should he indeed be burned? Is the offense that his writings constitute a reason for locking his work away, as he himself was locked away — and as his manuscripts were locked away for decades in the so-called "Hell" section of the French National Library? Or do his "efforts at liberation," or his decidedly unsentimental views on society, offer reasons to look beyond the parts we find distasteful? Is the threat posed by Sade that his books beget actual horrors, as Dworkin argued? Or that, long before Freud came along, they upended our complacent belief in the basic altruism of people and forced us to observe human nature at its ugliest and most unnerving?

The questions are all the more relevant in that, unlike so many of his contemporaries, Sade's impact did not fade with time. In 1959, the Canadian conceptual artist Jean Benoît, under the auspices of the Surrealist group, performed a piece called *The Execution of the Testament of the Marquis de Sade*. Benoît was well aware that his invitation-only audience would not be easy to impress: gathered that evening in the commodious Paris apartment of the poet Joyce Mansour were some one hundred "writers, poets, painters, filmmakers,

critics . . . women in evening gowns . . . their nails painted blue or green... As well as a woman in black velvet whose nipple fit through a small hole in her dress." At a prearranged signal, the attendees stood in a semicircle facing a stage area, their ears assaulted by the prerecorded sounds of an erupting volcano and readings from Sade's works. Benoît then appeared, dressed in an ornate black costume with sharp protrusions over his chest and legs, a grotesquely extended erection, and a cape from which blood seemed to be dripping. Piece by piece his costume was slowly removed by his wife, the artist Mimi Parent, revealing his nude body to be painted all in black, his heart covered by a red star (Sade's emblem). With a shrill cry, Benoît grabbed a red-hot iron placed nearby and branded the word "Sade" into his flesh, squarely over his heart. He then held out the still-smoking iron to his audience and demanded, "Who's next?" The Chilean painter Roberto Matta was so carried away by the performance that he spontaneously rushed up, tore open his shirt, and seared his own left breast.

Benoît's performance marks a relatively anomalous point on the timeline of outrage that I alluded to above: the members of the audience were clearly rattled — in Matta's case, to the point of voluntarily broiling his own flesh — but they were not offended. They had come in search of provocation and they were not disappointed. How that performance might fare sixty years on, in our own over-cautious day, is another story altogether.

Sade, as I have noted, was one of Surrealism's foundational pillars. Another was his spiritual great-grandson, the Montevideo-born poet the Comte de Lautréamont. Lautréamont, who died in 1870 at the age of twenty-four under mysterious circumstances, is mainly remembered as the author of the prose poem *The Cantos of Maldoror*. The narrative, such as it

is, follows the picaresque and often hallucinatory adventures of its eponymous anti-hero, who styles himself the personification of evil and who is engaged throughout most of the book with a battle to the death against God, or as he calls him, the Creator (when he isn't calling him worse). *Maldoror* is full of wild invention and grimly exhilarating humor over an underlayer of deep torment; the list of writers, artists, musicians, and filmmakers it influenced stretches from Dalí and Godard to Jim Morrison, John Ashbery, and the Beats. It is also full of what we would now consider child abuse, misogyny, sadism (that word again), animal cruelty, and various other atrocities. No doubt it would have been banned when it was first printed in 1869, had anyone actually noticed its existence at the time.

But then, shortly before his death, the author pulled an about-face. Immediately after celebrating evil in *Maldoror*, Lautréamont — this time under his birth name, Isidore Ducasse — published a slim pamphlet called *Poésies*, consisting of brief aphorisms in prose. On closer examination, it turned out that many of these aphorisms were actually canonical maxims by moralists such as Pascal and La Rochefoucauld, familiar to any French schoolchild, but turned on their heads to celebrate positivity and humanism. So, for instance, where Pascal had written, "Man is only a reed, the weakest in nature . . . a vapor, a drop of water is enough to kill him," Ducasse countered with, "Man is an oak. Nature contains nothing sturdier," and so on. As he announced in a programmatic headnote, "I replace melancholy with courage, doubt with certainty, despair with hope, wickedness with good... skepticism with faith."

Many, Ducasse included, have described *Poésies* as a "correction" of *Maldoror*, but we might also see it as a counterpoint.

Ducasse began with passion and rage, the sparks needed to light the fire and set revolutions in motion, then continued with the more sober and optimistic reflection needed to bring them to fruition. Faced with the cynicism and the defeatism of his own frenzied fantasies, as well as with the suppression of human grandeur in moralists such as Pascal, Ducasse replaced "despair with hope," offering a lesson of agency and uplift from within the very corpus of repression. Like Rimbaud, whose renunciation of poetry and disappearance into the African desert sealed his literary reputation, Ducasse's repudiation of his own jet-black apoplexies highlighted both the torment and its negation in an endless dialectical spin-cycle, an enigma forever to be read and pondered, never to be solved.

In embracing transgressive figures such as Sade and Lautréamont, the Surrealists were not merely straining for provocative effect. More substantially, the movement promoted itself as one of the great currents of liberation in the twentieth century, the resolute enemy of stifling social and moral conventions, and this extended far beyond literature and art. Its calls, in the 1920s and 1930s, for rethinking the status of women and people of different races, for freedom of imagination and sexuality, and for political revolution directly influenced the protests of May '68 and are not unlike calls that have sounded more and more urgently in recent years. It is also at the origin of many things we now take for granted, from the imagery that we respond to, to the humor that we appreciate, to the sense of strangeness that we unthinkingly call "surreal"; and it laid the groundwork for a larger degree of candor and personal engagement in artistic expression, to which today's productions owe a great deal.

In 1922, André Breton, Surrealism's founder and primary theorist, declared: "Poetry, which is all I have ever appreciated in literature, emanates more from the lives of human beings — whether writers or not — than from what they have written or from what we might imagine they could write." In other words, poetry was less about words on a page than about a living attitude, or, as Breton said, a "specific solution to the problem of our lives." It was an early version of what in the 1960s would be expressed as "the personal is political," and it implicated the poet and the artist in the work they created. It was not enough for your art to say the right things; if you were going to contribute a "specific solution," you also had to walk the walk.

What makes Surrealism such a good case study for our present context is precisely the disparity between the ideals that it promoted and the results that it often delivered, or the behavior that its members displayed. On the one hand, unlike their more sulfuric role models, the Surrealists might vehemently advocate for a positive and synthetic vision: the "point of the mind," as Breton famously put it, "at which life and death, the real and the imagined, past and future, the communicable and the incommunicable, high and low, cease to be perceived as contradictions." But they could also prove just as corrosive as Sade or Lautréamont, and were never shy about expressing their dislikes.

Their early version of "cancel culture" could take various forms, from the twin lists headlined "Read / Don't Read" — the "Don't Reads" being the longer of the two and ending in "etc., etc., etc." — to the so-called trial of Maurice Barrès. A renowned novelist, Barrès had been admired by Breton, Louis Aragon, and other future Surrealists in their formative years as a paragon of personal freedom, the "prince of youth," but

with World War I he had hardened into a super-patriot and arch-conservative. Feeling betrayed, Breton and his friends staged a mock trial of Barrès in May, 1921 before a packed house at the Hôtel des Sociétés Savantes, an ornate late-nineteenth-century edifice on the aptly named Rue Danton in Paris' sixth *arrondissement*. The charge: "conspiracy against the security of the Mind." When the "court" ultimately handed down a sentence of twenty years' hard labor for Barrès, Breton, who had pushed for the death penalty, was disappointed. Barrès himself, of course, was nowhere near the proceedings and probably couldn't have cared less — this was, after all, before social media existed — but Breton had prosecuted his case with such ferocity that some wondered what might have happened had Barres been present. (Fifteen years later, they would get their answer from Moscow.)

Much less symbolic were the Surrealists' true cancelations: the periodic exclusions of writers from within their own ranks. In 1926, not long after the movement's founding, several of the original personnel were drummed out of the group for not embracing its turn toward Communist politics. This was followed by other purges over the succeeding years, resulting in the loss of many prominent members, some of whom were pushed to the brink of suicide, or beyond it, for failings that ranged from practicing hack journalism to political waffling to not condemning vehemently enough those whom the group had condemned. While Surrealism promised many freedoms, the one freedom it apparently could not abide, and toward which Breton could react with remarkable savagery, was the freedom to dissent. In the name of emancipation it practiced excommunication.

These excommunications were in part a referendum on loyalty — are you with the program or not? — and sometimes

simply an outlet for personal spite, but more fundamentally they were an interrogation of identity: you are defined by the company you keep, by both your actions and theirs, and tolerating intolerable elements reflects back on you. Returning to Breton's statement about "poetry emanating from life," what happens when the life no longer lives up to the demands of the poetry? And more to the point, how successfully did Surrealism as a collective live up to its own demands? Let us consider three aspects of Surrealism's engagements: with race, with sexuality, and with gender.

In matters of race, the Surrealists publicly aligned themselves with people of color, denouncing French colonialism and the inequities it fostered at home and abroad. In 1941, under the collaborationist Vichy government of Marshal Pétain, Breton invited the Afro-Cuban artist Wifredo Lam to illustrate one of his books, telling a journalist from the conservative *Le Figaro* that the choice of Lam was meant "to make clear just how sympathetic I am to Marshal Pétain's racist concepts." (To Breton's disgust, the newspaper omitted that particular quote from the published interview.) Not long after, in Martinique, he met and collaborated with the poets Aimé and Suzanne Césaire, future founders of the Négritude movement. And in 1946, on a visit to Haiti, Breton told a student audience: "Surrealism is allied with people of color ... because it has always been on their side against every form of white imperialism and banditry." By many accounts, the popular uprising that deposed the repressive Haitian president Elie Lescot several weeks later derived some of its inspiration from Breton's statements.

All well and good. But figures such as Lam and the Césaires — as well as Hector Hippolyte, Hervé Télémaque, René Menil, Léopold Senghor, Jules Monnerot, Pierre Yoyotte, and Ted

Joans — remain an oft-neglected minority among the many who passed through Surrealism, and only recently have such artists and writers begun receiving serious attention from historians of the movement. The most meaningful blend of Surrealism with a specifically black vision, Afro-surrealism, did not originate within the European groups, but had to develop on its own, independent of them, and with distinct differences.

And this does not take into account other non-European Surrealists, such as César Moro, Fernando Lemos, María Izquierdo, and Frances del Valle; or Mahmoud Sa'id, Fouad Kamel, and Georges Henein; or Kansuke Yamamoto, Toshiko Okanoue, and Shūzō Takiguchi. Most of these figures, while retaining a greater or lesser identification with the movement, ultimately had to craft a version of Surrealism that spoke to their own cultural realities; whereas the Paris, Brussels, and London groups, even while promoting a broad internationalism, still kept their focus on a predominately white European set of references. There is more than a trace of exasperation in this remark by the Japanese Surrealist Takenaka Kyūshichi, from 1930, only six years after the movement was launched: "True Surrealists take a step beyond Breton. They are not confined by the Surrealism of Breton's 'Manifesto.'"

When it comes to sex, while Surrealism enjoys a libertine reputation in the popular imagination, all licentiousness all the time, the reality was that these bourgeois young men were rather prudish. Yes, they believed in "free union" and "mad love" and abhorred marriage as an institution (even though many of them were married); and yes, they promoted the idea that a grand passion could excuse anything — though, not surprisingly, that particular freedom generally ran in only one direction. The inquiries on sex that the Surrealists conducted

in the late 1920s and early 1930s were remarkably frank for the time, but also rife with the prejudices of the era, and quite a few strictures were voiced — particularly by Breton, who pontifically denounced sex workers, multiple partners, promiscuity, women's orgasms, and male homosexuality. Needless to say, most of these sessions were among men only; in one of the few that a woman did attend, she listened for a while, then remarked, "You boys need to learn a few things."

Which brings us to the most blatant and the most complex of the Surrealist double-standards, the status of women in this allegedly emancipatory and revolutionary movement. Where to begin? We could start with René Magritte's well-known canvas from 1929, *I Do Not See the [Woman] Hidden in the Forest*, which depicts a fairly classic painted nude framed by photographic portraits of seventeen Surrealist men: the fact that the men have their eyes closed does not make their gaze any less male. Or we could start with the many Surrealist visual works depicting the female form dismembered, disfigured, or otherwise deformed. Or with the many written works in which women appear as muses, lovers, inspirations, torturers, enigmas, enlighteners, or sorceresses, but almost never as autonomous individuals.

Conversely, we could cite this passage by Breton, written as World War II was drawing to a close, in which he calls for a matriarchal social order: "May we be ruled by the idea of *the salvation of the earth by woman*, of the transcendent vocation of woman...The time has come to value the ideas of women at the expense of those of men, whose bankruptcy has become tumultuously evident today." But since, good intentions aside, this still sounds a lot like mansplaining, let us bring in some other voices – for example, the British Surrealist painter Ithell Colquhoun, who reflected that despite pronouncements such

as the one by Breton quoted above, "most of [his] followers were no less chauvinist for all that. Among them, women as human beings tended to be 'permitted not required.'" The painter Leonora Carrington, when I once asked her for her opinion of Surrealism, called it simply "another bullshit role for women."

We can easily understand the resentment and the rage. On the one hand, Surrealism claimed to be one of the most woman-focused and erotically free movements in the history of literature and art. Alongside the paintings and photographs that mangled women were an equal number that exalted them, or at least the idea of them, as superior beings attuned to natural and supernatural forces beyond the reach of men. Within the movement, women were honored as muses and creative inspirations, and they were promised an alternative to the stifling roles that mainstream society expected them to fill.

But all too often these grand promises simply fell flat, and the women who came to Surrealism as artists and writers with their own talents and ambitions — Leonora Carrington, Dorothea Tanning, Remedios Varo, Joyce Mansour, Lee Miller, Leonor Fini, Meret Oppenheim, Eileen Agar, Jacqueline Lamba, Gisele Prassinos, Kay Sage, Nelly Kaplan, and others — or who claimed for themselves the same freedoms in lifestyle and beliefs that the men did were disappointed to find themselves facing obstacles from their own peers that hardly differed from those of society at large. Colquhoun, for instance, was expelled from the British Surrealist group because her interest in witchcraft was deemed inappropriate by her male colleagues, who otherwise championed all kinds of transgressive anti-rationalisms in their philosophy and their work.

Given all this, it would be too easy to brush away Surrealism as just another narcissistic patriarchal exercise

that failed to live up to its big claims. The more seductive the promise, the more painful the letdown. But there might be a better lesson to be drawn from the experience of women in the movement. Constituting a "minority within a minority," as Eileen Agar put it, they forged their own freedom and tilled their own ground, mapping out — as the critic Sacha Llewellyn writes — "their own autonomous identities... transforming and appropriating the iconography of women that male Surrealists ascribed to them... to produce radical works centered on the female condition." The point here is not to discard Surrealism, but instead to identify the moments it offers in which prohibition becomes opportunity. Rather than repudiating Surrealism for its failures, the women and the artists of color who gravitated toward it took its promise of liberation and made it their own. The best criticism is neither rejection nor apology, but constant reevaluation and regeneration.

What does it mean for the humanities now if art, writings, and philosophies deemed unworthy simply get thrown onto the trash heap of history because they fail to conform to prevailing notions of truth, goodness, or beauty? Where will fruitful challenges originate, if not in studying and debating works that offend and shock, or that fail to keep their promises? Must we "burn" everyone who, in their poetry or their person, does not live up to the ideals that we wish them to embody?

Over the years, as I continued to ponder my philosophical quandary from graduate school, I came to realize that the point of reading literature so closely was to learn how to read the world, that is, the fine print of the world, the signs and underlying messages encoded in people, things, events,

exchanges, and surroundings. Paradoxically, given the emphasis on hermetic concentration, what this training really provided was a wider and deeper sensitivity to the context surrounding these people and events. This involved opening my eyes and my mind to ways of thinking and expressing that I had not yet encountered — some of which troubled or upset me, but all of which were crucial steps in my learning how to understand my environments with discernment and with broadmindedness.

Writers such as Sade, Lautréamont, and the Surrealists are problematic in that they challenge the values we like to think we celebrate, or confront us with frustrations and disappointments; but as such they also open doors toward a meaningful response. They were desperate people living and creating in desperate and pivotal times, whether the French Revolution, the Franco-Prussian War, or the aftermath of World War I. As we live through our own desperate and pivotal era, we might do well to ask what work such as theirs, however removed or outdated it might seem at first, can tell us about our own volatile experience.

One of the most pernicious aspects of our fractious political and cultural landscape — alongside the decimation of our personal liberties, the erosion of civic discourse, governmental paralysis in the face of rising gun violence, and so much else — is the intolerance that it has fostered: not only the caricaturish intolerance for the values of diversity and inclusion that the liberal arts are meant to promote, but a resistance, even a fear — all along the political spectrum — toward engaging with viewpoints that we find alien and distressing, precisely because they *are* alien and distressing. As if we had somehow lost our ability to speak to things that we abhor in other than extreme ways. We demand, we shout,

we insist, which is sometimes the necessary response. But what we must not lose is the ability to talk, and more than that, to listen, to weigh, to ponder, to empathize.

If we are to be full-fledged human beings, we must learn the ability to enter into other points of view, including those that antagonize our deepest beliefs. Even as we disagree with or fight them, we must recognize them as human expressions. Saving ourselves from a reality soiled by ever more entrenched parochialism and flattened by defeatism and despair will depend on our capacity to evaluate lucidly, to look beyond buzzwords and bubbles, to see past labels that are often just a surrogate for thinking. There are no surrogates to thinking. It will depend on our ability and our willingness to contemplate the lessons offered by the humanities with minds wide open, and to interrogate our own and others' beliefs with honesty, compassion, and courage. Knowing how to read the world with an open mind is not just a life hack; it is also a tool for survival.

The Surrealists, for all their obsession with grasping the unconscious, were not particularly known for empathy. While some of their pronouncements, such as Breton's remark about the "point of the mind," might be read as aspirational, they generally preferred to operate in the vituperative register — which some, like Robert Desnos, elevated to a fine art. And yet they knew how to hear, and to hear effectively. Before they went on the attack, they did the necessary work. In 1949, for example, Breton unmasked a forged poem by Rimbaud strictly on the basis of intuitive affinity. His 68-page pamphlet, *Caught Red-Handed*, takes aim at the literary critics who fell for the hoax (basically all of them), dismantling their arguments point by point in a humiliating show of superior understanding. Not very friendly, perhaps, but in its wounding way more

respectful: Breton actively listened to what those critics had to say before offering his withering refutation. There is a lesson in that. We can, if we must, endure a culture of intellectual incivility; sometimes it might even be beneficial. What we must not abide is a culture of intellectual abdication, or intellectual cowardice.

# JONATHAN ZIMMERMAN

# *Memoirs of a White Savior*

Last year, a student came to my office hours to discuss her post-graduation plans. She said she wanted to travel, teach, and write.

"How about joining the Peace Corps?" I suggested.

She grimaced. "The Peace Corps is problematic," she said.

I replied the way I always do when a student uses that all-purpose put-down. "What's the problem?" I asked.

"I don't want to be a white savior," she explained. "That's pretty much the worst thing you can be."

Indeed it is. The term "white savior" became commonplace in 2012, when the Nigerian-American writer and photogra-

pher Teju Cole issued a series of tweets — later expanded into an article in *The Atlantic* — denouncing American do-gooder campaigns overseas, especially in Africa. His immediate target was the "KONY 2012" video of that year, a slickly produced film — by a white moviemaker — demanding the arrest of Ugandan warlord Joseph Kony. But Cole's larger goal was to indict the entire "White-Savior Industrial Complex," as he called it, which allowed Westerners to imagine themselves as heroic protectors of defenseless Africans. Conveniently, Cole added, it also let them ignore the deep structural and historical inequities that had enriched the West at the expense of everybody else. "The White-Savior Industrial Complex is not about justice," Cole wrote. "It is about having a big emotional experience that validates privilege." Instead of assuming that they know what is best, he urged, Americans should ask other people what they want. And instead of engaging in feel-good volunteer projects that do not do any actual good, we should challenge "a system built on pillage" and "the money-driven villainy at the heart of American foreign policy."

The Peace Corps is a volunteer agency as well as an agent of foreign policy. So it has also become a frequent punching bag on several popular Instagram accounts that have echoed — and amplified — Cole's critique. No White Saviors (906,000 followers) denounces the Peace Corps as "imperialism in action"; at the parody account Barbie Savior (154,000 followers), you can thrill to the pseudo-adventures of a Peace-Corps-like doll who takes selfies with orphans, squats over a pit latrine, and invokes famous humanitarians. ("If you put an inspirational quote under your selfie, no one can see your narcissism — M. Gandhi.") Never mind that Cole's original posts mocked digital activism such as the KONY 2012 video, which featured "fresh-faced Americans using the power

of YouTube, Facebook, and pure enthusiasm to change the world," as he observed. In the Age of the iPhone, apparently, the only answer to a misguided social-media campaign is another social-media campaign.

And now the campaign has spread into the Peace Corps itself, as my student noted. She alerted me to Decolonizing Peace Corps (9300 followers), which was started by three returned volunteers from Mozambique after the agency evacuated them — and the other 7300 volunteers around the world — amid the COVID pandemic in March 2020. Later that spring, following the police murder of George Floyd, the Mozambique trio circulated a petition urging the Peace Corps to reckon with its allegedly racist and colonialist roots. They sent it to No White Saviors, who told them a petition "wasn't going to be enough"; what the volunteers needed was, yes, their own Instagram account. Decolonizing Peace Corps went live shortly after. Inspired by campaigns to abolish the police, it demanded the abolition of the Peace Corps. "When you look at the Peace Corps and you look at the police and you see the origins, you ask yourself, can this really be reformed?" one of the account's founders asked. "How can you reform a system that was founded on neocolonialism and imperialism by a country built on genocide and slavery?" The question answers itself.

Meanwhile, as the pandemic continued to surge, No White Saviors stepped up its own attacks on the Peace Corps. Now that all the volunteers had come home, it wrote, the agency should permanently close up shop. "No more pretending inexperienced young people are actually useful in countries and cultures they are alien to," No White Saviors wrote in 2021. "Instead you could pay skilled local volunteers to work more effectively. No more spending money on flights or evacuations, no need to teach language or culture." Indeed,

171

a volunteer back from Nepal added, the worldwide evacuation was itself a "gross display of resource privileges." She still couldn't figure out why the Nepalese people in her community had wanted her there, "other than maybe for 'cultural exchange.'" But, as her air-quotes indicated, that "is not a good enough reason to invest so many resources into mostly fresh out of college, inexperienced Americans."

I served in the Peace Corps in Nepal, fresh out of college in 1983. My father was a Peace Corps director in India and Iran in the 1960s, when I was a child. The story of the Peace Corps is, in many ways, the story of my life. Now my student wanted to know: was it worth it? And for whom? In reply, I related an experience from my years in Nepal. It's all about who gets saved, and from what, and why.

I was teaching one day when a kid bounded into my classroom, breathless from running. "John-Sir," he panted, "your friend is in the valley!"

"Your friend" meant another white guy, a very rare sight in that part of Nepal. I taught at the top of a hill — we would call it a mountain, but in Nepal it was a hill — about two hundred and fifty miles west of Kathmandu. To get there, you took an overnight bus across the plains that bordered India and then walked north for three days. When I first arrived, some of the children thought I was a ghost. They had never seen someone so pale.

I peered down into the valley, shading my eyes against the sun. It was a picture-perfect, blue-sky afternoon in the Himalayas. And sure enough, there he was: another white guy. Everyone wanted to know what he was doing there.

So we cancelled the rest of the school day, and all of us — teachers, students, and curious hangers-on — started walking down the hill.

As we neared the valley, a villager approached me excitedly. He was holding a crudely printed pamphlet, which flapped in the mountain breeze. "John-Sir, your friend sold me this book!" he exclaimed. "Only five rupees!" Five rupees was what a man earned for chipping away all day at the tractor road, until it got washed away by the monsoon and you started all over again the next year. A woman got three rupees, and a child got one. It was a day's wage. I took one look at the pamphlet and right away I knew what it was. There was a figure that looked like Greg Allman — long straight hair, close-cropped beard — nailed to a cross. And he was white, of course.

We found "my friend" standing on the top of a rock at the bottom of the hill, selling dozens of pamphlets and collecting a large stack of cash. I walked straight up to him, ready for a fight. "What are you doing?" I demanded.

"I'm saving these people for the Lord," he said.

Saving! Of course he was. I told him that they already have a Lord — about twenty thousand Lords, in fact. He said that Hindus were thieves and murderers. Recognizing his accent as German, I asked him why his own church had rolled over and played dead for Hitler. He replied that the Holocaust was a tragedy, but mostly because of the gypsies who perished.

I told him to be fruitful and multiply, but not in those words.

He told me to fuck off, too. (So much for turning the other cheek, which was a pretty big deal to the white guy on the cross.) I told him that it was illegal to mission in Nepal, and that I would call the cop if he continued to sell the pamphlets. This was a total bluff, because "the cop" was a day's walk away

and — based on my encounters with him — most likely drunk. But the missionary didn't know any of that, of course. So he hoisted his backpack, told me to fuck off yet again, and started climbing into the hills.

By this time, a great sea of humanity had gathered. Nobody knew what the missionary and I were saying, but they could tell it wasn't good. "John-Sir, you were angry with your friend," someone said, as the missionary walked away. "Why don't you like your friend?"

"He's a very bad man," I said. "He doesn't like your religion."

Then I heard one guy say, "Hey, John-Sir's friend said if I believe in his religion, I'll go to heaven and won't be reborn over and over again." And someone else said, "Hey, can I buy your book? I'll give you six rupees for it." "Run after John-Sir's friend," another guy said. "Maybe he has some books left over."

I cursed the missionary again, and then I cursed myself. Many years later I figured out why: we were both white saviors, in ways that still mortify me today. His saviorism was more direct and straightforward: Hindus were thieves and murderers, so he was saving them for his Lord. My own brand of saviorism was dressed up in the liberal multicultural dogmas of the era: I had to protect my villagers' fragile and endangered belief system from an evil Western interloper. But I knew what was best for them, every bit as much as the missionary did.

When you get on your high horse, you can disregard everything below you. There have been Christians on the sub-continent for nearly two millennia. But I didn't know — or care — about that. Nor did I care what the villagers thought about what the missionary was saying (and selling). I knew what was "indigenous" to their "culture," or so I imagined. And Christianity wasn't.

Most of all, I wanted to defend their "authenticity" against

174

inauthentic outsiders. That echoes the type of white savior that you can find on Instagram today, condemning white saviorism. The classic version of white saviorism assumes that people in other parts of the world would be just like us, if they only had a better upbringing. The Instagram critique of white saviorism reverses that formula, insisting that they do not — or must not — embrace or imitate anything we do and say. That prescription is saviorist in its own right, wrongly and patronizingly ignoring the same local autonomy and agency that it claims to uphold. No White Saviors tells Western do-gooders to take account of what other people want, but it dismisses those wants if they do not correspond to its idea of the good.

Eventually, the Peace Corps would save me from that kind of white saviorism, too – from the idea that people who seemed so different from me should forever stay the same. But to see how, as I told my student, we have to go back to the beginning.

My father met John F. Kennedy by happenstance in August 1956, on a beach in the French Riviera. It was the day after the Democratic convention, when Adlai Stevenson — nominated for the second time for president — let the delegates select his running mate. Kennedy was hoping to join the ticket, but he was edged out by the Tennessee anti-mob crusader Estes Kefauver. Kennedy flew out that night to France, where my dad encountered him the next morning. When he heard that my father was at Yale Law School, Kennedy urged him to come work for the federal government. Most of the other students would head off to white-shoe law firms on Wall Street and

elsewhere, Kennedy said. But my dad should go to Washington, JFK urged, because that's where the action was going to be.

I have told that story to my students many times, because it highlights the cavernous gap between Kennedy's time and our own. Today, across the political spectrum, "Washington" is a symbol of dysfunction and decay. It is where action — and idealism — go to die. But not then. My father did go to Washington, where he held several government jobs. He also volunteered for Kennedy's presidential campaign in 1960. At a meet-and-greet, he waited on a long line to shake the candidate's hand. "Paul Zimmerman!" Kennedy exclaimed, to my dad's shock and delight. "I met you on a beach in France, right after the 1956 convention."

Kennedy proposed a new volunteer corps during a famously extemporized 2 a.m. campaign speech in Ann Arbor, Michigan in October 1960. Between that night and his inauguration, over twenty-five thousand Americans sent letters to Washington asking how they could join the agency. The Peace Corps sent its first volunteers out in August 1961, to Ghana. By the end of 1963, seven thousand volunteers — known around the world as "Kennedy's Kids" — were serving in forty-four countries. The agency received its largest weekly number of applications in the seven days after JFK's assassination.

My father signed on a few years after that. He made one phone call to the Peace Corps, which somehow patched him through to Bill Moyers. A fellow Texan and top aide to Lyndon Johnson, Moyers had been an assistant director of the Peace Corps under Sargent Shriver, the president's brother-in-law. My dad recalled that Moyers asked him a single question: where he went to law school. In the era of the best and the brightest, that was all you needed to know. Moyers told my father to walk over to the Peace Corps office, where he was

176

offered a job on the spot. His international "experience" was limited to two summer vacation jaunts in Europe, including the trip where he met Kennedy. But somehow, attending Yale Law School — and, I would imagine, working on a Kennedy campaign — qualified him to be the director of the Peace Corps in South India. He was thirty-two years old.

So off we went to Bangalore. My mother took my brother (almost seven) and me (four and a half) first, stopping along the way in Israel to visit relatives. My dad followed with my ten-month-old sister, whom he fed with a bottle on the long Pan Am flight. We camped at a hotel for a few weeks until my parents found a house on a lovely compound adjacent to Cubbon Park, the city's green oasis. When we got to Bangalore, in 1966, it had 1.4 million people. Today it is roughly ten times that size.

My memories of India are dim, obviously. But the family albums show scenes that would fit nicely on the No White Saviors Instagram account. Here I am, riding an elephant at what looks to be a birthday party. Here's my baby sister, in the arms of her Indian nanny. Here's the rest of our large household staff: cook, cleaner, security guard. Here's the whole family decked out in traditional Indian white cotton dhotis. The most remarkable photo shows my brother beaming next to Indira Gandhi, who towers a bit stiffly over him. Our family was visiting a volunteer somewhere on the country-side, and word spread that the prime minister was going to be disembarking at a nearby railway station. So we went down there to see if we could catch a glimpse of her. At such scenes, a child was customarily chosen to greet the arriving dignitary. The volunteer we were visiting held my brother aloft, urging officials to select him. Eventually young Jeffrey Zimmerman was ushered to the front of the crowd to hang a garland on

177

**Memoirs of a White Savior**

Mrs. Gandhi. Talk about white privilege! It doesn't get more privileged than that.

What were we doing in India, other than making it — to quote Teju Cole — a "backdrop for white fantasies of conquest and heroism"? A few months before we arrived, Indira Gandhi met with Lyndon Johnson at the White House to discuss food shortages in India. Under its "Food for Peace" program, the United States agreed to send 3.5 million tons of wheat, corn, and other crops to India. Gandhi's government also partnered with the Rockefeller and Ford Foundations to bring new methods and products to Indian farmers. Many of the Peace Corps volunteers whom my father directed were engaged in programs to improve agricultural practices, too. I can't say I know what effect they had on farming, or whether local workers could have performed the Americans' jobs more effectively or efficiently. But here's what I do know: India kept requesting more and more Peace Corps volunteers, until the Bangladesh war in 1971 soured India-U.S. relations and led to their withdrawal.

That has been the pattern for sixty years: when the Peace Corps is asked to leave a country, it is for geopolitical reasons rather than programmatic ones. The people who actually host volunteers — school principals, health-clinic directors, and government officials — almost always want more of them, which isn't something you see mentioned very often by the critics of white saviors. If the volunteers are so clueless and useless — or, worse, if they are actively visiting harm on other countries — why would these countries continue to invite them? When the question is asked at all, on anti-savior social media, the most common answer is that non-white hosts have "internalized" white-saviorism themselves. "I will always carry the assumptions of villagers that I am better, smarter,

and work harder than my local counterparts," a Peace Corps volunteer in Cambodia wrote in 2019, before the pandemic brought everyone home. "Does my contribution have enough value to outweigh the perpetuation of the white savior complex on the local people?" Note the choice of words here: his very presence foists white-saviorism on his hosts, who are feeble and powerless to resist its seductive wiles. That patronizes "local people" in the guise of protecting them.

And here is something else I know: my parents forged deep and lasting human bonds in India. Their closest friends were the parents of an Indian kid I met at school. (It was a girls' school, which is a whole other story.) The anti-savior critics might dismiss that as mere "cultural exchange," which doesn't do anything to change lives. They are wrong. At the Peace Corps' twenty-fifth anniversary march in Washington in 1986, a man accosted my father and declared, "I've been waiting two decades to talk to you." My dad had a self-deprecating sense of humor — that is to say, he was Jewish — and he told me he half-expected that the guy would raise his middle finger and shout, "Fuck you!" Instead the man said that he had gotten sick during the first months of his Peace Corps service in South India. He made his way to Bangalore, presented himself at my dad's office, and announced that he wanted to go home. My father suggested that he go back to his village and give it one more try. He did just that, and he had lived there ever since. He married an Indian woman, had a bunch of kids, and worked in several different jobs in the health and education sectors. Perhaps he had once believed that he would save India, from disease or destitution or something else. Instead, he said, India saved him from the dull and altogether predictable life that awaited him back in the United States. America was his birthplace, but it wasn't his home. India was.

**Memoirs of a White Savior**

Our next stop was Teheran, where we arrived in January in 1969. It was flush with oil money and foreign workers, which gave the city a lively boomtown feel. Out in the country-side, a different set of changes were underway. The "White Revolution," declared a few years earlier by Shah Mohammad Reza Pahlavi, redistributed land and sent health and literacy workers into rural areas. It also enfranchised and educated women, which outraged some Islamic religious leaders. So did the Shah's development of secular courts and schools, which reduced the clergy's power and influence in both realms.

Peace Corps volunteers participated deeply in all of these modernizing efforts. In the cities, they taught at universities, advised local governments, and worked in the arts; a handful of American professional musicians were even recruited by the Peace Corps as volunteers in Teheran's symphony orchestra and opera. Rural volunteers taught in primary and secondary schools or served in health clinics, sometimes alongside teams of urban Iranians who were doing the same. The Peace Corps volunteers tended to be slightly older and more skilled than earlier cohorts, owing to political changes back home. In 1969, shortly after Richard Nixon entered the White House, a group of returned Peace Corps volunteers called for the abolition of the agency: as the war in Vietnam raged, they argued, the Peace Corps provided cover for American violence and imperialism around the world. (Ours is not the first college generation to look askance at the Peace Corps.) Nixon was only too happy to get rid of the agency, especially after volunteers briefly occupied its headquarters in 1970 to protest the bombing of Cambodia and the slaughter of antiwar protesters at Kent State. Nixon told his aide Lamar

Alexander — later the Secretary of Education and then a senator from Tennessee — to seek an appropriations cut in Congress as the first step towards zeroing out the Peace Corps. But Patrick Buchanan, another rising young GOP politico, warned Nixon that slashing the Peace Corps' budget at that point would provoke a "real storm" among the "Kennedy-ites." Buchanan instead suggested publicizing drug arrests and other overseas blunders by immature volunteers, who would eventually dig the agency's grave.

No such luck. To the chagrin of Nixon and his cronies, the Peace Corps retained its strong bipartisan support in Washington. But it did shift its priorities towards older and more professionally prepared volunteers, to head off the charge that it was a haven for pot-smokers and draft-dodgers. ("'Technically qualified' was a euphemism for 'not liberal,'" quipped Peace Corps evaluator Charlie Peters, who went on to a distinguished career in journalism.) Several married volunteers who worked for my father even brought children with them, which was unheard of before that time. Yet this was hardly a straightlaced crowd; if anything, antiwar protest and youth culture back home probably made them more radical in their politics — and more hippyish in their habits — than earlier volunteers. My mother tells a great story about taking a long trip with my dad to visit a group of volunteers up in Tabriz, in the northwestern part of Iran. Famished upon her arrival at their house, she noticed a tray of brownies and asked if she could have one. You won't like them, the volunteers said; they're old and stale. My mother, charac-teristically, would not take no for an answer. Biting into a brownie, she deemed it delicious. She ate another, and then another. Eventually, the terrified volunteers drew her aside and explained that the brownies were laced with marijuana.

**Memoirs of a White Savior**

They pleaded with her not to tell my dad, who didn't hear about it until many years later.

Nor were the volunteers mere mouthpieces for the Shah, whom they mocked privately as "George" (as in "George Bernard Shah"). For a variety of reasons, including his recognition of Israel, the Shah was a strong ally of the United States. But he was also a brutal dictator, torturing dissidents and muzzling the independent press. Back in the States, protesters imagined that the Peace Corps — like other parts of the foreign policy apparatus — was helping to prop up pro-American tyrants. Around the world, though, a much more complicated pattern emerged. As the historian Beatrice Wayne has shown, the Marxist revolutionaries who overthrew Ethiopian ruler Haile Selassie often credited their changed political consciousness to the Peace Corps volunteers who taught them in the early 1960s, including the future senator Paul Tsongas. Most of the volunteers were middle-of-the-road liberals, not wild-eyed Marxists. But they led debates about Marx — and many other controversial matters — in their classrooms, which opened students' minds to new ways of thinking and acting. Likewise, Peace Corps volunteers in Iran subtly undermined the same regime that their government was supporting. Opponents of the Shah befriended several volunteers, who quietly cheered the campaign against him. And as enmity towards the United States mounted, fueled by the simmering Islamic revolution, the volunteers reminded Iranians that all Americans were not anti-Muslim bigots or stooges for the Shah.

But some of them were. The best decision my parents ever made was to send my brother and me to the Community School, which had been founded in the 1930s by American missionaries. It evolved into a thoroughly secular and cosmopolitan institution, patronized by families from

dozens of countries — including many Iranians. That made it very different from the Teheran American School, where most of the American military and corporate types sent their kids. They didn't speak any Farsi, and they called Iranians "ragheads." I played Little League with them at the U.S. army base in the heart of Teheran's Ugly American bubble, where they munched on hamburgers and made fun of the servants. Even as a nine-year-old, I knew that wasn't right.

Still, I was enormously proud of America. We were in Teheran for the Apollo 11 moon landing, a moment of huge American celebration — and, yes, American conceit — around the globe. And on United Nations Day, when everyone at Community School put on a short play about their country, we Americans staged the Thanksgiving story. We made a big Plymouth Rock out of papier-mâché, which we painted gray. I played Miles Standish, standing astride the Mayflower and shouting "Land ho!" as we approached the virgin wilderness. The folks over at No White Saviors would have a field day with this: it was a way to explain American power without addressing American conquest. A neat trick, if you can pull it off. But still I learned some important history lessons at U.N. Day. When I came home, I told my mother about the large Israeli delegation that marched under a blue Star of David. She laughed. The "Israelis," she explained, were Iraqi Jews who had fled the Baathist revolution. They didn't want to identify as Iraqis, which wouldn't go over well in Iran. So they were Israelis instead. Problem solved.

We were also in Iran for the epochal heavyweight boxing match between Muhammad Ali and Joe Frazier. As a Muslim, Ali was a huge celebrity across the Middle East. One evening, when my parents were on the road, our cook asked me why Ali was American but didn't look like me. My Persian had

183

gotten pretty good by then, and I explained to him—as best I could—that Africans had been enslaved by white people and transported across the Atlantic. "Really?" he asked. "You did that?" Well, yes. Not me personally, I said, but people who resembled me. The cook frowned and his brow furrowed. If our real purpose was to burnish white superiority in the non-white world, we weren't doing a very good job of it.

Neither of my siblings ever evinced any interest in joining the Peace Corps. My brother doesn't have as fond memories of those years that I do. My parents were away a lot, and I think he felt responsible for us while they were gone. And my sister was too young to recall much of anything. But I can't remember a time when I did not think that I would be a volunteer.

In 1983, when I graduated from college, I applied for exactly one job: the Peace Corps. The agency was weathering another round of assaults from another Republican administration. David Stockman, Ronald Reagan's famously Scrooge-like budget director, recommended a big cut for the Peace Corps. Meanwhile, GOP apparatchiks at the Heritage Foundation charged that the agency had lost sight of its Cold War mission: to provide a "counterweight" to America's Soviet foe. Indeed, the original Peace Corps charter in 1961 required volunteers to receive training in the "philosophy, strategy, tactics, and menace" of communism. To head off the Republican attacks — and, of course, to protect its appropriation — the agency reinstituted anti-communist lessons for trainees. When my cohort met in West Virginia, before we left for Nepal, a Peace Corps staffer wrote the charter language about anti-communism on a whiteboard and said, "This is

what the law requires us to teach." That seemed like something that might happen in a communist country, someone replied, and everybody laughed: the lesson was a joke, and we all got it. Maybe such instruction made sense when the agency was founded, but the Soviet Union was on its last legs by that point, and the entire exercise seemed anachronistic as well as propagandistic.

As in the Nixon years, meanwhile, the Peace Corps announced that it was recruiting volunteers who were "older and better-trained" (read: sober and politically moderate) rather than the presumably radical and irresponsible youngsters of the Kennedy-Kids prototype. I couldn't find much evidence of that shift in my own group. We were still mostly "B.A.-generalists" (as the Peace Corps called us) coming straight from college, who didn't know how to do much of anything. Out at my village, in the Pyuthan district of western Nepal, my closest Peace Corps neighbor was a woman who had earned an education degree and actually taught (imagine!) in an elementary school back in America. It took me three hours to walk to the house where she and her husband lived. On the weekends, I hiked over there and picked her brain. I still think she taught me more about teaching than anyone I have ever met.

But some of the work was intuitive, at least to an American. As a friend once told me, teaching is a lot like parenting: for the most part, you do it as it was done to you. In Nepal, most elementary-level teachers taught via repetitive chants. You knew you were approaching a school if you heard a chorus of kids singing in Nepali, "Two times two is four, two times four is eight, two times eight is sixteen," and so on. English instruction happened in the same manner. The kids would say an English phrase and then its Nepali translation, over and over again: "This is a cat. *Yo biralo ho.* This is a dog. *Yo kukur ho.*"

**Memoirs of a White Savior**

That wasn't the way I learned, and it wasn't the way I taught. Writing with a rock on the charcoal-covered piece of wood that served as our blackboard, I drew a cat. Everyone said the Nepali word for it: *biralo*. I said, "This is a cat." Then, pointing to the board, I asked a kid, "What is it?" With a bit of coaxing, she said, "This is a cat."

Soon I had the kids drawing their own pictures on the board and asking each other — in English — to identify them. I wrote little plays for them to stage, in which Ram and Sita (the Jack and Jill of Nepal) discussed feeding water buffaloes, cooking rice, and other day-to-day activities in their lives. Eventually the students wrote their own dialogues, introducing new characters — Gopal, Durga, Soorya — and different topics: marriage, childrearing, and school itself. A student played John-Sir in one memorable exchange, donning a makeshift straw wig to mimic my Jew-fro. It brought the house down.

Was my way of teaching "better" than the standard Nepalese method? Call me a white savior, but I believe it was. And here is how I know: my students told me. Nothing I did was particularly creative or innovative; it just made sense to me. But to the students it was a revelation. They had never experienced a classroom that required them to engage and imagine in the ways mine did. Eventually my Peace Corps neighbor and I designed trainings in these methods for other teachers in the region. We held three week-long sessions, in different parts of the district, where teachers put on plays and wrote songs and — most of all — laughed and laughed and laughed some more, in big collective guffaws that echoed out of the schoolhouse and into the hills. Sometimes, I'm sure, they were laughing at the weird Americans and our goofy, smiley mix of informality and exuberance. ("Why are you

people always so happy?" a Nepalese friend once asked me.) But I also think they were having fun, and learning. I can't tell you what effect these trainings had on their own instruction, or on anything else that happened in Nepal. But I also can't tell you whether the history course I taught last semester at Penn will make any difference in the lives of my American students, either. At some level, all education is an act of faith. You throw a whole bunch of stuff at a wall — or, in Nepal, at a charcoaled piece of wood — and you hope that something sticks.

And you never know what will. About fifteen years after I left Nepal, I got a call from Akron, Ohio. "John-Sir?" a voice on the other end said. That could only mean one thing: it was one of my Nepalese students. He had passed the national school-leaving exam and had gotten a job teaching in another district, where there was a female Peace Corps volunteer. The first thing he said to her, she later told me, was "Hello, Miss. Do you know John Zimmerman?" You know the rest. They had fallen in love, married, and moved to Ohio to be near her family. My student happily recounted our classroom dialogues as well as the "Steal the Bacon" game (which I rendered, he said, as "Steal the Pig's Meat") that we played outside. But he also said he had hesitated to contact me, because he feared that I was still "angry" with him. "Angry?" I asked. "About what?" Near the end of a class, my student recounted, he stood up and started erasing the girls' blackboard before they had finished copying the evening homework assignment. (Girls and boys sat on separate sides of the classroom in Nepal, each with its own blackboard, so I wrote the assignment on both of them.) I screamed at him, he recalled, the only time the students had ever heard me do that. "You should be ashamed of yourself!" he remembered me yelling. "The girls have as much right to learn as you do!"

187

I'd love to know how No White Saviors would parse this little tale. At first glance, it is perfect fodder for their critique: heroic white dude rides into town, spreading truth — his truth, that is — to the benighted brown people. Who was I, they might ask, to police how the Nepalese thought or acted around gender? At the same time, though, I'm sure that many people asking that question fashion themselves feminists of some shape or form. If I had failed to censure my student for erasing the girls' blackboard, wouldn't I have been "complicit" — to quote another of our current platitudes — in sexism and misogyny? When I tell my American students this story, they often say that my real mistake was raising my voice; I should have spoken to the student afterwards, calmly explaining the error of his ways, instead of humiliating him in front of his peers. Perhaps so. But whatever means I used, was it OK — or even necessary — for me to correct him at all? If he actually believed that the girls were second-class citizens, who says he was wrong?

Here's my answer: the girls did. When my student started erasing their blackboard, he told me, they raised *their* voices in protest. Indeed, he said, that's what drew my attention to him in the first place. You can say that I was behaving like a white savior, and you might be right. But I don't see how you can condemn me for imposing my views of gender, without regard for local tradition, and then disregard the expressed wishes of the girls. That sets *you* up as the arbiter of what is really "traditional" in Nepal, even as it throws half of the country — its female half, of course — under the proverbial bus. It is imperial anti-imperialism, the saviorism of No White Saviors.

I fell victim to that, too, in my fateful meeting with the missionary. Unlike the blackboard incident in class, where the girls objected to my student's behavior, I didn't hear anyone complain about the missionary. The complaints were in my head, and I projected them onto Nepal. Perhaps that's inevitable, to some degree or another, when human beings from different parts of the world encounter each other. Every living person's perspective is partial. People in Nepal projected onto America, too, in ways that I found endlessly fascinating. Americans made lots of money, I was told, and they also had sex 24/7. How are you so rich, a guy once asked me with a straight face, when all you do is screw? I laughed, but it was no joke for female Peace Corps volunteers who had to fend off the men who believed it. Racial minorities and LGBTQ volunteers have faced special challenges, too. Taboos against dark skin run rampant around the globe, as does discrimination against gays; in several Peace Corps countries, indeed, same-sex love is illegal.

Should Peace Corps volunteers try to challenge that kind of prejudice, as best they can? I think so. And if that sounds like white-saviorism, I have news for you: the Peace Corps isn't as white anymore. In 1990, four years after I returned from Nepal, just seven percent of Peace Corps volunteers were racial minorities; by 2020, when volunteers around the world were evacuated, 34 percent were non-white. That doesn't mean that they will be perceived as such outside of America, of course. Back in the 1990s, I conducted oral histories with black Peace Corps volunteers who had served in Africa. Many of them were called anomalous nicknames like "black white" or "native foreigner," which acknowledged the black volunteers' connection to the continent while simultaneously underscoring their difference from it. Most of all, the volunteers learned how much difference a category like "black" could contain. Countries

such as Kenya and Nigeria were as diverse as the United States, volunteers discovered, containing dozens of different ethnic and language groups. And these people often hated each other, too, just like racists back in the States. "The color of the foot on my neck doesn't matter, as long as there's a foot on my neck," one black ex-volunteer told me, describing the ethnic prejudices he observed in Africa. "Discrimination is discrimination."

And love is love, as another black returned volunteer added. "I got an appreciation of where I came from, and the beauty of that," he said. "Basically, we're all the same." Although it sounds hopelessly trite in these jaded times, love for our shared humanity, our universal commonality, is the only way to appreciate our differences and to communicate (literally: to make common) across them. Six decades after it was founded, the Peace Corps remains a foremost symbol of that ideal: love, respect, friendship, and cooperation across oceans and borders, cultures and races. So it will always be an easy target for politicians and ideologues who see it as either starry-eyed nonsense or blind propaganda. In 2017, the Trump Administration proposed slashing the Peace Corps' budget by fifteen percent; two years later, Republicans in Congress introduced a measure to eliminate the agency's appropriation altogether. Channeling his inner Donald Trump — or, perhaps, his subconscious Richard Nixon — co-sponsor Mark Walker (R-NC) said we should "put America first" by using the saved dollars to support disaster relief at home. The bill got 110 votes, all from the GOP, which wasn't enough to get it through. By June of this year, as the pandemic abated, Peace Corps volunteers had returned to eleven countries. The agency is recruiting for about twenty other nations, too.

Who will hear that call, especially on our increasingly particularist and identity-inebriated campuses? Very few

people, I fear, if No White Saviors and their allies have their way. They use a different vocabulary than conservative critics, of course, sounding more like Noam Chomsky than Newt Gingrich: the agency is racist, neocolonialist, and so on. But the upshot is the same: the Peace Corps is a bad deal, so it's time to bring everyone home for good. "If we actually solved the world's problems, who would pay us?" a volunteer in Zambia asked in 2019, shortly before volunteers were evacuated worldwide. The Peace Corps is a junket, she said, wasting scarce resources that could be better spent in America. Congressman Walker couldn't have put it better himself.

But that spectacularly misses the point. I have never met a volunteer who thought that they solved the world's problems, and I'm very sure that I didn't. I wanted to help, and to learn, and to live. That is all. The scorn and the distrust of our present-day politics—on both sides of the aisle—cannot refute or erase the simple desire for connection. I left Nepal feeling humbled, not privileged. I learned how many different ways there are to be human, and how difficult it is to connect across the differences. But I also learned that we can do it, by trial and — mostly — by error. I learned that universalism is real, that it can be verified by experience, and that difference is not the last word on human life; that one is made wiser by the people one teaches, even when the differences are colossal; that there is more to the human world than power relations, even as we work to make them more equitable; and most importantly, that we mock altruism at our peril. The greatest danger of our moment is not racism or sexism, ableism or cisgenderism. It is cynicism, which tricks us into believing that we cannot overcome the differences—and, yes, the prejudices—that separate us from each other.

When my service ended in Nepal, the teachers held a party for me at our school. The rice wine flowed, and everyone

recounted ridiculous things I had said when I first got there and didn't know any better. My favorite one: a teacher asked me to visit his house on the weekend, and I replied, in Nepali, "Yes, I'd like to meet your wife." That's what you might say in America, if a colleague invited you over, but nobody told me that the verb "to meet" in Nepal had another, earthier connotation. It was horrifying, humiliating, and altogether human: what used to be known as an honest mistake. "It doesn't matter," the teacher reassured me, patting my shoulder. And everyone urged me to "come back soon," a common Nepali farewell.

It wasn't soon, but I did come back. Twenty-five years later, in 2010, I returned to the village with my seventeen-year-old daughter. The tractor road was finally finished, so the three-day walk had been trimmed to about eight hours. The first guy I saw said, "Hey, John-Sir, where have you been?" Everywhere, I wanted to say. Nowhere. It doesn't matter. The school sponsored an impromptu "Welcome Home" reception, at which my daughter and I were pelted with flowers and doused in red tikka powder. I stood up to give a speech in my broken Nepali, which was slowly coming back to me. But I broke down in tears, overwhelmed by my good fortune to have loved — and been loved by — these good people. Was this sentimental? Sure. Was it condescending? Not for a second. Perhaps I had acted, in my worst moments, as their white savior – but they saved me too, from the rigid categories that we now deploy, loudly and dogmatically, to define and divide us. Black and white, Jew and Gentile, Nepalese and American: we are all different and we are all the same. Come back soon, John-Sir. Come back home.

MARISSA GRUNES

# *Projection*

This is the work of your own hands
strange to say, all these stories carved
with a certain severity, each woodcut brought forward
in strokes, a register of darkness
removed.

There's a tower and a bridge. A figure midway across
watches the shadows below. Midway between
what? Today and tomorrow, if you like, cross-hatched
in black and white.

There are ways to create gray here.
Inking techniques, washes that float the heavy black
up off the page like a boat at high tide,
like the slow stain of floodwaters seeping across mired ground
undoing the earth, loosening grubby fistfuls
to look for worms, asking endless questions,
         dragging weeds and fenceposts
until their roots give way. The clouded sky turns over
in its sleep and goes on raining.

I am like a person who has thought so vividly of someone else
for years that I no longer have room for them anywhere
and when you put No on the table between us, hardly taller than
the pepper grinder and salt cellar, I study it carefully
— the real thing, not stooping to If but
brief and apparent as sunrise

# Rapunzelania

It is not wholly myself, this shadow tugging itself loose
as though it knew better where to go from here
what to do and see
before the ship leaves with the tide. Not a thousand ships,
        you understand,
just the one. Tall and proud, I suppose, and in a dreadful hurry,
what with the wind so uncertain.

But we are not near the sea, my shadow and I,
we are in a high, quiet place, one of those improbable towers —
Rapunzel's, if you will —
and the prince is nowhere to be found, he is perhaps out
        sunning himself
on a rock, like a gecko
with destiny in the flick of his tail.

Every love story ends badly: we know this,
as we know that leaves will grow toward the sun, that
        the gods will die,
and the floodwaters rise.

I recall meeting a prince once or twice,
and a few princesses, slender and lethargic,
casting about for something to do.
One of them made luxury backgammon boards, boxes
of fine walnut wood inlaid with bees and cicadas.

Well. I will stand at the window, counting myself lucky.
            It is dark here,
and peaceful. Out flies my restless shadow. Let it.
You can only leave the tower if a prince climbs up your hair,
            and this is a challenge
because you know princes are quite heavy, heavy as earth,
they come bearing happiness which swells as they climb,
takes on its own shape, like a herald
riding the prince's shoulder.

# *Blurred World*

It has been here as long as I have I think,
settling in the sand.
The current drags through like a wind,
carrying small reef-building creatures
to this outpost.

When I was a child it looked different.
It was a room then, the brass knobs spit-shined
and the drawers filled with carefully folded clothes;
the sheets on the small bed slightly rumpled,
the corners tucked in. A lamp, a little table and chair.
These were mine. Back then, *mine* meant *always,*
or, if you like, an open cannister holding the two fragile wings
of *this* and *now*: mother and father and sister.

What brought me here? Algae covers the bedstead
like a tiny dark forest. A moon snail creeps across the floor
in a straight line.

Sixty feet down, color leeches from everything,
       even the red charm I bought in Tibet
for my mother, whose body had crystalized. Red is for
       long life. "Her abdomen is frozen,"
the oncologist said.

The moon snail is almost out of sight.
Its gray, wrinkled body passes over the sand in that
        same straight line
toward the end of the continental shelf
and the drop-off. I watch for others, visitors,
a gleam of something turning away
in the blue.

It is not childhood, exactly.
A shoe drifts by.

There are my table and chair
too small to sit at. They say: *all along*
*you have not seen even one thing clearly.*

# ANDREW BUTTERFIELD

# *Exile to Exile*

We live in a state of constant strife; the truths we relied on no longer seem certain; we are unsettled, shaken, adrift. Even those of us lucky enough to retain our health, homes, families, and jobs feel exiled from the lives we once knew. The bonds of friendship and community that secured us have loosened, and we are cut off in time as well: the past is more remote, the future unimaginable. In crisis, we face a world of danger: war, plague, apocalypse, discord, violence.

How odd that the work of literature which most fully describes our state, our emergency, was not written recently, but over seven hundred years ago. The evils and the fears that

troubled Dante in his *Divine Comedy* are uncannily like the ones that threaten us; his world is our world, so much so that the monsters of cruelty and lust that fill his pages are instantly recognizable — one only need change the names to see them as the figures of today's miserable news.

The ever-present relevance of the *The Divine Comedy* has long been noted. Almost one hundred years ago, Osip Mandelstam, who experienced some of modernity's worst darkness, observed that "it is inconceivable to read Dante's cantos without directing them toward contemporaneity. They were created for that purpose. They are missiles for capturing the future...His contemporaneity is continuous, incalculable and inexhaustible." This immediacy is no accident. Although he was writing in the early fourteenth century, the poet composed his poem to speak to us. All serious artists hope their work will endure, but Dante, as almost no writer before him, sought to address the future, not just the readers of his day. We know this because he says so. At the end of the *Paradiso*, he states that the *Divine Comedy* is for *la futura gente*, the people of the future.

The poem is a compendium, an encyclopedia, a summa, and yet there is one subject above all that gives it urgency, and that is exile. Displacement and the longing for return have inspired so much literature, beginning with the Hebrew Bible and the *Odyssey*. But perhaps no writer is more deeply associated with the theme than Dante. He was cast out from Florence, his birthplace, in 1302, after having served for two years as a high city official, a victim of the interminable political violence of the city. He was stripped of all his property; broken off from his family; threatened with death by fire at the stake if he ever dared to come back. He never did, wandering poor and dishonored through Italy until his death in 1321. With a single

exception, all his great works were written in exile; it was exile that made him a master artist, philosopher, and prophet. It was exile, and the causes of exile, that he needed to explain to himself and to warn us about.

Before his banishment he was a lyric poet, one of the pioneers of the literary movement known as the *dolce stil nuovo* — the sweet new style — who wrote love poetry of a philosophical cast. He composed his verses for the admiration of a tiny elite of other poets, a group of a few dozen men whom the great Dante scholar Erich Auerbach compared to a "secret brotherhood." His chief work of these years is the *Vita Nuova*, an autobiographical fantasy in poetry and prose about his love for the young Beatrice Portinari, her early death, and his spiritual reaction. (She was to become the avatar of salvation in *The Divine Comedy*, and thereby the most famous idealized woman in Western literature.) Although a work of great inventiveness, with passages of aching poignancy, other sections are plainly insincere, and Dante's language can often be vague and periphrastic. No one is sure what some of it means. Auerbach concluded that parts are "baffling... puzzling...obscure." Dante himself found much of his early poetry dissatisfying, and even called it *faticosa*, laborious.

How utterly different is *The Divine Comedy*. Written in a mode of Italian of Dante's own invention — the *volgare illustre*, or elevated vernacular — and addressing the broadest possible audience, the poetry is characterized above all by its vividness, lucidity, and dramatic appeal. No longer does he want to dazzle a few friends with his brilliance and his erudite allusiveness. Now he wishes to inspire and explain and guide and admonish. He throws away the ambiguities that he once adored and turns instead to "clear words and precise language" — to borrow the terms Dante uses in the *Paradiso* (the third of the three

201

"canticles" that comprise the work) to praise the speech of Cacciaguida, his ancestor and hero. The new goal is *visibile parlare* — visible speech, presented in tercets of eleven-syllable lines that makes the reader picture and see and hear the events and the figures that the poet describes in gripping detail.

The leap of imagination that this devising entailed would not have been possible without the experiences gained in exile. One of the wanderer's discoveries, for example, was the diversity of Italian as spoken throughout the peninsula — its richness, range, and dignity. This gave him the conviction that Italian could be a literary language of the highest ambition, worthy of the most serious subjects, a distinction previously reserved only for Latin. Another was his recognition that language, literature, and indeed all of civilization are part of an historical process, and thus evolve continually and ineluctably. We, who have been born and bred on historicism, may take for granted the idea of cultural change, but it was Dante, comparing the dialects in Italy and the Romance languages in Europe, who first realized that it did so. Words mutate; norms shift; poetry can grow, rather than repeat the forms of the past.

At the same time, it was only in banishment that Dante came to know Latin literature well. At the end of the Middle Ages, books were still immensely expensive and incredibly rare, and the libraries of Florence were poorly stocked. To be sure, Dante knew Latin before his expulsion, but as has been brilliantly demonstrated by Ulrich Leo, it was only after he was cast out that Dante "read again, or in part for the first time, classical Latin poetry and prose." It was in exile that he started to identify with another wanderer and founder of Italian civilization — with Aeneas; in exile that he learned to know deeply the *Aeneid*, whose Book Six, with its account of a descent into Hades, was fundamental for his creation of the *Inferno*. It

was in exile that he came to see Virgil as the greatest of Latin poets, *il mio maestro e 'l mio autore*, from whom Dante learned *lo bello stile che m'ha fatto onore* — "the beautiful style that brought me honor." This transformative encounter perhaps took place in Verona in 1303, or in Bologna a year or two later: both cities had libraries of classical texts far richer than those in Florence.

The new clarity of Dante's poetic language was stimulated not only by high-minded considerations. It was also sparked by the rage that he felt for the injustice of his punishment. We are accustomed to think of *The Divine Comedy* as a poem of love, and of course it is: the love of God, the love of Beatrice, the love of "the love that moves the sun and the other stars." But it is important to acknowledge that it is also a poem of hate. His wrath never left him. Such was its ferocity that even when he comes to the redemptive climax of the poem and describes the upper reaches of Paradise, where all is joy and harmony, light and laughter, he cannot resist pouring venom on Pope Boniface VIII, whom he held ultimately responsible for his ill fate. Until this point in *The Divine Comedy*, Dante had always portrayed Beatrice as an emblem of wisdom, grace, and love; and yet, quite shockingly, Dante makes her last words in the poem, spoken from the Empyrean, castigate the pope and pray for him to rot in Hell. His rage contaminates even her supreme purity.

Dante's lust for revenge is most palpable in the *Inferno*. Here we see him kick one sinner in the head, and pull another's hair, and give thanks to God for the dismemberment of a man whose family had taken Dante's house after his exile. Throughout the canticle, it is Dante's seething and uncontrollable

203

anger that powers the vividness of description. Consider, for example, the first punishment he recounts in the poem:

These wretches who never were alive,
were naked and beset
by stinging flies and wasps

That made their faces stream with blood,
which, mingled with their tears,
was gathered at their feet by loathsome worms.

*Translated by Robert and Jean Hollander*

The outcast poet stings with those flies and wasps; he cheers for those loathsome worms. With insatiable avidity, in canto after canto, he piles up images of muck, filth, and fire; devils cut, gash, strike, jab, and smite the malefactors; the air is greasy, dark, and grim; the shrieks of the damned are piercing and hopeless; blood and bones and guts and shit are everywhere.

Crafting these scenes of punitive horror gave his language an edge and bite, a richness and directness, all without precedent in European literature. Only the darkest moments in classical poetry can rival Dante's black passages for intensity. But really no one ever before had lavished so much talent on detailed and sadistic depictions of utter gruesomeness, and at such length. For Dante ancient literature was fundamentally tragic, a poetry of death and madness. Conquering this mode made him the rival of the masters of the past. This is perhaps most evident in Canto 25 in the *Inferno*, where amid descriptions of monstrous rape and cruel deformation, Dante triumphantly proclaims, "Silence Lucan ... Silence . . . Ovid."

Here he asserts that he has achieved the greatness and the stature that was implicitly promised him when he met these poets, and Homer and Horace, in Limbo, at the outset of his journey through Hell.

Dante's wrath in exile was not only an engine of creativity. It was also part of the great moral crisis whose reckoning and resolution lies at the heart of the poem. Dante knew that just retribution belongs to God, not to mortals. He portrays Hell full of "furious shadows" whose unquenchable ire contributes to their agony; and he repeatedly depicts the damned biting and beating themselves in a bestial frenzy. He knew that to allow anger to take hold of his life was a form of mortal peril. Indeed, many scholars believe that Dante may have been on the verge of insanity and contemplated suicide in the early years of his banishment. The challenge for Dante was how to exit the dark wood in which he found himself in the beginning of the poem, to master havoc and despair.

His few surviving letters show that he remained bitter and wounded to the end of his days. "We have long wept by the waters of Confusion" like "exiles in Babylon," he wrote in an epistle in 1311, echoing the famous Psalm. And yet *The Divine Comedy* is finally a manual of deliverance, an incitement to hope and action. It makes its way to paradise. The book itself is the product of the perseverance that it preaches. It took Dante about fifteen years to complete, working at the pace of about three lines — one tercet — a day. The longer his banishment went on, the more ardently he poured all his powers into the book, which he completed shortly before his death in 1321. The work is full of exhortations to himself: to start, to continue,

to persist to the end. "I leave behind bitterness and go for the sweet fruit," he writes in the *Inferno*. "Nothing hinders the ascent except the darkness of night which binds the will with helplessness," he reminds himself in the *Purgatorio*. He must go on because he "who robs himself of the world...and wastes his abilities, lamenting when he should rejoice," sins against God.

The poem was Dante's path to recognition and redemption. In the wilderness of exile, his understanding of exile deepened, his vision expanded, and he became the author of perhaps the most visionary work in Western literature. The book encompasses not only the details of his own suffering but also the reasons for the predation, fraud, and violence that humans have inflicted upon one another everywhere. All the theology in the work notwithstanding, he is a close and unillusioned student of human life. And as his conception of the theme expanded, so did the audience that Dante imagined for his work: not just other cultured elites or fellow Florentine citizens, but potentially all readers of his time and into the future.

While always grieving for his homelessness and dreaming of his return to Florence, he began to see that exile gave him an unprecedented perspective on human affairs, an intellectual advantage. In a world where everyone's identity was defined by their membership in groups — especially the family, the parish, the city, and the political party — Guelf or Ghibelline, the two alliances that poisonously divided all of Italy and much of northern Europe too — Dante came to view himself as a party of one, and to believe that this status was a badge of honor rather than blame. The loss of belonging stripped him of community, but in his isolation gave him new hope for understanding.

Exile became a voyage of discovery, for all its peril and humiliation. At times he compared his genius, his poem,

and his fate to a ship on a sea. Like Ulysses, with whom he so strongly identified, he was bound "to gain experience of the world and learn man's vices, and his worth," for man was "not made to live like brutes or beasts, but to pursue virtue and knowledge." This pilgrimage carried him from the dark wood, where all seemed lost and nothing could be seen, to ever greater distances, whose vantage point made all clear — first the extremities of Hell and then the mountain of Purgatory and finally the heights of heaven, from which he looks down and sees all of earth. From this vista he marvels not only at the sublimity of his apotheosis, but also at man's unending propensity for violence, comparing the world to *l'aiuola che ci fa tanto feroci*, "the threshing floor that makes us so ferocious." Even in heaven he remains troubled by earth.

Searching for the cause of this malevolence, he not only looked at mankind from above, he also turned inward. "If the world around you goes astray, in you is the cause and in you let it be sought," he instructs in the *Purgatorio*. One source of the power of the book is his capacity to empathize with the sinners whom he describes in all their misguided passion and intensity. The author of the *Inferno* is a connoisseur of human failings. The vividly portrayed characters are fragments of himself, intended to mirror his own passions and weaknesses, his own temptations to moral error. Dante lusts like Francesca and Paolo, and feels with them the seductions of literature; he thrills with partisan hatred like Farinata; he considers suicide like Piero della Vigna; he longs for vengeance like Ugolino; he abandons all for the pursuit of knowledge like Ulysses. Dante was certain of his own genius and his supreme stature as a poet, but he was also sure that he was an Everyman, who shared in the common flaws of humanity, as do all his readers.

In exile, Dante came to see the fallen nature of man after

exile from the Garden as the unifying force of human history. It is the disorder of human desires that propels the unfolding of events and ties them all together, so that Florence of his day resembled Babylon and Troy and Thebes of the past, each brought to ruin by unbridled passions for power and gold. Like Augustine, Dante believed it was not sexual lust but the lust for dominance — what Augustine called the *libido dominandi* — that drove history. For Dante, the world is "blind," a "bloody heap," a "desert devoid of virtue," a "nest of Leda," whose offspring in their lordly arrogance and mindless cupidity doom everyone around them to destruction. The uncontrolled appetite of humans began at the very beginning: according to Dante, Adam and Eve tasted of the fruit and were expelled from Eden only six hours after their creation.

It is a tragic view of life, and yet Dante entitled his poem a *Comedy*. (The name we know it by, *The Divine Comedy*, is a later convention.) He did so because, despite his belief in man's propensity for sin, he also believed that by nature humankind is virtuous, noble, and dignified, and supposed to live a life of happiness and fulfillment here on earth, not just in heaven. The poem is the story of the recovery and the unfolding of this destiny — at least for one exemplary pilgrim, Dante. He spells out his idea of human goodness most succinctly in the two philosophical treatises that he worked on during exile. In the *Convivio*, or *Banquet*, he declares that "there is no greatness greater for human beings than virtuous activity, which is our intrinsic good," and that "the fruits most properly ours are the moral virtues, since they are completely within our power." In the *Monarchia*, or *Monarchy*, he writes that "ineffa-

ble providence" has set before us the goal of "happiness in this life, which consists in the exercise of our proper virtues." In these opinions he was deeply influenced by Aristotle, whom he refers to as "the master of our life" in the *Convivio*. Dante had likely studied the *Nichomachean Ethics* under the guidance of a student of Thomas Aquinas at the Dominican convent of Santa Maria Novella in Florence in the 1290s.

So the human darkness that Dante chillingly portrayed reaches its limits. Fundamental to his analysis of human nature was his focus on love, and its expression as desire and appetite. "Desire is spiritual motion," he said, the force that drives our action toward evil or good. It is what defines and gives shape to an individual's character and destiny. You are bound or you are liberated by what you love. The major distinction between the figures of the *Inferno* and those of the *Purgatorio* and the *Paradiso*, between the sinners and the saints, is what they desire.

The figures in the *Inferno* suffer from insatiable appetite. They are ruled by their mouths, an image that Dante emphasizes repeatedly, from the mouth of Francesca trembling with passion for Paolo, to the mouth of Ugolino, stained with the blood of Ruggiero whose brains he has eaten in revenge, to the mouths of Satan at the very pit of Hell, stuffed with the three great traitors Judas, Brutus, and Cassius. The she-wolf of avarice who blocks Dante's way in Canto I sets the tone for the entire canticle:

> Her nature is so vicious and malign
> her greedy appetite is never sated—
> after she feeds she is hungrier than ever.

*Translated by Robert and Jean Hollander*

Avarice by nature always seeks an end — more, more, more — that can never be reached, thus unleashing a kind of frantic madness in those who experience it. According to Dante, Pride and Envy also share in this bottomless avidity. They are the three ruling vices of life on earth; they typify rulers, popes, warriors, and merchants—the effective lords of the world — and determine the unjust character of their governance and domination.

Dante believed that these vices were essentially anti-social, spurred by hatred, rather than love, for one's neighbor. They necessitated *ingiuria*, an Italian term whose meaning combines both injustice and harm to others. To highlight this idea as central in the poem's ethical philosophy, he composed this sentence for the exact midpoint of the entire *Divine Comedy*: "All these three forms of love cause weeping down below." Humans, at least after the Fall, are ensnared and distorted by these appetites. The war and the greed and the bad government that plentifully characterized his own era were thus bound to repeat forever.

The blessed of the *Purgatorio* and the *Paradiso* are likewise spurred by desire, but theirs is a need for God, and for the Common Good. It is a vision of love as Agape rather than Eros. On earth humans are locked in a zero-sum game, fighting over spoils than can never be divided equitably. In heaven, by contrast, what they seek and what they share is love, each of the blessed radiating benevolence to others, like an undiminishing light reflected among an infinity of mirrors. While continuously yearning for God, the truest object of love, this is a desire that is also continuously fulfilled. It is the zeal of the saints, and it pulls Dante upward with ever greater force as he ascends to paradise. And unlike the misplaced appetites of the fallen, it ends in the just and proper form of man. As

he explains in the *Convivio*, "The supreme desire of each thing, the primal one given by its nature, is to return to its principle. And since God is the principle of our souls and made them like himself...the soul desires more than anything else to return to him." Here exile is given a cosmic metaphor and becomes metaphysical. The greatest banishment is the banishment from God, and therefore from oneself. And rather than the mouth of the *Inferno*, here the essential human organ of love and desire is the eye, the recipient of heavenly light. "Beatitude itself is based upon the act of seeing," Dante affirms, almost as if from experience.

Dante's tale is one of optimism, too, because he believed man to be free to regulate his behavior and affect his destiny. In the *Paradiso*, he calls free will the "greatest gift" of God to man. It is this gift, the capacity to choose and to act, that emancipates us from the inevitabilities of fate and makes life into a journey, although a perilous one. "In the middle of the journey of our life": those are the famous opening words of the work. Auerbach has beautifully described the moral condition envisioned by Dante in *The Divine Comedy:* "God is at rest; His Creation moves along eternally determined paths, while man alone must seek his decision in uncertainty... Man alone, but man in every case regardless of his earthly situation, is and must be a dramatic hero." Even though he had been selected by God for his visionary voyage through hell and heaven, an honor among the living previously given only to Paul, and despite the traveler's aid granted to him by Virgil and Beatrice, Dante's trajectory is still beset with difficulty; he still must struggle to understand, to persevere, to act correctly, to be worthy of the mission with which God has tasked him.

In conceiving and writing *The Divine Comedy*, the poet reimagined his exile as a pilgrimage. No longer does he want

primarily to return to Florence, the city on the Arno. Now he seeks to return to Jerusalem, the city of God in heaven. To do so, he must transform himself. He must learn to control his anger, and act with right measure in his pursuit of knowledge, and temper his lust for fame, and constrain his pride. Only by doing so will be able to "return in beauty" like "new plants renewed with new-sprung leaves pure and prepared." And as a man remade, he will also return as a new kind of poet, one with a new language resurrected from the ashes of the tragic and the erotic, and reformed in the mode of what he exquisitely calls the *cantar di là*, the song of the beyond. Dante's voyage is one of hope, announced with nearly prophetic fervor in the face of disorder and destruction.

We tend to picture philosophers and writers in the setting of the cloister and the café, the library and the lecture room, but Dante saw them — and himself — as figures in the world, and he knew that like everyone else in the world, they are routinely tossed aside by the vicissitudes of power in war and politics, and often they end up on the margins of society, in exile or worse. Consider the fates of those whom Dante admired most: Socrates, executed; Plato, enslaved; Aristotle, exiled; Cicero, murdered; Seneca, exiled and later forced into suicide; Ovid, exiled; Augustine, dying in a city besieged by Vandals; Boethius, imprisoned, tortured, killed. The parade of woe continued into Dante's own time; indeed, almost all his mentors and friends among the poets of the *dolce stil novo* spent time in banishment. The greatest philosopher and theologian of the thirteenth century, Thomas Aquinas, had been assassinated (or so Dante believed). And as a member of the Florentine government council, Dante even participated in the decision to cast out a fellow poet, the remarkable Guido Cavalcanti. They suffer so, because everyone does.

His own experience did not offer Dante much ground for a worldview of hope, and so he had to locate it elsewhere. And yet he stubbornly counseled that, all the evils notwithstanding, we act with determination and purpose. Early in his exile, he observed that "truly I have been a boat without sail or rudder, carried to various ports and inlets and shores by the dry wind that painful poverty blows." But about five years later, having surveyed and described in the *Inferno* the damage that humankind perpetrates, he set out to find and show a better way in the *Purgatorio*. For the first line of this canticle, he wrote: "To course in better waters, raise the sails."

In our journey of recent years, we have seen some of the best and the worst of humankind. Like the wayfarer in *The Divine Comedy,* we have faced gruesome death, raged against despair, witnessed corruption, disorder and anarchy. We have asked what it means, and why we must suffer so. In my own experience of this symbolic exile, cut off from friends and from accustomed activity, I began reading Dante. He speaks to our troubles because he reminds us that the folly, vice, and depredation of humans will always be with us. We are always waking to find ourselves in the middle of the dark forest. Yet he leaves us believing that, armed with the recognition of both our vices and our virtues, we can find a better nature within our imperfect selves. If we can raise our sails, we can catch a breath of hopeful wind; and on that wind we can navigate life toward a better end, in the pursuit of knowledge and the reverence of love.

# SCOTT SPILLMAN

# *The Sorrow Songs*

## I

On New Year's Day in 1863, Thomas Wentworth Higginson was stationed in the Sea Islands of South Carolina, presiding over a large group of Unionist whites and formerly enslaved black workers who had gathered to celebrate the Emancipation Proclamation. A prominent prewar abolitionist, Higginson had recently become commander of one of the first black regiments in the Civil War, the First South Carolina Volunteers. At the emancipation ceremony that Higginson had arranged, a local planter who had converted to abolitionism read the great document. There was a presentation of colors. Then, unexpectedly, as Higginson started to wave the flag, an elderly black man

near the platform broke into song: *"My country, 'tis of thee, Sweet land of liberty."* Two women joined, followed by others in the crowd. Higginson could hardly contain his emotion; everyone started to cry. "I never saw anything so electric," he wrote in his diary; "it made all other words cheap, it seemed the choked voice of a race, at last unloosed; . . . art could not have dreamed of a tribute to the day of jubilee that should be so affecting; history will not believe it."

Higginson had arrived in the Sea Islands five weeks earlier. He was part of a wave of northern whites who, during the turmoil of the war, experienced their first sustained encounters with southern slaves. As Higginson later recalled, one thing that this group mostly shared was their view of black people as "intensely human." This differentiated them sharply, in Higginson's mind, from southern slave owners, who had long claimed to understand their slaves better than northerners but tended in practice to see them (according to Higginson) as "merely a check for a thousand dollars, or less, from a slave auctioneer."

Still, even though abolitionists tended to be relatively free from prejudices that were strictly racial in nature, they often harbored their own prejudices of culture and class. So while they never equated blackness with a permanent condition of barbarism, they did sometimes see black people as ignorant or backward, in need of education and guidance as they made their first steps in freedom. The result was a variety of responses, sometimes sensitive and sympathetic, sometimes condescending or patronizing, often a complex combination.

With all its complications, this sudden mass encounter between newly freed slaves and white people who saw them as "intensely human" opened a fresh possibility in the study of slavery: the formal study of slave culture.

At the time such a thing did not exist. This neglect obviously owed a good deal to slavery and bigotry. The largely illiterate society of black slaves was not seen at the time as contributing anything to American culture as it was usually understood. Slaves seemed to have no role in driving the progress of civilization toward its pinnacle in white European and American society — aside from, in the minds of southerners, performing the important role of propping it up. Writings on slavery up to that point had focused more on its political, economic, and social effects, especially its effects on whites, and abolitionists had catalogued slavery's physical cruelty and deprivation on blacks.

The neglect of slave culture also reflected a broader lack of attention to oral "folk" cultures, which tended to be either taken for granted or considered unimportant at a time when certain conceptions of cultural hierarchy and social evolution still held sway. White southerners did not become interested in black music or culture until after the Civil War, when they felt a strong wave of nostalgia for old plantation life. Some black music was known in the North before the war, but it was mostly minstrelsy.

White southerners and northern travelers surely would have seen and heard the cultural practices of enslaved blacks in the South, but such observations usually did not make it into print. "I believe they have no history or a very short one," one sympathetic southern white woman wrote, in connection with the slave songs, just after the Civil War; her mother had made a small collection around 1840, but it was never published. To the extent that antebellum Americans discussed slave songs, and slave culture more generally, it was primarily

to argue about whether they provided evidence of content-ment or sorrow.

That changed when northern abolitionists, missionaries, soldiers, and teachers encountered newly freed slaves during the war. Almost from first contact, slave music received significant attention. When Reverend Lewis Lockwood arrived as a missionary to the Union post at Fort Monroe, Virginia, in early September 1861, he took down notes about the music that he heard from southern slaves who had fled there. His initial report, written the day after he arrived, included the first written record of the song "Go Down, Moses." By December, Lockwood had the full text of the song, which was published in the *New York Tribune* and the *National Anti-Slavery Standard*:

> The Lord by Moses to Pharaoh said:
> "O let my people go!
> If not, I'll smite your first-born dead,
> Then let my people go!"
> O! go down, Moses
> Away down to Egypt's land,
> And tell King Pharaoh,
> To let my people go!

The song caught on with the abolitionist crowd. Henry Ward Beecher's Brooklyn congregation started to sing it, and sheet music went on sale at the Pennsylvania Anti-Slavery Society office in Philadelphia.

By that time, reports were also starting to come in from the Sea Islands, which became by far the most important site for sustained encounters between northern whites and newly freed blacks during the war. The Navy had secured a beachhead

there very early, in November 1861, as part of the larger effort to blockade the Confederacy. White planters fled the islands. They tried to convince their slaves to go with them, but the slaves — thousands of them — thought better of it and stayed put. These people technically became contraband of war — and, soon, part of a vast experiment in education and free labor centered on the islands around Port Royal, including Hilton Head and St. Helena. Abolitionist groups in Boston, New York, and Philadelphia raised money and recruited volunteers to serve as teachers, missionaries, and plantation superintendents.

In Philadelphia, the city's Port Royal Relief Committee was headed by James Miller McKim, who also helped run the Pennsylvania Anti-Slavery Society office where "Go Down, Moses" was for sale. McKim was an abolitionist of some distinction. Back in 1849, he had been the one to open the box containing Henry "Box" Brown, the enterprising slave who shipped himself from Richmond to Philadelphia, and a decade later McKim and his wife had helped John Brown's wife bring Brown's body back north from Harpers Ferry. In early 1862, McKim quickly raised more than five thousand dollars to send to Port Royal. A few months later, the committee decided to dispatch McKim himself to provide a report on conditions there. McKim brought along his eighteen-year-old daughter, Lucy, as his assistant. The McKims had raised their children as staunch abolitionists. Lucy's younger brother Charles Follen McKim — later the architect of New York's Pennsylvania Station and other masterpieces of neoclassical modernism — was named for a German-born abolitionist who had died in a shipwreck off the Atlantic coast in 1840. In the 1850s, Lucy briefly attended and then taught at Eagleswood, an experimental school in New Jersey run by the abolitionist couple Theodore Dwight Weld and Angelina Grimké.

James and Lucy McKim arrived at St. Helena Island on June 8, 1862 and stayed for three weeks. Within a day, Lucy felt that she was seeing slavery with fresh eyes. "The pro-slavery folks were right when they said, Go South, Abolitionists, if you want to have your views changed on the subject of slavery," she wrote to her mother. "Mine have been most profoundly." Even Garrisonian extremism seemed like a mild response now that she had seen the conditions of slavery for herself. "How lukewarm we have been!" she exclaimed. "How little we knew!"

She began to jot down notes about everything she saw. She and others in the Sea Islands seem to have been motivated by a desire to record what they could before the evidence of slavery was swept away by change. In one letter, Lucy described the typical layout of a plantation's "Quarters — or 'Nigger-houses'" for a friend. "These were built in two long rows, facing each other, with a row of beautiful trees ... down the center," she explained. Every cabin had a small vegetable garden and fig tree out back. Inside, the cabins were "inconceivably small & filthy. With but few exceptions, the occupants lie on the floor, in bundles of rags, that have been reduced to one common dirt color."

But what captured Lucy's attention most were the songs. Like many people who came to Port Royal, she started copying down the tunes and the words just days after her arrival. Unlike many others, she remained entranced by the songs even after her return to Philadelphia in July. A trained musician who had already spent a few years teaching piano, she was better prepared than most people to respond sensitively to them. She asked her friends in Port Royal to keep sending her examples, and she began to prepare a few piano arrangements for publication. "Poor Rosy, Poor Gal," the first in her series of "Songs of the Freedmen of Port Royal" — and the second

published slave song arrangement in the United States — came out in October:

> Before I spend one day in hell,
>     Heab'n shalla be my home.
> I sing and pray my soul away.
>     Heab'n shalla be my home.
>     Poor Rosy, poor gal!
>     Poor Rosy, poor gal!
>     Poor Rosy, poor gal!
>     Heab'n shalla be my home.

She sent a copy to *Dwight's Journal of Music* along with an introductory letter — which, when it was published in the journal in November, became the first article ever to describe the musical style and technique of the songs.

Beyond their purely musical interest, she noted, the songs were also "valuable as an expression of the character and life of the race which is playing such a conspicuous part in our history." She went on to provide a perceptive reading of what the songs revealed: "The wild, sad strains tell, as the sufferers themselves never could, of crushed hopes, keen sorrow, and a dull daily misery which covered them as hopelessly as the fog from the rice-swamps," she wrote. "On the other hand, the words breathe a trusting faith in rest in the future."

Lucy's second arrangement, "Roll, Jordan, Roll," appeared in January, just after Emancipation Day:

> March, angels, march!
> March, angels, march!
> My soul am rise to heav'n Lord,
> Where de heav'n'e Jording roll.

Little chillen sittin' on de Tree ob Life,
Where de heav'n'e Jording roll,
Oh! Roll, Jording, roll, Jording, Roll, Jording, roll!

She seems to have had a plan to publish four more, but life intervened. Young men to whom she had romantic attachments died in the war, and she soon entered into a courtship with Wendell Phillips Garrison, the son whom William Lloyd Garrison had named for his longtime abolitionist ally. She spent her time teaching piano and waiting for Wendell to find a steady job so they could get married.

Meanwhile Thomas Wentworth Higginson had arrived in Port Royal, called there in November 1862 to take command of the First South Carolina Volunteers, a regiment raised from the freedpeople on the Sea Islands. He got the position because he was one of the most fiery abolitionists in America. As a young man in Massachusetts, he spurned the law because he saw it as nothing but a system for the protection of property. Eventually trained as a minister — he dropped out of Harvard Divinity School because he was dissatisfied with the professors, then returned a year later -- he took a position in Newburyport, where he advocated abolitionism and temperance. Neither stance went over well in a town with a rum factory, and he was asked to resign.

After 1850, Higginson upped the ante. He became involved in the Underground Railroad and also helped to form Boston's Vigilance Committee, which tried to protect alleged fugitive slaves from being recaptured. In 1854, he bought the axes for an ill-fated attempt to free the alleged fugitive Anthony Burns

from Boston's Federal Courthouse. In the scrum, he got hit on the chin and acquired a scar that he carried for the rest of his life; but a federal marshal was killed, an event that Higginson later recalled with perhaps a hint of pride (and certainly little sadness) as the first casualty of the Civil War. His next act was to take rifles and ammunition to Kansas, where he learned about the violent exploits of John Brown in the battles going on there between slaveholders and free-soilers. A few years later, when Brown needed help planning and funding his raid on Harpers Ferry, the radical Higginson was one of the so-called Secret Six who provided assistance. After the raid went awry, he was the only one of the six courageous or foolhardy enough to spill his secret; he also raised money for Brown's defense and even planned an armed raid to rescue Brown before Brown learned of the scheme and called it off.

Higginson redirected his energy into an oblique defense of Brown mounted in a series of deeply researched articles on slave insurrections — Nat Turner, Denmark Vesey, maroons in Jamaica and Surinam — which appeared from 1860 to 1862 in a new magazine called the *Atlantic Monthly*. He also prepared for war. He did not volunteer initially because his wife was ill, but by 1862 he could no longer resist — particularly when he got the invitation to serve with black soldiers in South Carolina, a position he saw as the fulfillment of Brown's legacy. "As many persons have said," he wrote on board the ship taking him south, "the first man who organizes & commands a successful black regiment will perform the most important service in the history of the War."

Higginson thought he already knew all about slavery, but several months in the Sea Islands with his men showed him that he still had plenty to learn from the slaves themselves. At one point his black corporal, Robert Sutton, led the regiment

up the St. Mary's River to the plantation from which he had escaped, where the woman of the house remarked with some disdain that she had once known Sutton as "Bob." Sutton took Higginson to the plantation's slave jail for a look at the chains and stocks; in their presence Higginson felt himself choking, as if he couldn't swallow or breathe. He realized that Sutton had a "more thorough and far-reaching" understanding of the slavery problem than "any Abolitionist." That sense continued to grow as Higginson got to know his men better and talked to them about their experiences. "It was not the individuals, but the ownership, of which they complained," he later recalled. "That they saw to be a wrong which no special kindnesses could right. On this, as on all points connected with slavery, they understood the matter as clearly as Garrison or Phillips."

Higginson trained his men and led them on sorties during the day, and at night he listened to them as they gathered around their campfires to sing "these incomprehensible Negro Methodist, meaningless, monotonous, endless chants," as he wrote in his journal after about ten days, "with obscure syllables recurring constantly & slight variations interwoven, all accompanied with a regular drumming of the feet & clapping of the hands, like castanets." There was more than a little primitivism in this initial response, a sense that the songs were barbaric relics beneath the attention of cultured people. But soon Higginson learned to love the music, looking forward to it every night, running out of his tent when he heard a new song, writing down all the lyrics he could decipher (sometimes with pencil and notebook hidden in his pocket) and calling on Sutton to help fill in the gaps. "When I am tired & jaded in the evening nothing refreshes me more immediately than to go & hear the men singing in the Company streets," he wrote after about ten months in South Carolina.

He was particularly moved by the "graceful and beautiful" song "I Know Moon-Rise":

I know moon-rise, I know star-rise,
  Lay dis body down.
I walk in de moonlight, I walk in de starlight,
  To lay dis body down.
I'll walk in de graveyard, I'll walk through de graveyard,
  To lay dis body down.
I'll lie in de grave and stretch out my arms;
  Lay dis body down.
I go to de judgment in de evenin' of de day,
  When I lay dis body down;
And my soul and your soul will meet in de day
  When I lay dis body down.

"What ages of exhaustion these four words contain," Higginson marveled at the repetition of "lay dis body down." "Rivers of tears might be shed over them."

This was not idle talk; Higginson knew real artistry when he saw it. In addition to his abolitionist exploits, he was one of the most prominent literary men in America. He had studied French with Longfellow at Harvard and would later serve as poetry editor of *The Nation* for twenty-five years. Earlier in 1862, not long before he took command in the Sea Islands, a young woman from Amherst named Emily Dickinson had sent him, unsolicited, a few of her poems; recognizing their merit, he wrote back and kept up a correspondence with her for the next two decades. After her death, her family gave her poems to Higginson, who arranged for their first publication — today probably his chief claim to fame.

He lasted only a few months in South Carolina. He

was wounded in an upriver raid in July 1863, spent a month recovering in Massachusetts, and then contracted malaria soon after his return. Back in New England, Higginson started writing articles about his experience for the *Atlantic*, which were eventually collected in 1870, along with some of his journals and letters, in his book, *Army Life in a Black Regiment*. One of the articles, which appeared in June 1867, discussed "Negro Spirituals." Higginson included the lyrics to three dozen songs as well as an account of how the songs were composed, which he had learned on a boat ride from Beaufort to Lady's Island. His oarsman recalled a time when he had started a new song while carrying loads of rice. "De nigger-driver, he keep a-callin' on us," the oarsman explained. "Den I made a sing, just puttin' a word, and den anudder word." His song was called "The Driver." When he started singing it there on the boat, the other black men quickly caught the tune and joined in for the chorus even though they had never heard it before. The spontaneous composition showed how individual improvisation worked in concert with a vast reservoir of communal culture.

Like McKim, Higginson speculated about the role the songs — and religion more generally — played in slave culture. One thing that had surprised him a great deal in the Sea Islands was that while slavery struck him as even more brutal than he had imagined, the enslaved people themselves did not seem to be brutalized by it. He wondered for a while about this paradox, and eventually solved it with the songs he had heard. "They were a stimulus to courage and a tie to heaven," he believed. "By these they could sing themselves, as had their fathers before them, out of the contemplation of their own low estate, into the sublime scenery of the Apocalypse. There is no parallel instance of an oppressed race thus

sustained by the religious sentiment alone." Now that slavery was gone, he wrote, "history cannot afford to lose this portion of its record."

By chance, there had been a historian in the Sea Islands with Higginson, and he was also interested in the songs. His name was William Francis Allen, and he arrived in November 1863. A Massachusetts abolitionist, he was sent by the New England Freedmen's Aid Society, tasked with teaching one hundred fifty freedpeople spread across three plantations on St. Helena Island. He had studied philology and classics at Harvard and ancient history at Göttingen; after the war, he ended up at the University of Wisconsin, where he became a mentor to the great American historian Frederick Jackson Turner, who always considered Allen the finest scholar he ever met. Like McKim, Allen was also an enthusiastic amateur musician who could sing by sight and play flute and piano. Walking through the woods one day in South Carolina, for example, he heard a bird singing a trill of notes that reminded him of Beethoven's Sixth Symphony.

Allen's reactions to the slave south mirrored those of McKim and Higginson. He was struck above all by the humanity of the people he met. Abolitionist rhetoric often emphasized the degrading aspects of slavery, but Allen discovered that the freedpeople were "much, very much, less degraded than I expected." For him, that threw the evil of slavery into even sharper relief. "They seem human beings, neither more nor less," he wrote after a few days in the Sea Islands. "It seems trite and common-place to say so, but I must say that the wickedness of slavery never seemed so clear as

when I saw these people (about 240 on this plantation), so entirely human as they appear, and considered how they have been treated, and how little reason there is that they should be selected from all mankind for this awful abuse."

Throughout his eight-month stay, Allen remained impressed by the lack of degradation (a word he used often) among the former slaves he encountered, even as he learned more about the abuse they had endured. He was staying on what had previously been John Fripp's thousand-acre plantation, where he taught school in the big house. Among the formerly enslaved people still living there, Fripp had a reputation as a "kind master." "Still," Allen wrote, "the whipping-post stands within twenty feet of the school-room window (which used to be the drawing room) — a sprawling Asia-berry tree, leafless now and completely covered with long gray moss. It looks weird enough. Mrs. F. used to stand at the window to see the flogging." Among other masters, even less "kind," there were tales of "putting a hot poker in a girl's mouth, and sprinkling red pepper in her eyes."

In addition to stories of brutal punishments, Allen recorded everything he saw and heard: the arrangement of the Quarters, the location of the slave cemetery, the provisions the slaves had received (a peck of corn a week; some meat and eight yards of cloth twice a year). Trained in philology, he also paid attention to the grammar and the vocabulary of the local dialect. "It is really worthwhile as a study in linguistics," he wrote after a few weeks. He kept gathering examples during the rest of his stay, and at the end of the war he wrote an article "to put them on record" before they vanished in the changed conditions of freedom.

Above all, Allen recorded the songs. He arrived in the Sea Islands late enough that he was already primed to appreciate

**The Sorrow Songs**

slave music. A few months before his trip, he read an article called "Under the Palmetto," by the Unitarian minister Henry George Spaulding, which included some song lyrics and melodies that Spaulding had encountered during his own trip to Port Royal. Allen had started to sing some of the songs at home on his own. He first heard the singing for himself on the Sunday after his arrival, standing outside a packed Praise House in the Quarters. All he heard at first was a standard hymn, "Old Hundred," but it was the style of singing that truly fascinated him, with the song "maintained throughout by one voice or another, but curiously varied at every note, so as to form an intricate intertwining of harmonious sounds." He added, "no description I have read conveys any notion of it." He started to copy down all the lyrics and tunes he could.

Allen went back to Massachusetts in the summer of 1864, then returned to South Carolina at the end of the war to serve as assistant superintendent of schools in Charleston. That summer, he started to write dispatches on conditions in the South for a new magazine called *The Nation*, which Lucy McKim's father, James, had just cofounded as a venue for antislavery writers to discuss the problems facing the country after the war. The McKims probably had a hand in ensuring that the magazine's first literary editor would be Wendell Phillips Garrison, Lucy's fiancé; once he had this steady job, he and Lucy were married on December 6, 1865, the same day the Thirteenth Amendment was ratified.

Lucy had been living in the North since 1862, but she remained marked by her brief stay in the Sea Islands. Sometime in the first year of her marriage, she seems to have suggested to Wendell the idea of publishing a book-length collection of slave songs. Serious planning was under way by December

1866, and they began to reach out to contributors in early 1867. They knew of Allen from his articles for *The Nation* and quickly got him on board; Allen then brought on his younger cousin Charles Ware, who had collected more than four dozen songs in the Sea Islands during his time there.

The core team for the collection was now in place: Lucy had come up with the idea, Ware was contributing many of the songs, and Allen took over much of the editing in the spring of 1867, when Lucy gave birth to her first child. Allen was teaching in New Jersey at the time, by chance at the same abolitionist academy that Lucy had attended a decade before, and he often traveled to New York to work on the book with Lucy and Wendell. He drafted the introduction in May, before he headed west to start work at the University of Wisconsin. The editors also got in touch with Higginson, who sent them his own collection of lyrics (which he was preparing for publication in the *Atlantic*) as well as a host of observations and insights. The book was ready by late summer.

## II

Published in November 1867, *Slave Songs of the United States* was the first book on slave music in America as well as the first book on African American culture and perhaps even the first book-length collection of American folksongs of any kind. Among its 136 songs were beloved tunes such as "Michael Row the Boat Ashore" and "The Good Old Way":

> As I went down in de valley to pray,
> Studying about dat good old way,
> When you shall wear de starry crown,
> Good Lord, show me de way.

In his meticulous introduction, Allen laid out four reasons (besides sheer beauty) why such songs were worth saving and studying. The first was that they revealed something about slave life. The content of the spirituals illustrated "the feelings, opinions and habits of the slaves," Allen wrote, as well as their customs and their attitudes toward religion — though Allen himself did not probe very far in that direction. The songs could even provide evidence about the patterns of slave labor, he noted, since the tempo of the songs always depended on the activity they accompanied: what kind of work, what pace of work, and so forth.

The songs also raised the question of what ingredients had gone into the making of slave culture in the South. This was Allen's second reason for paying special attention to the tunes and the lyrics of freed slaves. The central question — which later recurred again and again in studies of slave culture — was how much consisted of so-called survivals from Africa, how much was adopted or adapted from white Americans, and how much was the spontaneous product of slave life itself. Culture is always the product of both inheritance and experience, but in this case the question was fraught with considerable ideological weight that often influenced people's answers. Before the war, slavery's defenders had argued that slavery operated as a means of education for a barbarous black race, gradually replacing African superstition with American civilization. In a more negative light, some antislavery authors saw the Middle Passage and the process of enslavement as splintering experiences that stripped Africans of their heritage, making them "a mass of broken fragments, thrown to and fro," as one black writer put it before the war.

Now there was new evidence — and a new perspective. To James Miller McKim, for example, some songs and

dances that he saw in the Sea Islands seemed like "a remnant of African worship." Higginson suggested, based on his conversations with some old Sea Islanders, that the phrase "mighty Myo" in the song "My Army Cross Over" might be an African term meaning "the river of death." "In the Cameroon dialect," he noted, "'Mawa' signifies 'to die.'" For his part, Allen — making use of his classical training — speculated soon after his arrival in the Sea Islands that one song might be "of African origin, with Christianity engrafted upon it just as it was upon the ancient Roman ritual." He stuck to a similar interpretation in his introduction to *Slave Songs* a few years later, though with a somewhat heavier emphasis on white American influences. "The chief part of the negro music is *civilized* in its character," he decided — "partly composed under the influence of association with the whites, partly actually imitated from their music." Yet he added that there always remained "a distinct tinge of their native Africa" somewhere in the mix.

There had clearly been some sort of cultural exchange between whites and blacks under the slave system. One interesting aspect of that exchange was that it had not operated evenly across the South. This was the third reason Allen gave for collecting slave songs: to see how and where slave culture shifted in form. Close attention to variations in different versions of the songs showed that slave culture actually consisted of several related regional cultures that shared broad characteristics but differed in the details — differences that the editors chose to highlight by grouping the songs they had collected by place of origin: southeastern seaboard, northern seaboard (North Carolina to Delaware), inland, and Gulf Coast. "The songs from Virginia are the most wild and strange," Allen noted. He and the others even noticed

variations from one plantation to the next, and specified the exact source whenever possible.

Finally, the fourth reason to collect and to study the songs was that they were rapidly disappearing under the new conditions of freedom. Already in 1867, Allen said, it was becoming hard to find unaltered slave songs. Some black Americans regarded emancipation as a new start to their story, with slavery as a shameful prehistory that they did not wish to revisit, and some freedpeople, especially upwardly mobile ones, associated the songs so strongly with enslavement that they had no desire to sing them anymore. The music of slavery seemed not in keeping with "the sense of dignity that has come with freedom," as Allen put it.

But much broader forces of cultural change, such as education, urbanization, and modernization, were also at work. Abolitionist teachers across the South were among the culprits in this cultural loss, since they sometimes considered the old songs barbarous and often introduced new songs in their classrooms as part of their effort to Christianize and civilize. "Even the 'spirituals' are going out of use on the plantations," Allen lamented, "superseded by the new style of religious music" that conformed to white standards.

This suggests one reason why *Slave Songs of the United States* ended up as a false start in the formal study of slave culture: at the time, the prevailing view of culture was closer to a ladder than to a buffet. Slave culture, no matter how interesting or affecting, was still seen as something primitive to be overcome on the path to civilization. From the perspective of the twenty-first century, *Slave Songs* was a landmark book, the only attempt

of its kind to preserve the songs with as few modifications as possible. Yet Allen, Ware, and Lucy McKim Garrison's careful work of collection and interpretation was not seen at the time as a contribution to American historical scholarship or the study of slavery — or to anything, really. Lucy and Wendell wrote an unsigned review in *The Nation* (one of the perks of being an editor) and arranged for several others, but more popular magazines such as *Harper's* and the *Atlantic* ignored the book. After a reprint in 1871, it was promptly forgotten for more than fifty years. Even then it would take yet another fifty years for many academic scholars to begin to study the songs as Allen had studied them, as both a form of art and a part of American life. As it took shape across the twentieth century, the academic study of slave culture eventually broadened to examine an astonishingly wide range of practices and customs, but it is worth continuing to focus on the study of the songs, especially the spirituals, because they have usually been regarded as the emblematic case.

Lucy, the driving force behind *Slave Songs*, soon saw her health decline. After suffering two strokes, she fell into a coma and died in May 1877, at the age of thirty-four, leaving behind her husband and three young children. A few years later Wendell Garrison sent a packet with some of the publication correspondence for *Slave Songs* to the Cornell University library, thinking that the letters might be of interest to some future scholar. They were deposited in the archive, in a collection about freedmen.

In the meantime, music programs at black colleges helped keep the slave songs alive, preserving them through practice and performance. Fisk University in Nashville led the way. Starting in 1871 at Henry Ward Beecher's Brooklyn church, Fisk's Jubilee Singers made a name for themselves and raised

quite a bit of money for their school by performing shiny renditions of old spirituals in concert halls and cathedrals across the United States and Europe. Over the next generation, students and professors at Fisk, Hampton, and Tuskegee started some efforts to collect, sing, and study African American folk music.

But this activity lay outside the mainstream of American slavery scholarship, which took a different path as Reconstruction unfolded. At first veteran combatants continued to spar over slavery's role in causing the war, with former Confederates such as Vice President Alexander Stephens writing tendentious Platonic dialogues saying that slavery was just a sideline in the South's noble stand for constitutional liberty, while old abolitionists such as Henry Wilson, Grant's vice president, spun out mammoth volumes showing the centrality of slavery to prewar American politics. Soon a new generation of "scientific" historians at a new breed of research universities attempted to demonstrate their objectivity by draining slavery of its political and moral baggage and tracing its evolution in the legal code. This paralleled developments in the Supreme Court, which narrowed what counted as slavery to a legal definition that did not include social discrimination or economic deprivation.

In this environment, slave culture was relegated for a while to the realm of *Uncle Remus* — a book that William Francis Allen took the time to review upon its publication in 1881, calling it "a contribution from a new and almost unworked field." Over the next decade, as the egalitarian advances of Reconstruction stalled and were rolled back, the new regime of segregation found its justification, in part, in the nostalgic rehabilitation of the old plantation as a place peopled by supposedly happy slaves and their benevolent masters. Even

an old abolitionist such as Thomas Wentworth Higginson was reduced to tears by Thomas Nelson Page's sentimental plantation story "Marse Chan."

This spirit of nostalgia also informed new scholarship on slavery, particularly among progressive southerners who saw in the old plantation a model of both racial and industrial relations. In 1918, in *American Negro Slavery*, by far the most influential scholarly book on slavery written between Reconstruction and the civil rights movement, Ulrich Bonnell Phillips portrayed plantation life as essentially jolly. "On the whole," he wrote, "the fiddle, the banjo and the bones were not seldom in requisition." One of the few songs that he quoted, and one of the few examples of sadness that he cited, involved slaves weeping because their beloved master had died: "Down in de cawn fiel' / Hear dat mo'nful soun'; / All de darkies am aweepin', / Massa's in de col', col' ground." Phillips believed that the plantation had been a benevolent institution, similar to a school or a settlement house, serving to civilize a supposedly barbarous black race.

Throughout this period, slave culture, and black culture more generally, was often regarded with condescension. The American exhibition at the World's Fair of 1893 contained no contributions from black culture, and neither did the fair's Concert of Folk Songs, put on by the International Folk-Lore Congress. "Excepting some selections representative of the music of our North American Indians," declared one representative in his introductory address, "the utterances of the savage peoples were omitted, these being hardly developed to the point at which they might be called music." Yet by the time *Slave Songs of the United States* was reprinted again in 1929, this was no longer the case, as the rise of a new generation of black scholars and artists collided with the new disciplines

of cultural anthropology and folklore studies to make slave culture the subject of serious academic and artistic attention.

The first and deepest student of the slave songs in this new era was W. E. B. Du Bois, who arrived at Fisk University as a seventeen-year-old sophomore in September 1885, walking in the shadow of the grand Jubilee Hall built with money earned by the school's famous singers. Du Bois went on to get a second bachelor's degree at Harvard, did graduate work in historical economics and sociology in Germany, and — when the white administrators of the agency funding his education made the petty decision not to renew his grant — returned to Harvard to become, in 1895, the first black American to receive a doctorate in history. A few years later, he sharply criticized the way American scholars had studied slavery to that point:

> The slaves are generally treated as one inert change-
> less mass, and most studies of slavery apparently have
> no conception of a social evolution and development
> among them. The slave code of a state is given, the
> progress of anti-slavery sentiment, the economic results
> of the system and the general influence of man on
> master are studied, but of the slave himself, of his group
> life and social institutions, of remaining traces of his
> African tribal life, of his amusements, his conversion to
> Christianity, his acquiring of the English tongue—in
> fine of his whole reaction against his environment, of all
> this we hear little or nothing, and would apparently
> be expected to believe that the Negro arose from the
> dead in 1863.

By that time, Du Bois had been hired by Atlanta University to continue and expand the school's annual series of studies on Negro problems, which had started in 1896. With Du Bois in charge, the studies quickly moved to the leading edge of empirical sociological research in the United States, with annual conferences attracting activists and scholars including Jane Addams, Florence Kelley, and Harvard president Charles William Eliot. The topic changed each year, cycling through issues such as education, business, the church, and the family.

Du Bois believed it was impossible to understand the present problems and the future prospects of the Negro "without knowing his history in slavery," so his Atlanta University Studies included some of the only analyses of slave society and culture that existed at the time. His descriptions of slave culture could sometimes take a distinctly negative tone, both because he believed in relatively strict Victorian notions of morality and because he saw black social and economic inequality in his own time as rooted in the lingering effects of slavery (then just a generation past). He even stretched his historical studies back to Africa so that he could give a full account of how customs and institutions changed across the wrenching transitions of the middle passage and emancipation. "There is a distinct nexus between Africa and America which, though broken and perverted, is nevertheless not to be neglected by the careful student," he explained.

In 1903, in the midst of this scholarly activity, Du Bois published an odd but moving collection of essays, simultaneously lyrical and empirical, called *The Souls of Black Folk*. At the head of all but one of the essays, he paired a few lines of European poetry with a few bars from a Negro spiritual, placing the two forms on an equal cultural level. The one exception was the final essay, where the European poetry was

replaced by lines from the spiritual "I Know Moon-Rise," the same song that Higginson had praised so highly some forty years earlier. (Du Bois seems to have known of Higginson's article and Lucy's arrangements, but not of *Slave Songs of the United States*.)

Du Bois sketched an account of the songs' historical evolution — one that doubled as an account of American culture itself. In the beginning, he wrote, was primitive African music, of the kind sung by his great-great-grandmother, seized by a Dutch trader some two hundred years before:

Do ba-na co-ba ge-ne me, ge-ne me!
Ben d'nu-li, nu-li, nu-li, nu-li, ben d'le.

Du Bois no longer knew what it meant, but it had been passed down through his family all the same. The next stage of development was one he called "Afro-American," with songs "of undoubted Negro origin" and "peculiarly characteristic of the slave." Among these he listed "Nobody Knows the Trouble I've Seen" and "Swing Low, Sweet Chariot." The third stage started to show the influence of white American culture. The result remained "distinctively Negro," Du Bois noted, as in the songs "Bright Sparkles" and "I Hope My Mother Will Be There," but "the elements are both Negro and Caucasian." Finally, he identified a fourth step of cultural evolution in the rise of white American songs that were influenced by black melodies, as in "Swanee River" and "Old Black Joe."

"What are these songs, and what do they mean?" he asked. Against the popular plantation myth of the time, which deployed slave songs as evidence of happiness and contentment, he declared (as Higginson, Allen, Ware, and Lucy McKim Garrison had decades earlier) that they were in fact

"sorrow songs." "They are the music of an unhappy people, of the children of disappointment," he wrote; "they tell of death and suffering and unvoiced longing toward a truer world." At the same time, he saw in them a breath of hope, "a faith in the ultimate justice of things . . . that sometime, somewhere, men will judge men by their souls and not by their skins." Yet with black political rights being rolled back and a regime of racial segregation rising all around him, he could not help but wonder, "Is such a hope justified? Do the Sorrow Songs ring true?"

## III

In 1910, Du Bois resigned from Atlanta University. He was frustrated by his inability to attract funding for his work, especially after his public break with Booker T. Washington earlier in the decade. He moved to New York and took a job as director of publicity and research for the newly established NAACP. As he shifted from scholarship to activism, the study of slave culture proceeded along two separate paths in his wake, one anthropological, the other sociological. Both disciplines were in the process of emerging into their modern forms — anthropology from an older racialist ethnology, sociology from a haze of social Darwinist theorizing — and they took on the study of slave culture in part to prove their value in analyzing contemporary social problems.

In anthropology, the central figure was Franz Boas, a Jew from Germany who had come to believe in the 1880s and 1890s that racial differences had environmental rather than genetic causes, and that the primary causes of racial inequality were prejudice and discrimination. He and Du Bois spoke the same language, and soon became allies. In 1906, Du Bois invited Boas, by that time on the faculty at Columbia, to come to the Atlanta University conference on "The Health and Physique of the

Negro-American." Boas discussed the cultural basis of racial behavior, and while there he also gave the school's commencement address, in which he praised the genius of African cultures. "I was too astonished to speak," Du Bois later recalled. He had never heard someone talk about Africa in that way.

Boas saw the study of folklore as a way to demonstrate racial equality, since a sympathetic understanding of a people's folklore could go a long way toward explaining their thought and behavior as a result of culture and society rather than genetics. He helped to found the American Folk-Lore Society and had a hand in directing its journal until the 1930s. From the start, the *Journal of American Folk-Lore* planned to devote fully one-quarter of its space to black folklore. The trouble was that most anthropologists and scholarly collectors lived in the North, while most black Americans — some ninety percent at the time — lived in the South. Boas and his colleague William Wells Newell had some success with collectors based at southern black colleges, but that sputtered after a few years, in part because Boas had many demands on his attention and in part because he was simultaneously pushing for the professionalization of the field, a cause that cut against the use of amateur collectors.

240 Everything changed with World War I. The war accelerated the rise of a mass national culture, symbolized most prominently by radio and movies, which by its very nature threatened the survival of various ethnic and regional cultures — even as new technologies made it possible (though still difficult) to record the actual sounds and songs before they died out. Simultaneously, the war fostered a feeling of nationalism, including cultural nationalism, in whose warm glow America's threatened ethnic and regional cultures were now seen as authentic and worthy of preservation. And the war undermined easy ideas about civilization and progress, opening

even greater space for these non-dominant cultures to be seen in a positive light. (It is worth noting that none of this was unique to the United States, as, for example, the modernist primitivism of artists such as Gauguin and Picasso demonstrates.)

Perhaps most important for the study of black folklore in particular, the war increased the demand for industrial labor at the same time as it cut off the supply of immigrant workers, thus inaugurating the decades-long Great Migration of millions of black Americans from the South to northern and western cities. This had a huge number of ramifications for American society, one of which was the rise of the "race problem" as a national (rather than primarily southern) issue for the first time since Reconstruction. A range of new social scientific funding organizations suddenly became interested in pouring money into research about black life. At the same time, conveniently, the migration also solved the old problem of the distance between northern anthropologists and southern blacks. Now all Boas and his students had to do was walk down the hill from Morningside Heights to Harlem. With the help of a wealthy white anthropologist named Elsie Clews Parsons, Boas made a renewed push to collect and publish black folklore. Starting in 1917, fourteen single-topic "Negro Numbers" of the *Journal of American Folk-Lore* appeared over the next twenty years.

During these years, Boas' ideas gained prominence among some academics as well as black intellectuals and activists, in part because Du Bois gave them space in *The Crisis*, the NAACP's journal. The collection of black folklore was central to the Harlem Renaissance, serving as a symbol and source of cultural pride. In 1922, the black poet James Weldon Johnson edited an anthology of Negro poetry, which he hoped would raise the status of black Americans by demonstrating their artistry. He

noted that the slave songs contained flashes of "real, primitive poetry" and could be counted among the American Negro's handful of truly important artistic creations (along with the Uncle Remus stories, the cakewalk dance, and ragtime music).

Three years later Johnson edited a full volume of Negro spirituals, which he soon followed with a second volume. He celebrated efforts by black Americans to preserve and promote the spirituals instead of neglecting them as unwanted reminders of slavery. "This reawakening of the Negro to the value and beauty of the Spirituals was the beginning of an entirely new phase of race consciousness," he wrote. It was akin to the rediscovery of the classics in late medieval European culture, which also led to a cultural and intellectual renaissance. In 1925, Alain Locke's influential anthology *The New Negro* included an entire section on folklore, called "The Negro Digs Up His Past," as well as a separate essay by Locke focused specifically on the spirituals. By the time Allen, Ware, and Lucy McKim Garrison's *Slave Songs* collection was reprinted in 1929, studies of black folk music were tumbling out of American presses.

242

Still, Boas' ideas about race and culture remained marginal in American society until Nazism discredited "scientific" racism starting in the late 1930s. With genetic explanations of racial difference collapsing, what could explain the apparent inferiority of black Americans? The most influential answer came from sociology, where the study of slave culture had proceeded for several decades along a somewhat separate track — one that descended from Booker T. Washington instead of W. E. B. Du Bois.

In sociology, the central figure was Robert Park. A white man who grew up in Minnesota, Park took an extraordinarily circuitous route to becoming perhaps the most influential sociologist in America, a route that included studying philosophy with John Dewey as an undergraduate at the University of Michigan in the 1880s, a decade-long career as a newspaper reporter (which he regarded as his true sociological training), stints in graduate school at Harvard and Germany (in philosophy and psychology), a few years as publicity agent for the Congo Reform Association, and finally a position doing similar work for Booker T. Washington at Tuskegee, where he started in 1905 (after Du Bois turned down the job). A firm believer in industrial education for black Americans, Washington sometimes seemed to join the chorus of plantation nostalgists in viewing slavery as a necessary precursor to his own work. In 1901, in his autobiography *Up from Slavery,* which became one of the central racial statements of the age, he observed that

> when we rid ourselves of prejudice, or racial feeling,
> and look facts in the face, we must acknowledge that,
> notwithstanding the cruelty and moral wrong of
> slavery, the ten million Negroes inhabiting this country,
> who themselves or whose ancestors went through the
> school of American slavery, are in a stronger and more
> hopeful condition, materially, intellectually, morally,
> and religiously, than is true of an equal number of black
> people in any other portion of the globe.

Park absorbed much of Washington's worldview as he worked for the next eight years as Washington's ghostwriter, publicist, and bulldog, building up Tuskegee and tearing down its rivals, including Du Bois.

**The Sorrow Songs**

By 1913, Park was ready for a change, and he seized an offer from the University of Chicago's sociology department, then one of the top two departments in the country, to start teaching a course on "The Negro in America." Soon he published his first major article, "Racial Assimilation in Secondary Groups with Particular Reference to the Negro," which grew out of his time at Tuskegee. "Slavery has been, historically, the usual method by which peoples have been incorporated into alien groups," he wrote. "When a member of an alien race is adopted into the family as a servant, or as a slave, and particularly when that status is made hereditary, as it was in the case of the Negro after his importation to America, assimilation followed rapidly and as a matter of course." Park went on to have an extraordinarily influential career at Chicago over the next two decades, making the school practically synonymous with sociology in America. Among other things, he trained a generation of important black sociologists such as Charles S. Johnson and E. Franklin Frazier, both of whom did vital work in the 1930s collecting the testimony of formerly enslaved black southerners (in Johnson's case) and studying the structure and evolution of the black family in slavery and freedom (in Frazier's).

While some anthropologists, particularly Boas' student Melville Herskovits, saw evidence of cultural diffusion in the African diaspora, Park did not. He subscribed to the more common view at the time, which was that the middle passage had acted as a kind of cultural holocaust. In 1919, in an essay called "The Conflict and Fusion of Cultures with Special Reference to the Negro," Park declared that "there is every reason to believe, it seems to me, that the Negro, when he landed in the United States, left behind him almost everything but his dark complexion and his tropical temper-

ament." In this view, with freshly imported slaves as blank slates, slave culture could not be either an original production or an adaptation of African traditions to American conditions, but only an imperfect copy of white American culture as filtered through "the racial temperament of the Negro" and the strain of slavery. This was, indeed, the prevailing interpretation of slave songs at the time, as scholars looked at the lyrics, saw similarities to some white hymns, and assumed the line of influence must have flowed in only one direction.

This view of slave culture may not have allowed much room for African influences or black cultural creativity, but with the collapse of scientific racism in the late 1930s and 1940s, it proved useful as a framework for combating segregation. Slavery had stripped black people of their African culture, the argument implicitly went, so now, with no cultural baggage to hold them back, the only things preventing their full assimilation into American society were prejudice and discrimination.

For roughly a full generation, liberal scholars pushed hard on the "damage" thesis to demonstrate all the ways that slavery and segregation had left black Americans as mere husks of humanity. It was apparent, for example, in the Swedish sociologist Gunnar Myrdal's mammoth study of American race relations, *An American Dilemma*, which appeared in 1944, and for which several of Park's former students, including Franklin Frazier, served as researchers. "In practically all its divergences," Myrdal famously wrote, "American Negro culture is not something independent of general American culture. It is a distorted development, or a pathological condition, of the general American culture." Another member of Myrdal's team, the psychologist Kenneth Clark, went on to do doll studies showing that segregation caused black children

to associate white dolls with being pretty or nice and black dolls with being bad or ugly.

This work was successful. In 1954, Chief Justice Earl Warren cited Clark, Frazier, and Myrdal to help justify ending school segregation in *Brown v. Board of Education.* Over the next few years, the "damage" thesis made its way into two important new books on slavery as historians joined the crusade against segregation. Kenneth Stampp's *The Peculiar Institution* came first, in 1956. Determined to use slave testimony to overturn Ulrich Phillips' plantation idyll, Stampp ended up portraying slave life in a pitiful light. His chapter on slave culture, tellingly titled "Between Two Cultures," emphasized the slaves' lack of "cultural autonomy." Not only had slaves "lost the bulk of their African heritage," Stampp argued, but they "were prevented from sharing in much of the best of southern white culture," resulting in a "culturally rootless people." "In slavery," he went on, "the Negro existed in a kind of cultural void. He lived in a twilight zone between two ways of life and was unable to obtain from either many of the attributes which distinguish man from beast." Stampp allowed that slave songs and folklore were important exceptions, but the overall picture was almost irredeemably bleak.

A few years later, Stanley Elkins took out the "almost." Using insights about the supposedly "closed" nature of North American slavery along with psychological studies of "infantilization" among Nazi concentration camp inmates, he set out to show that "Sambo," the lazy, childish slave of southern lore, was not a stereotype but rather a fact — the natural product of the American slave system. Elkins thought this was the only explanation for how the "native resourcefulness and vitality" of West African culture, as

described by anthropologists such as Herskovits, somehow degenerated "to such a point of utter stultification in America." Slave songs and folklore, which may have complicated that assessment, did not enter into his analysis. The fantasy lives of slaves, he noted in passing, were "limited to catfish and watermelons."

Arguments about the damage inflicted on slaves and its lingering effects on black Americans crested in 1965, at the same moment as the civil rights movement achieved its major legislative goals. That spring, Daniel Patrick Moynihan, then the assistant secretary of labor, drew on Elkins' work as he prepared a report for Lyndon Johnson's administration about the problems facing black families and the need for a wide range of federal programs to support them. Moynihan also drafted a speech that Johnson delivered in June at Howard University, which was intended to outline the rationale for the policies that Moynihan's report proposed. "Much of the Negro community is buried under a blanket of history and circumstance," Johnson declared, urging federal action to undo the damage. But this did not work out as planned. Moynihan's report was unfairly pilloried for a relentlessly negative view of black society and culture (probably a tactic to persuade politicians — Moynihan was motivated by a deep sympathy for his subjects), and instead of paving the way to new programs it ended up serving as a convenient marker for the death of a view of slave culture defined by "damage" and the rise of new studies interested in exploring the varieties of black resistance and cultural vitality under slavery.

## IV

By that time, two or three decades' worth of scholarship had emphasized the damage wrought by slavery and segregation,

portraying black culture as little more than an incomplete or pathological version of white American culture. A generation of black activists and intellectuals — Ralph Ellison was usually quoted as the emblematic example — was getting tired of this paternalistic attitude, of seeing mostly white scholars and politicians run their culture down and tell them what to do. Some of them began to assert (partly out of fear, partly out of faith) that there was, in fact, a distinctive black culture worth preserving and even celebrating — that, as the new civil rights legislation broke down the formal barriers of segregation that had kept black Americans apart, they could not and would not simply be assimilated as undifferentiated Americans. The experience of the civil rights movement itself bore this out, buoyed as it was by black leaders, black churches, and black songs, including spirituals.

Meanwhile, thanks to the GI Bill, the vast expansion of American higher education after World War II, and the simultaneous decline in racial and ethnic (and gender) barriers to access and employment, there were suddenly whole new groups of people writing and teaching and studying history, and they brought with them their own experiences, questions, and concerns. Not only black scholars but also the scholarly sons and daughters of Jewish and Italian immigrants might have some interest in, and insight into, processes of oppression and acculturation. And, finally, there arose at precisely that moment a "new sensibility" (as Susan Sontag put it) among educated Americans which collapsed old cultural distinctions between high and low. Pop cultural productions such as rock music and folk music and movies, previously disdained or dismissed, became worthy of serious analysis and explication. It became possible to study pop, folk, and other non-mandarin cultural expressions in a way

that was critical and historical, not just anthropological or sociological.

The result of all this was an explosion of slave culture studies throughout the 1970s. The black scholar Sterling Stuckey forecast the shift in 1968 in an essay called "Through the Prism of Folklore": "No study of the institutional aspects of American slavery can be complete, nor can the larger dimensions of slave personality and style be adequately explored, as long as historians continue to avoid that realm in which, as DuBois has said, 'the soul of the black slave spoke to man.'" Over the next decade, this basic idea guided several different scholars who pursued it mostly independently and who sometimes felt as if they were discovering the source material for the first time: John Blassingame's *The Slave Community* (1972), George Rawick's From *Sundown to Sunup* (1972), Eugene Genovese's *Roll, Jordan, Roll* (1974), Herbert Gutman's *The Black Family in Slavery and Freedom* (1977), Lawrence Levine's *Black Culture and Black Consciousness* (1978). Though they varied quite a bit (especially Genovese), they were all intended to demonstrate the strength of the community and culture that enslaved people forged largely on their own. (At the same time, Dena Epstein's *Sinful Tunes and Spirituals* became the first book to look closely at Allen, Ware, and Lucy McKim Garrison's collaboration on *Slave Songs of the United States*; among other sources, Epstein consulted the correspondence that Wendell Garrison deposited at Cornell after Lucy's death.)

To understand this wave of slave culture studies, Levine's case is instructive. Born to Orthodox Jewish immigrants in Washington Heights, he attended City College of New York in the 1950s.

He later said his familiarity with the cultural inheritance of the shtetl and the ghetto helped him more easily grasp the nature of black folk beliefs, but he also thought that anyone who did the necessary work to enter deeply into that cultural world could have seen the same thing. After getting his PhD at Columbia and taking a job at Berkeley in 1962, he joined the local branch of CORE. He worked on fair housing and picketed stores that did not hire black employees. In the spring of 1965, he and Kenneth Stampp served as the department's representatives to the Selma-to-Montgomery march; they happened to spend the night in Tuskegee, of all places, on the way from Atlanta to Selma. Back in Berkeley, Levine had a research sabbatical the next academic year and used it to start a project on *Black Protest in Twentieth-Century America* — essentially a long history of the civil rights movement.

At first Levine was reading only about the leaders, not the masses of people who made protests and movements possible. Like many other historians working on similar topics at the time, he looked at the previous generation of scholarship, saw that black people had "been rendered historically inarticulate by scholars," as he put it, and set out to fix that problem. Dipping into anthropology, he realized that folklore and folksongs might provide a point of entry. Soon they took over his whole project as he realized that black folk culture (like all culture) was essentially a form of philosophy. "In their varied forms of oral expression," he wrote, "they thought about who they were, what their situation was, how it could be changed, and how best to teach their children how to survive without succumbing to the forces that had them in their grasp." The way he interpreted black culture and slave culture would undermine the views of Park, Myrdal, and Elkins — and even of Kenneth Stampp, who "was not amused by it," Levine

recalled, when his young colleague showed him a draft.

Levine recognized that culture was not a fixed thing but a process, one in which it was possible to trace African folkways interacting with the Euro-American world to forge a new African American perspective. This was most clearly apparent in the songs, which Levine worked on first, presenting a paper about them at the American Historical Association conference in 1969 (he was given a whole session to himself) and publishing it in an edited collection two years later. "It is to the spirituals that historians must look to comprehend the antebellum slaves' world view," he wrote, "for it was in the spirituals that slaves found a medium which resembled in many crucial ways the cosmology they had brought with them from Africa and afforded them the possibility of both adapting to and transcending their situation."

Yet he threw the whole origins question overboard as ultimately irrelevant. Where the cultural forms came from was less important, he said, than what people did with them. He carefully worked out how songs were created and re-created through improvisational group sessions in which pre-existing lines were mixed together with new tunes and lyrics, and how that process balanced "individual release" with "communal solidarity," and how slaves tweaked the Christian doctrines they had learned from their white masters and preachers to fit their own needs. Like Du Bois and Allen, Ware, and Lucy McKim Garrison before him, he believed the songs expressed deep sorrow but were relieved by an abiding hope. He concluded:

> Slave music, slave religion, slave folk beliefs — the entire sacred world of the black slaves — created the necessary space between the slaves and their owners and were

the means of preventing legal slavery from becoming spiritual slavery. In addition to the world of the masters which slaves inhabited and accommodated to, as they had to, they created and maintained a world apart which they shared with each other and which remained their own domain, free of control of those who ruled the earth.

In many ways, the culture studies of the 1970s laid the foundation for the next few decades of research about slavery, at least in the sense that slave culture became indispensable to any attempt to analyze the institution. Instead of establishing only that slave culture existed, however, the main questions shifted to how that culture changed across time and space as well as how it developed in a complicated dance with the surrounding culture of slaveowners and other whites, with mutual influences in both directions. The essentialist assumptions that lurked in the background of some of the major studies of the 1970s, which occasionally implied that there was a distinctively "black" family or culture and treated origins in slavery as the measure of authenticity, faded in those years of relative optimism about race relations. More recently, as that optimism has waned in the face of ongoing discrimination and injustice, essentialism has seen a resurgence among authors who posit unique racial inheritances and forms of knowledge, eternally separate but equal. Meanwhile, slave culture, at least in the form of songs, has receded a bit into the background as scholars, black and white, concern themselves with issues that are either overwhelmingly macro in scale (imperialism, capitalism) or extremely micro (reconstructing the experiences of a single enslaved person from traces in the archive).

One major exception is a big recent book by David Hackett Fischer called *African Founders: How Enslaved People*

*Expanded American Freedom.* Calling his study an "inquiry into what happened when Africans and Europeans came to North America, and the growth of race slavery collided with expansive ideas of freedom and liberty and rule of law," Fischer goes region by region to trace how specific clusters of Africans (and their cultures) interacted with specific clusters of Europeans (and their cultures) to make something new. In New England, for example, Akan-speaking groups brought an ethical philosophy of doing good and doing well, which dovetailed with New England Puritanism to create what Fischer calls a "new syncretist ethic" focused on expanding rights through petitions for freedom, schooling, and the right to vote; in the Chesapeake, people such as Frederick Douglass and Harriet Tubman built on a regional tradition of leadership exemplified by George Washington and Thomas Jefferson to push for freedom for all.

Some of the conclusions can feel a bit pat, but on the whole Fischer's book is effective, thanks to the wealth of detail that he includes along the way to show exactly how specific peoples and cultures mixed. At the very end he borrows from Du Bois, who, more than a century earlier, concluded his own essay on "The Sorrow Songs" with a list of "three gifts" that Africans brought to America "and mingled them with yours": gifts of story and song, of sweat and brawn, and of the Spirit. Fischer adapts and expands the list for his purposes, but it includes a gift of language, a gift of music, and a gift of spirit and soul — gifts that culminate, for him, in the spirituals. He quotes several of them, including "Nobody knows the trouble I've had / Nobody knows but Jesus" and "I want to climb up Jacob's ladder, / But I can't climb it till I make my peace with the Lord." He also cites William Francis Allen, Charles Ware, and Lucy McKim Garrison's *Slave Songs of the United States.* "In

**The Sorrow Songs**

a large literature," he writes, their book, now more than one hundred fifty years old, remains "the most important work" on the subject.

What lessons does the long history of the study of slave culture hold for us today, especially for those who are not professional historians of slavery?

First, the history of the study of slavery in America is in many ways the intellectual history of America. It is not only recently that we have reckoned with slavery. Not at all. We have been reckoning with it from the beginning. Slavery first became a major problem in American life around the Revolution, and Americans have continued to wrestle with the nature of slavery and freedom ever since — not to mention all the other issues connected with slavery, such as race and labor, agriculture and industry, culture and conquest, opportunity and inequality. Not only has thought about slavery reflected the changing contours of American intellectual life, but in many cases it has shaped those contours, as founding figures in various scholarly disciplines — Boas in anthropology and Park in sociology, but also Herbert Baxter Adams in history, Francis Lieber in political science, and plenty of others — saw slavery and its legacies as central problems that their field would have to puzzle out in order to prove its worth.

The story of slave studies suggests also that older scholarship is valuable. Despite their avowed interest in the past, historians tend to dwell on recent work when it comes to our own field. This may be because we believe in history as a progressive science, or because we want to be a part of the conversation, or simply because we (like most humans) are

attracted to things that are shiny and new. We often think of older scholarship as incomplete or incompetent or biased — all of which is true, to be sure, but no more true of scholars in 1822 or 1922 than in 2022. It is precisely because those older scholars had a different view of the world and of history that they can help cure us of our habit of following the herd in writing about all the faddish varieties of historical capitalism or whatever other topic is now academic catechism. Moreover, although historians often think of near-contemporary accounts as blind to their full situation, those accounts can be penetrating and revealing because their sense of the stakes, and of the constellation of relevant questions, is second nature, in the same way that near-contemporary translations often capture something about a book that later translators miss.

We can also intuit from the study of slave culture something about the way culture works. All culture — slave culture, certainly, but also abolitionist culture, academic culture, American culture — is syncretic, variegated, improvisational, combining influences in ways both obvious and subtle as it wends its way through history. As many early writers recognized, slave songs were a complex combination of African inheritance and American experience, and slaves shaped their owners just as surely as owners shaped their slaves. Whether as an act of description or prescription, it is always false to say that any culture is closed or isolated or pure. (And it can lead to hideous politics.)

The most stirring lesson of slave studies, certainly, is that no group or individual lacks some kind of cultural autonomy. Victims are always more than their victimization; people are defined more by what they do than by what is done to them. Inner resistance is possible against even the most obscene oppression. Our contemporary obsession with trauma

sometimes threatens to turn us into a catalogue of everything that has been done to us and to our ancestors, just as abolitionists sometimes made slaves into nothing more than a catalogue of the brutalities that they had suffered. But the skill for coping knows no racial or historical boundaries. The true subject of slave studies is human resilience. Slave songs were one of the ways of coping, as Higginson and his abolitionist friends learned in the Sea Islands, but they were also something more. They were evidence of undefeated spirits. That they continue to resonate with us today is a testament to the power of the people who first sang them in slavery — and, perhaps, to the universal need we all feel, at one time or another, for the good Lord to show us the way.

# LEORA BATNITZKY

# *The* **Holocaustum** *of Edith Stein*

Edith Stein, a soulful modern thinker, was murdered in
Auschwitz in August 1942. Born to a Jewish family in 1891, she
was baptized into the Catholic faith on New Year's Day 1922.
In October 1933, she began the process of becoming a Carmel-
ite nun, in which capacity she would take the name Teresa
Benedicta of the Cross. Pope John Paul II beatified Sister Teresa
Benedicta of the Cross on May 1, 1987 and eleven years later, on
October 11, 1998, he canonized her. One year later he declared
Saint Teresa Benedicta a patron saint of the European Union.

Despite her conversion, or perhaps she would have said
by way of her conversion, Stein continued to see herself as a

Jew. On Easter in 1933, with a deep foreboding of the tragedies to come, Stein, as she described it, "spoke with the Savior to tell him that I realized it was his Cross that was now being laid upon the Jewish people, that the few who understood this had the responsibility of carrying it in the name of all, and that I myself was willing to do this, if he would only show me how. I left the service with the inner conviction that I had been heard, but uncertain as ever as to what 'carrying the Cross' would mean for me." In his homily on the occasion of her canonization, John Paul II described Stein and her beatification as opening "a new encounter with her God of Abraham, Isaac and Jacob, the Father of our Lord Jesus Christ." He further prayed that "her witness [would] constantly strengthen the bridge of mutual understanding between Jews and Christians."

In the thirty-five years since he uttered these words, John Paul's vision has not come to pass. After the Nazi genocide, in the wake of catastrophic Jewish suffering, the Church's canonization of an apostate Jew who was murdered in Auschwitz felt to many Jews as if the Church was pouring salt onto the wounds of historical Jewish persecution. This was made all the worse when, in 1984, Carmelite nuns, with the support of the Vatican, established a convent at Auschwitz in Stein's honor. The Polish Church described the convent as "the sacred sign of love, peace, and reconciliation which will testify to the victorious power of Jesus." International outrage ensued, and a ferocious controversy, with the Vatican agreeing five years later to move the convent, though the re-location did not happen until 1993, after further protests.

For many Catholics, Stein remains not just an exemplar of Christian life and death, but also a symbol of the hybridity of human identity. When declaring Stein a patron saint of the European Union, John Paul II expanded his earlier character-

ization of her as a "bridge between her Jewish roots and her commitment to Christ" to "a banner of respect, tolerance and acceptance which invites all men and women to understand and appreciate each other, transcending their ethnic, cultural and religious differences in order to form a truly fraternal society," which was symbolized by the European Union. In more academic contexts, Stein is often depicted as epitomizing the fluidity of identity as well as the human capacity for self-creation. In both religious and scholarly circles, many have pointed to Stein's philosophical work on the problem of empathy, completed under the tutelage of Edmund Husserl, the founder of phenomenology, as an example of life imitating art. Stein's ostensible hybridity is taken as evidence of her arguments about empathy, and vice versa.

But the thought, the life, and the afterlife of this extraordinary woman are more complex than these triumphalist stories might suggest. She was without question a decent, honorable, brilliant, and intellectually honest person who, by all accounts, exemplified kindness and care for others. Stein was indeed ready and willing to be sacrificed along with her people. But precisely in the context of anticipating their annihilation, Stein also criticized Jews for over-valuing life in general, and their own lives in particular. She saw herself as a prophet, writing in 1930 of "the urgency of my own *Holocaustum*," and she believed that the fate of the Jewish people in the hands of the Nazis was, as she put it, "atonement for their disbelief." Stein exhibited a fascinating combination of supreme confidence, some might say arrogance, and humility. In a meditation that she wrote in the last year of her life, she cast herself as a new Queen Esther, who had returned to history to save her people for a second time. But as opposed to the Esther of the Bible, who saved Jewish lives, Stein returned to

the world to usher Jews to "the final battle" that would at last bring them to Christ and thereby bring Christ's return. The new Esther and the old Esther had different notions of Jewish salvation.

So too, ironically, if not tragically, the divergent Catholic and Jewish interpretations of Stein's life and death point not to an empathetic loosening of rigid identities, but to a failure of empathy on all sides, and perhaps even to the reality of persistently fixed identities. Far from bridging Jewish and Christian identities in the service of Jewish-Christian dialogue, Edith Stein's real contribution to Jewish-Christian dialogue is the challenge for each side to recognize the deep, perhaps insurmountable, chasm that lies between Judaism and Christianity, a chasm of which Stein seemed at times unaware while at other times all too aware.

These larger questions of the nature of personal identity and the specificity of religious identity make thinking about Stein's life and philosophy more urgent in our time. It is simply not possible to rest with a singular judgment of Stein. She reminds us that moral exemplarity does not exist without its own ambiguities, and that one can only claim otherwise by discounting the fragility of being human.

It is important to begin by acknowledging Stein's courageous solidarity with the plight of Jews in the darkest hour of their suffering. This is especially true when recalling others of Jewish descent who at this cataclysmic historical juncture not only denied their Jewishness but took the Nazi genocide of European Jewry as an opportunity to denounce Judaism and a persecuted people. Here the contrast between Edith Stein and

Simone Weil could not be starker. Weil, also a brilliant thinker, lost her teaching post in 1940 because of a statute issued by the Vichy government denying rights to those of Jewish descent. Her response was to write a groveling letter to the minister of education stating that "mine is the Christian, French, Greek tradition. The Hebraic tradition is alien to me, and no Statute can make it otherwise." Although she is often described by her admirers as a "saint" because of her self-mortifying concern for the suffering of others, Weil did not hesitate at this time to declare stingingly that "Israel" is "repulsive" and the "Great Beast of religion," adding that "[a] pharisee is someone who is virtuous out of obedience to the Great Beast." Seven years earlier, Stein had also lost her teaching job after the Nazis seized power in Germany in 1933. Her response was to write an autobiography, *Life in a Jewish Family*, whose purpose was to counter the Nazi's "horrendous caricature" of the Jews and to depict for the German nation the "goodness of heart, understanding, [and] warm empathy" of Jewish individuals and families that she had known growing up in a Jewish family. In April 1933, she wrote a letter to Pope Pius XI begging for a response to the Nazis from the Catholic Church. As she pointed out, "Everything that happened and continues to happen on a daily basis originates with a government that calls itself 'Christian.'... Isn't the effort to destroy Jewish blood an abuse of the holiest humanity of our Savior, of the most blessed Virgin and the apostles?" Stein noted in her diary in 1938 that she knew that her letter had been received by the pope, but she never received a reply.

It is precisely because of Stein's human decency that Jewish outrage at Stein's canonization has felt so painful for all involved. In its narrowest form, Jewish and Catholic discord over Stein's legacy hinges on whether it was appropriate or even honest for the Church to declare Stein a

Christian martyr. Stein was initially considered for beatification as a "confessor," that is, on the basis of how she lived an exemplary Christian life and not on the grounds of how she died. Church doctrine requires verification of two miracles attributed to a "confessor"; but no miracles were in evidence. For this reason, the case for Stein's beatification changed course by proclaiming Stein not a Christian wonder-worker but a Christian martyr, which clearly implies that she died in Auschwitz because of her Christian faith. As an historical matter, this is plainly false. Following a Nazi order for the deportation of all of Holland's Jews, Stein, along with her sister Rosa, who had been inspired by Edith to convert to Catholicism, were taken by the SS on August 2, 1942 from the Dutch Carmelite Monastery in Echt. By the following week, according to an official document provided by the Red Cross of the Netherlands, Edith and Rosa had been murdered in Auschwitz "for reasons of race, and specifically because of Jewish descent."

The motivations for the Vatican's alacrity in beatifying Stein as a Christian martyr — instead of waiting for confirmation of miracles associated with her, as often is the practice in cases for beatification — remains a topic of heated speculation. Other questions have been raised about the miracle that ultimately qualified Stein for canonization after beatification. In 1987, a two-and-half-year-old American child, Benedicta McCarthy, who had been named for Stein, swallowed what amounted to sixteen lethal doses of Tylenol and went into a coma. Her parents prayed to Stein for little Benedicta's recovery. When she did recover, her doctor, Ronald Kleinman of Massachusetts General Hospital, while noting that children did often recover from such overdoses, commented: "I'm saying it was miraculous. I'm Jewish. I don't believe per se in

miracles, but I can say I didn't expect her to recover." Referring to the fact that Kleinman was Jewish, Reverend Kieran Kavanaugh, who was involved in investigating this miracle, remarked that "Dr. Kleinman's willingness to give testimony and witness, to me that was a miracle itself."

Even if one believes — correctly, I think — that in beatifying and then canonizing Stein the Vatican was not seeking directly to promote Jewish conversion, it is difficult not to conclude that the rush to beatify her was, at least in part, an attempt to burnish a terribly tarnished Catholicism after the Holocaust and the Church's neutrality if not complicity in the Nazi genocide. In 1990, for his book *Making Saints: How the Catholic Church Determines Who Becomes a Saint, Who Doesn't, and Why*, Kenneth Woodward interviewed Father Ambrose Eszer, the German Dominican who pushed for Stein's beatification as a martyr for her faith. Eszer insisted that "Today, many Jewish writers don't admit that the Catholics did anything for the Jews. But I know that in the case of Edith Stein she was killed because the Catholic Church did something to the Jews." A decade later, in *Papal Sin*, Garry Wills elaborated that Eszer was referring to what came to be the Vatican's argument that Stein was a Christian martyr and not a Jewish one. When, in 1942, Catholic bishops joined Protestant ministers in opposing the deportation of Dutch Jews, they emphasized that they were especially concerned about the deportation of baptized Jews. The Nazis agreed not to include baptized Jews so long as the bishops and ministers would not protest the deportation of all others of Jewish descent. While most appeared ready to accept this deal, the bishop of Utrecht urged his parishes to continue to criticize Nazi deportations. Apparently this led the Nazis to revoke the special dispensation for baptized Jews, and it was in this context that Stein and her sister were sent to Auschwitz.

**The *Holocaustum* of Edith Stein**

Eszer, along with the Vatican, believed that this provided causal evidence that Stein was martyred for her Christian faith. In light of historical reality, this reasoning is a stretch.

While Eszer's, and ultimately the Vatican's, characterization of Stein's Christian faith as the historical cause of her murder may seem dubious at best, the truth is that its tone deafness is a common feature of the majority of Catholic — and Jewish — responses to Stein's beatification and canonization. Consider this statement by the Jewish historian Arthur Hertzberg about Stein's death: "As she inhaled the Zyklon B in the gas chamber, did Edith Stein really think she was dying as a sacrifice for the Church?" Hertzberg's remark suggests that he did not grasp the genuineness of Edith Stein's theological conviction that she could die *as a Jew* as a sacrifice for the Church. For Stein, this was not a contradiction, as she continually insisted that, in her words to her Jesuit confessor Father Hirschmann, shortly before her death, "You don't know what it means to me to be a daughter of the chosen people — to belong to Christ, not only spiritually but according to the flesh." Indeed, in 1939, three years before she died, Stein included the following in a handwritten will: "I ask the Lord to accept my life and death...for the expiation of the unbelief of the Jewish people and so that the Lord may be welcomed by his own people and his kingdom come in majesty."

Although she made these statements before she, or anyone else, knew of the depths of the genocidal horrors to come, Stein was making what is for many people, and especially Jews, a deeply disturbing and very old Christian claim that Jewish unbelief in Christ is responsible for Jewish suffering. Stein was a supersessionist, meaning that she believed, as most Christians historically have believed, that the Church replaced, or superseded, the synagogue, just as the New Testament

replaced the Old. Yet Hertzberg's anger is stirred not by the intricacies of Jewish and Christian theological disputation, but rather by an all-too-typical Jewish obtuseness to the very possibility of Christian faith. The willful obliviousness of most Jewish responses to Stein's canonization stems not from the psychological pain that some may feel about the Church glorifying an apostate Jew who was murdered in Auschwitz, which is certainly understandable, but from the refusal to conceive of the possibility that Stein could have genuinely believed herself to be a Jew who would die for Christ. Jews, moreover, allow for the possibility of conversion to Judaism, and they regard the transformation as so complete that one is legally forbidden to mention a convert's prior life to her. The integrity of Edith Stein's conversion must be respected. She was no longer "ours."

Such obtuseness is matched only by the Church's tone-deafness to Jews and Judaism, which stems not from what is surely an internal Catholic decision about whether Stein should be counted as a Catholic saint, but rather from the assumption that canonizing Stein would be good news to Jews and improve relations between Jews and Catholics. Debates about whether Stein died as a Christian martyr or Jewish martyr, or even only as an apostate Jew who had converted to Christianity, are symptoms of a larger problem, which concerns the possibility of understanding or even experiencing perspectives other than our own. This was precisely the philosophical question — the question of empathy — that consumed Edith Stein in her academic work prior to her conversion to Catholicism in 1922.

Born to an observant Jewish family on Yom Kippur in 1891 in Breslau, Stein was the youngest of seven children. When Edith was two years old, her father died suddenly, leaving her mother to run the family lumber company, which with her at the helm became a thriving and prosperous business. By all accounts (including her own), Stein was an extremely bright and hard-working student who, along with her sister Erna, became one of the first women to be admitted to the university in Breslau. In her second year studying psychology, Stein encountered Edmund Husserl's *Logical Investigations,* which had appeared in 1900 and 1901 and quickly became one of the most important works in modern philosophy. Stein chose to spend the summer reading Husserl and, in 1913, set out to Göttingen to study with him. With the outbreak of the First World War, she returned to Breslau and joined the Red Cross, serving in 1915 as a nurse in an Austrian hospital for infectious diseases. In the meantime, Husserl, whose son was killed in Flanders during the war, had received a professorship in Freiburg. After finishing her work for the Red Cross, Stein joined him there, completed her dissertation on *The Problem of Empathy in its Historical Development and in Phenomenological Consideration* (translated into English as *On the Problem of Empathy*), and received her doctorate summa cum laude in 1916. Stein stayed on working for Husserl as his private assistant.

What can we know with certainty? Is knowledge outside our own experience possible? Whether we can know or experience perspectives other than our own is an old philosophical problem, often associated with skepticism about the existence of other minds or even about the existence of a world external to ourselves. With his famous "I think therefore I am," Descartes gave modern expression to this problem when, in search of certain knowledge, he system-

atically doubted his senses, his ability to differentiate between reality and dreams, and even the external world, the imagining of which, he argued, could be the product of some evil genius. But what Descartes could not doubt was his own doubting — that is, his thinking. Descartes also believed that he found a way to reason himself away from skepticism by arguing that infinity, a mathematical concept, is one that neither he nor anyone else could have come up with had God not implanted this idea in his mind. Infinity leads the way to an argument for the existence of God, which leads to an affirmation of both the external world and the possibility of certain knowledge.

While Descartes is thought of as a rationalist because he grounds knowledge in concepts of the mind, the opposing early modern school of philosophy known as empiricism, which insisted that the mind, in Locke's words, is a "blank slate" and that knowledge comes from our senses, also grappled with the difficulty of knowing anything or anyone outside of our own minds. The empiricist critique culminated in Hume's sharp distinction between the information which derives from our senses and that which derives from human imagination, which imposes order and continuity not only onto the external world but also onto a stable self. Hume came to doubt even Descartes' thinking "I." The self, Hume skeptically concluded, is not a stable entity, but only "a succession of parts, connected together by resemblance, contiguity, or causation."

Neither the rationalist nor the empiricist approach seemed able to refute the other, which led Kant to worry deeply about the very possibility of knowledge at all. Kant sought to defeat this skepticism by arguing that, in his famous statement, "thoughts without contents are empty; intuitions without concepts are blind," meaning that the empiricists and rationalists are both right: we need sense experience ("contents") and

we need mental concepts, such as causality, because human experience and human knowledge simply are not conceivable without both. This brings us back to Descartes. Kant argued that he solved Descartes quest for certainty of the external world (for which Descartes had required God) by showing that any conception of an "I" requires time. It is because I can track my experiences of myself over time that I am able to consider myself an "I" in the first place. Time also confirms the reality of objects external to the mind, which are necessarily experienced and conceived spatially. Time and space, then, are what Kant calls the pure forms of sensible intuition, and human experience and cognition are simply impossible without them.

Kant derives the pure forms of sensible intuition on the basis of what he termed a transcendental argument. This is a kind of logical argument about what is required for human experience to be possible in the first place. The first question is not, what do we know?, but more fundamentally, what is it possible for us to know? This Kantian innovation is important for understanding Edith Stein's work on empathy and beyond, for three reasons. First, there is the price of Kant's "transcendental idealism," which allows us to rest easy knowing that there is an external world and that knowledge of the external world is possible, but comes at the cost of knowing what Kant calls a "thing in itself." While Kant thought he had proven that there are objects in the world outside of our minds, he also concluded we can never know these objects as they intrinsically are, because our knowledge of them is always filtered through the mind's sensible forms and categories. All post-Kantian philosophy would grapple with this problem in one way or another. Second, even if he succeeded in establishing objects outside of the individual's mind, Kant had little interest in the problem of other minds, what

is often referred to now as "intersubjectivity." The problem of intersubjectivity would also become a cornerstone of post-Kantian philosophy. And third, Husserl's development of his phenomenological method, which is what attracted Stein to him in the first place, offered a framework for responding to exactly those two problems.

Husserl was born in 1859 to an assimilated Jewish family in Moravia. He converted to Lutheranism in 1886. Jewish conversions to Christianity, and especially to Protestantism as opposed to Catholicism, the dominant religion of the Austrian empire, were rapidly increasing at this time, with some scholars estimating that between 1868 and 1900 Jewish conversion to Christianity increased by as much as eighty percent. Many converted because baptism remained a requirement for most professions, businesses, and governmental employment. But Husserl linked his conversion to Protestantism to a conversion to philosophy: in a letter of 1917, he described the influences "which drove me from mathematics to philosophy, as my vocation may lie in overpowering religious experiences and complete transformations. Indeed, the powerful effect of the New Testament on a twenty-year old gave rise to an impetus to discover the way to God and to a true life through a rigorous philosophical inquiry."

Not that Husserl's philosophy was religious; not at all. Husserl came to equate the true life of rigorous philosophical inquiry with what he called phenomenology, a method for analyzing our experience of ourselves and our observations of the world rooted in the concept of "intentionality," which suggests that an individual's consciousness is not wholly autonomous but always reaching (or intending) towards an object of consciousness: "the I is not thinkable without a not-I to which it intentionally relates." It is the intensity of

the intentional relationship between consciousness and its object, the purity of the focus, that gives the phenomenological attitude an aspect of secular revelation.

Husserl coupled his conception of intentionality with a reevaluation of Hume's account of experience so as to move beyond the problems left in the wake of post-Kantian idealism. The problem with Hume's account of experience, argued Husserl, was that he, like the British empiricists before him, approached experience as the perception of discreet sensations bundled together by the imagination. But, continued Husserl, we do not perceive objects in the world by way of discreet sensual impressions. We perceive them as part of a prior conceptual whole. Perception, argued Husserl, includes processes and events as well as static objects and their relations to each other. If this is correct, we need not worry about Kant's "thing in itself," for experience simply is the givenness of the world.

At the same time, phenomenology could build upon Kant's attempt to provide an account of the underlying conceptual structures of science through transcendental argumentation, which Husserl also projected back onto Descartes' method of doubt. Husserl called this process *epoché*, an ancient Greek philosophical term for the "suspension of judgment." *Epoché* is a meditation on the essential structures of consciousness — a kind of careful distillation of the experience of consciousness. It begins with everyday experience and then attempts to bracket all aspects of the everyday in order to get to the essential structure of the "transcendental ego," which lies hidden beneath the mundane details of life. Here, too, Husserl likens phenomenology to a religious conversion. *Epoché* affects a personal transformation in which the most ordinary and fundamental assumptions about personal identity are

suspended: "I am not *an* ego who still has his *you*, his *we*.... All of mankind, and the whole distinction and ordering of the personal pronouns, has become a phenomenon within my *epoché*." Just as a religious convert reevaluates the mundane world through the prism of the divine, phenomenology reconceives conventional assumptions about personal identity through the prism of the transcendental ego.

The inclusion of "all mankind" with the operation of a single consciousness — the socialization of consciousness — raises a tension that pervades all of Husserl's phenomenology. On the one hand, *epoché*, the procedure of isolating the essential features of consciousness, shows that consciousness always reaches (or intends) toward the consciousness of others. In this sense, the self is always bound up with other selves. On the other hand Husserl insists in some of his later work that the transcendental ego is self-contained and purely subjective and even, following Leibniz, "monadic." This tension lines up with another one that continues to plague (or inspire) Husserl's interpreters: is Husserl a phenomenological realist who ultimately grounds the self in a real world of genuine and embodied others? Or is he a transcendental idealist, since everything seems to come down to the mind of the self-contained, self-conscious subject? This is where Edith Stein and the problem of empathy come in.

Husserl had addressed empathy — *Einfühlung*, or "feeling into" — and characterized it not as a feeling per se, but rather as a "transcendent perception" of a foreign corporeality similar to but also different from one's own. *Einfühlung* differs from *Mitfühlung*, usually translated as "sympathy," or "feeling with," in that the latter preserves a distinction between self and other, while the former suggests a degree of constitutive commonality — we might call it an overlap of being — that makes

possible an entry into the experience of another in which the other's experience becomes my own. Husserl described empathy, the perception of another, as co-originating with a perception of oneself, but he did not clarify much beyond this. Stein's dissertation was an attempt to provide a fuller phenomenological account of empathy. Although she presents her work as merely the ramifications of Husserl's investigations, Stein moves beyond him in further stressing the necessity of other people for self-knowledge. On the subject of empathy, she was a deep and original thinker.

Empathy, according to Stein, provides not just knowledge of another but also knowledge of the self. In making this argument, Stein, following Husserl, disrupts neat distinctions between interiority and exteriority, between self and other. Such divisions stand, for example, at the heart of Mill's conception of sympathy as an analogical relation. Following Locke, Mill argues that it is because of my own inner experiences that I am able to understand the experiences of others: "First, they have bodies like me, which I know in my own case, to be the antecedent condition of feelings; and because, secondly, they exhibit the acts, and outward signs, which in my own case I know by experience to be caused by feelings." When I see someone blush, I can recognize this as an outward sign of their inner state of shame or embarrassment because I have had that same internal experience. Sympathy, in such an account, is a generalization from, a scaling up of, individual experience.

Stein offers two correctives to Mill's account. First, she contends that his characterization of empathy actually makes it impossible, since it begins with a conception of myself as

"imprisoned within the boundaries of my individuality."
Second, phenomenological analysis corrects this problem by
recognizing the constitutive role of bodies in perception and
knowledge: I experience sensations in my body, but I also can
observe these sensations from a third person perspective. This
means that there is not a distinction between inward shame
and the external act of blushing. They are one and the same
and are both anchored in what Stein calls "the continuity of
being." Empathy helps us "obtain the world's second and third
appearance, which are independent of my perception."

Appreciating the link that Stein makes between memory
and empathy makes her argument a bit clearer. Stein distin-
guishes between the act of experiencing and the content of
experience. Both memory and empathy are second-hand
experiences, in that both are the experience of something
that is not happening to me in the moment in which they
are experienced. When I remember something, the content
of a previous experience is experienced not as something
happening to me in the present, but as an experience of
the past. When I empathize, I also experience a "content"
(such as embarrassment or shame), but it is displaced, it is
not happening to me in this moment. In this way, memory
and empathy may be likened to the experience of oneself
as another.

To some extent, it may seem that Stein is still making an
argument from analogy. Just as a memory requires that the act
and content of experience were one and the same for me in
the past, so too empathy seems to necessitate a prior integra-
tion of the act and content of an experience in *my* experi-
ence of *myself*. This might suggest that I can only empathize
with someone if I have had a similar experience of my own.
But this is actually where Stein's theory of empathy gets most

273

interesting. Stein contends that empathy for another does not begin and end with my own experiences. She knows that we certainly can and do misunderstand the experiences of others. Yet for Stein, the possibility of error in empathy speaks to empathy's strength, not its weakness. It is helpful to quote her at some length:

> To consider ourselves in inner perception, i.e., to consider our psychic 'I' and its attributes, means to see ourselves as we see another and as he sees us... Inasmuch as I now interpret it [the other's psychic life] as 'like mine,' I come to consider myself as an object like it.... This is how I get the 'image' the other has of me.... the reiterated emphatic acts in which I comprehend my experience can prove to be in conflict with the primordial experience so that this empathized "interpretation" is exposed as a deception. And, in principle, it is possible for all the interpretations of myself with which I become acquainted to be wrong.... Inner perception contains within it the possibility of deception. Empathy further offers itself to us as a corrective for such deceptions along with further corroboratory or contradictory perceptual acts. It is possible for another to "judge me more accurately" than I judge myself and give me clarity about myself.

At its finest, empathy can be a form of self-correction by way of another's perception of me. In this way Stein arguably saves empathy from accusations that feeling with another is ultimately only self-projection. Indeed, she stresses that far from affirming our perceptions of ourselves, empathy can be an instrument of self-criticism.

As is apparent even from this brief explication, Stein's consideration of empathy is technical but deep in its focus on discrete affective experiences of empathy. There is also something moving, and expressive of her temperament, in her choosing empathy as a subject for close phenomenological investigation. And there is a great irony here: Stein's sophisticated account of empathy foreshadows empathy's failure in the competing Catholic and Jewish arguments about her legacy. Stein concludes her study by arguing that empathy opens the door to "the understanding of spiritual persons." There she writes: "Whenever we come into contact with realms of value that we cannot enter, we become aware of our own deficient value and unworthiness." But in celebrating Stein's hybrid Jewish and Christian identity as a marker of Jewish and Christian reconciliation, Christians have not become aware of their "own deficient value and unworthiness"; instead they have looked at Jews and seen only themselves. And in vehemently denying Stein's hybrid identity and opposing the Church's canonization of Stein, Jews have also not become aware of their "own deficient value and unworthiness," but have looked only within and, not surprisingly, seen only themselves.

Most strikingly, Stein's analysis of empathy also allows us to recognize how the inability to see another can simultaneously be a failure to see ourselves. What is perhaps most notable about the lack of empathy in Jewish and Christian responses to Stein's canonization is their shared inability to recognize how their respective reactions conflict with their own distinct commitments. From an internal Jewish theological perspective, Stein, despite her conversion, was, as she believed, still a Jew, albeit, from a traditional Jewish point of view, a bad one. That Stein was, from the internal

perspective of the Jewish tradition, both Jewish and Christian is the harrowing challenge that Stein, and Stein's alleged synthetic Jewish-Christian identity, puts to Jews. And just as the Jewish response to Stein's life and death is problematic from an internal Jewish point of view, so too the Catholic understanding of Stein's life and death is problematic from an internal Christian theological perspective, if that theological perspective is committed to Jewish-Christian dialogue, which was certainly the case for John Paul II, who more than any other pope devoted himself to the tortured question of Jewish-Christian relations after the Nazi genocide. But if we understand dialogue as a serious exchange between two positions, then the Catholic view of Stein as a Jewish-Christian synthesis essentially silences any distinct Jewish perspective, not just in terms of Stein's self-understanding but in terms of Judaism's distinct point of view as such. That the Church, despite what at times appears to be a valiant struggle to the contrary, cannot overcome its supersessionism — and thereby, arguably, its anti-Judaism — in its continual denial that Judaism has an integrity of its own is the harrowing challenge that Stein, and arguments about Stein's synthetic Jewish-Christian identity, puts to Christians. She remains a test of both faiths, and of the possibility of the moral and psychological self-overcoming that she studied in her inquiry into empathy.

It is important to stress that Stein herself, Sister Teresa Benedicta, fully embraced Christian supersessionism. Her understanding of her Jewishness is predicated on the distinct language of the New Testament. Her statement to her Jesuit

confessor Father Hirschmann — "you don't know what it means to me to be a daughter of the chosen people — to belong to Christ, not only spiritually but according to the flesh" — reflects a particularly Pauline distinction between spirit and flesh. Stein seems to have *Galatians* 5 in mind:

> Walk by the Spirit, and do not gratify the desires of the flesh. For the desires of the flesh are against the Spirit, and the desires of the Spirit are against the flesh;... the fruit of the Spirit is love, joy, peace, patience, kindness, goodness, faithfulness, gentleness, self-control; against such there is no law. And those who belong to Christ Jesus have crucified the flesh with its passions and desires.

Stein's allusion to *Galatians* to describe herself is intimately tied to her view that, in keeping with most (but not all) interpretations of Paul, the problem lies with Jewish clinging to the flesh and denial of the spirit. When she reported that she "spoke with the Savior" on Easter in 1933 and "realized it was his Cross that was now being laid upon the Jewish people," her willingness to carry the cross on behalf of the Jewish people was owed to her view that the Jewish people needed to (finally) recognize that their "desires of the flesh are against the Spirit." Stein believed that Jewish suffering was a direct result of the Jewish refusal to believe in Jesus -— that, theologically understood, the Holocaust was punitive. This was further articulated in her response to Kristallnacht in November, 1938: "That is the cross which falls upon my people. Oh, if only they could see the light! That is the fulfillment of the curse which my people have called upon themselves!"

In her autobiography, Stein again affirms the Pauline distinction between the flesh and the spirit and its corollary

277

belief in the spiritual inferiority of the Jews, who abide only by the flesh. That is, of course, the most ancient Christian canard about the Jews. Referring to the "rather frequent occurrence of suicide among Jews" after Hitler's rise, Stein coldly remarks: "A Jew is able to endure severe hardship and untiring labor coupled with extreme privations for years on end as long as he sees a goal ahead. Deprive him of this goal and you destroy his vigor; life then appears meaningless, and so he can readily decide to throw it away. The true believer, of course, is deterred from such a course by his submission to the will of God." Stein also at times traffics in other anti-Jewish stereotypes. About her friend Eduard Metis, for example, who "had one attribute which set him apart from all my other companions: he was an orthodox and observant Jew," she remarked that she found his "Talmudic sophistry" "repugnant," and described him in the following way:

> He had a delicacy of feeling that might almost be termed maidenly. He was tall and slim; his face, rather thin, was usually slightly flushed; outwardly he gave no indication of being ill, but he suffered a great deal from migraines and many days was unable to work at all. Since I was always in excellent health during my university years, I pitied him for being less robust.

These pronouncements and others suggest that Stein did not see herself as a hybrid after all. Her worldview was Christian through and through; and like many Christians before her and after her, she simply wished that Jesus' own people would see the light.

Stein is clear that, since she was a teenager, Judaism was not a living option for her. She was increasingly attracted to

Christianity during her university years, but it was only after she read Teresa of Avila's autobiography in the summer of 1921 that she decided to convert to Catholicism. As Stein reported, "I picked at random and took out a large volume. It bore the title *The Life of Teresa of Avila*, written by herself. I began to read, was at once captivated, and did not stop until I reached the end. As I closed the book, I said, 'That is the truth.'" While Stein was unaware of this, historical scholarship has since uncovered the fact that the sixteenth-century Spanish saint was of Jewish descent, as her father and grandfather were forced to convert to Catholicism during the Inquisition. And although she did not publicly acknowledge it for obvious political reasons, Teresa was apparently aware of her lineage. It seems safe to assume that Stein would have been heartened to hear this.

Teresa's description of the different stages of grace that are experienced as an increasingly deeper interiority likely resonated with Stein's earlier attraction to Husserl's phenomenology and its practice of *epoché*. Just as bracketing is an attempt to weed out the mundane exteriorities of lived experience in order to get to the transcendental ego's essential structure, prayer for Stein, following Teresa, is a movement from the activity of the world to the passive reception of God's grace, which "is love, and love is goodness giving itself away." While phenomenology is hardly a mystical doctrine, it does proceed by keeping the world away from consciousness so as to isolate from all its distractions an essence of experience and therefore an apprehension of truth. And in keeping with her preference for spirit over flesh, Stein writes: "the work of salvation takes place in obscurity and stillness" and "the soul no longer sees or hears anything, the body no longer feels pain when injured, and in some cases becomes rigid like someone dead. But the soul lives an intensified life as if it were outside

its body." This is somewhat reminiscent of the phenomenological structure of empathy.

Yet despite whatever formal parallels there may be between phenomenology and Teresa's account of prayer, Stein's conversion to Catholicism was not just a movement away from the Judaism of her birth, but also a movement away from Husserl's philosophy, which she came to equate with "the obscure faith of the intellect." In her contribution to a *Festschrift* on the occasion of Husserl's seventieth birthday in 1929, Stein imagined a conversation between Edmund Husserl and Thomas Aquinas. Adopting Thomas' point of view, she contrasts what she calls "Catholic philosophy" to phenomenology. Whereas Husserl's phenomenology is egoistic, idealist, and insists on a divorce between reason and faith, Catholic philosophy is theocentric, realist, and ultimately rejects a distinction between reason and faith. These points taken together may explain why Husserl, in Catholic Austria, was attracted and converted to Protestantism, while Stein, in Protestant Germany, was attracted and converted to Catholicism. Broadly speaking, Husserl's and Stein's differences, as she describes them, map onto Protestant and Catholic differences more generally. Although Husserl likened phenomenology to a religious conversion, he, following Luther, posited an absolute distinction between philosophy, which is fundamentally rational, and faith, which is fundamentally non-rational, if not irrational. Philosophy for Husserl is an approach to "knowing that does not know any revelation or that does not recognize it as an already given fact...[it] is a-theistic." Stein, in contrast, following Thomas, believed that faith rightfully informs philosophy just as philosophy clarifies faith. This is because God's reality infuses all of creation, and not just the inner lives of the faithful. Stein learned this as well from Teresa's autobiography.

Stein saw parallels between her life and Teresa's. In her autobiography, Stein describes herself as a child as introverted, bookish, and detached from life with others in terms similar to Teresa's description of her own early years. Despite the alienation from other people that both Teresa and Stein felt as children, Teresa focuses on her grandmother's pious presence much as Stein focuses on her own mother. Most notably perhaps, Stein shared Teresa's struggle to reconcile her love of her family with her love of God. In a hagiographical essay on Teresa, written in 1934, Stein comments that "after the interior battle came a difficult outer one. In spite of all his piety, Don Alonso [Teresa's father] does not want to be separated from his favorite daughter. All her pleas, and the advocacy of her uncle and siblings, are in vain." In her memoir Stein writes movingly of her deep love for her family and especially her mother. Painful as it was for Stein's mother to accept her conversion, they continued to have a close relationship. But Stein knew that her decision to enter a monastery would be incomprehensible to her mother. And indeed it was. Stein entered the Carmelite monastery in Cologne in 1933. She remained there until the last day of 1938, when, for the sake of the safety of her sisters in Cologne, she found refuge in the monastery in Echt. During her first year in the monastery, Stein's mother did not acknowledge her letters, though she did ultimately resume limited communication with Edith. She died in Breslau in 1936, and was thereby spared the fate of her daughters and other family members.

The relationship between Stein and her mother (as well as her family more broadly) is a testament to the kind of empathy that Stein described in her dissertation, and which Christians and Jews in arguing about her death seem unable to achieve. Once again, in Stein's words: "Whenever we come into contact

with realms of value that we cannot enter, we become aware of our own deficient value and unworthiness." Perhaps Stein learned about the possibility of this kind of empathy from her life in a Jewish family.

After her conversion, however, Stein came to reassess her account of empathy. Whereas her dissertation was premised on her view that human experience alone provided both the fact and the possibility of empathy, Stein now believed that God's intervention was necessary. As she put it in her most mature work of Christian philosophy, *Finite and Eternal Beings*, which appeared in 1936, "many sources of error are...hidden from us so long as God does not, through a genuine interior shock — through a call in the interior — take the bandages, which cover the interior of each human being in a special way, from our eyes." It is hard not to read this reference to God's removal of bandages from our eyes without being reminded of the canonical anti-Jewish image of the blindfolded and broken synagogue, and of Paul's words in *Romans* 11:7: "Israel has not obtained that which it seeks; but the elect have obtained it, and the rest were blinded."

The ambiguities of Stein's moral exemplarity are captured in her extremely Christian belief that God's love begins and ends with the annihilation of Jewish particularity. To be sure, this may seem a surprising conclusion, given how the Church has presented Stein and how the Church has attempted to understand itself after the Nazi genocide. But Stein's Jewishness, as she affirmed again and again, was in the service of the fulfillment of the Christian message, which for her meant sacrificial atonement for Jewish unbelief. (There were other

German Jewish intellectuals, most famously Franz Rosenzweig, who believed that Judaism was a stage on the way to Christianity, though Rosenzweig eventually revised his spiritual itinerary and offered instead a kind of inverted supersessionism in which Christianity is always trying to catch up to Judaism.) She wrote of "the urgency of my own *Holocaustum*" before the Nazi genocide, but the term that she used — which eventually became the name for the genocide itself — neatly captures her theological vision, as well as the starkly divergent Christian and Jewish perspectives on both Stein and the catastrophe. The term comes from the Septuagint's translation of the Hebrew *'olah,* a burnt offering, a sacrifice that is wholly consumed by fire. The word is used in *Leviticus* and in *Samuel* with reference to Temple sacrifices, but it is also used in *Genesis* 22 when God commands Abraham to sacrifice his son Isaac, referred to as Abraham's "only son," as a burnt offering. From a Christian perspective, *Genesis* 22 is a foretelling of God's sacrifice of his only son Jesus. Stein is on strong Christian theological grounds, then, in understanding herself and the Jewish people as a *holocaustum.* But for most, though not all, Jews, and perhaps also for many non-Christians, the horrors of the Nazi genocide make the ascription of any theological meaning to it, any redemptive purpose, perverse and grotesque. It is for this reason that Jews have increasingly referred to the Nazi genocide as the *Shoah*, a Biblical Hebrew word for catastrophe with no theological connotations attached to it.

Edith Stein was willing to pay the ultimate price for her convictions. That in itself is courageous and rare. She started as a Jew and ended as a Christian, and Jews, who themselves believe in the possibility of conversion, should let her go and respect the authenticity of her spiritual experience. Christians,

meanwhile, must teach themselves to revere her while looking askance at the anti-Jewish dogmas that she endorsed. As a philosopher, she has a lesson to teach about the human quality that our society most desperately needs now. And yet Edith Stein's most enduring legacy may be not her doctrine of empathy, but the hard questions about the value and meaning of human life that her life and her thought broached. The questions that she left us are more valuable than the answers.

# HELEN VENDLER

# The New Statue

**Morning Song**

Love set you going like a fat gold watch.
The midwife slapped your footsoles, and your bald cry
Took its place among the elements.

Our voices echo, magnifying your arrival. New statue.
In a drafty museum, your nakedness
Shadows our safety. We stand round blankly as walls.

I'm no more your mother
Than the cloud that distills a mirror to reflect its own slow
Effacement at the wind's hand.

All night your moth-breath
Flickers among the flat pink roses. I wake to listen.
A far sea moves in my ear.

One cry, and I stumble from bed, cow-heavy and floral
In my Victorian nightgown.
Your mouth opens clean as a cat's. The window square

Whitens and swallows its dull stars. And now you try
Your handful of notes;
The clear vowels rise like balloons.

<div align="right">

SYLVIA PLATH
19 FEBRUARY 1961

</div>

When my son was born, I was shocked to realize that among all the poems I knew, hardly any were about a baby or about becoming a mother. For a long time I had been accustomed to find, on almost any occasion of substance, a line of verse rising unbidden to consciousness, unerringly telling me what I was feeling. But the joyous line that had risen spontaneously and immediately at childbirth —"For unto us a child is born, unto us a son is given" — was followed by no others, and an unaccustomed silence lay heavy on my mind with the absence of any resonance between my life and a poem commenting on it.

One of the poems that I did know (remembered from childhood because my mother had quoted it) opened with a putative dialogue between a mother and her newborn baby:

Where did you come from, baby dear?
Out of the everywhere into the here.

I eventually read the poem (by George MacDonald, the Victorian novelist), and while I recognized the wit in the graphic decline of the enormous invisible "every*where*" into the dimin-

ished visible *"here,"* as a whole the fantasy was too sentimental for me:

> Feet, whence did you come, you darling things?
> From the same box as the cherubs' wings.

I flinched at that as I did at Mother's Day cards.

When, as an adult, I read Blake's *Songs of Experience*, I at last found (in "Infant Sorrow") a newborn baby speaking credibly of its own birth-agony. Outraged by its forced eruption from warm amniotic comfort into an unfamiliar and chilling world, and rebelling against both its restrictive swaddling clothes and its father's constraining arms, the helpless baby screams cries unintelligible to the horrified parents, who wonder what demonic force is obscured behind the cloud of their struggling infant's flesh. The exhausted baby, in its first intellectual moment, thinks it best to retreat into a silent sulk:

> My mother groaned! my father wept.
> Into the dangerous world I leapt:
> Helpless, naked, piping loud;
> Like a fiend hid in a cloud.

> Struggling in my father's hands:
> Striving against my swaddling bands:
> Bound and weary I thought best
> To sulk upon my mother's breast.

The poet — imagining the words a terrified newborn might shriek if it had language — exposes the pieties of the usual "baby poem." A fierce empathy with the baby's sufferings at

**The New Statue**

birth prompted Blake's glimpse here into the disillusioned state he called "Experience," while his earlier "Infant Joy" (from the *Songs of Innocence*) screened out the real baby, entering instead into the new mother's projection (onto her actually silent baby) of her own self-absorbed joy. The mother's fantasy that her infant (the Latin *infans* means "unable to speak") begins life by complaining of its lack of a name prompts, with exquisite reciprocity, her own mirroring response: "What shall I call thee?" The baby declares that its name is "Joy," and the mother, completing the circuit of dialogue, utters a blessing: "Sweet joy befall thee!" As the dialogue opens, the baby speaks first:

> I have no name
> I am but two days old.—
> What shall I call thee?
> I happy am
> Joy is my name,—
> Sweet joy befall thee!

The whole second stanza belongs to the mother, as she ecstatically reinforces (with "pretty" and "sweet") the exclusive symbiotic delight of shared harmonic naming-and-echoing. The baby smiles while the joyful mother sings, and her repetition of the sixth line is no longer a wish but a concurrent fact, confirmed by the song, the smile, and the closing period:

> Pretty joy!
> Sweet joy but two days old,
> Sweet joy I call thee;
> Thou dost smile,
> I sing the while
> Sweet joy befall thee.

Liberties

The ecstatic narcissism of this (imagined) dialogue is surreally critiqued by Blake in "Infant Sorrow." The "experienced" mother — disabused of her naive girlish image of a loving dialogue with her child — is groaning in her birth-pains, the father is weeping in alarm, and the baby is furious.

These were to me real poems, confronting both the "innocent" virginal fantasy of purely joyful motherhood and the dark trauma of experience — both equally human, both requiring acknowledgment, both known to any sheltered girl who has become a mother.

And so, when I first saw Sylvia Plath's "Morning Song," her narrative of how a clueless young wife gradually becomes able to love her infant, I felt astonished relief. A modern poet had at last told the story of her gradual initiation into motherhood. As "Morning Song" opens, a couple stand awkwardly around their newborn baby, conceived in love but now an unfamiliar stranger to its parents. Petrified by anxiety into immobile "statues," the couple fear what they may have done in admitting a "new statue" into their uneasy "museum." The house is now merely the curator of its own past, a museum of former selves, unable to conceive of a future with this unfathomable inhabitant. The naked creature intrudes into the scene by making an unfamiliar animal sound, while the parents, in joint unease, echo and magnify, with their adult voices, the infant's inarticulate cry.

Plath's wonderfully unexpected third stanza expresses, in its peculiarly slow and evolving syntax, the mother's gradual perception-by-negatives of her new state: "I'm no more your mother than. ..." The husband and the collective "we" vanish

289

permanently from the scene, leaving the wife, a single "I," to clarify her relation to the child she addresses. Unable as yet to conceive of that relation in human terms, she resorts instead, in the pivot of the poem, to the vague climatic terms of cloud and wind. She progresses haltingly to acknowledge that in giving birth she has signed the warrant for her own eventual death, her literal "*effacement*." The sentence (which at first almost defeats understanding) offers each halting realization slowly, each segment suppressing the realms of animal and vegetable to become purely mineral, each segment answering an unpredictable question that itself stems from the words just uttered and issues in an unpredictable answer generating yet another question:

> "I'm no more your mother than"—
> > than what?
> "than the cloud that"—
> > that does what?
> "distils"—
> > distils what?
> "a mirror to"—
> > to do what?
> "to reflect"—
> > what?
> "its own slow"—
> > slow what?
> "effacement at"—
> > at what?
> "at the wind's"—
> > the wind's what?
> "hand."

As the new mother stumbles along the corridors of this intellectual labyrinth, every expected "natural" foresight in pregnancy of what motherhood has to offer (love, curiosity, nursing, "baby-talk") is subtracted; the self-effacement becomes increasingly inorganic, un-mammalian. The syntax of this tercet, so peculiar and arresting, displays Plath's talent for saying something — "I don't know where this experience is leading me" — without making the statement explicit. It mimics, in its pacing, the experience itself. A comparable thought-process precedes each of Plath's powerful words in this late phase: "What is it in this phenomenon that makes me call it 'drafty'? What makes it a 'museum'?"

The second half of "Morning Song" takes place some weeks later. The baby has been put to bed, and the maternal ritual of the first sleep-deprived months has begun. The new mother, awakened in the middle of the night by the child's demanding cry (so aggressively different from its soft breathing in sleep), hastens to transfer the baby and its noise into another room. There, while she nurses the child in solitude, the day slowly dawns at the windowpane. Plath, by her title inserting the time of day into the poem, is transforming a known genre. The traditional "morning song" — an *aubade*, from the French *aube*, dawn — shows two lovers in bed, regretting the arrival of the sun (as in Donne's "The Sun Rising"). The baby's open-mouthed hunger-cry modulates over time, as it nurses, into musical cooings of satisfaction, repeated like the notes of a melody. In her startled recognition that the small foreign animal in her arms is now emitting not merely sounds but syllables (vowels and consonants linked into the first phonemes, "ma-ma"), the elated young mother comes to feel that in its possession of even rudimentary language, her baby is another human being like herself. Her spirits rise with the baby's rising notes,

**The New Statue**

and the atmosphere becomes one of festivity, with imaginary birthday balloons.

And that is the plot, a relatively bare one (sketched almost a year after Plath's baby was born), of the speaker's gradual transformation from wife into mother. As the poem opens, the wife (with her husband in attendance) is in her bed at home as the baby is born; she feels for the first time the clash between her former idealizing simile of conception and pregnancy (that love had set in motion a "fat gold watch" inaugurating a golden time) — and the jarrings of childbirth, the midwife's slap and a naked cry. The cry is shockingly perceived as repellently "bald," unadorned, featureless, intimidating. The speaker and her husband fuse to a single "we" at the birth-moment against the baby "you." But in the second half of the poem, the wife leaves the marital bed for the nursing of the child; she becomes (and remains) a single "I," and the husband does not reappear. The marital duo has ceded (at least temporarily) to the maternal one.

Plath was a terribly hard-working poet from her teen years on (as evidenced by her technically fully articulated, if still mostly formulaic, juvenilia). Very early, she had formulated a fully conventional idea of a happy life: she would be a gifted and sexual wife to an exceptional and universally admired husband, and would give birth to many babies (always imagined as babies rather than as children). After her marriage, as soon as she was attempting pregnancy, she raced to find independent imaginative forms for that envisaged life, many of them invented to express in both themes and styles a new, rich, and relatively untreated poetic enterprise: motherhood.

A full year before she had her first child, Plath wrote a single-stanza nine-line (for nine-month) poem entitled "Metaphors," comparing (too archly) the pregnant body to a playful set of equivalents. Each of the nine lines of "Metaphors" has nine syllables, presenting ill-assorted and jesting definitions of the swelling body and its ultimate direction. The pregnant first-person speaker is "an elephant, a ponderous house," and, ridiculously, "A melon strolling on two tendrils." The last metaphors initiate pregnancy's dangerous momentum: "I've eaten a bag of green apples, / Boarded the train there's no getting off." Too self-conscious and effortful in its casting around for whimsical metaphors, the poem nonetheless is anticipating more work ahead to illuminate motherhood. Less than two months before her child was born, Plath rewrote "Metaphors" into "You're," doubling its size into two stanzas of nine nine-syllabled lines addressed to her fetus (but with the same disorienting overplus of description). One moment the fetus is "gilled like a fish," at another it becomes "my little loaf," at yet another, it reverts to "our traveled prawn," before ultimately becoming "A clean slate." "Metaphors" and "You're," with their incoherence of imagery and artificiality of tone, cannot become interesting poems. A better poem, "Mushrooms," written halfway through pregnancy, did not attempt an individuated embryo, gilled or baked or traveled: instead, it imagines an undifferentiated chorus of half-formed fetuses masquerading metaphorically as speaking mushrooms. They push up irresistibly through loam to air, uttering in tercets (often an "incomplete" form by comparison to couplets or quatrains), their compact two-beat threats of eventual victory:

Overnight, very
Whitely, discreetly,
Very quietly,

Our toes, our noses
Take hold on the loam,
Acquire the air.

Like fetuses, they require no external feeding: "We //
Diet on water, / On crumbs of shadow." Although they are
initially "meek," they become "nudgers and shovers / In spite
of ourselves," propelled by genetic force:

We shall by morning
Inherit the earth.
Our foot's in the door.

"Mushrooms" convinces on its own terms, not presuming on
the "human" personality or individuality of the fetus, but aware
that it is unstoppable in its arrival.

It will not be surprising to any reader of Plath that her
youthful imagination, long before it was alerted to pregnancy,
had specialized in disastrous outcomes (see her doomsday
poems in the Juvenilia). Now, with a focus not global but
personal, the dooms become biological. The anxiety felt during
pregnancy by any mother is displaced, in "Stillborn," onto the
writing of poems, as Plath, a few months into motherhood,
finds yet another seam opening in possible biological sources
of poetry. But the elegy for the stillborn embodies none of the
grief a mother would feel when her expected child does not
survive. When unsuccessful poems become fetuses in formal-
dehyde, Plath's brittleness offers a derisive grotesquerie:

These poems do not live: it's a sad diagnosis.

. . .

O I cannot understand what happened to them!
They are proper in shape and number and every part
They sit so nicely in the pickling fluid!

Plath never ceased to explore motherhood, in many poems evoking maternal joy even in tragic contexts. Before I return to that joy, it must be conceded that tragedy had the ultimate victory, and so I glance ahead here to her final visual tableau of maternity, "Edge." It opens with a posthumous tomb-sculpture of a mother and two children, but its second tableau softens to recount the slow hemorrhaging of still-living garden flowers. It is austere in its conviction of the conceptual finality of death, but surprisingly lavish in its gradual farewell to the young bodies of the children. As always in her best poems, Plath's investigation of a topic has both intellectual weight and emotional resonance. In "Edge," the objective, intellectually accurate, immobility of marble "motherhood" co-exists with the lamenting heart's mimicry of the gradual dissolution of the body. The chill of the sepulchral group (conveyed in the third person: "The woman is dead") coexists with the weeping sounds of mourning: "odours bleed / From the sweet, deep throats of the night flower." In a bold move, Plath diminishes her multiple dying flowers to a single one, but the single flower, remembering its past companions, bleeds from multiple throats. Motherhood both is (in sculpture) and is not (in life) eternal.

As "Edge" closes, the spectator looks upward and says, of the indifferent moon, that in the long view of history "She is used to this sort of thing." Of course she is; history is one long bloodbath. But Plath being Plath, fact and intellect, compelling

**The New Statue**

as they are, are not allotted the last word of the grave-garden. As the spectator looks up from earth, the moon, humanized, becomes visible as a skeletal hood of bone. But Plath insists on making the moon audible as well, and creates a cold flat music for her witch-cloak: "Her blacks crackle and drag." Plath could not envisage her own death except by making the tomb-sculpture include her children; unless she had her two children with her, she would not be the person she is, but some past self long relinquished. Motherhood is preserved, even after death. "Edge" is an irreproachable poem, but because it memorializes her deathbed self, it belongs thematically with Plath's meditations on death rather than with her poems on living motherhood.

So I turn back here to my central topic — how motherhood allowed Plath to invent a poetics of motherhood — situations, elements, analogies, feelings — and to write sane and joyous poems about and to her children. Although she was never a religious believer, her interest in imaginative emblems of motherhood inevitably led her into the territory of the Christian Nativity myth. The birth of Christ to Mary offered Plath temptations to sharp modern contrasts, of which the most amusing is Plath's playful lyric in which the Magi come to the wrong address. Yeats' magisterial poem "The Magi" might have daunted any successor from appropriating that title, but Plath was bold enough to call her poem, too, "The Magi." Yeats' solemn portrayal of "unsatisfied" Magi compelled to return from Calvary to "The uncontrollable mystery on the bestial floor" is comically repudiated in Plath's re-imagining of the encounter of a baby girl with such would-be male sponsors.

The scholarly Magi, guided by a moving star, journeyed

to greet the Second Person — the Son — of the Holy Trinity of Father, Son, and Holy Spirit. Plath's irony and humorous skepticism mock the idea of wise old men as the best company for a newborn baby. Instead of the biblical gold, frankincense, and myrrh, modern male sponsors in our rational era would bring as gifts to the cradle the Platonic Triad of abstractions: "The Good," "The True," and "The Beautiful." Such philosophical sponsors are a two-dimensional sort of "papery godfolk" who have followed the wrong star to the wrong crib. Because they are looking for a rationalist God, a "lamp-headed Plato," Plath waves them away airily: "What girl ever flourished in such company?" She does not suggest what "company" her baby girl might thrive in. She certainly would need better patrons than the "disquieting Muses" of Plath's own christening, or the star-followers of the Christian story, or the rationalist world's bearers of the Platonic triad. No invented modern benefactors can fill the gaping absence, and Plath's closing flippancy, though memorable, cannot conceal the lack of suitable protective elders for the modern female baby.

It took a miscarriage and almost a full year of living with her first child to enable Plath to write "Morning Song" for her second. It has many virtues: it does not fall into the sterile unlived jokes of "Metaphors" nor into the uneasy repetitions in "You're"; it doesn't impose the Gothic gloom of bottled babies in "Stillborn"; it restrains itself from repeating either reverent biblical mythology or the frustration of Yeats' Magi. Its discipline continues the purity of "Mushrooms," in which, by pluralizing her fetus and reducing it in category from mammal to vegetable, Plath could create an apprehension of threatening organic growth without imposing on her invisible fetus a humanity not yet perceivable. "Morning Song" has the inevitability of birth-momentum — what will happen next once a child

is born — but lets the child remain ungendered and unnamed, only a step — one could say — from its fetus-existence.

"Morning Song" hints immediately at biological momentum: the "new statue" utters a "bald cry" — unlovely, unsettling, and insistent, and the first sign of the mother's response to her child is unnervingly intellectual, non-human, as abstract as wind and cloud. That relation, not yet humanized, has its own ongoing momentum, as distillation effects effacement. Surely this is the most detached portrait of motherhood in literature. Without the strangeness of its first three stanzas, "Morning Song" could not have gained the measured steps into love by which it progresses, never putting a foot wrong in its steady pace.

Just as ontogeny recapitulates phylogeny in "You're" (in which the fetus has gills as it goes about becoming human), so motherhood in "Morning Song" begins its metaphors for the baby in the strange realm of a remote insect-species as the child produces its "moth-breath." (Alliteration at the end of a word rather than the beginning —moth/breath" — although almost invisible, is one sound-connection that often gives Plath's poetry an unusual texture.) At the next level of being, the new statue has now advanced in species from insect to animal, uttering an urgent cry from a mouth like a cat's; the cry produces a companion animal, a "cow-heavy" lactating mother. The mother's swift removal of the child and herself into another room takes a further step — the grounding of the "I" of the mother in a physiological function, nursing, that is impossible to the male. The collective "we" of the couple never returns after the double establishment of the female "I" — first in the abstract terms of "I'm no more your mother" and secondly in the down-to-earth self-description by the young woman: "One cry, and I stumble from bed, cow-heavy." The

298

inalterable momentum of the cosmos (the cloud, the effacing wind) creates the rising dawn that "swallows" the night stars, past selves, as they dull after the irrevocable change of motherhood. The penultimate moment of the poem — in which the child, choosing its "notes," becomes a human creature of intentional melody — arrives prefaced by the traditional "Et iam" remembered from the Latin poets, the "And now" that lifts an ongoing temporal curve into the present. Plath may be remembering Keats' closing of his autumn ode:

> And now
> The redbreast whistles from a garden-croft,
> And gathering swallows twitter in the skies.

The completeness implied in the conventional end-point — "And now" — wraps mother and baby and reader in the ecstatic moment in which the baby becomes human, the mother perceives the first sign of communication, and the reader feels the lift of the mother's imagined balloons.

It was the impeccable constancy of pace that moved me when I first read "Morning Song": everything now on its way, the sequence of phases confident, the ending happy — not triumphant like the victory of those mushroom-invaders, but mutual, intelligible, reassuring. Later, as I saw further into the poem, its shadows troubled me: the permanent vanishing of the husband; the disappearance of the marital "we" in favor of the maternal "I"; the severe apprehension of personal effacement by the very decision to give birth; the permanence of universal natural "elements" of inorganic and organic existence (cloud, wind, birth, cry, nourishment, mind, death) within the swift transience of a single life from birth to the sepulcher; the conceptual incompatibility of abstractions

**The New Statue**

(cloud, mirror, wind) and individuals (mother and infant).

My first emotional and structural responses to "Morning Song" did not yet admit me into Plath's subtlety of sound, her claim on our subliminal response to the phonetic transfusion of the poem even as we gather the plot, the architecture, the pacing, and climax (or climaxes) as we traverse it. I hadn't at first seen that the "moth-breath" was so styled because it reproduced part of the word "mother," or that "mirror" echoed "mother" in rhythm and length as well as in sound. "Midwife," "mother," and "mirror," all trochees (with stressed / unstressed rhythms), fit together as a birth-trinity; the cosmic wind's invisible "hand" condenses itself into the audible "handful" of notes. Even the changes of agent in the closing lines make a container for the reader's sense of closing events. We look in different directions — north, south, east, west — as the human gives way to the non-human: the organic dyad of mother and baby disappears into the inorganic dyad of window and dawn; the organic living body of the child produces the inorganic "notes" and "vowels." Only a very flexible mind can hold in a single instant a whitening window swallowing stars, a baby's proffering of melodic notes, and a mother's vision of phonemic sound-balloons defined by their vowels. The "thickness" of such coalescences gives weight and solidity to Plath's conclusion, bestows on the "new statue" an earned animation, and prompts in the new mother an awakening of love.

Plath's meditations on motherhood continue to deepen, enabling the reach and success of "Parliament Hill Fields," a poem written when Plath suffered a miscarriage less than a year after her daughter Frieda's birth. For the poem, Plath invents a yes-no structure replicating the existence/nonexistence of the fetus as it bleeds out, and replicating the movement of thought

as well, as it returns repeatedly to a trauma. She interrupts her verse-narrative in this way with sad but stoic addresses to the never-to-be-known fetus:

> Your absence is inconspicuous;
> Nobody can tell what I lack.
> . . .

> I suppose it's pointless to think of you at all.
> Already your doll grip lets go.
> . . . .

> Your cry fades like the cry of a gnat.
> I lose sight of you on your blind journey.

> The day empties its images
> Like a cup or a room.

The day discards its hopes as the womb discards its burden. For consolation, Plath reminds herself that she has a living daughter at home, and summons up, as she walks, the glow-in-the-dark picture on the nursery wall. One by one, in her imagination, the objects in the picture begin to reveal their colors, but as Plath tries to install haloed angel-presences, each image collapses into transparent falsity; each "Blue shrub behind the glass // Exhales an indigo nimbus, / A sort of cellophane balloon." She returns home apprehensively: "The old dregs, the old difficulties take me to wife."

It was only a week after that depressed requiem for a miscarriage that Plath turned to the past and wrote "Morning Song" for comfort, but its closing joy took on weight, I believe, through her continuing sorrow over the lost pregnancy. The

instability of her mood is such that two days after writing "Morning Song" (February 19), Plath's mind, meditating on motherhood, raises two unnerving specters: she composes "Barren Woman" (February 21) reflecting her fear of infertility, and its parallel "Heavy Women" (February 26) about disillusion after childbirth. The pregnant women "Smiling to themselves" and "beautifully smug" await birth in an ominous landscape where "the axle of winter / Grinds round, bearing down with the straw, / The star, the wise gray men." "Bearing down," the women will experience grinding tragedy as an inevitable consequence of giving birth.

Plath had thought that her life would offer, as sources of joy, the rich aesthetic stimuli of conception, pregnancy, and motherhood, and after her miscarriage her imagination clung to those stimuli even as suicide (presided over by a funereal yew-tree and a moon "with the O-gape of complete despair") rises into competition with them.

Although it is true that Plath's suicidal depression and the violent poems that it produced won her fame, the tragic evidence of her mental illness has so dominated anthologies that her efforts to record and express joy tend to recede out of sight. Except for "Morning Song," the selections from Plath's poetry in *The Norton Anthology of Poetry* introduce readers solely to the grim Plath, each poem bearing its portrait of ruin:

> "I crawl like an ant in mourning" ("The Colossus");
> "The tulips should be behind bars, like dangerous
>     animals" ("Tulips");
> "I have suffered the atrocity of sunsets" ("Elm");

"If I've killed one man, I've killed two--" ("Daddy");
"The dew that flies / Suicidal," ("Ariel");
"I rise with my red hair / And I eat men like air"
    ("Lady Lazarus").

But as Plath, with her acute ear, completed and disciplined experience into form, the work of analysis permitted her an impersonal joy in creation that inspires even in her tragic poems an inescapable vitality. Even when Plath cannot maintain her joy in motherhood, even when a menacing darkness encroaches upon the child, the initial hope and joy appear and reappear in Plath's lines.

"Nick and the Candlestick" begins in a sunless underground cave, lit by a single candle. We see Plath transform the hellish cave into a place beautiful enough to house her beloved new child, Nicholas. The vowel-sound of the word "love," touch by touch, ("Love, love," "hung," "rugs," "of") decorates the space of the poem, while alliterations ("roses," "rugs," "[Victo-]riana") link the images:

> Love, love,
> I have hung our cave with roses,
> With soft rugs--
>
> The last of Victoriana.

Excoriating "the mercuric / Atoms that cripple," Plath confirms to her son the cosmic new era produced by his birth:

> You are the one
> Solid the spaces lean on, envious.
> You are the baby in the barn.

**The New Statue**

Still, the secularized parallel with the birth of Christ weakens, rather than strengthens, the poem. To demonstrate the inspiration that Plath found when she turned her gaze to motherhood (as well as her anticipatory guilt as she planned her death), there is no better illustration than "Child," where even her hyperboles turn tranquil:

> Your clear eye is the one absolutely beautiful thing.
> I want to fill it with color and ducks,
> The zoo of the new
>
> Whose names you meditate--
> April snowdrop, Indian pipe,
> Little
>
> Stalk without wrinkle,
> Pool in which images
> Should be grand and classical
>
> Not this troublous
> Wringing of hands, this dark
> Ceiling without a star.

Plath could include the joy of "Child" at the same time as she was foretelling her death in "Edge." The longer she lived, the more inextricable the alternate truths became.

There were, and are, many difficulties in inventing poems transmitting the labile emotions surrounding the birth of children. As Plath's efforts suggest, it is hardest of all to attach poems to pregnancy when it is uneventful: while the cells are merely multiplying, no intellectual cause wakes the imagination. When Plath treats only the physiological events, the

poems ("Metaphors," for example) are unfruitful; as soon as there is an emotional event (a miscarriage, say) the poems reach fullness and credibility. Since so much of the biology of fertility is routine, biology alone cannot provide subjects for poems. Lived responses to motherhood — because there is so little access to them in the poetry of the past, and because biology itself seemed fatally governed by that indifferent moon of the impersonal universe — have not been easy to galvanize into poetry. But Plath had courage: even when life seemed meaningless, she actively sought out new genres of childbirth and motherhood (a miscarriage poem, a Thalidomide poem, a posthumous poem).

What medicine had to offer Plath — electroshock, inefficient medications, "talk-therapy" — was too little. (A few years after Plath's death, Robert Lowell began treatment with lithium, which, for all its drawbacks, enabled him to live.) Plath, who studied with Lowell, admitted her debt to his autobiographical *Life Studies*, but their styles distinguished them — his, ever more forcefully adjectival and "plotted," hers, more surreal and fanciful and excited (she had a weakness for exclamation marks, which she vigorously deleted in revision). "To add to the stock of available reality" — R.P. Blackmur's definition of the purpose of art — requires the day-by-day courage to devise an individual style, which issues from a strongly individual sensibility inseparable from a desire to play with language. (Pound defined poetry as "the dance of the intellect among words"). In Plath's *Unabridged Journals*, published in 2000, thirty-seven years after her death, we follow, with pity and confusion, the incessant nightmares and tormenting emotions of an incurable patient hurled hither and yon by episodes of insanity. But from those chaotic journal pages, Plath somehow, by a perfectionism of instinct

**The New Statue**

and intellect, drew her painstaking and commanding map of madness — madness disciplined, made strikingly euphonious, rhythmic, plotted, and controlled.

In the *Journals* during periods of illness, she is baffled, hysterical, malicious, vengeful, paranoid, frightened, self-loathing, and lonely beyond belief; and on the other hand, at her less anguished moments she is boastful, idealistic, hard-working, vain, self-congratulatory, self-sacrificing, resolute, and--in her best and sanest moods — tender, kind, and loving. She had an eye that noticed the smallest details of life, and her poems of motherhood are full of them: who else would say of motherhood (as she does in "Thalidomide"): "All night I carpenter //A space for the thing I am given, /A love // Of two wet eyes and a screech." In her poems of motherhood, her highly-colored lines strive constantly for truth, irony, comedy, and wit before they are bleached out by death.

The paucity of convincing poems about motherhood remains evident. Few people are educated to the level needed to write original verse. (Most of the great English lyrics came from writers who knew several languages, usually including Latin, were beset by imagination, had a keen sense of poetic genres, were delighted by etymology, had read hundreds of fine poems and knew many of those by heart, and possessed an instinctive ear for cadence. The autodidacts — Clare and Blake in England, Whitman and Dickinson in America — taught themselves by reading intensely, not least the Bible and Shakespeare, and often by loving another art, see Whitman on "the trained soprano" and Dickinson on "The fascinating chill that music leaves.") Few women writers become mothers; and too few mothers have the time, energy, money, and talent to write works of genius. Successful women writers have been, for the most part, single, protected, and rich. Too late for the

eras of patronage and too early for reliable birth control, many talented women gave up creative hopes.

Plath did have a patron — a wealthy woman novelist named Olive Higgins Prouty — and she grew up in a house full of books, the child of two teachers. But the familial heritage of depression proved a lethal one. Plath's father Otto refused for four years to be examined or treated for an illness that he insisted was lung cancer but that was actually treatable diabetes; Sylvia, by her own account, felt that she died when her father did, and first attempted suicide (almost successfully) at nineteen, then gassed herself at thirty-one; and her son Nicholas — "the baby in the barn" — after years of depression, hanged himself at forty-seven. The darkness finally defeated, too early, the gifts even of this first adequate and observant poet of motherhood.

# JARED MARCEL POLLEN

# *The Metaphysician-in-Chief*

On February 22, 1990, Vaclav Havel spoke to a joint session of the United States Congress as the newly elected president of a free Czechoslovakia. Just a few months earlier, he had been detained (the last in a long line of arrests) by the StB, his country's infamous secret police; he said he didn't know whether he would be going to jail "for two days or two years." But a mere three weeks later, as the satellites of the Soviet Union began to topple, overwhelming demonstrations throughout the country forced the Communist Party to agree to the first genuine elections since the Soviet-backed coup in 1948. Nearly two months to the day of his last arrest, Havel emerged as the only viable candidate for the

presidency, and was rhapsodically elected on December 29, 1989, with a level of consensus unseen since Washington.

As a playwright, a philosopher, an essayist, and one of the eminent adversaries of his country's regime, Havel initially regarded his election as "an absurd joke." (Philip Roth privately described it as Josef K. making it to the Castle.) And Havel was not the only one: Michael Žantovský (known for his translations of James Baldwin, Norman Mailer, and Joseph Heller) was elected to the Senate; Eda Kriseová (a journalist and short story writer) became one of Havel's key advisors; and Jaroslav Kořán (who helped introduce the works of Henry Miller and Charles Bukowski into the Czech language) was elected the mayor of Prague. Never before or since had so many literary intellectuals found themselves in the house of power. Indeed, at the time of Havel's address in 1990, the reality of Czech politics seemed to be almost the stuff of satire, befitting the sense of irony that had proved such an effective weapon against totalitarianism for nearly half a century.

This showed itself in the language that Havel used in his speech to Congress, in which he spoke in terms that were utterly foreign to American politics and its everlasting anti-intellectualism. He stood before the assembled politicians and declared that "consciousness precedes being" — a line that weirdly received enthusiastic applause. It was classic Havel: the Goethe of government, the Metaphysician-in-Chief, addressing not just the state of the nation, but the state of the soul. I am reminded of the title character in Saul Bellow's *Humboldt's Gift*, who riffs on the candidacy of Adlai Stevenson (an image of Aristotle's "great-souled man"), hoping that he will bring about an administration in which poets will be consulted for foreign policy and cabinet members will cite Joyce in their deliberations.

Havel was frequently referred to as a "Philosopher King," though almost never with the acknowledgement that this is, in fact, a smirking term, an oxymoron that denotes one of the oldest problems in Western thought: the inherent conflict between truth and power. Plato concocted a utopian and essentially satirical (which is not to say unserious) exercise to try to deal with this problem. The conclusion of this exercise was that philosophers were ultimately unfit for power, because the pursuit of truth — which is all too easily corrupted — is imperiled by politics, with its deceptions and duplicities. The joke that closes *The Republic* is that we should sooner expect kings to become philosophers than philosophers to become kings. And this "joke" was precisely the moral and philosophical challenge that confronted Havel the moment he went from being a dissident whose mantra was that one should always strive to "live in truth" to being the first democratically elected president of his country in over four decades.

Before 1989, Havel had lived his life in opposition, in what Hegel called "the labor of the negative." But when this labor suddenly finds itself in the positive — becoming constructive rather than deconstructive — what is the dissident to do? Havel's trajectory broaches the most fundamental questions about morality and power. Is morality enough for governance? Is compromise, which is the heart of democratic politics, an ethical defeat? How much realism can the moral man stomach? Do high ends require equally high means? Were Vaclav Havel's ideas, which he forged as a rebel, compatible with the responsibilities of power? Did they prepare him adequately to rule?

In many ways, Havel's ascension was a real-life dramatization of a tension that had always existed in his thought: the uneasy relationship between an acute sense of irony (what

Czesław Miłosz called "the glory of slaves") and an often impossible moral seriousness. Generally, this is a tension that afflicts the oppressed: the acknowledgement of irony is one of the key resources of the disempowered, whereas the empowered, while fully outfitted with irony, are routinely disabled from acknowledging it. (Irony is incompatible with the solemnity, not to mention the majesty, of office.) Acutely conscious of this, Havel spent much of his early years as president attempting to qualify his new position. In *Summer Meditations*, written in 1991 on the eve of his reelection, he insisted that a person of his experience is not only suited to politics but destined for it, as long as they maintain good instincts and good taste: "The *sine qua non* of a politician is not the ability to lie; he need only be sensitive and know when, what, to whom, and how to say what he has to say." But this must be contrasted with what Havel had written only a few years earlier, in 1985, as a dispossessed citizen in "The Anatomy of Reticence":

> A dissident runs the risk of becoming ridiculous only when he transgresses the limits of his natural existence and enters into the hypothetical realm of real power... Here he accepts the perspective of real power without having any genuine power... he leaves the world of service to truth and attempts to smuggle his truth into the world of service to power without being able or even willing to serve it himself.

311

Plato could not have said it better. And yet this reluctance to seek power turns out to be one of the better measures of a person's fitness for it — as ambition itself is suspect, and a capacity for self-doubt is surely preferable to none at all.

**The Metaphysician-in-Chief**

(In more recent decades, of course, and certainly in America, ambition has lost the odium that was attached to it, and perhaps for the better.) The question that Havel's purist position raises, ultimately, is whether the intellectual's role in society is necessarily an adversarial one, whether the intellectual can acquire power and exercise it without betraying his vocation or the truth.

From his biography we know that Havel had never demonstrated any visible ambition for power, and that he was acutely aware of its toxic effects on the psyche. He was also, by all accounts, undestined for leadership, being not especially gifted with charisma, oratorical power, or bureaucratic savvy. Nor is there much evidence to suggest that he was ever motivated by a sense of vanity — that he wished to be seen as a martyr, or as a symbol of his country's triumph over totalitarianism. Havel could have easily remained in an adversarial role for the rest of his life, scribbling implacably and leaving plays and essays for posterity. But like so many of his contemporaries, he was conscripted into a political life. This is a boomerang of totalitarianism's own making: in seeking to abolish private life, it makes an apolitical life impossible.

Vaclav Havel was born in Prague in 1936, which means that he was two years old at the time of the Munich Agreement and the Nazi annexation of the Sudetenland; and six when Reinhard Heydrich was assassinated in the streets of Prague by a secret Czechoslovak paratroop unit; and twelve at the time of the communist coup ("Victorious February"), which saw his family's property confiscated and transferred to the state. The Havels were a landed family, known for their real estate and

their presence in the film industry, and provided a prominent image of prosperity in a new era of national independence: a cultured and conscious *noblesse*, modeled by Tomáš Garrigue Masaryk, the founding father of the First Czechoslovak Republic, which lasted from 1918 to 1938, and one of the central influences on Havel's political philosophy. Masaryk, himself a Philosopher President, studied phenomenology with Husserl and taught at Charles University in Prague before becoming a member of the Austro-Hungarian parliament in Vienna. Masaryk was an Enlightenment humanist, devoted to the principles of liberal democracy and the right to self-determination. As a politician, Havel frequently located himself in this tradition and the republican values that he believed ran deep in the national psyche.

Branded a "bourgeois element" by the communist authorities, Havel's class background disabled him from attending any academic *gymnasium* or studying the humanities. He almost certainly received a good education at home, but he was by all accounts an autodidact. After dropping out of a technical university in his early twenties, he began working at the Theatre on Balustrade, one of the few creative avenues open to him in the early 1960s, when the political culture in Czechoslovakia began to thaw. In 1963, his first (and still his finest) play, *The Garden Party*, was performed. The play is a satire on the insanities — and the inanities — of communist bureaucracy, and the absurdities of language in which its characters find themselves trapped (unknowingly) in cyclical deliberations, which allow them to speak only in party-line platitudes.

Crucially, *The Garden Party* exploits the intrinsic connection between linguistic manipulation and political manipulation, mocking the socialist *langue de bois* and showing how the "ritualization of language" leads to the ritualization of

thought. Like much of Havel's work, it dramatizes the menace of banality, and reminds us that one of the many tyrannies of totalitarianism is the tyranny of cliché. We also see — in this regard Havel is the heir to Kafka and Hašek — the existential dread that comes from being trapped within a system, which can only be undermined by replicating the features of that system, thus reinforcing (and making oneself complicit in) one's own alienation, something that Havel would attempt to break out of in his own life, in what he described as a search for an "absolute and universal system of coordinates."

Czech politics in the 1960s turned out to be strangely literary. The same year in which *The Garden Party* premiered, the Czechoslovak Writers Union organized a symposium to discuss Kafka's work for the first time since it had been banned as "decadent anti-realism" during the Stalinist period. The symposium is now widely cited as the opening shot of the Prague Spring. Since it was met with no retaliation, the Writers Union convened again every year, and in 1967 it decided to air its grievances with the regime, an event that assisted in the ascension to power of Alexander Dubček, whose democratic reforms set out to create "socialism with a human face." (Before too long Soviet troops put an end to that fantasy.) Havel was not in the forefront of the Prague Spring. His activities in 1968 were mostly rearguard, and he was already displaying a non-partisan, anti-ideological approach, in contrast to his contemporaries, who were largely on the side of reform communism. He nonetheless penned an eloquent essay titled "On the Theme of Opposition," in which he argued for creating a second political party instead of hoping for transformation within the communist bureaucracy.

Havel's real entry into political life came in the 1970s, the era odiously known as "normalization." In 1977, he and

several other Czech intellectuals in the Committee to Defend the Unjustly Prosecuted, known as VONS, momentously published "Charter 77." Written in response to the trial of the (truly) underground psychedelic rock band, The Plastic People of the Universe, it was less a declaration than a reminder of human rights, which the Czechoslovak Communist Party had agreed to uphold at the Helsinki Accords in 1975. The Charter pointed out that in Czechoslovakia any existence of human rights, or a "freedom from fear," was "purely illusory." The extent to which these rights existed was "regrettably, on paper alone," and the regular harassment of citizens--not for openly opposing party ideology--but merely holding opinions that differed from it, constituted "a virtual apartheid." Havel would be imprisoned for nearly four years for his role in helping to draft the Charter, which would circulate as *samizdat* until the revolution, by then accumulating thousands of signatures.

Another of the Charter's signatories was the philosopher Jan Patočka, who had studied with Husserl and Heidegger and had written extensively on Plato, Aristotle, and Masaryk. Patočka's existential phenomenology, which heavily influenced Havel, was based on the very Hegelian notion that history is the process of overcoming alienation, and that "authenticity" comes from engaging in "truth-revealing" activities, which liberate the mind from the technological and political currents of the "everyday" world. Importantly, the phenomenological standpoint intuited a connection between the utilitarian and the totalitarian, in regarding an unspeculative, mechanized life as essentially tyrannous, and its emphasis on personal responsibility constituted a direct threat to state ideology, as it did to the whole "system" of anonymous, depersonalized power.

Patočka, who was nearly seventy, was subjected to many lengthy police interrogations for his role in the

Charter. These sessions were so stressful that he was eventually admitted to the hospital for chest pains, where he died within a week, in March 1977, of a cerebral hemorrhage. But not before firing off two extraordinary essays. One of these was "The Obligation to Resist Injustice," which appealed to "a higher authority, binding on individuals in virtue of their conscience..." and "something that in its very essence is not technological, something that is not merely instrumental: we need a morality that is not merely tactical and situational but absolute." "Absolute" is a very strong word. One notices, even at a glance, how this way of thinking is visibly imprinted on Havel's philosophy. Some of these ideas would be modified — the notion of "authenticity" would be relabeled as "living in truth" — but the language that Havel used, even in his address to Congress years later, is traceable to Patočka's thought.

Despite having been a vocal defendant of Charter 77, Patočka's philosophical approach was essentially Platonic, in that truth, or Truth, was something to be pursued hermetically, outside of the norms of the political order — a necessity, in this case, of living under an oppressive regime. This was the lesson that Plato learned from the execution of Socrates, which made it clear that philosophy could not be practiced in the polis. Where Havel broke from Patočka (and Plato) was in his belief that Truth could be, and must be, discovered socially. He would develop these ideas in his long and imperishable essay "The Power of the Powerless," written in 1978, between the publication of the Charter and his imprisonment the following year. The essay diagnoses the state of one's consciousness under what Havel preemptively termed the "post-totalitarian" age — the last days of a walking-dead ideology, in which the system is held together not by the integrity of its ideas but by a hollow devotion to procedure,

and — crucially — by a mass falsification of opinion.

In Havel's account, life in a post-totalitarian society was characterized by an elaborate fiction, in which people became complicit in their own oppression by their willingness to "live within the lie." Havel uses the example of an ordinary shopkeeper who places a sign in his window that says "Workers of the world, unite!," not because he believes it but because he knows that he is expected to do it: it is a signal of his auto-obedience. He also knows that his neighbor, who might inform on him lest she be suspected, does not believe it either; nor does the policeman who questions him, nor the bureaucrat who penalizes him by reducing his pay. They are all simply protecting themselves. Thus, everyone becomes an instrument of obedience, a link in a chain of mendacity and self-oppression, knowingly contributing to a "world of appearances trying to pass for reality." Any refusal to prop up this world, therefore, is an act of "living in truth." Such a refusal might consist in writing a novel, putting on a play, or simply changing the punctuation on the shopkeeper's sign: "Workers of the world, unite?" What qualifies for being a "dissident" (a word Havel always used in scare quotes) is nothing more than recognizing and pointing out the fraudulence of the world of appearances.

Under such conditions, civil disobedience becomes a somewhat quixotic affair, with the dissident solipsistically battling forces he is powerless to stop and knowing that he will likely be punished for it. Jiří Němec, a Catholic philosopher and fellow member of VONS, once remarked that Havel had "always written as though censorship did not exist." This "as though" is an essential test of one's character, and something that no regime can hope to claim or conquer. Alexandr Solzhenitsyn, another great exemplar of this politically unreachable personal

autonomy, insisted that it is a way of preserving a sense of "innocence." Havel, like Solzhenitsyn, was not just talking the talk: if the Charter was an act of "living in truth," based on a moral obligation to resist injustice, then it was an act that he knew would likely result in his imprisonment.

But at what point does such an act become a display of one's purity? This criticism came from Milan Kundera, who accused Havel of moral exhibitionism (a charge that Havel's detractors would level against him all his life) for the role that he and Němec had played in drafting a petition for the release of political prisoners after the Warsaw Pact invasion in 1968 — a petition that Kundera refused to sign. "Such action" Kundera argued coldly, "has only a twofold aim: (1) to unmask the world in all its irreparable amorality, and (2) to display its author in all his pure morality." Kundera would eventually dramatize this in *The Unbearable Lightness of Being*, in a scene where a newspaper editor ambushes Tomas with a petition for the amnesty of political prisoners, which Tomas considers "possibly noble but certainly, and totally, useless." The more worldly Kundera, who had already emigrated to France by the time Charter 77 was published, would in time be proven wrong. As a symbol of solidarity, the Charter's significance was undeniable. Still, it resulted in Havel's removal from public life for many years — years that might have been more productive had he managed to avoid imprisonment.

When Havel was released from prison in 1984, he wrote "Politics and Conscience," a continuation of his argument against "automatism" and mechanized life. He claimed that the values on which all societies are based are self-evident to us — values that are in our world before we recognize them, or even speak of them, and that these values are tangible in phenomena such as aesthetic revulsion. Havel uses an example

from his childhood, walking to school every day under the smog of a polluting factory, which "soiled the heavens." The existence of the factory is not just harmful to the environment, or to human health, he wrote — it is metaphysically offensive, it violates our "pre-speculative" sense that there is a "hidden source of all the rules, customs, commandments, prohibitions and norms that hold within it."

Havel's critique of the spiritually empty machinery of everyday life went both ways, recognizing that post-totalitarian automatism had an analogue in the West, in the hideously lit spaces of shopping malls and TV screens. He argued that modern consumer societies and techno-capitalist democracies were ultimately unfit as an alternative to communism, because they too released the citizen from a sense of "personal responsibility" and were based on "man-made absolute[s], devoid of mystery, free of the whims of subjectivity." This was not long after Solzhenitsyn's infamous lecture at Harvard in 1978, an acerbic sermon in which he denounced the West for making man the measure of all things and domesticating the human soul in favor of the "cult" of individualism. This bi-directional criticism, this "third way," was not uncommon among dissidents, nor were the appeals to a deeper humanism. Havel was not at all cynical, nor did he stoop to an embittered and reactionary chauvinism, like Solzhenitsyn. Still, his warnings about the culture of nihilism that characterizes "Western totalitarianism" — strong words, coming from him — against which we must rekindle a sense of "higher responsibility" because "man has abolished the absolute horizon of his relations" — these chastisements cut eerily close, and carried clerical overtones.

Havel's vision of the polis was essentially Aristotelian: a state grows out of human relations just as a seed grows into a

tree. Modern civilization, however far it appears to stray from the natural world, is nonetheless founded on a "pre-objective" conscience about our relationship to one another. (Throughout his work, Havel variously referred to this as "anti-political" politics, "non-political" politics, and "genuine politics.") The basis of a society is to serve Truth; it should be predicated on the pursuit of a meaningful life, with humans as ends in themselves. Like Patočka, Havel frequently argued that we are bound to "something higher," though that exact something — Nature? God? Conscience? — is left rather vaporous.

This was the intellectual and "spiritual" (a word that Havel used a lot) opportunity presented by the collapse of communism, which looked like the moment when an "existential revolution" was finally ready to launch, the moment when capital-H History had breached a new epoch, amid George H.W. Bush's declarations of a "new world order" and Francis Fukuyama's celebrated reflections on "the end of history" (a triumphalism that now seems impossibly quaint, or worse). But 1989 turned out not to be the end of history, of course. It turned out to be the resumption of history, after many decades of interruption by History and its vast social experiments that ended in failure and disgrace. Havel rightly understood that this resumption could not be smooth — that the end of communism signaled not just an ideological failure, but an existential one, which would leave deep wounds in the next century if its consequences were not properly identified and treated. Totalitarianism had attempted to denature — or re-nature — human beings, and succeeded only in deforming them. Since the system infiltrated every aspect of existence, attempting to

320

abolish not only private life but also the privacy of the mind, it followed that whatever came in its wake would require some renovation of our sensibilities.

Havel recognized that communism's sudden evacuation from the world left a vacuum in people's hearts, making them vulnerable to surrogate ideologies such as nationalism and religious fanaticism, as well as political extremism and the "primitive cult" of consumerism. In addition to political revolution, a metaphysical revolution was also needed, precisely because totalitarianism sought to eliminate metaphysical life. How this revolution would be achieved he left characteristically vague. Havel claimed that a new "self-understanding" was needed, that "we must discover a new relationship to our neighbors, and to the universe and its metaphysical order, which is the source of the moral order." This existential revolution was not limited to post-communist polities. With globalism in view, Havel argued that one of the great challenges of the twenty-first century would be to overcome a "purely national perception of the world." The only way to transcend this would be to cultivate a "worldwide, pluralistic metaculture" based on a recognition of our common humanity.

But from which body would this new metaculture emerge and be upheld? The UN? A new North Atlantic Treaty Organization? A Metaphysical Council? Institutions — especially rules-based ones — which arise mainly out of the need to restrain truancy are ill-equipped for such a task. After all, it is not the role of the state to be a smithy of the soul. Its spiritual responsibility is, at most, to create the conditions of freedom in which this work can take place. Jefferson understood this, which is why the Declaration of Independence does not offer happiness, but only a door open for its pursuit. The conditions

for this pursuit — human rights and civil liberties — are only the beginning, and securing them is not a guarantee against the nastier aspects of human nature. The question, which Havel addressed only indirectly (it is the question that lies at the heart of the *Republic*), is whether fit people are needed to build good institutions or fit institutions can build good people.

Havel was especially perceptive about what Karl Popper called "holistic social engineering" — the willingness to use human beings in an experimental manner, something that Marxist utopian materialism tried for the better part of a century to hammer out. And here it is worth remembering that the Bolshevik coup, which set this experiment in motion, was brought about by an ascension of intellectuals to power — Lenin and Trotsky were both brilliant intellectuals — who made philosophy the business of the state, believing that it was the job of an educated vanguard to organize life for the rest of society. More still, these men justified their actions by their belief, their certainty, that they were doing good. The corruption of the good is often the worst corruption of all. (*Corruptio optimi pessima*, though the application of that adage to Lenin and his comrades flatters them.) Conscious of this, Havel was careful not to suggest that an "existential revolution" would be the business of institutions conforming to ideologies and the ideologists who propound them. Where Havel broke with the tradition of social engineering from Plato to Lenin was in his profoundly anti-ideological approach. The revolution would be bottom-up and intellectually libertarian, rather than the top-down approach of state-sanctioned philosophy. It was less a call for a "new man" than an appeal to auto-enlightenment.

This drew a poignant criticism from Joseph Brodsky, who knew a thing or two about prison and life in a totalitarian state. He agreed that communism had been a human failure

322

as much as a political failure, but he pointed out that this was less an aberration than another example of humanity's repeated mishandling of the attempt to establish justice. The "metaphysical order" on which new institutions are to be built should thus begin with self-examination and the recognition of our tendency to bungle justice. (A look at how revolutions devour their own and the ways in which the oppressed come to resemble their oppressors is evidence enough.) Among other things, this means that calls for a "perfect society" or a "new man" are to be distrusted on principle, as they are so often the intellectual roots of horrendous social experiments.

Like Jefferson, Havel seemed to believe that institutions could accomplish only so much, and that most of the important work involved building spiritually fit people before we could expect true justice. He was inclined to see our institutions as potential manifestations of our essential goodness — but here we must remind ourselves, against Havel, that the true legacy of the Enlightenment, a time of accelerated transformation in human consciousness, was that the new constitutions, which allowed people the freedom to pursue Truth, were based on the recognition not of our essential goodness but of our propensity for error. We cannot assume that people will become more virtuous; we must assume the opposite. ("If men were angels, no government would be necessary.") A state of civility, however we achieve it, should be a constant reminder of how easy it has been for us at times to abandon it. If this is optimism, it is not quite idealism. And what Havel's picture of the world was lacking was a certain degree of moral realism, which is not the same as cynicism even if it can degenerate into it.

Havel's sense of morality must have derived partly from having lived most of his life under a brutal regime. In such circumstances, it is tempting to perceive oneself as good and true simply by being in opposition to power. The recognition of oneself as virtuous is in many ways a luxury of the oppressed (who do not have many luxuries), one that those in power cannot always afford or justify. Thus, Havel's famous civility — his great strength of character — became his main political weakness. Though he found himself a revolutionary, Havel did not have the rigid, unreflective mind that revolutionaries often need to repress empathy and irony. This is the "old disease" described by Rubashov in Arthur Koestler's *Darkness at Noon* — the tendency to "think through the minds of others." For better or worse, Havel was usually *too* willing to think through the minds of others, of his opponents and his enemies, and he always seemed ready to give them the benefit of the doubt. This was a reflection, certainly, of his own self-doubt. But it left him ill-equipped for some of the harder responsibilities of politics and governance.

The challenge, at home and abroad, was how to build new institutions that could overcome the legacies of totalitarianism, both within the mind and in everyday life. Temperamentally a dissident, Havel was not well prepared to build these institutions, and his idealistic notions of Truth could not find a place in the new circumstances of reform power. He lacked the practical knowledge to construct institutions that would restrain the greed, corruption, and opportunism that followed the collapse of communism in his own country (and elsewhere), in which many former apparatchiks simply changed the color of their ties and went into business for themselves, accumulating pelf in an engorged era of mafia capitalism. One of those characters was Andrej Babiš, a former

StB stooge and the country's second-wealthiest man, who served as the scandal-plagued prime minister of the Czech Republic from 2017 to 2021.

Havel was also unable to restrain the rise of nationalism in his own backyard, when the Slovaks separated from the Czechs on New Year's Day, 1993. The country literally fell apart. He had supported the continuation of the union, but he did not oppose the decision to separate, recognizing the Slovaks' right to self-determination, which had been an important part of Czechoslovakia's independence from the Austrian empire. He argued incessantly for a new global identity, but he could not dissuade the Slovaks from the cult of their own particularism and from secession from the pluralistic federation to which they had belonged since 1918. Havel was one of many impotent leaders who had to watch as the world failed to respond to genocides in Rwanda and the former Yugoslavia, for which he and many others urged international action to no avail. (Eventually the Americans and NATO took belated action in Bosnia, though not owing to Havel-like strictures of conscience.) His noble calls for an existential revolution and a worldwide metaculture came to seem absurd, and blind to the realities of an increasingly Hobbesian and particularistic world.

It should be noted in fairness that the Czech president is a different kind of executive, not ensconced in immense power like the president of the United States, but rather draped in symbolic cloth. A largely ceremonial figure, with the power to sign and occasionally to veto laws, Havel's duties were different from those of other politicians. It was his job, in a certain sense, to raise questions of selfhood, nationhood, conscience, goodness, civility, destiny, determination, the nature of Truth, and the nature of power itself. Still, his philos-

ophy, which he developed as a dissident, showed itself to be inadequate once he came to occupy a position of power. It also revealed the irony of "the power of the powerless," because it demonstrated that the powerful, too, are often powerless — to acknowledge and to act on the truth.

Havel taught that we must trust our conscience. Who will deny it? Yet how does this teaching account for others who do not trust their conscience, or who do not even know what conscience is? How are we to relate politically to people who display no conscience on matters such as Rwanda, or who are content with having power guided only by interests or prejudices? Can you persuade them to have more of a conscience? Do you encourage more self-examination? Surely they will be deaf to such exhortations. (Consider the question of China and human rights.) When Havel became a politician, he experienced the very thing that he had loathed, which is that the calculus of impersonal bureaucratic power domesticates the conscience and restricts its deployment to convenience and expedience. The repeated failure of Western leaders to react to pressing threats and emergencies — the annexation of the Sudetenland, say, a miscarriage of justice that Czechs love to remind the world of — is proof enough of this discouraging understanding of the actual career of conscience in power.

Now, more than eighty years later, with the Russian invasion of Ukraine, we have had to watch yet again as another aggressive, expansionist regime threatens the sovereignty of one of its neighbors and the stability of Europe as a whole, and once more suffer the shame of having done so little to prevent it. Havel supported NATO expansion in Central and Eastern Europe, which would suggest that he had no illusions about Russia. But this lack of illusion was set in a larger intellectual

framework that was rife with illusion. Very few people anticipated that a crabbed and revanchist Russia could once again come under the rule of one man, rebuild a "pact" in its sphere of influence, and strike out against the West. But now that all this has transpired, the view that conscience can suffice as a guiding force in world affairs without the robust assistance of power, and that a "rules-based international order" can act as a deterrent for those who clearly have no conscience, is unrealistic to the point of naïveté. Perhaps naïveté is the occupational hazard of conscience. In any event, the campaign for an increased role for conscience is certainly necessary; but it is dangerous to believe that it is sufficient.

Havel's "letters" to the Czech presidents Aleksander Dubček (in 1969) and Gustav Husák (in 1975) have the voice of a kind of court philosopher, one trying to enlighten his despots in the unwisdom of torturing their subjects. (This was a compromise that intellectuals made for centuries.) But when the intellectual then finds himself in power, does it become his job to turn over the task of enlightenment to society? The question we might ask ourselves is, how much should we ask of our elected officials? Do we want them to be gurus, spiritual guides, telling us in their televised addresses that we need to rekindle our relationship to a metaphysical order? Are we willing to tolerate this kind of talk from tax collectors? Or do we expect them only to perform the tasks of government effectively, and to leave questions of the soul to us, whatever our philosophical qualifications?

Many of the questions that Havel posed in the wake of communism's collapse anticipated what we now recognize as the great challenges of our century: the move from a bi-polar to a multi-polar world of international relations; the tension between national identity and global identity, particularly in

the confrontation with global problems such as environmental degradation; the recrudescence of tribalism, nationalism, fascism, xenophobia, incivility, and a well-heeled techno-utopianism that threatens to make automatons of us all. Addressing these challenges is surely a duty shared by both writers and elected officials. They are both agents in the discourse, but in their own ways. No one (I hope) would dispute that intellectuals have a leadership role in society, and that their responsibilities bend toward an enlightened citizenry. (The definition of this enlightenment can be debated, but there are cruel and violent worldviews that it obviously excludes.) Yet the greatest contribution that intellectuals have made to their societies has generally been made outside the halls of power, and sometimes in opposition to power. When Vaclav Havel went from dissident to president, he tried to make history and found himself at its mercy. His story has an element of late tragedy. We are all, it is true, at history's mercy, including the non-intellectuals who occupy the presidencies and the palaces. But if justice is possible, it will require qualities of will and determination, and a comfort with power, that are not the strengths of saints.

PAULA BOHINCE

# *Albino Deer*

Stunning as noon sun or psychosis aftermath, vase
flung into the garden, but surely the porcelain
was speaking and the mother, she couldn't let it go on
terrorizing the household, could she?
White noise, attention span frail as a ghost crab
clattering into surf, washed backwards into the mist
of Ansel's photographs, synth to soften a century,
gallows clouds fusing with Osipova's jetés in the Bolshoi.
From the green edge stepped innocence, sobs
of snow from the orchestra warm-up (first post-
disaster performance) hushed by the soloing oboist,
slow whole notes, quarter notes hoof-black, O solemn
comet, you bride, you confusion, you phantom.

# *Ouroboros*

Frigid in vibrating daylight, with no distinction
between indoors and out. Ailene on the gurney
asked her children, *Am I dying?* and received
a coward's answer. How she eyed the ward, panicked,
more alive than ever. Once a lounging

teenager, biting the brush end of her braid,
the lattice more alive than ever with carnations.
Braised rabbit hunted that morning, not sleeping, no
indeed, beneath silver. Relieved of instinct.
Retold in a tempo to correct the grievous echo.

# Glass of Milk

Was a swell commandment: drink up, sleep. She'd
relinquished the vampy black and absconded to her toddler
color (muddy sunset) as we, one from each grief stage,
commissioned to flock her, petal'd her pale strapless,
pressed the appliqué along her spine with dancer's glue,
all funds sunk into that silk, hence the wan hors d'oeuvres,
sheepish flasks, White Album on a loop.
Eventual brood snug in her ova, she straightened, candle-
brave before that noonday deadline. Startled nipples
got plastered. A dose of almonds
so no swooning during forevers. Preview
of losing it, Skyping with her guru
to parse the voice of God thunderstruck into the nib of
a midcentury housewife. Waking rapturous, un-entombed,
to commune with birdsong and him in the mystical
five am. An Oona holding hydrangeas, she was. Soon
to vanish into a strobing, off-kilter rainstorm,
the frothy whitecaps of a harbor's embrace and resistance.
There stands her hometown man. A future of borax-
bleached nappies, the Paxil. She turned us a keen look
sailing down satin. Absolute abandonment, *can't come with,*
the fox's grin plunging unabashed into snow drift.

# CELESTE MARCUS

## *A Wounded Loyalty*

*You shall not hate your brother in your heart,*
*you shall surely reprove your fellow and not bear guilt*
*because of him.*

<div align="right">LEVITICUS 19:17</div>

"This last winter was another lost in fog. As usual he did nothing." In this way A.B. Yehoshua introduces readers to the anonymous, plodding, intellectually undistinguished Israeli protagonist of his story "Facing the Forests," which appeared in 1968. The character betrays clumsiness even with his own perceptions, which often strike him as blurry, out of focus. A haze encircles him. At first he seems merely lazy, but slowly, slowly, at the glacial pace of a narrative that unfolds in a universe staggering beneath its own drowsiness, the reader realizes that this man is bound by an incapacitating awareness that something terrible has gone wrong. He has been sewn

into an inheritance, bequeathed to him at birth, which he is powerless to set right. This awareness thickens and befuddles him, affecting him more than it seems to affect anyone else in the story. The other characters are utterly immune to whatever dark reality shackles him in place.

Solitude, his friends decree, will cure him. They propose a plan: he must become a forest ranger — ads in the newspaper assure them that such a position exists. All alone for months on end surveilling the trees in case of fire, this isolation will invigorate him, they insist, and shake loose the clutches of inertia. They do not know what the reader freshly suspects: that inertia is the mechanism by which he ignores an unbearable truth. It *is* his cure, and there is no cure for it.

Since protestation requires energy, which his crushing passivity saps, he finds himself some days later at the Forestry Service where "in a sort of dangerous drowsiness" he cannot stop himself from expressing his disbelief that there are any forests at all in a country as arid as Israel. The manager of the department, visibly insulted, assigns our gloomy hero to one of the larger forests. He will not be alone there; there is also an Arab laborer, about whom "they feel certain he has no prejudices." Before his departure, a friend suggests that he make use of his leisurely job as a scout to finally distinguish himself academically. Why not sink his teeth into a subject — the Crusades, for example? Together they pack a suitcase full of history books.

A truck from the Forestry Service carries him from Jerusalem — "fading like a dream" — into a forest populated with pines so alien to that topography himself is surprised they could take root in the rocky soil. The dream that he leaves behind is a world in which everyone but himself goes about ignoring a past which they are powerless to alter, though it

**A Wounded Loyalty**

hangs heavily over their present and their future. In this land, the Holy Land, more perhaps than any other track of earth, the living live alongside ghosts, and the ghosts preside.

At long last he alights at a small house, a two-story lookout post, in which an Arab man and his daughter also live. The man is mute — his tongue was cut out long ago. ("Did we cut it out or did they?" our hero wonders.) The Fire Scout's solitude remains virtually undisturbed until, soon after his arrival, his timid father comes to visit. In this confrontation between father and son, Yehoshua forces the generations to face one another. The story presumably occurs in the year it was published, which means that the Fire Scout was ten years old when his country was established. His father's generation oversaw that creation, and so this father bequeathed to this son not only a great victory but also a painful past. In the Fire Scout's case, this father is the one responsible — though no single individual bears the blame for the ruthlessness of history.

Father and son sit in silence, broken occasionally by the old man's awkward mutterings as he tries to strike up discussion. Why, he asks, doesn't his son treat the Jewish dimension of the Crusades? The mass Jewish suicides in the Rhineland, for example, rather than the Muslim blood spilled by Christian hands in the Holy Land? This is the only time in Yehoshua's tale that the two histories which are the ultimate subject of the story, winding around one another like twisted arteries, are overtly juxtaposed: the Muslim presence on the land from which the Jews were evicted a thousand years before the First Crusade, and the Jewish longing for return, punctuated and deepened by slaughters in exile. But the Fire Scout does not know this history, and he cannot answer his father. The son smiles and the two slip back into silence.

Their silence is symptomatic of an overwhelming historical ignorance, which is often the condition of citizens who live in the grip of history. This ignorance, and the complacence that it fosters, is the ultimate villain of the story. A day or so before the father leaves, he mumbles warnings about the Arab who might any day set fire to the forest. Why not? he asks. His son offers no answer.

The Fire Scout returns to his books, but after a week heaving himself from line to line, he finds that he has read only three pages. Discouraged and distracted, he ventures out into the forest for the first time since his arrival. On the stones at his feet, he notices brass plaques glittering in the dappled sunlight. The plaques have names stamped on them: "Louis Schwartz of Chicago" and "the King of Burundi and his People." These are the names of donors who have contributed to the national project of afforestation, to plant trees in a land so lacking in them. He stoops and reads plaque after plaque, repeating the names to himself, and is suddenly overcome by a great sadness.

Hikers begin to flow into the forest for the summer. From afar they look to him rather like Crusaders. At night they set small, harmless fires. At first he worries that a stray spark will set the forest ablaze, but after some time he discovers in himself a vague longing to see the trees go up in flames. A group of hikers seeks out the Fire Scout to ask a question: Where exactly is the Arab village marked on the map? It should be here, right in the forest where they are standing. Has he seen it? He assures them that there is no such village. The map must be mistaken. But that night he cannot sleep. The names on the plaques resurface in his memory, taunting him. He climbs out of bed, plods downstairs, and brusquely wakes the Arab on the floor below. When he tries to pronounce the name of the missing

**A Wounded Loyalty**

village, the mute Arab is overcome with astonishment and excitement. He jumps out of bed and points excitedly outside the window. The Fire Scout smiles and retreats back upstairs. So there was an Arab village there, long ago, or not so long ago, before the war for independence in 1948.

A brief historical excursus: Since the first Aliyah (or wave of Jewish immigration to the land of Israel) beginning in 1882, Jews had journeyed across Europe and Russia to their ancient homeland, the promised land, which was then under Ottoman control. Most of the land that these beleaguered, penurious Jews could afford to buy were plots of mosquito-infested swampland owned by absentee Arab landowners who were glad to sell. The pioneers' momentous task was to make that land habitable. It was grueling, maddening work. Some went back to Europe, many died from malaria, others committed suicide. The few that survived managed to drain and convert the swamps into farmland. It was not long before these extraordinary pioneers had established a sufficiently large and thriving society and accumulated enough property — legally, according to the Ottoman legal code which the British, who governed the land after 1922, largely adopted — that the British proposed a partition plan: in 1936, as a solution to the growing conflict between the Arab and Jewish communities in Palestine, the British suggested that the Jews would maintain control of all those regions which were already under Jewish control and the Palestinian Arabs (as they were newly called) would get the rest. The Jewish leadership accepted this proposal; the Palestinian and Arab leadership rejected it. A similar plan was proposed by the British, accepted by the Zionist leadership, and rejected by the Arab and Palestinian leadership again in 1947. On the night of November 29, 1947, when the United Nations voted to adopt the partition plan and

authorized the establishment of a Jewish state and a Palestinian state, Jews danced in the streets. Eight of them were murdered by Palestinians. The British withdrew on May 15, 1948, the State of Israel was declared, and the War of Independence (as the Jews call it) immediately ensued, between the Jews of the new, internationally ratified state and the attacking armies of Syria, Iraq, Transjordan, and Egypt. Israel won an unlikely victory, and territories within the Mandate of Palestine that had been controlled by Arabs before the war came under Israeli control. For Palestinians, the war became known as *al Naqba*, the Destruction, in which many Palestinians were expelled by Israeli forces and many fled. The Palestinians were rebuffed or forced into refugee camps by all of the Arab countries into which they fled. Those who remained within the borders of the newly founded Jewish state became its citizens, guaranteed fundamental rights by its Declaration of Independence, which the Jewish rulers of the state sometimes honored in the breach.

In the decades after 1948, wealthy Zionists from other countries, and many thousands of Jewish families and school-children, donated trees to create forests like the one that the protagonist in Yehoshua's story oversees. These trees grew over evidence of the forest's former life. Nature often erases history, though frequently it requires the cooperation of politics and people. They are historical documents. The Fire Scout begins to perceive this, to notice the revisions in the arboreal palimp-sest over which he keeps watch, though Yehoshua does not communicate this realization outright. He gestures towards it. His Israeli readers know what it means; they understand the implicit condemnation. As Yehoshua — a patriarch of Israeli literature, who died in Tel Aviv last June — said in a speech to Israeli college students a few years ago, "We cannot behave as

**A Wounded Loyalty**

if the war did not happen. We cannot behave as if the Naqba did not happen. Yes, it was a just war. But even in a just war, terrible things happen." His story is a critique of the cognitive consequences of victory. Reading it now, one wonders whether the Israelis have ever adequately faced the forests.

Back in the forest, the procession of hikers gives way to a procession of ceremonies. Donors teem in, the old manager from the Forestry Service returns each day to give speeches and cut ribbons while photographers flash their cameras. New plaques are fastened to rocks, and new trees take root. The Fire Scout confronts his old acquaintance, the manager, who says triumphantly, "You see? There are forests after all!" Before leaving, the manager asks what the Fire Scout's opinion is of the Arab worker at the station, whom a department official suspects of harboring a stock of kerosene. The manager thinks there is no need to worry: the Arab seems a placid fellow. "He's a local isn't he?" the manager asks. "A local?" "Because our forest is growing over, well, over a ruined village... a small village... But that is a thing of the past." Is it?

The Fire Scout's mistress comes to visit him, and insists that he return with her. He refuses, and when she leaves she takes all connection with his former life with her. All hope for return to an untroubled, uncomplicated existence, to a past in which he was ignorant of the forest and all it hides, is extinguished. On the way back to his cabin on a cold evening, he meets the mute Arab. Gripped by a strong desire to warm his hands, the Fire Scout strikes match after match, each of which are blown out by "damp, traitorous air." The Arab stares with wild eyes as the scout walks over to the hideout where the kerosene is hidden, and pours a flask of clear liquid onto the ground. He throws down a lit match and flames shoot up. The two men stand, bodies pressed close to the bonfire, which

338

slowly dies. The Arab watches in despair as the scout stamps out the lingering sparks. "It was only a lesson," the Fire Scout thinks to himself.

The Fire Scout's alienation has thickened after being forced to reckon with the forest's tainted past. He wants his guilt to be exorcized — specifically, he wants the accursed place burned to the ground — but he cannot bring himself to set the fire. He wants the Arab to do it for him. The mute man tries to communicate with the Fire Scout. He gesticulates wildly and thrashes the stump of his tongue inside his mouth so that his whole head shakes. He wants to tell the Fire Scout about his wives who were murdered right here on this land, but the Fire Scout smiles and pretends not to comprehend. "Did there used to be a village here? He sees nothing but trees."

Finally, at midnight on the eve of the Fire Scout's last day on the job, the Arab sets fire to the forest. The scout watches happily at first as the flames lick at his small two-story house. Eventually the Scout grabs the Arab's daughter and carries her for miles, until the pines thin out and give way to parched, struggling shoots. The Arab appears from out of the wreckage, takes his daughter, and vanishes. The police arrive and after a few hours of uncomfortable interrogation the Fire Scout implicates the Arab, as the police had hoped and expected he would. The conclusion is nauseating.

Like the rest of us, Yehoshua's protagonist finds himself in a national community with many of whose inhabitants he would never willingly form a moral community. (There are no morally homogenous communities, no perfectly evil or perfectly good societies.) Disquiet, malaise, suspicion, alien-

ation, a vague but increasingly vivid awareness that he is building on something that is, at least in part, unstable or unjust — all this rises within him. There develops a peculiar heartsickness. It is the special agony of incomplete alienation, the torment of a wounded loyalty.

There are many ways to respond to the immorality of one's own people. The most common response, of course, is no response at all, a numb complacency. Of course one can also righteously defect and relinquish one's membership in the group. This is usually the response of fools who insist on an impossible purity in human affairs. Do its immoral actions morally vitiate an entire polity? Is the United States nothing but slavery and racism? Is Ukraine nothing but its corruption? Is Israel nothing but occupation? (It may be necessary, alas, to remind the present-day reader that Israel's very existence is also an expression of right and justice.) The task is to honor what deserves to be honored and to renounce what deserves to be renounced. Too many Zionists find this too difficult to attempt. They have trouble making such distinctions, as if loyalty is incompatible with honesty. They protest that since Israel is constantly under attack (and its enemies, they argue, never are), only traitorous Zionists would publicly accuse Israel. Such an orientation conditions — insists upon — dishonesty.

What is instead required is heartsickness. Not of the passive sort, to be sure; but heartsickness that provokes debate and dissent and political action. Heartsickness is a healthy expression of patriotism, and it is also an expression of honesty. A Jewish prooftext, if one is required: the exacting duality of heartsickness is broached by the verse in the Torah from which the rabbis deduce that we are commanded to hold our people to account *and* that we not hate them: "You shall not hate your brother in your heart, you shall surely reprove

your fellow and not bear guilt because of him." Such heartsickness is a regular feature of responsible commitment to any state, including the Jewish one.

The Fire Scout's heartsickness is commendable, but his befuddlement and confusion are failings. His heartsickness, like everything else about him, is passive. He cannot bring himself to read the history with which he must reckon. But the realities of power demand, among other things, introspection and unflagging alertness. Moral membership must overpower inertia, platitude, and bleary-eyed habituation. The vague sense that we have inherited guilt must precipitate education and then action, as opposed to brutish outrage or lazy complacence.

Yehoshua's extraordinary story, which was a sensation when it was originally published, is a useful lens through which to interpret the evolution of Israeli politics. In 1968, when the story appeared, the mute and powerless Arab seemed to Yehoshua representative of the Arab-Israeli experience. Much has since changed. The Arabs of Israel still suffer considerable discrimination, but, for now, they have a strong political voice. Mansour Abbas, the heroic member of Knesset who in 2021 secured his party's place as the first Arab party to sit in a governing coalition in Israel, is a repudiation of Yehoshua's wounded, tongueless Arab whose only recourse was to burn the forest down. Abbas joined Naftali Bennet and Yair Lapid to form the coalition that finally ousted Benjamin Netanyahu from power, but Bennet and Lapid would never have been able to invite Abbas into their coalition if Netanyahu had not legitimized Abbas by trying to secure his partnership first. Netanya-

341

hu's cynical courtship of the leader of the community that he had previously slandered had a sanguine consequence: it made Abbas *halal* for Israeli politics. This is what Israeli politics are like: there are myriad rules and biases which dictate what will be construed as too Arab-friendly. Even actors who are impartial to the Arab question (and a growing majority would rather ignore the question altogether than address it in any way) must obey these etiquettes or suffer political obscurity.

Abbas has gentle eyes and a sweet, soft voice. He is often described as a teddy-bear, which is surprising, because he has spent his political career nimbly and courageously walking a hair-thin tightrope in order to accrue and maintain the legitimacy necessary to advocate for his constituents in a political order in which Arab Israelis have enjoyed, before him, practically no influential representation. According to the 2020 national census, there are 1,956,000 Arab residents in Israel, out of a total population of 9,291,000; they comprise twenty percent of the Israeli nation. Most of them live in all-Arab villages in the north and the middle of the country, though about ten percent of Arab Israelis live in integrated villages and cities alongside Jews. Thirty-six percent of Arab-Israelis suffer from poverty, which is double the national average. In the last six years, crime waves have ravaged Arab cities in Israel, and criminal gangs have come to dominate the community. Abbas, who often acts as peacemaker in the bloody disputes between gangs, has pledged that he will serve as an effective advocate to address these and a complicated web of related maladies. His efforts have yielded results: he has secured billions of dollars' worth of support for Arab communities.

Abbas has sacrificed much in order to demonstrate that it is possible to improve conditions for Arab Israelis while

still respecting the Jewish majority: "I'm trying to show Jews and Arabs a new way to live together in which each side will realize itself as a collective and as individuals. It is [my party's] role always to emphasize the rights of the minority, but the majority has rights too, and we have to preserve them as well." For his trouble, he has become reviled both by the Israeli right and by segments of the Arab Israeli population who consider him a quisling and a sell-out. This is because Arab Israelis, who increasingly call themselves Palestinian Israelis to signal solidarity with the Palestinians in the West Bank and Gaza, know very well that Abbas has had to steer clear of the Palestinian issue entirely. He does not mention the occupation, or the national aspirations of the Palestinian people, because if he did the Jewish majority in Knesset would not do business with him. Out of fear for his own safety, he has had to stop praying at Al-Aqsa in Jerusalem. Abbas is confident, however, that a significant majority of Arab-Israelis are heartened by the progress that he has made in the government over the course of the past year.

In his lack of revolutionary sentiments Abbas is a revolutionary figure, rather like what Salam Fayyad once was in Ramallah. In an environment inflamed on all sides by ideology and bigotry, he is a practical man. In his person and in his program, he demonstrates that it is possible for an Arab Israeli to assume a position of leadership in Israel. Indeed, his objective should be the objective of every Zionist and every Israeli: to transform his constituency's conception of citizenship in Israel. He has said with pride that "it has been my great pleasure to gain support among the Arab sector. In most public opinion polls, no less than 60 percent support what we are doing. Even among people who have not voted for UAL [United Arab List] and voted for the other [Arab] party,

the Joint List, almost 45 percent of their voters support what we are doing. Many are waiting and seeing what we can do, what we can accomplish. Of course, this depends on the other side, on the Zionist parties, and whether they will give us the opportunity to succeed. If we succeed, then I have no doubt that more than 85 percent of the public in Israel will support us." He is right: whatever progress he is permitted to make will be determined by the fate of the Israeli right in Israeli politics, and a particularly ferocious segment of the Israeli right is committed to his failure.

In 1968, the same year that A. B. Yehoshua published "Facing the Forests," a man named Meir Kahane founded the Jewish Defense League in Brooklyn. It began as a Jewish vigilante group patrolling high-crime neighborhoods in which Jews lived and were endangered, and then it got into the struggle on behalf of Soviet Jewry, distinguishing itself from more influential groups in that cause with its use of violence: but eventually it became perhaps the most influential, and certainly the most extreme, of the extremist groups in the Israeli right. Kahane emigrated to Israel in 1971, just three years before the official launch of *Gush Emunim*, the Bloc of the Faithful, the movement dedicated to the (illegal) Jewish settlement in the territories that they call Judea and Samaria. Its purposes were strategic — to foreclose any possibility of territorial concessions in any negotiation about the disposition of the territories — and spiritual — to fulfill a religious vision of Zionism with the Bible as its justification. (The settlement saga also began in the year that "Facing the Forests" appeared, when a group of militant religious Zionists posing as Swiss tourists checked in to the

Park Hotel in Hebron for Passover in March, 1968 and then refused to leave.)

In Israel Kahane started promoting what he called T.N.T. — or *teror neged terror*, terror against terror — which in practice meant countering Arab violence with Jewish violence. (A decade later his anti-Palestinian bloodthirst would be fulfilled by a terrorist network of settlers that became known as *Hamahteret* or "the underground.") He preached the rankest hatred of Arabs and promulgated a worldview that was the mirror-image of the worldview that nearly destroyed the entirety of European Jewry. He lamented, for example, "the growing number of Jewish girls who date and sleep with and marry Arabs. Who easily bed the foreign laborers and foreign soldiers. The incredible pollution of the Jewish seed." His blatant, disgraceful racism also matched inch for inch the ugliest expressions of Arab anti-Semitism. It is darkly ironic that, for Kahane's twisted followers, Arab anti-Semitism implicitly legitimated Kahanism. The logic is as simple as it is barbaric: fight hate with hate, ugliness with ugliness, dehumanization with dehumanization.

Forty years ago Kahane developed a strain of Jewish anti-Arab racism which was so morally vile that his party — *Kach*, or Thus!, with a fist for its logo — was eventually banned from the Knesset, in 1985, under the Racism Law, which banned parties guilty of inciting racism. In 1990 Kahane was assassinated in Manhattan by an Islamist Arab gunman who had ties to the terrorist network that would perpetrate the first bombing of the World Trade Center three years later. But his movement, his party, did not die with him. For a while its standard-bearer was a madman named Baruch Marzel, Kahane's right-hand man, who personally assaulted a Palestinian, an Israeli police officer, and a left-wing Israeli

activist, but serially failed to make it into the Knesset. The legacy of Kahanism is now represented in Israeli politics, and prominently, by the foul Itamar Ben Gvir, who was a member of Kahane's Kach party just as his father was before him.

Ben Gvir has given wild speeches at commemorations of Kahane, celebrating his ideology of hatred. For several years he has participated in and led "the flag march", an annual provocation in which xenophobic Jewish extremists carry Israeli flags through the Muslim Quarter of the old city of Jerusalem, reminiscent of the march that Kahane led along that same route the day after his party was elected to the Knesset. Both marches were and are intended to elicit violence. Ben Gvir appears regularly with members of Lehava, a far-right Jewish terror group which, among other things, targets Arab-Jewish couples and community projects. Ben-Gvir calls himself an anti-assimilationist, which is his euphemism for a racist obsession with biological purity. Polls have predicted that his party, Otzma Yehudit, may achieve a significant number of seats in the Knesset after the next election in November. It is not speculation to suggest that Netanyahu will invite him into the governing coalition if it means securing the premiership: Netanyahu flirted with inviting Otzma Yehudit into the government in 2021. Ben Gvir detests Mansour Abbas, of course; he refers to him as a supporter of terrorism, and in a tweet he complained that "after they raised prices and taxes to enrich the terrorist supporter Mansour Abbas, even the prices on bread have risen by tens of percent and Yair Lapid does not care. A disconnected group that does not care if children go to bed hungry. With God's help in the next election we will correct the injustices of the part of 'healing and change.' We deserve better."

This despicable individual became an avatar of the extremist underbelly of the Israeli right in 1995, a few weeks

before Prime Minister Yitzhak Rabin's assassination, when he wrenched the Cadillac logo off of Rabin's car and boasted to the television cameras that "if we can get to his car, we will get to Rabin too." In the intervening years he became a lawyer, and, like Kahane before him, offers legal services to Jewish terrorists. Ben Gvir told a disciple, a woman named Roni who became a member of his gang when she was fourteen years old, that whereas Kahane was defanged because he broke Israeli law, he, Ben Gvir, will cunningly stay within the boundaries of the law while promulgating his doctrine: "They placed Kahane outside of the law. But I will play by their laws. They will not manage to place me outside of the law." And he has succeeded.

The Israeli channel MAKO conducted an interview with Roni about her time under Ben Gvir's influence, and it is among the only windows into his netherworld. Roni recalled that one weekend, when she was fourteen years old, Ben-Gvir invited her and others to his house outside of Hebron (where, incidentally, a monument to Kahane stands in the nearby settlement of Qiryat Arba), and advised the children to go into the Arab casbah, approach an Arab man, and quietly mutter the words "Mohammed is a pig." His plan was to ignite a conflagration. Her interviewer asked, "What went through your mind when you whispered that?" Roni replied: "I would provoke him to start a commotion and then I could say that he started it, not me." She also described another instance when she and a group of Ben Gvirists were together on Shabbat and saw an Arab boy walking alone. They ganged up on him and then ran together into the closest Arab house and trashed it while the family watched. "When you're in such a group," she explained, "you feel like you are in a Jewish supremacy, you feel like you are better than them and... you end up doing things that are not so far from what was done to the Jews." The interviewer

asked, "Because you did something that were not so different from a pogrom?" Roni answered: "Correct." Eventually Roni dropped out of school and went to live on a hillside with other teenagers who would organize attacks on nearby Arab villages and on Israeli army bases.

Ben Gvir has said that he would never represent rapists or those guilty of indecent acts, but he is willing to represent Israeli terrorists such as the ones who used arson to kill the Dawabsheh family in their house in the village of Dum in the West Bank in 2015. "That was an entirely different matter," he explained. "It was not murder for the sake of murder. It was ideologically motivated." At a wedding of right-wing settlers later that same year, videos circulated of the guests stabbing a photograph of Ali Dawabsheh, the baby who had been killed in the fire. Ben Gvir was at the wedding; he said that it took him a little while to realize that the baby in the photo was Ali Dawabsheh, and that when he realized it was, he was surprised and ashamed. Apparently he thought the guests were stabbing photos of a different baby.

Itamar Ben Gvir and his contemptible comrades are useful to extremists on both sides. For those who hate Israel, their ascendance confirms everything that they already believe. For those who hate Arabs, their ascendance whets an appetite for intolerance and cruelty and even blood. Kahane's ideological grandchildren are fittingly responsible for the new mainstreaming of a repulsive Jewish racism. Otzma Yehudit is a minority party, but it is not the smallest minority party in Israel, and it is large enough to figure in Israel's endless and byzantine parliamentary politics. The harsh truth is that the party's extremism has

been steadily normalized, and this has had the effect of shifting the entire spectrum rightward.

Otzma Yehudit's undemocratic tendencies are mirrored by more moderate right-wing colleagues in the Knesset who recently passed a law criminalizing the flying of Palestinian flags in publicly funded places, such as universities. The bill was introduced by Eli Cohen, a member of the center-right Likud Party, in response to a particularly large demonstration commemorating the Naqba at Ben Gurion University. At the debate preceding the vote on the bill, he shouted at those in opposition to "go to Gaza or Jordan." He also snarled at the Arab members of parliament that "Naqba Day is your day of jealousy against Israel... your eyes pop out when you see how we turned the state of Israel into a powerful country." Israel Katz, another member of Likud, declared: "I warned the Arab students who are flying Palestine flags at universities: Remember '48. Remember our war of independence and your Naqba. Don't stretch the rope too thin.... If you don't calm down, we'll teach you a lesson that won't be forgotten."

It is true that a number of the people participating in the protests commemorating the Naqba are agitating for the destruction of the Jewish state. They fly the Palestinian flag, in many cases, because they want the state of Israel to be destroyed and for Palestine to include all the territory "from the river to the sea." Zionists, on any point of the political spectrum, must oppose those aspirations, on moral and historical grounds; allegations of illegitimacy and fantasies of elimination are not criticisms, they are threats. But these same self-respecting Zionists must also allow the demonstrations to take place, because they live in what they love to call "the only democracy in the Middle East," and democracies must tolerate non-violent protest no matter how unpleasant.

**A Wounded Loyalty**

On March 10 of this year, members of Knesset also renewed the Citizenship Law, which bans Palestinians who marry Israelis from obtaining permanent residency in Israel. Whereas the country generally grants residency to most non-citizens who are married to Israelis under a policy called Family Unification, this law was designed to exempt Palestinians married to Israelis from reaping that benefit. About 12,700 such Palestinians live in Israel. Many are not permitted to drive or to open bank accounts. If their marriage ends — through death or divorce — the Palestinian partner may be separated from their children and deported to the West Bank. In early 2022, Ayelet Shaked, the Interior Minister, gave instructions to continue enforcing the law even though it had not yet been renewed. Ben Gvirism is only a few steps away from the spirit of this effort.

It is important to note — to insist — that the Palestinian question and the Arab Israeli question are distinct. The former concerns an occupied population in need of a political settlement, the latter concerns citizens of the state. Those who insist that the Palestinian problem will be solved as soon as Israel halts the occupation ignore the role that the Palestinians themselves play in the perpetuation of violence. Israelis are right to be mindful of the history of Palestinian behavior in the West Bank and Gaza. Though Israel cannot survive as both a democratic and Jewish state unless the occupation ends, the occupation cannot be unilaterally dismantled, at least not responsibly. When Israel tried to do so in the past in part of Gaza, Palestinian extremists responded with violence because they did not want a two-state solution, they wanted a one state solution, which is to say, they wanted the elimination of the

Jewish state. This conflict will not be resolved by people who refuse to acknowledge the dangers to Israel.

Still, as the Citizenship Law makes plain, the Arab Israeli issue and the Palestinian issue often overlap. Arab citizens of Israel are rightly reminded often that in their country they enjoy rights which would be denied them in any Arab country — but they are not in an Arab country, and it is abundantly clear to them, and to honest observers of Israeli society, that they enjoy fewer of the fruits of life in a democracy than their Jewish cohabitants do. It is morally wrong and politically imprudent to strip a minority, especially a large minority, of their rights. These existential disparities only increase resentment — and Palestinian nationalism — among Arab Israelis, many of whom are related to Palestinians who live nearby in the West Bank.

The controversial Nation-State Law of 2018 was another awful reminder that Israel serves it Jewish citizens before its Arab citizens. The law was designed to protect the Jewish character of Israel (as if it is under threat by anything except the prospect of the annexation of the territories), and it states that "the right to exercise national self-determination" in Israel is "unique to the Jewish people." It also stripped Arabic of its status as one of the national languages, and demoted it to a language with "special status." This was a slap in the face of Arab Israelis. The symbolism was clear: Arab citizens are second-class citizens. The legislation underscored the already manifest reality that Arab citizens of Israel are considered by a majority of the Israeli government to be a subaltern group and a threat to the country. It also repudiates the remarkably inclusive and egalitarian spirit of Israel's Declaration of Independence, which somehow found a way to combine a universal guarantee of rights with a powerful statement of Jewish self-determination.

These are just some of the laws that overtly affect Arab Israelis. But then there are the unspoken rules that dictate their quality of life. The crime waves in Arab communities that Mansour Abbas has dedicated enormous effort to quelling should be dealt with by the government, but so little of the national budget (and national interest) is dedicated to the maintenance of Arab cities and villages. The spending package that Netanyahu passed for Arab communities (shockingly, the biggest to date) was largely wasted because the infrastructure was not prepared for the proper allocation of funds. It is incredibly difficult for Arab Israelis to get permits to build homes legally. Many sit on waiting lists for years. Owing to this, most of the buildings in Arab cities and villages in Israel are illegal, which means, among other things, that their homes cannot be hooked up to the electricity grids in the country. Black market electricity circuits are set up in these places, and they explode regularly. In addition, the demolition of illegally built Arab buildings accelerated during the pandemic and left almost a thousand Arabs homeless. If the Bennett-Lapid government had been permitted to last longer than one year, perhaps Abbas would have been able to attend to these and other conditions. But that is a senseless hypothetical: there is a reason the government was forced to collapse. There were just too many opponents of decency.

And all of this leaves aside the other forest: the question of peace with Palestinians. About this the majority of Israelis, like Yehoshua's forest ranger, would rather not think at all. Mansour Abbas was able to achieve as much as he did in a coalition with Naftali Bennet because the two agreed to leave

the issue alone. Abbas has made it clear that he considers it his responsibility to do what he can for his constituents, and that he can only ameliorate conditions for them if he steers clear of the Palestinian conundrum. But I find myself returning to the following questions. There is a politically significant abundance of right-wing Zionists who insist that the only solution to the Palestinian question is the annexation of all territories into a single Jewish state *and* who remind the Arab Israelis at every opportunity that they will never be treated as equal citizens of a Jewish state. As the ancient rabbis used to say when they were incredulous, do their ears hear what their mouths have just said? What do these Jewish patriots think will happen if a one-state solution is declared? Do they imagine that the Arab citizens of their newly established utopia will go merrily into that good democracy, or is democracy not a part of their plan? Do they believe that 3.2 million Palestinians can be smoothly and justly absorbed? Have they forgotten that a permanent demographic majority of Jews in the state is the very essence of Zionism's revolutionary promise of security for the Jewish people?

The right-wing integrationists, in other words, are the ones who need to believe in Arab and Israeli comity from the river to the sea. (They deny this, of course, because for them integration has nothing to do with emancipation and everything to do with domination.) Their single state will be a multi-ethnic state. One would think, therefore, that if they want their single multi-ethnic state to function and to sustain itself, these Zionists' top priority should be the amelioration of the quality of life for Arab Israelis. Why aren't *they* protesting Ben Gvir? Why aren't they protesting the Nation State Law? Why are they regularly insulting the people with whom they propose to share a polity, and already do share a polity?

**A Wounded Loyalty**

Why, indeed, aren't they voting for Mansour Abbas? As it happens, some Jewish Israelis are. Polls indicate that in the next election Jewish votes will account for fully half a seat of Mansour Abbas' party. The handful of Jews who vote for Mansour Abbas represent an enlightened minority. They are taking the future seriously. But most Israelis, like the characters in Yehoshua's story who live in Jerusalem and have never been to the forest, prefer to ignore the problem. Their willful ignorance is one of the villains of our story. Since 1968, Israelis have developed more elaborate methods for ignoring the problem than simply planting trees over it. Highways are designed, for example, in such a way that Israelis never have to look at the long wall that they have constructed between the Israeli and Palestinian populations. (As a security measure, the wall is a success and a necessity. But it has the added "benefit" of shielding Israeli citizens from ever having to face the realities of life on the other side of it.) Except for *Haaretz* and some smaller publications, the reporting on most of these issues is highly selective. There exists an infrastructure for ignorance and indifference.

As should be obvious by now, the kind of Zionists who do not care about the fate of the Palestinians are also the kind who do not care about Arab Israelis. For this and many other reasons, a one-state solution is no solution at all. Is there really any point, at this late date in the history of this conflict, in pretending that neither Israel nor the Palestinians have committed crimes and abuses? But is there really any point in pretending that these crimes and abuses vitiate the right of each people to part of the land? These two peoples are not going anywhere. They have nowhere to go. They both deserve safety and dignity. Their fates are forever intertwined.

Heartsickness is not the same as heartbrokenness. Heartsickness is a finer kind of pain. The unalloyed emotions are more common: usually one is either enraptured or envenomed. But heartsickness is nothing so unitary. Through it one is both steadfast and wounded. It is the only politically responsible kind of loyalty, because it makes room for criticism, even withering criticism, within loyalty, within *ahavat yisrael*, or love of the Jewish people. Zionists, like the decent citizens of all actual states, must learn to be cognitive contortionists, condemning Israel for what it does wrong, praising it for what it does right, and defending it when it is wrongly accused. One must be careful not to commit the Fire Scout's mistake: one must not allow the admixture of diffidence and ignorance to congeal into hatred and incite one to burn the whole thing down. The existence of Israel, and its security, is completely justified. But the duties of a Zionist do not stop at support. One must also not permit a marrow-deep loyalty to compel one to defend the indefensible, or to silence criticism for fear of abetting ideological enemies.

This is difficult work, especially regarding a conflict upon which so many people opine but which so few understand. The conflict itself must be disentangled from the discourse about it, the one which rages on social media and college campuses every time influencers are reminded about that tempestuous plot of Earth to which they have not given a thought since the last related virality. The ferocity of that discourse is sustained by an obnoxious disdain for the full history. Virtually all involved developed their view of the Israeli-Palestinian conflict from the political and cultural environment that they inhabit, without bothering to learn about the mind-boggling intricacies that characterize it. Everyone's position is *a priori*.

On the left, the loudest and most common criticism of

Israel begins and ends with the assumption that Israel is an illegitimate state, that it is a colonialist enterprise, that the Jews materialized in the Levant after the Holocaust as devastated interlopers and that that tragedy blinded the international community long enough to grant that traumatized mass statehood. Jewish history and Middle Eastern history are ignored. Millions of people blithely pass judgment about the existential legitimacy of a country about which they know only what they have gleaned from headlines and infographics. For this reason, they often criticize it for the wrong thing and with the wrong intensity. (I leave aside the considerable segment of Israel's critics, here and abroad, that is animated by anti-Semitism.) Why bother learning about a country that shouldn't exist in the first place? And the loudest and most visible responses from the Zionist right are often also fueled by selective ignorance. They know enough to defend Israel when it is wrongly accused, but not enough to criticize it for its transgressions; or they do not wish to know the latter, because their Zionist pride is too coarse to practice such self-scrutiny. Why bother criticizing a country that everyone else is already lambasting?

Consider the terrible killing of Shireen Abu Akleh on May 11 during an Israeli military raid on the city of Jenin in the West Bank. The raid was precipitated by Arab terrorist attacks that resulted in the death of nineteen civilians within Israel in the preceding weeks. Is nineteen a negligible number? During the raid, the renowned *Al Jazeera* reporter was shot in the head. Though the circumstances of her death remained murky for months, Al Jazeera insisted immediately, with perfect certainty, before any investigation was even possible, that she had been "assassinated in cold blood" by the Israeli army. There was no evidence that this was true, or that it was false;

but news outlets across the globe repeated the "analysis." Most consumers of mainstream media therefore continue to believe that Israel ordered the assassination of a journalist.

For months the Palestinian Authority held onto the bullet that had killed Abu Akleh, preventing a third-party investigation. Meanwhile CNN published a "report" thirteen days after the tragedy which stated that "new evidence suggests Shireen Abu Akleh was killed in a targeted attack by Israeli forces." But the report itself contained no new evidence. Thirteen days is not enough time to conduct a responsible inquiry. *The New York Times* released a report on June 3 in which two experts analyzed the sound of the gunfire from a video recorded close to the site when Abu Akleh was shot. One expert deduced that it was likely fired by Israeli forces from "at least 181 yards... and up to 211 yards away;" the other deduced that it was fired "from a distance of 170 to 196 yards." That means it was fired from about one tenth of a mile away — and Israeli soldiers were about that distance from Abu Akleh at the time. When the bullet was finally handed over to American investigators, the Department of State reported that, though the bullet was severely damaged, it is likely that it was fired by an Israeli soldier. The United States Security Coordinator "found no reason to believe that this was intentional, but rather the result of tragic circumstances." But the *a priori* crowd — the priorists, we might call them — hardly noticed. In their minds the verdict was obvious, and was delivered on the day Abu Akleh was shot. (According to the Committee to Protect Journalists, the number of journalists killed while covering the Israeli-Palestinian conflict since 1992 (25) is significantly smaller than the number killed covering Afghanistan (65), Russia (82), Syria (141) and Iraq (248) during the same period. Moreover, mainstream media outlets do not accuse American

soldiers of "assassinating" journalists when they are killed in battle, but of killing them — a distinction with a good deal of difference.)

Then another terrible thing happened. At the funeral procession held on May 13 in East Jerusalem, Israeli riot police officers attacked the mourners carrying Abu Akleh's coffin. In the videos of the event, a dozen or so armed and helmeted officers can be seen beating the unarmed mourners with batons. The coffin was barely saved from smashing to the ground. The Israeli police later said that they had attacked the pallbearers because the coffin had been carried rather than driven in a hearse, as had been agreed beforehand. The defiling of the funeral, the conduct of Israeli policemen at the event, was a disgrace. But most consumers of mainstream media had stopped paying attention to the Abu Akleh affair before the time of the funeral two days later, and so did not blame Israel for attacking the mourning procession. If the subject comes up, they blame Israel for deliberately assassinating a journalist, which is precisely what Israel did not do. In this way Israel is both wrongly accused and yet not held to account. And so it goes with many events related to the Israeli-Palestinian conflict.

And there are blinding and corrupting ways of defending Israel. Zionists repeat catechismic assurances of Israel's perfect innocence, which is priorism of the other kind. While Itamar Ben Gvir defends Israeli terrorists, many Zionists reflexively point out that there are more Palestinian terrorists, which is true but a way of changing the subject. While Ben Gvir's political strength in Israel grows, many of Israel's defenders protest — truthfully — that the Palestinian government rewards the families of Palestinian terrorists, and that Palestinians give their children candy in the streets when a terrorist murders a Jew. That, too, is a way of changing the subject.

While Israeli Arabs are targeted directly and blatantly by Kahanists, many Zionists point out — truthfully — that the quality of life for Arab Israelis is better than the quality of life they enjoy in any Arab country. Again, a different subject.

Let us stop changing the subject. Is it really so difficult to condemn racist and violent Palestinians *and* racist and violent Israelis? What kind of a democracy justifies itself by comparing itself to non-democracies? These comparisons are sophistical and pathetic. Enslaved to a merely tribal loyalty, such Zionists are derelict in their duties and may preside over the corruption of their own country. After all, Ben Gvir and his supporters, and the radical Israeli right more generally, do not represent the majority, even if the undercurrent of racist hatred in the country is metastasizing beyond tolerable proportions. They depend for their political success on the passivity of the tribal loyalists, of the forest scouts, who are content to put no pressure on their own patriotism and never admit that Israel has moral failings.

It is never the duty of a citizen, or an ally, or a supporter of any cause, to lie, to evade and digress, to refuse knowledge, to suffice with slogans, to ignore or excuse the ugliest permutations of their own community. Right-wing Zionist extremism is growing in Israel. I am not a bad Jew or a bad Zionist for saying so, and you are not a good Jew or a good Zionist for changing the subject. Too many Zionists who live far from Yehoshua's forest teach their children to fear the truth, as if Zionism or Israeli identity cannot withstand it. But the fear of truth is a dereliction of civic duty. The forests must be faced.

**A Wounded Loyalty**

# LEON WIESELTIER

# *The Future of Nature*

*Being implies obligation.*

HANS JONAS

The most unconscionable moral idiocy of our time is indifference to the fate of the planet. I say this humbly, because I have not really said it until just now: I am late to the truth. Not that I ever denied it, of course; deferring to science on matters about which only science has authority is a quintessential act of reason and even of love, if love includes the desire to protect and protract the life of who and what is loved. The problem with environmental concern has been precisely that its grounds are so obvious — it has become a part of the standard equipment of an enlightened individual, an ambient truth dulled by its own ambience. It has produced, since the nineteenth century, a

beautiful literature, whose beauty seems almost a promise of its futility: to read Muir or Leopold or Carson is to be enchanted when one should be agitated. What does "nature writing" have to do with nature policy? In politics, certainly, the cause of the environment, when it is not outrightly rejected by liars and profiteers, occasions more lip service than any other cause. The apocalypse has become a platitude, as it often does. For many years, the temporal distance of the doom blunted the fear of it; time, in a rare role for it, seemed like our friend. And so, like many people, I prevaricated. I cared, but not the most. The truth is never enough to set you free.

Yet now, at least in my case, the fear must be dusted off, and the shock of environmental awareness must be refreshed. Time is a false friend. It helps that the weather is increasingly the breaking news above the fold. (Remember the fold?) Suddenly one must add to the expertise of the scientists the evidence of one's senses. No, every scalding day of summer does not prove that the world is burning up, but it is invidious — it is unempirical — to pretend that nothing is happening, that it has not begun, that the question of climate change is still purely futural. Have we ever lived so meteorologically? Even in regions of the world where human evil seems unsurpassable, the cruelties of the environment are catching up quickly; but then those cruelties, too, are the consequences of human evil — or more precisely, of human action, even of laudable human action, which, if it continues unmodified into this early era of climate disaster, will indeed become a variety of human evil. About some things, the age of unanticipated consequences is over. We know what the planetary effects of some of our actions will be.

What, really, is the other side of this question? Clearly nobody is for environmental holocaust. But there are political

leaders and political parties that, in their anti-regulatory zealotry and their cultural hostility to ecological concerns, may as well be for it. It is indeed the case that scientists may sometimes be wrong; but the fallibility of science is one of its glories, because scientists are the first to acknowledge it, and it comes with a principled impatience for its own correction. The repudiation of science that is now one of the defining characteristics of the American right must not be allowed to hide behind the provisional and experimental nature of scientific research. Being wrong is not as egregious as being stupid. And environmentalists, for their part, must learn to accept that dogmatism is not more attractive when it serves the proper side. The sanctimony of the party of the earth is sometimes hard to take. The worst scenario is not the only scenario. There are many legitimate debates to be had within the community of alarm.

Many years ago I became interested in a debate about environmental regulation between the advocates of the "precautionary principle" and the advocates of cost-benefit analysis. The latter contend that the best way to evaluate environmental damage is in economic terms, as if all of it is quantifiable; and that precipitous action against a particular risk often produces other risks, so that we will only aggravate the problem that we set out to solve; and that a policy of preemption, of general foreboding, would have an excessively inhibiting effect on innovation and growth. The former, the precautionists, who are arguing for extra dollops of prudence, prefer philosophical arguments and humane attitudes that come without the apparatus of social science; they insist that the stakes are too high to think in merely economic ways, which in any event are no guarantee of accuracy or success, and that erring in the direction of caution, which is to say, of economically contested policies, is morally and practically

justified. Precaution has been more popular in Europe than in America, as in this typical declaration of a United Nations Economic Conference for Europe in 1990: "In order to achieve sustainable development, policies must be based on the Precautionary Principle. Where there are threats of serious or irreversible damage, lack of full scientific certainty should not be used as a reason for postponing measures to prevent environmental degradation."

It is hard for me to believe that if sensible precautionary measures, which is to say, regulations unpopular in some of the business community, had been adopted in this country (and some were) years ago, the iPhone and the app would not have been invented. Nor should greed be permitted to disguise itself as a high-minded anxiety about sustainable growth. In truth, our predicament is Pascalian, and it calls for a wager: if a strict regime of regulation makes a decisive difference in saving us, then we (and all life) will have won everything, and if it does not, then we will have lost nothing, except some profits. Better safe than incinerated. My summary of this important debate, which is pertinent to many areas of human affairs, will strike economists as tendentious, and they will be right: in a conflict between economics and ethics, I stop caring about the money. When I listen to the anti-regulatory protestations of many Republicans, what I hear is not much more than expressions of corporate avarice, which are hard to dignify in the face of the dangers under discussion. (I feel the same way about our economic policy toward China: on the one side, concentration camps; on the other side, the terrifying prospect that American executives may not be able to afford summer homes.)

In a time when the early ravages of global warming can be witnessed and not merely modeled, I cannot compre-

hend, except in terms of base human motives, the resistance to ambitious historical action. Capitalism has become hysterical. The biggest whiners in our society are its richest members. Every attempted intervention in American capitalism's own idea of what is best for itself is regarded by its titans as the slippery slope to the Komsomol and the Gulag. Of course, the controversial environmental interventions are animated by values that are not at all anti-capitalist, but they do not concede the primacy of economic values. After all, the question of the place of business in a society is not a question for businesspeople to answer, and not only because they are the interested parties. It is a question of philosophy and politics, about which high net-worth individuals have no special competence. Compare the earthly gains of heavy regulation to the earthly costs of light regulation or no regulation at all, and the hit that American capitalists must take for the good of the earth will seem stupendously slight. (We can always give them medals.) Anyway, isn't existence good for business? And aren't there obscene sums of money — if that is the only language we wish to understand — to be made in new forms of energy and more responsible forms of consumption? And why should the American people be stirred instead by the cause of carried interest? The capitalists of our day are giving capitalism a bad name, which is unfortunate for many reasons, not least because the alternatives to the capitalist order have not exactly distinguished themselves with their sensitivity to the skies. They emit a lot of smoke.

There are few more difficult assignments for the human mind than the calibration of fear. Reason and unreason run smack into each other on this ground. Scholars have developed an enormously sophisticated body of work about risks, probabilities, and the "heuristics" that are required for the

accurate analysis of them. All this is a boon to technocracy, and people who are in the grip of fear — about the environment, about public health, about the economy — should spare a few kind words for the technocrats. They exist because of the diabolical complexity of the perils we face, and their efforts are a tribute to the astonishing expansion of knowledge in our time. We suffer from conditions that we, I mean the ordinary people in the street, cannot sufficiently understand, and so we are hugely indebted to those who devote their lives to doing so. In its coldness, technocracy is a kind of compassion. It is certainly a part of the answer to fear. But it is not the entirety of the answer, because existential fear needs to be addressed by more than governmental policy. The problem of fear, in the individual and in the mass, is a political and cultural and even spiritual problem — a circumstance in which public reason must be supplemented by private reason, and self-mastery must accompany collective action. Those are glib formulations, I know — Stoicism, yet again; but I am afraid. One must find a way not to be rattled by every news cycle, by every report of every flood and every drought and every riven glacier.

The important thing is that the fears of others must not be belittled. We saw the results of such disrespect in the election of 2016. But neither should the fears of others command perfect deference. Nobody's fear can have the last word about us all. Fear cannot be overcome without making discriminations among its varieties. There are instances in which the threat precedes the fear and instances in which the fear precedes, or invents, the threat. There are fears that have a basis in reality, the so-called rational fears, which cannot be reduced to psychology or psychopathology. And there are fears that are expressions of subjective realities searching for objective realities with which to justify themselves, and

**The Future of Nature**

usually finding them. Those latter fears are the ones that hurt people, sometimes many millions of them. The challenge for politics in a populist era is how to address false fears. Of course they will not be constructively addressed unless we are willing to recognize fears that are true, not least in people with whom we disagree. But that is not easily accomplished: the most crushing blow of the pandemic, aside from the number of deaths, was the discovery that not even the plain factuality of the virus sufficed to unite the country, to join us all in a single, empirically warranted fear. If this damaged sense of reality persists into our confrontation with the future of nature, we truly will be the authors of our own destruction.

The singular urgency of the threat to the environment poses also another intellectual difficulty: how to reconcile it with all our other commitments. It is partly for the sake of those other commitments that the campaign to reverse our current course of environmental abuse is conducted. This endangered planet teems with good and beautiful activities (and with bad and ugly activities, of course), and beneath the injured ozone layer there are struggles for justice that do not deserve to be trumped. But there are those who believe that the environmental danger is the danger of dangers, that it trumps everything. Emotionally speaking, the fanaticism on this question can seem commensurate with the fear. Anybody who is not a little panicked is a little crazy. In some instances the fanaticism has issued in violence, in "eco-terrorism," in an environmental suspension of the ethical, though it would be wrong to tar the whole movement with these crimes; and there have also been explosions of "eco-fascism," in which right-wing shooters

have invoked environmentalism as a motive for their racist massacres. (They are the intersectionalists of the right.)

The problem with environmental fanaticism is not that the cause is wrong but that the feeling is wrong. Fanaticism always represents an erroneous analysis of human existence. It erases every commitment except one, and thereby refuses to recognize the unalterably multifarious nature of being human — the multiplicity of the spheres that we inhabit, which is the most fundamental fact about us, more fundamental even than our animal nature because it is our distinction among the animals. We are the species whose diversity is not only external but also internal, in each one of us. We famously search for meaning, and even before we find it, if we find it, we find meanings. There are so many of them because we have so many possibilities and capabilities. Philosophers sometimes call us "self-interpreting beings," and with that capacity for self-interpretation, with our powers of mind and imagination, we surmount our biology, even to the grotesque point of attempting to surmount our mortality. This defining trait of variousness extends also to the assessment of threats: there is never just one. Obviously we should prioritize the threats we face, but almost never down to one. One way of characterizing the abundance of human life — a dark way — is that there are so many things to be threatened, so many things to protect.

"How immensely the world is simplified," Walter Benjamin observed, "when it is examined for its worthiness for destruction." Fanaticism is not the only instrument of simplification in our time. There is a new instrument, a theoretical and ideological innovation, and it has been extended to the discussion of the environment. It is the social and political monism known as intersectionality. It was designed to make the many one. (Monism is the brainstorm of people who are fatigued by their

367

own plurality.) It is a cheap answer to the problem known as the incommensurability of values, which recognizes that there are differences and contradictions, their terms irreducible and irrefutable, that will not be reconciled. Intersectionality knows no such tensions, except with oppressors. It is a theory of the commensurability, the even weighting, of all injustices, though there are victims of prejudice and violence to whom the intersectionalists do not extend their otherwise categorical concern. How ironic it is, that an idea that was originated by celebrants of diversity should be so flattening. Here, for example, is the beginning of a recent book, a rich document of contemporary progressivism, called *The Intersectional Environmentalist*:

> We can't save the planet without uplifting the voices of its people, especially those most often unheard. We should care about the protection of people as much as we care about the protection of our planet. Unfortunately, as with other animals, some humans are endangered and facing a multitude of social and environmental injustices that impact their ability not only to survive but also to thrive in liberation and joy. Why, then, are conservation efforts not extended to the protection of endangered humans and their human rights? This is a question I've struggled with as a Black environmentalist for years, because in my environmental practice, caring for the earth means caring for its people.
>
> When I studied environmental science as an undergrad at a predominantly white institution, social issues were perpetually separated from environmentalism, and sustainability, conservation. As a Black student in STEM,

I had to search beyond the classroom to learn about the contributions of people of color to sustainability. The lack of representation of Black, Brown, Indigenous, Asian, low income, LGBTQ+, disabled, and other marginalized voices has led to an ineffective mainstream environmentalism that doesn't truly stand for the liberation of all peoples and the planet. Social injustice and environmental injustice are fueled by the same flame....

And then the author, a well-known activist named Leah Thomas, continues even more personally:

Patience begins to run out and internal fires begin to burn when you're silencing parts of yourself. Did the environmental leaders I followed understand the gravity of risk associated with Black citizens across the world who faced violence for public demonstrations? Did they understand the fear that I faced at every protest I've attended since watching non-violent protesters in Ferguson be beaten, maced, and terrorized and Black reporters harassed and jailed?

The disconnect was isolating. I watched predominantly white environmental protestors chain themselves to buildings, illegally deface property, trespass, and flaunt their arrests on camera during their protests and I started to wonder: how? When non-violent protesters or innocent Black, Indigenous, Latinx, and Asian citizens are met with injustice for smaller infractions, such as existing, I had to ask: how privileged must one be to so boldly participate in theatrical protests?

Never mind the downpour of cliches. There is an idea here, and a very popular one with a long past unknown to the author. The idea is that every unfairness is like every other unfairness; and luck runs together, too. There is only the party of misfortune and the party of good fortune. In such an account, the similarities between social injustice and environmental injustice outweigh the differences, or there are no differences at all. Warming temperatures are "oppression," like all other oppression. A disconnect, indeed. Or rather, a disastrous connect. I say disastrous, because the conflation of these problems, of these injustices, will have the consequence of making their respective solutions harder to attain, all the joys of solidarity notwithstanding.

One must begin a critical analysis of this progressive mentality by noting immediately that there is indeed a linkage between the injustices that enjoys an incontrovertible basis in reality. There is no question but that the poor suffer environmental afflictions as they suffer all other afflictions: more severely than the rest of us. Is there a more punished land on earth than Bangladesh? They have no need for war; they have water. Moreover, the conjunction of poverty with race and ethnicity validates the claim that in heterogeneous societies such as ours the effects of environmental degradation fall disproportionately upon people of color. (This is not to say that as a rule pollution is racially motivated, though in a case such as Flint, Michigan, and I do not doubt that there are others, the relevance of race is difficult to deny.) Thomas cites a paper by researchers at USC called "The Climate Gap: Inequalities in How Climate Change Hurts Americans and How to Close the Gap," in a journal called *Race, Poverty & the Environment* in 2009, which concluded that "African Americans on average emit nearly twenty percent less greenhouse gases than non-Hispanic whites

per capita. Though less responsible for climate change, African Americans are significantly more vulnerable to its effects than non-Hispanic whites." The distortions of inequality penetrate everywhere. In Flint, inequality was in the water supply.

There are two reasons, however, for dissociating the injustices even when they are experienced by the same people. The first is that, like all "systemic" approaches, the intersectional or conflationary approach increases the difficulty of identifying actual causality and attributing actual responsibility. Isolation may be emotionally crushing, as Thomas attests, but it can be intellectually clarifying. To argue that the hole in the ozone layer was made by racism is to play into the hands of the hole-punchers. Such an account distracts attention from the actual etiology of the crisis, which is the necessary preliminary to measures for change. In the reckoning with how technology and economic development came to disfigure the atmosphere, political and cultural analysis must take a back seat to more proximate causes. In an emergency, one must be concrete. When a scientist or an engineer makes a significant breakthrough in the struggle for the planet, it may turn out that the providential individual in the lab coat or the hard hat is also a bigot, but that must be left for another day. His or her scientific integrity will be all that counts; we possess, or we lack, many integrities, and everyone's record is mottled. And so I could not care less that medical discoveries have been made by anti-Semites. I do not mean to say that science washes away all sins; but the application of science to particular political and social objectives, its historical alliances with good or with evil, is another matter — another blessing or another curse. Moreover, if we were to postpone the healing of our environment for the healing of our society, if the regulation of air and water must await the eradication of prejudice, then we will all

die. The rhetoric of activism is not the language of research and reform. Everybody always complains about the weather but nobody ever does anything about it, said the Catskills comedian, and he was onto something.

The second reason for insisting upon a disjunction between the explanations, for making a distinction between the social climate and the physical climate, is that it honors the scale of the environmental crisis — the natural scale and the ethical scale. I know how I would respond if one of my brethren asked whether carbon is bad for the Jews: I would be embarrassed by the solipsism and amused by the provinciality. The same holds for all other groups. Sometimes only a thin line separates the special pleadings of identities from the special pleadings of interest groups. The analysis of a planetary crisis in terms of identity misunderstands the reach of the crisis, unless of course the identity that is championed is the human one. Now there is an intersection — the one between every living being on the planet! An intersection, and an opportunity for the most comprehensive solidarity in history. Indeed, the planetary character of this crisis arrives as a correction to the plague of particularisms that is injuring so many contemporary societies. There is no greater commonality than the sky. ("When skies are blue," says the holy fool in the Ian Dury song, "we all feel the benefit.")

Is it selfish to evaluate the danger only, or mainly, in terms of one's own? Environmental catastrophe is a great equalizer, and it is equality that we seek, though not only of the morbid sort. It is *wonderful* that we are all in this together. Surely we can devise ways to fulfill our specific identities without squandering the occasion for a genuinely universal affirmation. A great philosopher once wrote that "humanity" is a name not only for a species but also for a quality — that is,

we may interpret our biological being in a way that raises us above it, and above the self. The entirety of the human world now finds itself joined in a single desperate situation, even if it is experienced at different intensities. And so does the non-human world, thanks to us.

For this reason, the environmental crisis should complicate the centripetal tendencies of our society, the post-liberal shibboleths that now abound. The prestige of universalism has long been in tatters, for various sorry intellectual and political reasons, but in recent years we have seen the same scorn applied to the category of the global. It is true that globalism served for decades as an alibi for economic rapacity, and that the globalized economy issued in obscene disparities in wealth and security, though it did raise standards of living for untold millions as well. For these reasons — and for uglier ones, including a frightened international recoil from the strenuous expectations of modernity, such as liberty, democracy, egalitarianism, and toleration — there is occurring a great revival of localism. I am told that even corporations, recently schooled in the fragilities of far-flung supply chains, are now "coming home." The spirit of all this localism is exclusionary and unadventurous. We have become habituated to the tiny idea that all that we must become is what we already are. We regard influences as assaults, as appropriations, as betrayals; we are always policing the cultural and psychological perimeters. Increasingly the only nationalism that we can envision is ethnonationalism. We mistake tradition for a sacralized sclerosis. Within the confinements of our specificities, we exhaust ourselves in strident differentiations from all others. We are authenticity gangsters. When it comes to a generous sense of the other, there is little to choose between the Magyarism of the post-liberal right and the indigenism of the post-liberal left.

As we contract ourselves, however, the environmental crisis requires that we expand ourselves. Not in our customary way, by clinging against all sense to a program of reckless development or endless growth: the earth has had quite enough of our expansionist talents. We are headed into an era of restraint or ruin. No, this time we must expand ourselves imaginatively, by recognizing that similarities are sometimes more significant than differences, and that the local and the global coincide. Culture is replete with examples of this coincidence. When we enjoy foreign music, it is because the local and the global coincide. Is rhythm particular or universal? When we celebrate the beauty of a building whose design is based on native traditions unlike our own, we erase the tiresome distinction between here and elsewhere. There are cases in politics and policy in which the same erasure must be performed. When we oppose nuclear war and nuclear proliferation, are we dreading only for the fate of one, or some, of our communities? When it comes to the environment, every person is a microcosm of our macrocosmic — of our cosmic — vulnerability. This time we represent not only ourselves but also each other. (And owing to our accountability for their predicament, we represent non-human beings and other organic entities as well.) The forces that are now indifferent to the fate of the planet, who are damaging the air and the water, who refuse to accept the science because they are economically dependent on, or prosper from, fossil fuels — they are the ones who represent only themselves.

"You shall not take a wife nor shall you have sons and daughters in this place. For thus said the Lord concerning the sons

and concerning the daughters born in this place and concerning their mothers who bore them and concerning the fathers who begat them in this land: Deaths by illness shall they die. They shall not be lamented and shall not be buried. Dung on the face of the soil they shall become, and by the sword and by famine they shall come to an end, and their carcasses shall be food for the fowl of the heaven and the beasts of the earth." The sixteenth chapter of Jeremiah records this Divine admonition to the tormented prophet. The promise of catastrophe compels a drastic renunciation: Jeremiah is forbidden to have a family, to wed and to have children. The prohibition flies in the face of God's first instruction to humankind, which was to be fruitful and multiply, and also in the face of the moral priority of the family that was established in the Biblical pre-history of Judaism. It also defies the ancient Jewish belief, stated in the Psalms and elsewhere, in the eternal perdurability of the Jewish people. It is a shocking punishment. But it is not delivered as a punishment: the ferocity of God's description of the coming horrors makes the command to the prophet seem almost merciful. Jeremiah will be lucky: he will have less to lose, his childlessness will spare him the savage experience of parental bereavement. It would be wrong to bring children into such a world, says the deity who has authorized the inexorable atrocity.

"Is it still OK to have a child?" Not long ago Alexandria Ocasio-Cortez asked the question on social media. This is more radical than anything in the Green New Deal. But the question is not hers alone. Environmental alarm has shaken many people's confidence in the future to the point of their speculating about a willing abdication of it. A parent who reads the macabre timeline to 2° C and its aftermath is immediately put in mind of the age of his own child. (I speak from unpleasant experience.) In a brilliant essay in the

375

*London Review of Books* two years ago, Meehan Crist reported that "I have spent more time than I'd like to admit scrolling through posts by people who have made the decision not to have children because of the climate crisis. These posts radiate varying degrees of fear, despair, political commitment, solidarity, anxiety, and a care for and delight in already existing children." One such post read: "I always imagined myself having children. However I have felt incredibly hopeless for our future for many years because of the interaction [*sic*] of governments on climate change ... I love kids and feel deeply saddened by this, but I would not willingly want to bring a child into a world I see will be plagued by disaster, ruin, famine & wars... total destruction." Another post read: "The science is clear. We are about to witness the destruction of everything we love because of the climate crisis. I feel incapable of welcoming an innocent human being into this world knowing the facts." Crist's essay was cited by Jia Tolentino in a heartfelt but somewhat incoherent piece in favor of abortion in the *New Yorker*, where she noted: "I gave birth in the middle of a pandemic that previewed a future of cross-species viral transmission exacerbated by global warming, and during a summer when ten million acres on the West Coast burned. I knew that my child would not only live in this degrading world but contribute to that degradation."

Along with the ecological skepticism about reproduction, the outraged response to *Dobbs v. Jackson Women's Health Organization* has contributed to a certain progressive disenchantment with pregnancy. "It was violent even as I loved it," Tolentino remarks. She describes "the paralyzing back spasms, the ragged desperation of sleeplessness, [and later] the thundering doom that pervaded every cell in my body when I weaned my child." And she concludes: "Abortion

is often talked about as a grave act that requires justification, but bringing a new life into the world felt, to me, like the decision that more clearly risked being a moral mistake." By all the authority vested in me by fatherhood, I cannot follow her. I do not live in a surfeit of enchantment, and "a new life," if it landed in a basket at my doorstep like in the old movies, would justify adjustments to my urbanity. Or at least it could not be summarily dismissed as a "moral mistake." My mother once told me that, when I was three years old, I rushed home from school one afternoon to tell her exciting news: I had just learned that because I was a boy I would never have to endure labor pains. It was good to be me! Later the gender boundary — the womb that I lack — prompted me to empathy and respect: women have physical and biological experiences that men can only imagine, if they can, and their singularity in this regard must be honored. But the fact that I cannot speak about the birth process from the inside does not disqualify me from speaking about it altogether. (Women have hardly been inhibited by their personal unfamiliarity with the subjectivity of manhood from telling men how to live; women's knowingness about men is one of the salient themes of our culture.) So the bad reputation of pregnancy troubles me, and not only because I have a gamete to give. Soon afterward, in *The New York Times*, Amanda Hess, one of the paper's gender commissars, developed the alienation further. "Pregnancy" she complained, "has the power to render any body ridiculous. And yet, as I trudge down the street, my increasingly preposterous dimensions inspire such affirmational outbursts from strangers that I feel at the center of an immense gendered conspiracy, where the self-evident absurdity of my physical situation is instead pitched as the cheerful apotheosis of my life as a woman." And this: "Though I am of course aware of the

377

biological process through which babies are made, it still feels so supernatural that if you told me that people get pregnant by gobbling up live infants, I might believe it." I am quite sure that there is nothing that I, or perhaps any man, could have said to relieve her distress. But I swear I never saw a pregnant woman who looked absurd to me.

There are two ways in which human fertility is considered bad for the planet. The first is that the decaying world will be bad for the child. The second is that the child will be bad for the decaying world. The latter worry is as old as Malthus, and eventually issued in the doctrines of population control and family planning. Those doctrines insist that every decision to have a child, a personal decision if ever there was one, must include a sense of planetariness; and that on the same cosmopolitan grounds measures must be introduced to lower the numbers of involuntary pregnancies and unwanted children. Or, to put it differently, love and desire must find a place for reason, so that values can have an influence on passions. All this, of course, is premised on a consciousness of limits, which is easier said than done for limited beings with dreams of limitlessness. The population of the world is now close to eight billion. The fastest doubling of the world population occurred between 1950 and 1987, from two and a half billion to five billion. The peak population growth in a single year — 2.1% — happened in 1962, and the rate of growth has somewhat slowed. By the end of this century the planet is projected to hold more than eleven billion people. The case for population control is completely persuasive, and the distaste for large families among secular people in the West is morally admirable if emotionally unattractive. (It is worth noting that there may be groups who demand an exemption from demographic austerity as a consequence of historical injustice.

Consider the prodigious fertility rates of haredi Jews. Of all the Jewries that were decimated in the Holocaust, the haredim were among the most decimated. Their rate of reproduction is owed, if you will pardon the expression, to a replacement theory, but they are not replacing the living, they are replacing the dead. Genocide, after all, is also a method of population control. There are tens of millions of Jews missing from the world today. When I was growing up, I often heard Jews assent to the idea of population control on condition that we do not go first. My inner universalist and my inner particularist began a battle that has not yet ended.)

The world will not be redeemed, of course, by a loss of enthusiasm for babies in progressive neighborhoods of the West. But that is hardly the only objection to such a policy. The decision not to have children so as not to increase the burden on the world's resources is based on a probability, not on a certainty; and the precise probabilities for particular calamities differ, including among scholars. There is, again, a plethora of scenarios. I cannot pretend to be impartial about the outcome of this debate, or to follow only my intellect. There is an outcome that I wish, and it looks like a child. And so I intend to think my way out of the Jeremiah paradigm, and refuse to allow (in Crist's splendid words) "the toxic logic of the carbon footprint to shape our sense of what [is] possible." This is not only for sentimental reasons; there are also philosophical reasons to eschew fatalism. There is a lower limit of human renunciation beneath which life is no longer recognizably human. Human parenthood serves more than a merely evolutionary end; it is a laboratory of our beliefs, of our understanding of the aims of human existence. Thoughtful parenthood is lived philosophy. And history has shown again and again that survival need not require a

**The Future of Nature**

surrender of our deepest purposes. There are many ways to propagate the species and the communities that comprise it, but childlessness is not one of them: it is another technique of extinction. Why would we mortify ourselves for the sake of nature if we did not hold that our humanity, our supra-natural meaningfulness, is worth preserving? The good news about climate change, as well as the bad news, is that it is a dynamic situation, and a great deal will depend on how we intervene against it. We have not yet really begun the fight.

The question of the environment is the question of technology. It was technology that enabled us to despoil the environment and it is technology that may enable us to repair it.

I met Hans Jonas before I knew who he was. When I was seventeen, and a little restless at the end of my high school years, I received permission from its intellectually encouraging principal to attend a few night courses in philosophy at the New School for Social Research. One of the courses was on pre-Socratic philosophy — the remarkable rabbi who was the head of my school had agreed to my study of *chochmah yevanit*, or Greek wisdom, which was precisely what the ancient rabbis had forbidden me to study! I still remember the strange magic of reading Anaxagoras and Parmenides on the D train from Flatbush to Greenwich Village. The instructor was a certain Professor Jonas. I did not know that he was the author of probably the greatest book ever written about Gnosticism, or that he was one of Heidegger's most distinguished students (the faculty of the New School in 1969 was rich with students of Husserl and Heidegger) and then one of Heidegger's most withering critics, or that he had been a confirmed Zionist who

lived in the *yishuv* in Palestine for sixteen years, or that he had served as a soldier both in the Jewish Brigade of the British army in the Second World War and in the Haganah, or that he was the world's preeminent philosopher of the environment. Some of his earliest elaborations of his philosophy of biology, his "philosophy of life," were made in 1944 and 1945 in "didactic letters" to his wife during his military service in southern Italy. The man was, in a word, a hero. I had never before heard such a pure philosophical voice. Many years later we came to know each other and I was able to express my admiration. By that time I had read his environmental-philosophical writings — first *The Phenomenon of Life*, according to which "the organic even in its lowest forms prefigures mind and mind even in its highest reaches remains part of the organic," and which appeared in English in 1966, and then *The Imperative of Responsibility: In Search of an Ethics for a Technological Age,* his masterpiece, which appeared in English in 1984. When its German original appeared in Germany five years earlier, it was a sensation, intellectually and politically. He died in New York in 1993.

In his posthumously published memoirs, Jonas attributed the enormous influence of his book "to the general recognition, which even then relatively attentive observers could less and less ignore, that something could go wrong with the human race, that it was even on the verge of putting its own existence in jeopardy through ever-increasing technical interventions in nature." The critique of technology was one of the distinctive contributions of German thought in the twentieth century: from Heidegger to the Frankfurt School, in their different idioms, technology was denounced as a way of denaturing the human, of compressing the individual into a life of pure instrumentality, of alienating us from what we

most profoundly are. "There are times," Jonas wrote, "when the [technological] drive needs moral encouragement, when hope and daring rather than fear and caution should lead. Ours is not one of them." And Jonas went further. In his writings technology is not an impersonal force that acts upon us. He was exercised not only by what technology is doing to us, but also, and even more, by what we are doing with technology. And so he was moved by the plight of nature, technology's great target, because his "philosophical biology" persuaded him of the unimaginability of human meaning without the nexus with the natural world. In technology Jonas saw, above all, human agency. His critique of technology led him directly to ethics, because human agency implied human responsibility. There was nothing anti-modern about him. He did not bemoan our powers; he demanded that they be responsibly used.

The primacy of ethics in Jonas is not to be confused with the primacy of ethics in Buber and Levinas. The ethical relationship that Jonas enjoins is larger and deeper: it is not a relationship between individuals and it is not occasioned by an encounter with an "other." For Jonas, "being is obligation" — not social being or communal being, but being itself. Heidegger's renegade student was still in the business of ontology, except that it served for him as a basis for duty rather than rapture. In Jonas' account of the human, to be alive is to be responsible for life. One takes away from his work an indelible sense of stewardship. He is a philosopher of our obligations to the world. (His teaching is a little reminiscent of Aldo Leopold's "land ethic" and "ecological conscience.") Our species-task is to do everything we can to avoid what he nicely calls "the apocalypse of the 'too much.'" And this requires a new ecological focus. "We know the thing at stake only when we know that it is at stake," Jonas wrote. "Because this is the

way we are made: the perception of the *malum* is infinitely easier to us than the perception of the *bonum*."

But is that really so? The widespread spectacle of environmental complacence would suggest otherwise. The *malum* is everywhere and it is still unimpeded. Perhaps our ability to sustain a commitment to historical change died with the death of our attention. There is also a vexing political dimension to the environmental challenge. Aside from the satisfaction of doing the right thing, is it realistic to rely for the salvation of the planet upon the consciences of individuals? Will there ever be enough of them, in our country and in others, to form a social basis for decisive ecological action? Did David Buckel, the man who set himself on fire in Prospect Park in Brooklyn some years ago because "my early death by fossil fuels reflects what we are doing to ourselves" — did his suicide change a thing? The biologist Garrett Hardin, in a famous lecture on "the tragedy of the commons" in 1968, warned, against the grain of his conscience-stricken time, about trusting in appeals to conscience: they would produce mainly anxiety and "feelings of guilt in non-cooperators." Moreover, decisive ecological action will involve infringements on personal freedom — not for the first time in our constitutional order, to be sure, but these infringements may be ascetic and rough. Hardin called them "mutual coercion mutually agreed upon." But we are not living in the heyday of mutual agreement, and there are powerful interests at work to prevent any such consensus, even though Congress has passed the Inflation Reduction Act as I write. Nor are we living in a society with any special skill for mortifying itself even in the name of a high ideal.

Recall the conundrum of population control. Hardin cites a resolution in the United Nations in 1967 that reads: "The Universal Declaration of Human Rights describes the family as

the natural and fundamental unit of society. It follows that any choices and decisions with regard to the size of the family must irrevocably rest with the family itself, and cannot be made by anyone else." From the standpoint of the failing environment, however, this is untenable. The family's autonomous power to determine its own size cannot be completely sacrosanct. But what political power will revoke it, or modify it? Will the government deliver the blow? That will depend on its composition — on us. We live in a democracy: arriving at a social basis for policy is how we govern ourselves. We believe, as a matter of principle, in persuasion and deliberation, one by one by one. But there will never be a majority of citizens who will agree to allow the government into the bedroom, China-style; and their objections will not be shabby or mischievous. That is why the logic of environmental reform has led certain thinkers into heretical precincts of thought. "Coercion is a dirty word to most liberals now," Hardin remarked, "but it need not forever be so." It comes as a bit of a shock to read Jonas, who was a lifelong foe of totalitarianism and whose mother was murdered in Auschwitz, suggest that "in the coming severity of a politics of responsible abnegation, democracy (in which the interests of the day necessarily hold the stage) is at least temporarily unsuited, and our present comparative weighing is, reluctantly, between different forms of 'tyranny.'" Socialism — by which he meant a directed economy — "has an advantage here." Many readers were upset by these pages in *The Imperative of Responsibility*. They are weak pages. Which socialist or communist regime has ever improved the environment?

Jonas was aware that his "reluctant" conclusion about politics, his uncharacteristic soft spot for *dirigisme*, was owed to his importation into political philosophy of a criterion — will it protect life? — that is not native to it. The environmen-

talist imperative was given sway over everything else, including liberty. And yet Jonas' perplexity must be faced. The question of whether the many processes of democracy can work effectively enough and efficiently enough to retard and reverse our present trajectory is a discomfiting question, because it may not have an edifying answer. The scale of the crisis and the speed of the crisis mean that solutions will have to be the work of concentrated political power. Bold legislation and stringent regulation, the work of elected bodies and federal agencies, need formidable political cover. Does the cause of the planet warrant a "unitary executive" of its own?

Once nature mastered us. Then we mastered nature. Now we must master our mastery. Hardin was wrong when he assured his listeners that "the tragedy of the commons" was a "no technical solution problem." In the end, so that there will be no end, we may be dependent on technology to save us from the ravages of technology. This is certainly more likely than a massive intellectual and political mobilization across the globe and its various regimes to enact with alacrity a broad and concerted series of unilateral and multilateral measures to reverse all aspects of the planet's decline. We may be wiser to turn to Prometheus to make amends for the excesses of Prometheanism. Our powers can take back what our powers wrought. Science and technology can vindicate themselves as never before. The prospects for humility, then, are mixed: a crisis that was supposed to convince us of the limits of our power may require more gargantuan exercises of it. The instrumental mind may yet save us for the elevated life beyond instrumentality. With some luck, we may preserve both the earth and the republic.

**The Future of Nature**

Liberties

387

# CONTRIBUTORS

**CASS R. SUNSTEIN** is the Robert Walmsley University Professor at Harvard Law School and is the author, among other books, of *This is Not Normal*.

**CARISSA VELIZ** is an Associate Professor at the Faculty of Philosophy and the Institute for Ethics in AI, as well as a Tutorial Fellow at Hertford College, at the University of Oxford. She is the author of *Privacy is Power: Why and How You Should Take Back Control of Your Data*.

**EKATERINA PRAVILOVA** is a professor of history at Princeton, and the author of *A Public Empire: Property and the Quest for the Common Good in Imperial Russia*.

**RICHARD TARUSKIN**, the great musicologist, died in July. He was the author, among many books, of the *Oxford History of Western Music*.

**CLAIRE MALROUX** is a French poet and translator and the author of *Daybreak: New and Selected Poems* translated by Marilyn Hacker. **HENRI COLE** is an American poet and translator, and the author most recently of *Blizzard: Poems*.

**RICHARD WOLIN** is a professor of intellectual history at CUNY Graduate Center in New York. His new book, *Heidegger in Ruins: Between Philosophy and Ideology*, will be published this winter.

**MARK POLIZZOTTI** is the author among other books of *Revolution of the Mind: The Life of Andre Breton*, and a translator. He is the publisher and editor in chief of the Metropolitan Museum of Art.

**JONATHAN ZIMMERMAN** is a Professor of History of Education at the University of Pennsylvania. He is the author most recently of *Free Speech: And Why You Should Give a Damn*.

**MARISSA GRUNES** is a poet whose work has appeared in *Nautilus*, *Atlas Obscura*, and *The Paris Review*.

**ANDREW BUTTERFIELD** is President of Andrew Butterfield Fine Arts, and was Guest Curator of *Verrocchio: Sculptor and Painter of Renaissance Florence* at the National Gallery of Art.

**SCOTT SPILLMAN** is a writer based in Denver.

**LEORA BATNITZKY** is the Ronald O. Perelman Professor of Jewish Studies at Princeton.

**HELEN VENDLER** is the A. Kingsley Porter University Professor Emerita at Harvard University. Sylvia Plath's "Morning Song" is from *Collected Poems* (HarperCollins Publishers, 1992). Copyright © 1960, 1965, 1971, 1981 by the Estate of Sylvia Plath. Editorial matter copyright © 1981 by Ted Hughes.

389

**JARED MARCEL POLLEN** is a writer living in Prague. His book *Venus&Document* was published last spring.

**PAULA BOHINCE** is the author of three books of poetry, including *Swallows and Waves*.

**CELESTE MARCUS** is the managing editor of *Liberties*.

**LEON WIESELTIER** is the editor of *Liberties*.

*Liberties — A Journal of Culture and Politics* is available by annual subscription and by individual purchase from bookstores and online booksellers.

Annual subscriptions provide a discount from the individual cover price and include complete digital access to current and previous issues along with the printed version. Subscriptions can be ordered from libertiesjournal.com. Professional discounts for active military; faculty, students, and education administrators; government employees; those working in the not-for-profit sector. Gift subscriptions are also available at libertiesjournal.com.

*Liberties — A Journal of Culture and Politics* is distributed to booksellers in the United States by Publishers Group West; in Canada by Publishers Group Canada; and, internationally by Ingram Publisher Services International.

LIBERTIES, LIBERTIES: A JOURNAL OF CULTURE
AND POLITICS, is published quarterly in Fall, Winter,
Spring, and Summer by Liberties Journal Foundation.

ISBN 978-1-7357187-8-1
ISSN 2692-3904

Printed in Canada.

The insignia that appears throughout
*Liberties* is derived from details in
Botticelli's drawings for Dante's
*Divine Comedy*, which were executed
between 1480 and 1495.